Photoshop Element
for
Digital Art, Illustration & Cartoons

Drawing, Painting and being Creative in Elements

INKLINE PRESS

Photoshop Elements 8 for Digital Art, Illustration and Cartoons

Copyright © 2010 Chris Madden

ISBN: 0-9548551-5-9

Published by Inkline Press

Quick Contents

Contents

Contents

Contents

PART 3 Working on Images

Chapter 6: Brushes (& Erasers)

Chapter 7: Working in Black and White for Print

Contents

Contents

Chapter 10: Cutting, Copying, Pasting and Moving

Contents

Chapter 11: Adding Colour

Chapter 12: Altering Colours

Contents

Contents

Contents

PART 4 Scanning Outputting Organizing

Chapter 17: Scanning

Contents

Chapter 18: Outputting

Chapter 19: Organizing

Chris Madden started creating artwork on computers in the mid 1980s while working as an illustrator and graphic artist for the Guardian newspaper and the Press Association news agency in London. He is now a freelance cartoonist.

By the same author

The Beast That Ate The Earth
A Funny Year In The Garden
Where Are We, What Are We, Why Are We?

Introduction

This book is for anyone who wants to produce artwork on a computer. The only qualification needed is that you don't know how to do it yet.

Drawing and painting on a computer may sound slightly daunting when you first think about it, but in many ways it's actually much easier to undertake than working on paper. In fact, once you've got used to being creative on a computer you may find that it's more intimidating to be confronted with a pencil and a large sheet of white paper than with a computer screen (because you can ruin the artwork on a sheet of paper with one careless slip of the hand, which is something that's much less likely to happen on a computer).

And when it comes to using colour there's no contest. On a computer you have millions of colours to choose from, any one of which you can pick almost instantly. Not only that, but after you've applied your colours you can then alter them all in a matter of seconds, literally changing blues to greens or reds to yellows until you get exactly the colours that you want. And all with no mess or cleaning up afterwards.

It's not only colours that you can change on a computer. You can change just about everything in an image over and over again until you get it right, as there's never a final moment of commitment.

The learning curve for acquiring the skills involved in drawing or painting on computers may seem quite steep at first, but the reason for that is because you're being confronted with the whole range of incredible creative possibilities all at once. Taken one step at a time the whole process isn't anything like as daunting as it first seems.

And remember that creating traditional art isn't exactly child's play itself. Even the humble pencil can be quite a hard instrument to manipulate in order to achieve its full potential, and as for creating a basic watercolour painting – that's definitely no simple task, Water's a very tricky medium to work with because it's so wet.

Of course you probably know all this already, which is why you're reading this book in the first place. So I won't go on. Let's just crack on with something that you don't actually know yet.

Get that computer turned on and pick up that digital pencil.

Let's find out how to draw a learning curve.

How the Book is Laid Out

Typical manuals for Photoshop Elements are aimed primarily at using the programme to manipulate photographs, so naturally they have section after section on how to alter and adjust photos. Because of this concentration on photographic images most manuals follow a route that isn't necessarily of direct relevance to someone who wants to learn how to draw and paint using the software. Few people would want to read a book about photo editing in order to learn how to use a paintbrush, but with Elements manuals that's about the only option available.

This book remedies that situation.

The basic techniques of drawing and painting in Elements are essentially very simple skills to acquire, so the book includes a step by step 'quick start' section – a guide to the fundamental, no frills techniques necessary to create artwork. This is a hands-on section introducing specific features for creating finished artwork, with no technical knowledge required whatsoever. This whole section can probably be completed in only one or two sessions at your computer.

Later chapters elaborate on different aspects of the programme, starting with those that are most useful to the drawing and painting processes such as the use of brushes and layers. Later chapters deal with more esoteric subjects such as how to embellish work by using special effects.

The final chapters deal with importing work using a scanner, printing your work, putting it into emails or onto the web and, finally, organizing your ever increasing number of images so that they are easy to find again.

The Graded Contents System

The contents of the book are split into three categories, shown below. They're based on importance and complexity. You can identify the two more complex categories by the shaded strips down the sides of the page. This allows you to concentrate on the parts of the book that are relevant to you, and saves you the bother of wading through pages of information that is either too complicated or too basic, or too irrelevant.

The Essentials and Basic Skills
(No strip)

If you're new to Elements you can concentrate on this category, skipping the other sections (indicated by a shaded strip down the side of the page) until you're more familiar with the workings of the programme.

This category deals with the knowledge and skills that are necessary for the basic, competent use of the programme.

Intermediate Skills

You can use Elements satisfactorily without knowing a lot of the information in this category. Read these sections when you're ready to broaden your skills and increase your enjoyment of the programme.

Advanced Knowledge

This category deals with aspects of the programme that you can probably manage without knowing about for months, or even years – by which time you'll be so familiar with the programme that these subjects won't seem as complex as they would if you came to them as a novice.

Before You Start: Seeking Help

Should you ever be working in Elements and you find yourself in a position in which you don't know what to do next Elements offers you a number of ways of seeking assistance.

Like most software, Elements provides a selection of Help pages – a form of digital manual – that you can access by clicking the word Help in the menu bar at the top of your screen. If you're using a Mac you can also access the pages via the question mark button near the top left.

The Help pages don't open in Elements itself but in your web browsing software, such as Internet Explorer or Safari.

The Help pages come in two forms – one form that's stored on your computer, where it was placed when you installed Elements, and one that's available over the internet on Adobe's web site. If you're connected to the internet when you press the Help button you'll be automatically routed to the on-line version. The on-line pages are more comprehensive than the version that's stored on your computer, which is a pared down edition with fewer pages.

The full, on-line version of the Help pages can be downloaded as a 300 page manual onto your computer in the form of a pdf file (by clicking the link at the top of any of the Help pages). Placing this pdf copy on your computer means that you can access the full pages without having to be on-line. It's a large file so it may take a while to download if you're on a slow connection.

There are other ways to access the information in the Help pages.

Many activities in Elements entail the opening of panels into which you need to enter relevant information. These panels are called dialogue boxes. Many of these panels have links inside them that will take you straight to the page in the Help pages that deals with the activity that the panel is associated with. The link is preceded by the words 'Learn more about:' followed by the subject of the activity in question.

When you place your cursor next to items such as buttons and control panels on the Elements interface a small box describing the item's function pops up next to the cursor. This box is called the Tool Tips panel. It's particularly useful for reminding you of the functions of buttons and controls that are represented only by symbols. Many of the tips in the panel are underlined in blue, indicating that if you click on them they will take you to the relevant page in the Help pages. If the boxes aren't popping up on your computer go to Preferences>General>Show Tool Tips to activate them.

Part I

The Basics

Equipment
1

This chapter is an introduction to the equipment that you'll need in order to use Photoshop Elements.

This equipment includes the computer itself and a monitor, and a piece of kit that's almost essential for creating computer generated art – a graphics tablet. You'll probably also need a printer and a scanner, depending on the type of work that you produce.

If you've already got most of this equipment you can skip a lot of this chapter – however if you don't possess a graphics tablet, don't miss that section.

In This Chapter:
The Computer Specifications Needed for Elements
Graphics tablets
Scanners
Printers

The Computer Specifications Needed for Elements

Most modern computers are more than powerful enough to run Photoshop Elements 8, and if your computer conforms to the recommended minimum specifications listed below you'll have no problems. If these figures mean nothing to you, and you want to know a little more about their significance, they're followed by a brief description of their meaning.

If you're using Windows:
1.6GHz or faster processor speed,
1GB of RAM.
2GB of space on your hard disk.
1,024x576 or greater monitor resolution.

If you're using a Mac:
Multi-core Intel processor.
Mac OS X v 10.4.11 through 10.5.8 or Mac OS X v10.6.
512MB of RAM (1GB recommended).
2GB of space on your hard disk.
1,024x768 or greater monitor resolution.

Obviously these numbers are very important because they're so unintelligible, but what do they all mean? Here's a quick explanation.

First, there's the processor speed. Essentially, this is the speed at which the computer 'thinks': the lower the processor speed, the slower your computer will do its work. It's measured in megahertz (MHz), or gigahertz (GHz). A gigahertz is a thousand megahertz.

There's also something called Random Access Memory (RAM), which is essentially the computer's thinking capacity, or the amount of information that it can hold in its head at any one time while it's actually working, without writing it down. Its capacity is measured in megabytes (MB) or gigabytes (GB), where a byte is the basic unit of memory. If your computer has 1 gigabyte of RAM it can remember a billion things at once without having to make notes.

You can buy more RAM and add it to your computer if necessary: it comes on small modules that you slot into place. Get a computer literate friend to install it if you're not sure about doing it yourself. It usually just involves undoing a few clips or screws to give you access to the inside of your computer, where there'll be some slots ready and waiting to accept any new RAM. Although the very idea of opening up a computer may sound ridiculously scary, it's actually not too difficult, so if you're competent with a screwdriver and

can read the computer's manual you should be able to do it yourself.

There's another item on the list of specifications that is measured in gigabytes – the amount of space on your hard disk. This is the storage capacity on your computer, where the computer records and stores the digital information that makes up your work (along with the digital information that makes up the software that you're using, such as Photoshop Elements). The hard disk is a physical disk that spins round inside your computer.

The final item on my list of computer specifications is the resolution of the monitor. This is the number of tiny dots of light that make up the screen. A monitor with a resolution of 1,024x576 has 1,024 dots across its width and 576 from top to bottom. The actual size of your computer's screen in inches or centimetres is independent of its resolution (In other words a 15 inch screen and a 21 inch screen can have exactly the same resolution, just as with tv sets).

The physical size of your monitor is a much more important consideration when you're using your computer to create artwork than it is when you're using it to do word processing or browsing the internet. The larger the screen the better – but also, unfortunately, the more expensive. It's best to use a relatively big screen if possible, firstly because you'll want to look at your work as large as you can make it, and secondly because as well as displaying your artwork your screen will need to display various panels and palettes, which can significantly eat into the available space. Having said that, although larger screens are best, they're not absolutely essential (For example, although most of the illustrations in this book were done on 17inch and 21inch screens, more than a few were done on a laptop with a tiny 11inch screen).

Screen sizes are measured diagonally, from corner to corner.

Graphics Tablets

A graphics tablet is a vital piece of equipment for anyone who wants to do any form of serious visual work on a computer.

It *is* possible to draw on a screen using your standard mouse, but it's not particularly effective. A mouse is a rather clunky and unresponsive tool for such purposes, being designed mainly for pointing and clicking. If you want to do anything more than very basic drawings I'd recommend you invest in a graphics tablet immediately, even before you buy a scanner (described next). It will transform the way you work on your computer.

Drawing on a computer takes a little getting used to (whether you use a mouse or a graphics tablet), partly because of the fact that while you move your hand round at table top

level the image itself appears in a totally different place, up on your monitor. But it does only take a *little* getting used to, and after a very short time it'll become second nature. In fact, because the image that you're working on is on a screen and not under your hand, drawing on computers has the happy advantage over conventional drawing media that your hand doesn't hide any of the image.

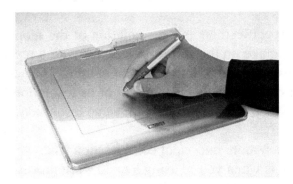

Figure 1-2
A typical graphics tablet and pen

What Do Tablets Do That Mice Don't?

The most obvious feature of a graphics tablet is that it uses an electronic pen, or stylus, which looks and feels quite like a conventional pen.

The pen (which takes the place of the mouse) is used on an electronic drawing board or tablet (which takes the place of the mouse mat). The tablet contains a grid of wires beneath its surface to register the position of the pen.

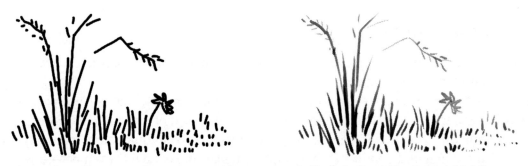

Figure 1-3 The same lines drawn with a mouse (left) and a graphics tablet (right)

Unlike a mouse, the pen is not simply a positioning tool for moving a cursor round the screen. When using a mouse as a brush in Elements (Figure 1-3, left), the mouse simply

tells the brush where to place itself on the screen, and moving the mouse makes the brush dutifully snake its way across the screen creating a uniform and unchanging line. Things are different when you use a graphics tablet and pen however. The line responds to how hard you press the pen on the tablet, changing the line's thickness or tone and making the strokes spring to life (Figure 1-3, right).

The graphics tablet market is dominated by one company, Wacom, which produces several types of tablet including the Intuos range, which is primarily aimed at professionals and serious amateurs, and the Bamboo range, which is targeted at the home user.

The Bamboo tablets aren't as accurate or feature-heavy as the professional quality Intuos tablets, but they're good enough for everything except the most demanding work, and make a very good introduction to the technology.

All graphics tablets come with a pen, and some come with a cordless mouse too. You can purchase a variety of different, specialized pens to use with the Intuos tablets, but I'd recommend that you ignore these until you've become familiar with the standard pen, which for most purposes is more than adequate.

Wacom also produce a super-expensive device called the Cintiq, which is actually a monitor that takes the place of your normal computer screen, and onto which you can draw directly without the need for an intermediary graphics tablet. While this is closer to drawing naturally with a pen on paper, it has the disadvantage of having part of the image hidden by your hand and pen. The screen probably gets covered in greasy fingerprints too, which after spending so much money on the device must be quite irritating. If you think that you fancy one of these, and you think you can afford to pay for it, I'd recommend that you try it out first to check that it's really what you want.

What Size Graphics Tablet?

Tablets come in a wide range of sizes, from small A6 (about 4x5in or 10x15cm) up to massive A3 (about 12x18in or 30x42cm), with the larger tablets being a lot more expensive than the smaller ones. Fortunately, large size is not necessarily important, or even desirable.

I have an A4 (9x12in or 21x30cm) tablet, and even that sometimes seems too big when I have to move my arm right across it to draw a line.

I also have an A5 (8x6in or 21x15cm) tablet, which for me is just about the right size.

The A5 tablet is very portable, and is very convenient for travelling around with. The actual physical size of the A5 tablet is about an inch (2.5cm) larger than an A4 sheet of paper, which makes it about the same size as a laptop, so you can carry the tablet and a

laptop round together in the same bag.

Even if you think that you need a large tablet it's probably sensible to buy a small one first to check how a tablet suits your style, and possibly to discover that you don't need a large one after all.

Don't labour under the misapprehension that working on a particular size of tablet is the equivalent of working on a piece of paper of that size. For instance, if you use an A5 tablet, this doesn't mean that you have to draw or paint as though you're working on an A5 sheet of paper. The size of the tablet isn't related to the size of the image that you're working on.

The area of your tablet directly represents the area of your computer's screen, as shown in Figure 1-4. This means that when you place your pen at the top left of the tablet the cursor on the screen appears at the top left of the screen, and if you place the pen at the bottom right of the tablet the cursor appears at the bottom right of the screen.

Figure 1-4
The area of the tablet directly represents that of the screen (The image isn't visible on the tablet as it is in this illustration, where it's added for clarity)

When you're working in Elements you can magnify your image on the screen so that only a portion of it fills the whole screen. When you do this, the area of the tablet represents only that portion of the image that's on the screen (because the tablet represents the screen directly, remember). So it's as though the 'image' on the tablet has been enlarged, allowing you to work on a magnified version (Figure 1-5).

Figure 1-5
You can increase the size of the image on your screen, which magnifies the 'image' on the tablet

Scanners

If you have an image on paper, and you want to transfer that image to your computer, you need a scanner (Figure 1-6).

A scanner is a device with a hinged lid, beneath which is a glass plate onto which you place the image that you want to transfer to your computer. When you use the scanner, a beam of light travels along the length of the glass plate to analyze the image and break it down into electronic information suitable for the computer.

Scanners come in a huge range of prices, from suspiciously cheap to incredibly expensive. Fortunately the ones that are worth considering for most purposes are those closer to the suspiciously cheap end of the range. The truly expensive ones are used for obtaining absolutely perfect professional photographic results for high quality reproduction: for artistic purposes you're much more likely to need one only in order to scan images for reference purposes or in order to manipulate them once they're on the computer (and as soon as you manipulate an image you alter it, so you probably don't need to have the incredible degree of accuracy provided by an expensive scanner).

Figure 1-6 A typical scanner

Scanners analyse images by breaking them down into tiny dots. Different scanners are capable of producing different sized dots – the smaller the dots created, the more detail there is in the captured image. The degree of detail that a scanner can capture is measured in dots per inch (dpi), and is known as the resolution. If you're trying to compare the resolution of different scanners before buying one, bear in mind that there are *two* different types of resolution that may be quoted in the specifications. These are known as the optical resolution and the interpolated resolution. It's always best to compare scanners by looking at their *optical* resolutions, which is the true size of the dots produced when the scanner

executes a scan. Interpolated resolution is a measure of a secondary process, where the size of the dots in the scanned image is broken down into smaller dots *after* it's been scanned. This figure is often quoted because it sounds more impressive than the optical resolution, being a larger number, but it doesn't actually mean that there's more detail in the scanned image (because that detail wasn't scanned in the first place). Think of interpolated resolution like cutting a cake into portions – you end up with more pieces of cake, but with no more actual cake itself.

Printers

Home printers usually work on the ink jet principle, in which tiny jets of ink squirt out of holes and hit a sheet of paper as it's fed past the jets. Although this sounds quite crude, the quality of prints on modern inkjet machines can equal that of photographs. You can vary the quality of the printout – at high quality settings the printing slows down a somewhat so that the print may take a while coming out of the machine, but it'll be worth the wait.

Figure 1-7 A typical desktop printer

The other type of printer that you may come across is the laser printer. The laser beams involved in the printing don't actually burn colour onto the paper, as I'd like to believe, but sensitize a drum that then picks up colour that's transferred to the paper.

Laser printers are more expensive than inkjet printers, but their running costs are lower, as their ink is cheap (The ink used in inkjet printers is a significant expense). They also print faster than inkjet printers, which makes them suitable for high volume printing. This combination of efficiency and economy makes them useful for small businesses.

Most printers aimed at the domestic market print up to A4, a very commonl size for documents, pamphlets, newsletters and of many magazines.

Equipment

The Essentials:
Step by Step
2

This chapter is a step by step introductory guide to the basic stages of drawing and painting images in Photoshop Elements.

If you're already familiar with Elements through working on photographs it's still advisable to start at the beginning of this chapter, as some of the settings may be different to those that you're used to.

There's nothing here that's too demanding in terms of artistic technique, and the chapter assumes practically no computer knowledge whatsoever, other than the ability to turn the machine on and open a programme.

During this introduction a few points are described in more detail than may be strictly necessary at this stage. This is partly in case you're not using the programme straight out of its box, in which case some of the settings may need altering, and partly because there are areas where a little insight can help you to understand exactly why you're doing things in a particular way.

In This Chapter:

A step by step guide to the basics of producing images in Elements

2

Drawing Your First Line

In this section:
Opening a new document
The basic controls
Drawing a line
Saving your work and closing the document

Open a New Document

Before you can draw on your computer you have to create a surface to draw on – the digital equivalent of a blank sheet of paper.

The first step to doing this is to open the programme.

It's at this point that you'll come across one of the very few differences between the Windows version of Elements and the Mac version.

If you're using a PC read the following section, Opening in Windows. If you're using a Mac skip straight to Opening on a Mac. (You'll be relieved to hear that there are very few instances like this in this book, where you have to choose which part to read based on whether you're using Windows or a Mac.)

Opening in Windows

When you open Elements on a PC the first thing that you'll see will be a panel known as the Welcome screen. On the left side of the panel are two buttons: one labelled Organize and the other labelled Edit. These buttons open different parts of the programme, known as the Organizer and the Editor.

The Organizer and the Editor are two more or less separate (though linked) parts of Elements that perform different functions: the Organizer is used for cataloguing and organising the images that you've created or imported, while the Editor is the part of the programme in which you create new images or alter and manipulate pre-existing ones.

Most books about using Elements on PCs start with a section detailing the workings of the Organizer, because quite understandably they assume that most people want to open a pre-existing photographic image from a batch that's probably been downloaded from a camera and that thus needs to be 'organized'. The book that you're reading now is different however, as it's about how to create original images in Elements. Therefore I'll bypass the Organizer for now and jump straight into the Editor (For more on the Organizer see Chapter 19 at the very back of the book).

To open the Editor, click the button labelled Edit.

This will open the Edit interface (Figure 2-1), on which are arranged a variety of panels that are called into action for the manipulation of your images. The proportions of the items on the screen may be different to those shown here, depending on the monitor that you're using. The screen may appear to be dauntingly overcrowded by panels, especially because of the peculiar selection of apples displayed on the upper right, but it can easily be simplified by removing items that you don't need, as I'll explain soon. I'll introduce the contents of the screen as they become relevant, rather than pointing them all out now.

The interface can be displayed in a choice of two shades of gray - light or dark. Both are too dark as far as I'm concerned, but that's all that's on offer unfortunately. To find out how to change the shade see page 75.

Figure 2-1
The interface as it appears when you first open Elements on a PC. You can choose to display the interface in either a light version or a dark version. This is the light one, which is still too dark as far as I'm concerned

At this point there is no image on the screen for you to manipulate, so you need to create one or open a pre-existing one. As this book is primarily about the creation of new images rather than the manipulation of photographs or similar images I'll explain how to create a new image from scratch.

Go to the top of the screen and click your cursor on the word File.

A list of operations that you can perform, called commands, will appear (Figure 2-2).

Click on the command labelled New at the top of the list.

This will open a further list. Click on Blank File at the top of the list.

A panel, called the New File dialogue box, will appear on the screen. It'll look similar to the one in Figure 2-5, which you can find after the following section which explains how to get to this point when you're working on a Mac.

Figure 2-2
Clicking on an item
in the Menu bar will
open a list of oper-
ations or
commands.
Clicking on a
command that has
three dots after its
name will open a
further list

Opening on a Mac

When you open Elements on a Mac the programme's interface appears, on which are arranged a variety of panels that are called into action for the manipulation of your images (The Mac version goes straight to this interface, unlike the Windows version which gives you a choice between 'Organize' and 'Edit' modes. This is because the Mac version of Elements doesn't have the Organizer side (for cataloguing image files) that is possessed by the Windows version. This doesn't mean that the Mac version is deficient in its cataloguing capabilities however, because that side of things is taken care of by a feature called Bridge, which is a separate item of software that comes bundled with Elements and that allows you to organise your images and to access them whether you're using Elements or not. It's described in more detail in Chapter 19).

If you're opening the programme for the first time, the display will look something like Figure 2-3. The proportions of the items on the screen may be different to those shown here, depending on the monitor that you're using. The screen may appear to be dauntingly over-crowded by panels, but it can easily be simplified by removing items that you don't need, as I'll explain soon. I'll introduce the contents of the screen as they become relevant, rather than pointing them all out now.

The interface can be displayed in a choice of two shades of gray - light or dark. Both are too dark as far as I'm concerned, but that's all that's on offer unfortunately. To find out how to change the shade see page 75.

A separate panel appears in the centre of the screen in front of the interface panels, announcing 'Welcome to Photoshop Elements 8' (If the panel doesn't appear it's because it's been turned off by someone, because using the panel isn't really necessary, and to be

honest having it popping up every time you open Elements becomes a little irritating after a while). This panel, which is called the Welcome Screen, contains a number of buttons that allow you to open images from a variety of different sources such as cameras or scanners. Right now you want to create a brand new image, so click on Start from Scratch.

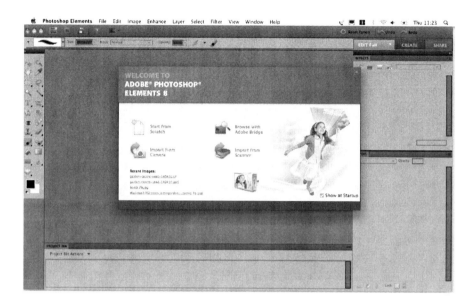

Figure 2-3
The interface
as it appears
when you first
open Elements
on a Mac

If the Welcome Screen doesn't appear when you open Elements (because someone has very sensibly turned it off) you can create a new sheet to work on by clicking the New File button (Figure 2-4) near the left end of the bar near the top of your screen (This button doesn't work if the Welcome Screen is present, in which case, as I mentioned, you click the Start From Scratch option on the Welcome Screen).

 Figure 2-4 The New File button

Using either the Start From Scratch option on the Welcome Screen or the New File button, a panel will appear on the screen, similar to the one below in Figure 2-5. This is the New File dialogue box. (The box depicted in this figure is actually the Windows version of the dialogue box. You'll find that nearly all of the figures in this book that show interface features are displaying the Windows versions of those features. One of the reasons for this is that the Mac versions don't print as clearly on these pages as the Windows versions, due to their darkness.)

Setting the Values for a New Document

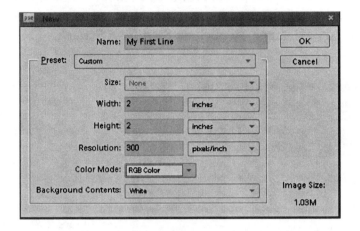

Figure 2-5
The New File dialogue box,
in which you enter the
dimensions and other
details of the image that
you want to create

The New File dialogue box is where you set the values for your document (or file or image if you prefer - the terms are interchangeable).

The panel is called a dialogue box because you enter information into it in a 'dialogue' with your computer. Into this particular dialogue box you enter basic settings of the new document that you're creating.

You can vary these settings depending in the type of image you're intending to create. I won't explain what they all mean in detail yet, as it's all a bit irrelevant at this stage, not to mention a tad confusing.

Here's how to enter the setting that I'm using for my example.

First you need to give your new document a name, so that you can store it after you've finished working on it. You type the name into the box labelled Name, naturally enough. There'll be a default name in the box already, which the file will use if you neglect to enter a name of your own (The default name will be Untitled-1, unless there's already a file with that name, in which case it'll be Untitled-2, and so on). Initially the default name will be highlighted on a coloured background, indicating that you can just type straight onto your keyboard to change the name without bothering to delete the default name first. Type whatever name you like, as long as it's reasonably short and to the point – something like 'My First Line' would be a good choice for any tentative first step into drawing.

Now you have to set the size of the sheet on which you're going to create your image, by entering measurements into the width and height boxes. You can choose which units you want to use as your dimensions, such as centimetres, inches or numbers of pixels (the tiny coloured squared that make up an image). The units in use are displayed in the panels

alongside the width and height measurements. If the units that are displayed aren't the units you prefer to use, click the panel to reveal a list of choices (Figure 2-6). Then move the cursor to the units that you'd like to employ. When the desired units are highlighted click to select them.

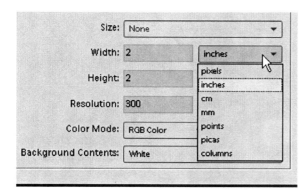

Figure 2-6
To change the units that are being used to measure the dimensions of the sheet that you're creating, click on the units panel and highlight the units of your choice

To change either the width or the height, place the cursor over the panel containing the value of the measurement. The cursor will change from an arrow to a vertical bar. Press and drag the cursor across the value that's present, or double click on the value, to make the value editable.

For the purposes of this demonstration, type in the values below as the dimensions of your new document.

In the width box type 5 if you're using centimetres, or 2 if you're using inches.

In the height box do the same.

In the box labelled Resolution, set the units to pixels/inch and enter a value of 300 (It's conventional to express this value in inches, even if you use metric measurements elsewhere).

At the bottom of the box, set the Color Mode to RGB Color and the Background Contents to White by clicking on the panels and moving the cursor to highlight those options.

The box should now have the same settings as in Figure 2-5.

Now that the settings are all to your liking, click OK at the top right of the panel.

The dialogue box disappears, to be replaced by a white square on your screen – your electronic sheet of paper (Figure 2-7).

The assorted bars and panels round your sheet give you access to the tools and controls that you'll use when creating images, described next.

An Introduction to the Controls

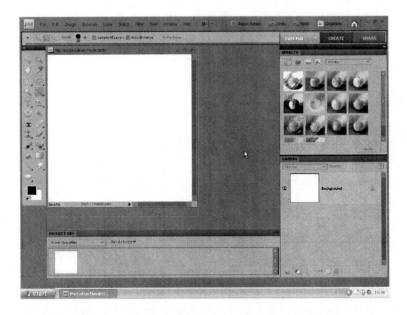

Figure 2-7
Your blank sheet of
'electronic paper',
ready for use, and
the controls that
give you access to
the tools

Having to work on an electronic sheet of paper sounds much more intimidating than having to work on a normal sheet of paper, but in fact it's exactly the opposite. Working electronically is actually very liberating, as I'll show you soon.

All of those bars and panels on the screen may seem a little unnerving too, but you'll be pleased to hear that many of these panels are irrelevant at the moment, and that soon you'll be shown how to remove most of them.

All you need to concentrate on for now are the narrow bars that run across the top of the screen (There are two in Windows and three on a Mac) and the bar that runs down the left side. Here's a quick introduction to them.

At the very top of the screen is the menu bar (Figure 2-8), which gives you access to actions that you can take when creating and manipulating images. These actions are called commands. I'll demonstrate how this bar works right away, by showing you how to use it to remove the panels on the screen that you don't really need.

Figure 2-8 The menu bar as it appears in Windows (top) and on a Mac (bottom)

In the menu bar click your cursor on the word Window, which will open a list of names, called a menu (Figure 2-9). This particular menu shows the names of various panels that can be displayed on the screen in order to facilitate your work. Some of the names in the list are ticked, which indicates that those specific items are already on display.

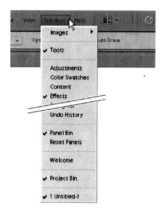

Figure 2-9
The Window menu in the
menu bar (truncated here
to save space on the page)

Move your cursor down the list and click the words Panel Bin. This will make the large panel that takes up most of the right hand side of your screen disappear: a great improvement. (When you remove the Panel Bin by this method it will reappear every time you relaunch Elements, which is a bit irritating because the Panel Bin is nothing more than a waste of space in every sense of the term. Fortunately there's a way of removing it permanently, which I'll describe soon.)

Go back to the word Window in the menu bar, click it again to reopen it, and this time go down to the word Project Bin. Clicking this will make the panel across the bottom of the screen disappear. Another great improvement!

You now have a much clearer screen, with only the essential items on display.

One of these essential items is the long thin panel that runs down the left hand side of the screen and that contains several dozen perplexing and intriguing symbols (Figure 2-10). This is the Tools panel. The symbols are the buttons for all of the tools that you need in order to create your drawings or paintings: things such as brushes, pencils and erasers. You can choose to have the tools displayed in either one or two columns to suit the size of your screen (See page 80).

Figure 2-10 (right)
The Tools panel

Mac only: the Application bar

As I mentioned, on Windows computers there are two bars across the top of the screen while on a Mac there are three. On both types of computer the top bar (the Menu bar) and the bottom bar (known as the Options bar, discussed in a moment) are the same.

The extra bar on the Mac is the second one down – the middle one. It's known as the Application Bar (Figure 2-11). It's similar to what used to be known as the Shortcuts Bar in earlier versions of Elements. Amongst other things this bar displays some of the more common commands from the menus in the menu bar, giving you access to them without you having to bother opening the menus themselves.

Figure 2-11 The Application bar (only present on Macs)

Choose the Colour With Which to Draw or Paint

Now that you've been introduced to most of the controls that you'll be using, it's time to actually prepare to put some marks on your blank sheet of 'paper'.

First, it's probably sensible to choose the colour that you want to use to create your image. Black is perhaps the best choice to start with.

To choose your colour, move your cursor to the bottom of the Tools panel – the vertical strip down the left edge of your screen – where you'll see two overlapping squares (Figure 2-12). If you can't see the overlapping squares it's probably because your Tool panel is too long and is disappearing out of the bottom of your monitor. Shorten it by clicking the dark band that contains two tiny white triangular arrowheads at the top of the Tools panel. The top square shows the colour of the 'paint' or 'ink' that you'll be applying when you paint or draw.

If the top square's black and the bottom one's white that's the setting you want at the moment, so you can leave them unaltered. If they're different, click the very, very small black and white squares that accompany the large ones (They are either tucked in to the bottom left of the larger squares or are just above them, depending on your Tools panel layout). This will automatically make the large squares black and white.

Figure 2-12 The top square shows the colour of the 'paint' or 'ink' that you're using

Pick up a Paintbrush

Having selected the colour of your 'ink' or 'paint' you now need to select an instrument to apply it with.

Do this by clicking the icon in the Tools panel that resembles a paintbrush, about two thirds of the way down the Tools panel (Figure 2-13).

Figure 2-13
The icon for the Brush tool

In the unlikely event that the icon is slightly different to the one shown above (in that the brush has a curved line across it or a small black square to the top left, or it looks like a pencil), press and hold your cursor on the icon – this will open a short list of different types of brush (Figure 2-14), where you should click on the one that's labelled Brush tool. Don't be tempted to use the Pencil Tool for drawing at this early stage. It's an excellent instrument for drawing with in certain conditions, but it needs extra considerations explained before it's used, otherwise it produces disappointing results.

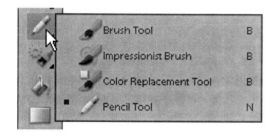

Figure 2-14
Several tools occupy the same spot in the Tools panel.
Access the dfferent tools by pressing and holding on the currently displayed tool

A small warning! There's an icon that may be visible about a third of the way from the top of the Tools panel that resembles a brush with dotted lines next to it – don't select this tool by mistake thinking that it's a paintbrush, as it has a totally different function (and isn't really a paintbrush at all). The one you want is a third of the way from the *bottom* of the panel.

Now that you've chosen to use a brush with which to draw, you have to decide on the brush's properties, such as the size and shape of its tip.

To do this you use the bar near the top of the screen, the Options bar (Figure 2-15).

Figure 2-15 The Options bar, here showing the options for the Brush

The options bar contains controls that are relevant to the tool that's in use at the time. When you change tools the contents of the bar change to suit the new tool.

Near the left hand end of the options bar for the Brush tool is a box with a curving line in it (Figure 2-16). This shows a sample stroke of the brush that's in use at the moment.

 Figure 2-16 The box where you choose your Brush

Click on the box to reveal a list of more shapes and sizes of brush from which you can choose (Figure 2-17). The list of brushes may not look like the one shown here, as there are a variety of ways of displaying it, however this doesn't matter for now.

Figure 2-17
A selection of the brushes in
the Brush Presets panel

At the top of the list there's a small box labelled Brushes. For now you want this to be displaying the words Default Brushes. If it isn't, click on the panel and choose Default Brushes from the top of the list that appears.

Choose a brush from near the top of the selection displayed in the palette – the examples with the numbers 5 or 9 (indicating the size) are reasonable for experimenting with. If you find that the lines that these brushes produce are either too thick or too thin for your liking you can return to the palette and choose a different size from the other nearby brushes (smaller numbers are smaller brushes, and vice versa).

Alternatively, although you've selected a specific size for the brush from the palette, you can alter the size by overriding the selected size. Do this by entering a different value in the Size panel in the options bar (Figure 2-18). There are several ways to do this. You can directly type a number into the panel (The letters next to the brush size show the units of measurement: you don't have to type in these letters when you change the brush size, as they are added automatically to the end of the number). Alternatively you can click the arrowhead in the Size box to reveal a slider. Move the slider by pressing and dragging with the cursor to alter the brush size.

Figure 2-18
You can change the size of the brush
by using this slider

Make sure that the other options in the options bar are set to their default settings, which are: Mode, Normal; Opacity, 100 percent; Airbrush mode (the icon immediately to the right of Opacity), Off (When it's turned on the icon appears against a dark square background).

If you're using a graphics tablet there are more settings that you can alter in order to produce more varied strokes, but for now the settings here should be fine

Drawing a Line

Now, finally, you're ready to start drawing.

This is a tense time for all artists, making the first mark on a blank surface, so you're in good company.

But the really great thing about drawing on a computer is that you can change what you've drawn so easily that you hardly ever have to commit yourself to what you've done, which takes a lot of the pressure out of the work.

To illustrate this lack of commitment, the first lines that you draw on your nice white sheet can be deliberately bad scrawls. They'll probably be quite messy anyway, just because of the initial strangeness of drawing onto a computer screen with a mouse or a graphics tablet.

You draw a line by moving your mouse or pen, which moves the brush's cursor on the screen. Depending on how Elements has been configured on your computer the cursor for the brush will look like a small paintbrush, a circle or a cross (Figure 2-19).

Figure 2-19 Different manifestations of the Brush cursor

Before you actually make any marks on your sheet, move the cursor around the screen a little to get the feel of things. Do this by moving the mouse around without pressing it, or if you're using a graphics tablet, by wiggling the pen around just above the tablet. This is the digital equivalent of holding a conventional brush just above the surface that you're working on. You can see the cursor moving about on the screen, indicating the position of the brush.

Position the cursor at an appropriate spot on your sheet and start drawing by pressing

and holding down your mouse button, or by pressing your pen onto the tablet. Move the cursor across the sheet to draw a line. Finish drawing your line by releasing the button on the mouse or by lifting the pen away from the tablet.

Repeat the process five or six times, preferably drawing lines in a haphazard style not unlike that shown in Figure 2-20. Put as little effort into quality as you can manage.

Figure 2-20
To begin with, draw
several random lines
on your sheet

Because these are your first attempts at drawing anything, the results will undoubtedly be of a dubious standard, so you may want to get rid of some of the lines and try again.

This couldn't be simpler.

Look at the bars that span the top of your screen, where towards the right hand end you'll see two curving arrows pointing in opposite directions: one that's labelled Undo and the other Redo (Figure 2-21). In Windows they are in the top bar (the menu bar) and on a Mac they are in the middle bar (the Application bar).

Figure 2-21
Move to previous states of your work using these buttons

Move the cursor up to the arrow that points to the left and that's labelled Undo (Notice that the brush cursor changes to a pointer when you move it off the surface of your drawing sheet: this is because the cursor is context sensitive and takes on the role that's required for the area of the screen that it's on). Click on the arrow to see what happens.

The last line that you drew disappears! Brilliant!

The arrow that you just pressed – the Undo button – is there so that just about anything that you do to your image can be cancelled with a simple click.

By clicking on the same arrow a second time, the second to last line that you drew will disappear.

Keep clicking and each line that you drew disappears in turn.

This is because the Undo button takes you back one step at a time through your work. It's very useful when you find that your immediate efforts are starting to go horribly awry and you want to cancel the last few actions that you've made.

In the default setting the Undo button can move back 50 steps through your work.

Now that you've removed some, or all, of the lines from your sheet, have a go at clicking the other arrow, the one that points to the right rather than the left and that's labelled Redo.

The lines that you've just removed return one by one with each click on the arrow. This arrow – the Redo button – is most useful for restoring work when you go too far with the Undo button.

You've been working for several minutes now, so it's probably time for you to save your work. And if you feel that you've learned enough for the time being, you may want to close the file that you've been working on too.

If you're familiar with computers you'll already know how to do these things, so you can skip the next two sections. Otherwise, read on.

Saving Your Work From Oblivion

When you do any work on a computer the results of your efforts appear on the screen as you work. But initially that's all they do – appear on the screen. The work isn't actually stored permanently on the computer until you specifically tell the computer that you want to keep it, which is done by recording it onto your computer's hard disk (where it will stay until you deliberately remove it).

To store, or save, your work go to the File menu and click Save.

Mac only: you can click on the Save button in the Application bar (Figure 2-22). The icon shows a representation of a removable floppy disk (a type of storage device that's now quaintly obsolete, but which is visually easy to depict).

Figure 2-22
The Save button (Mac only)

The first time you save an image, a dialogue box will appear asking you where you want to put the file (This only happens the first time that you save it, so this isn't as much of a bother as it first seems). In the dialogue box there's a panel titled Save in (on Windows computers) or Where (on a Mac). Clicking this box opens a list of folders on your computer

in which files are stored. Choose the folder in which you want to store your file. Depending on whether you're using a PC or a Mac this list of folders will be presented differently.

Navitate through the list to the location in which you want to store your image.

There's more on the issue of saving images in Chapter 4.

Closing Files

When you don't want to do any more work on a file you can close it.

Along the top of the image that you're working on is a strip that acts almost as the upper side of a frame around your image (Figure 2-23). This strip is known as the title bar, and it contains the title that you've given the image along with some information about it and a number of small buttons. One of these buttons closes the file when you click on it. In Windows the button is a cross at the far right hand end of the bar. On Macs it's the red circle in the 'traffic lights' at the extreme left hand end (inside which a cross will appear when you move your cursor close, unless the file has got any unsaved changes, in which case a black dot appears instead as in the figure here).

If you click on the Close button while the file has got any unsaved changes a panel opens asking you whether or not you want to save the changes.

Figure 2-23 The Close File button on a Mac (left) and in Windows (right)

Closing a file doesn't close the actual programme itself, it only closed the individual document. The advantage of this is that you can then open another document in Elements without the whole programme having to be started up again from scratch.

When you've finished using Elements altogether you should close the entire programme to stop it using up valuable memory and to thus allow your computer to run more efficiently when you're using other programmes.

To do this in Windows, go to File>Exit in the menu bar. If you're using a Mac, in the menu bar go to Photoshop Elements>Quit Photoshop Elements.

Creating a Basic Drawing

In this section I'll outline some of the basic steps involved in producing drawings on computers, shown in the illustrations below (Figure 2-24)

1: Creating a rough preliminary sketch
2: Fading the rough sketch to make it less prominent so that you can trace over it
3: Tracing over the rough sketch
4: Removing the rough sketch, to leave only the finished drawing

Along the way I'll also introduce you to:
Creating layers
Enlarging and reducing the size of the image on the screen
Erasing

Figure 2-24 The basic stages of producing an image, from rough sketch to final artwork

In the previous section I explained how to create basic marks in Elements.
Now I'll show you how to join the marks up in order to create a proper drawing.
Start by opening a new file by following the opening instructions from the previous section. Use the same settings except that this time give your file a different name, such as My First Drawing.

Creating a Rough Sketch on a New Layer

In the previous example I explained how to make marks on the white surface of your document, just like drawing onto a sheet of paper.
However, just as with drawing onto paper, it's not necessarily a good idea to plunge

straight in and to draw directly onto the surface.

Working with paper it's common to create preliminary versions of artwork on sheets of tracing paper, and even to produce different parts of the final artwork on sheets of transparent plastic film that can be overlaid on top of each other.

Elements provides you with the digital equivalent of these sheets of plastic film (or totally transparent tracing paper if you prefer). They're called layers.

Normally it's best to work on these layers rather than directly onto the original white surface (which is known as the background layer) because it makes it *much* easier to alter and manipulate your image later on.

To create these transparent layers, you need to open the Layers panel, which is shown in Figure 2-25.

Figure 2-25
The Layers panel

The following description of how to open the Layers panel, and how to position it on your screen, may seem rather long-winded and convoluted, but this is because in this early stage of using Elements the programme isn't configured for optimum use. You'll only have to do the next bit once.

In Elements' default setting the Layers panel is found in the Panel Bin, which runs down the entire right hand side of your screen. You may remember that earlier I described how you could remove the bin from the screen in order to remove clutter from the interface. If you removed the bin and you haven't shut down and relaunched Elements since, the bin will still be absent from the screen. If you've relaunched Elements in the meantime, the bin will be back. If the bin is missing you need to reopen it (temporarily). Do this by going to the menu bar, to Window>Panel Bin.

The Panel Bin is a bit of a nuisance, but fortunately it's possible to take the Layers panel out of the bin and place it on the screen independently. The independent Layers panel takes up much less space than the bin, and it has the advantage that you can move it wherever

you want on the screen rather than having it permanently anchored to the right hand edge.

Here's how to remove the Layers panel from the Panel Bin.

In its default configuration, the bin contains two panels: the Effects panel and the Layers panel. Each has a shaded title bar along the top with the name of the panel in it.

Press the cursor on the title bar of the Layers panel. While still pressing, drag the cursor over towards the middle of the screen (Figure 2-26, left). This will drag the panel with it and remove it from the bin (Figure 2-26, right).

Figure 2-26 Removing the Layers panel from the Panel Bin

Now to remove the pesky Panel Bin permanently, so that it doesn't reappear every time you relaunch Elements.

The secret is to know that the Panel Bin only opens when it actually contains any panels, so all you have to do to make it disappear is to remove any remaining panels from it (In the default setting it should now contain only the Effects panel, with its rather distracting arrangement of apples). To remove the remaining panel (or panels) drag them out of the bin by dragging their title bars (as you did with the Layers panel a moment ago).

The Panel Bin will now have gone, but you'll have at least one unwanted panel floating around on your screen getting in the way. It's easy to remove a panel from the screen, fortunately. All you need to do is to click on the Close button in the bar at the top of the panel – in Windows it's a cross at the right hand end of the bar, while on a Mac it's a circle at the left hand end.

That, mercifully, is the end of that. Now that the Panel Bin's out of the way let's get back to the Layers panel, which is the whole point of this section.

You can move the Layers panel round the screen by pressing and dragging on either of the two shaded bars that run along the top of the panel. A warning though! Make sure that you press and drag – don't simply click. Clicking on either bar makes the panel shrink in size to a narrow band, which is useful when you need it (in order to liberate valuable screen space) but which is alarming if you don't. If you do accidentally click on one of the bars rather than pressing and dragging just click on it again to reverse the action.

Now that you have the Layers panel nicely positioned on your screen you can use it to create a new transparent layer onto which to draw your image.

Look at the row of icons at the bottom of the Layers panel (Figure 2-27). Notice the one at the left hand end that looks vaguely like a sheet of paper with the corner turned up revealing, rather too subtly, another sheet beneath it (to show that there are sheets above each other). This is the New Layer button.

Figure 2-27
The buttons in the Layers panel, with the New Layer button indicated

Click this button to create a new layer.

In the Layers panel a new layer appears, called Layer 1 (See Figure 2-25).

The small panel to the left of the layer's name, by the way, is a thumbnail representation showing the image that's on the layer. This will have a checkered effect on it (unless this effect has been turned off), that's there to show that the layer is transparent. The thumbnail of the original white surface below it, known as the background layer, will be white, showing that it's opaque (and white). Neither thumbnail will have any detail in it, as both surfaces are as of yet blank.

The new layer is placed directly above the original white surface, although it won't be obvious by looking at the image area on your screen because the new layer is invisible (being transparent).

When you draw now, your drawing will be on the new transparent layer rather than on the original white surface. This is because you've just created the new layer, so by default it's the layer that you'll be working on. Its box in the Layers panel will be highlighted to indicate that it's the layer in use. If it isn't highlighted, perhaps because you've been fiddling around and have altered something, just click on the layer's box in the Layers panel to reactivate it as the chosen layer.

To produce a drawing, create a rough version of a very simple image on the new layer. Make the image as simple as you like, especially if you haven't got used to the feel of drawing on a computer screen yet. I've chosen to draw a tree, shown in Figure 2-28, which is basically an amorphous squiggly shape with a few lines coming out of the bottom, so it's hard to get wrong.

Figure 2-28
A simple rough sketch

This drawing is just a very basic sketch. But it can act as the starting point for a better and more detailed drawing, as explained next.

Trace and Improve

The best way to improve on your basic sketch is to trace over it, as you would if you were producing a conventional drawing on paper, adding extra detail or making modifications (Figure 2-29). The new, traced version should be done on another new layer, similar to the one on which you drew your original sketch.

Figure 2-29
Tracing over the rough sketch
on a new layer to create an
improved version

Create your second new layer by again clicking the New Layer button at the bottom of the Layers panel (Figure 2-27), as you did to create the layer for the original sketch. The new layer will be called Layer 2.

The new layer is automatically placed above the previous one, ready to be worked on.

What you're going to do now is to trace over your rough sketch with a black line. But there's a slight problem. The lines of the original sketch are already black, and tracing over one black line with another one is very difficult, as it's hard to differentiate between the two lines. The solution to this problem is to make the lines of the rough drawing fainter so that they don't distract from the new lines. In essence what you want to do is to make the lines look like the faint lines of a lightly drawn preliminary sketch.

Here's how to do this.

First, look at the Layers panel, where you'll see that the panel for the new layer that you've just created is highlighted in a different colour to the other layers in the panel. This shows that this layer is 'active', and is the one that will be affected by whatever action you do next, such as drawing. Before you do any work on this new layer though, you want to do something to the layer that contains your original rough sketch (making the lines on it fainter), so you need to make that layer active instead. Do this by going to the Layers panel and clicking on the box for the layer containing the original sketch (called Layer 1). That layer will then become highlighted, indicating that it's the active layer.

In order to make the lines of the sketch fainter, go to the top of the Layers panel, where you'll see a box labelled Opacity. The box will be showing a setting of 100 percent.

Press on the arrow on the right of the box, and a panel opens (Figure 2-30).

Figure 2-30
The Opacity slider, for altering
the transparency of a layer

This panel is a representation of a slider control, such as the ones you find on some audio equipment for adjusting the volume. Press on the control at the end of the slider, and drag it to the left while holding the cursor down. As you move it the opacity of the layer decreases and the image on the layer fades. Stop dragging when the image is quite faint. The new opacity is indicated in the box. A value of between 10 and 20 percent is probably about right, but the exact setting isn't critical at all.

Now, in order to draw your improved image you need to go back to the new, second blank layer that you created above the original sketch, Layer 2 (otherwise you'd be drawing

on the same layer as the rough sketch).

To do this, go back to the Layers panel and click on the name of the new layer (the top one). It will become highlighted, indicating that any work that you do now will be done on that layer.

Getting a Closer Look at Your Image

In order to draw an improved version of your rough sketch you may find it useful to magnify the image on the screen so that you can see it in more detail.

To do this, in the Tools panel click on the icon near the top that resembles a magnifying glass (Figure 2-31). This is the Zoom tool.

Figure 2-31
The Zoom tool button, shaped like a magnifying glass (or possibly a lollipop)

In the Zoom tool's options bar tick the check box labelled Resize Windows to Fit (Once you've set this option you may seldom want to change it again).

Move the cursor onto the image, where it becomes a magnifying glass with a plus sign inside it (If it has a minus sign inside it instead, you should change it to a plus sign before you use it, as explained in a few paragraphs).

Place the magnifying glass over part of the image that you'd like to look at more closely, and click.

The image is enlarged, centred on the spot where you clicked (Figure 2-32).

To enlarge the image more, click again.

To make it larger still, click again, and so on.

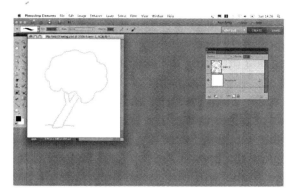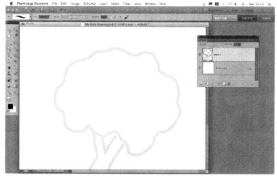

Figure 2-32 Enlarge the image on the screen using the Zoom tool

After zooming in to take a close look at your image, you'll probably want to reduce the size again, by zooming out.

At the left hand end of the Zoom tool's options bar you'll see two adjacent symbols representing magnifying glasses – one with a plus sign in it and one with a minus sign (Figure 2-33). Click on the one with the minus sign. Now, when you move the cursor back onto the image the cursor will appear as a magnifying glass with a minus sign inside it, which indicates that when you click the cursor the image will get smaller.

Figure 2-33
The buttons that allow you to change between zooming in and zooming out

The Zoom tool will stay in whichever mode it's set at, zoom in or zoom out, until you specifically change it.

(Zooming in and out can be done using much quicker methods than those described here, which I'll describe once you're more familiar with the programme, at the end of Chapter 3.)

When you've magnified the sketch it may be too big for it all to be seen on the screen at once.

You can move the image round the screen, revealing parts that are hidden, by using the Hand tool (Figure 2-34).

Figure 2-34
The Hand tool, for moving images to reveal parts that are out of view

Select the Hand tool in the Tools panel, then press and drag on the image to move the image on the screen.

The whole image window (the frame immediately surrounding the image) can be moved to different parts of the screen by pressing and dragging the cursor on the window's title bar (the strip immediately above the image, containing the name of the file that you're working on). A couple of small warnings are in order when pressing and dragging the title bar. Firstly, avoid clicking on any of the symbols at either end of the title bar, as these are specific control buttons for closing or resizing the window. Secondly, if you drag the bar onto the orange line that spans the screen just below the bars at the top (and that eminates from the 'EDIT full' tag on the right) the image frame will disconcertingly fade. If you release the cursor at this point the layout of the image frame will morph into a different

configuration known as 'tabbed layout'. To avoid it, don't release the cursor when the image is faded, just keep moving it until the effect passes. If however you do release the cursor by mistake and you enter tabbed layout mode, you can get out of it and back to the previous layout simply by pressing on the image's title bar (or any part of the dark bar that now spans the screen immediately below the orange line mentioned a moment ago) and dragging it away from the line.

Now that you've used the Zoom tool to magnify your sketch (if necessary), you can 'trace over' the image to produce a more accurate drawing (Figure 2-35).

Figure 2-35
Trace over your first sketch
with an improved version

The line that you draw when you're tracing will be black, so it'll be easy to distinguish it from the fainter line of the sketch on the layer below it. If the line you're drawing appears to be as faint as the faded lines on your original sketch, it means that you're accidentally drawing on the original sketch layer by mistake, so change layers.

Erasing Mistakes

While you're tracing over your sketch your lines will almost inevitably veer off course, requiring parts of them to be removed. To remove the whole of the last stroke that you made, click the Undo button (the left pointing arrow that's in one of the bars at the top of the screen, Figure 2-21) as described earlier. If however you only want to remove part of a line, or you want to remove a line that you drew a lot earlier, you can 'rub out' the offending line using the Eraser tool in the Tools panel (Figure 2-36), which works using a similar action to a conventional eraser.

Figure 2-36 The Eraser tool

If the image on the Eraser's button in the Tools panel includes a pair of scissors or a star at the top left (meaning that a specialized eraser is occupying the tool's space), press and hold on the tool that's there, which will open a panel that contains alternative erasers (Figure 2-37). Choose the standard Eraser by clicking on it. The eraser will then remain in the Tools panel until you deliberately change to one of the others, which may be never.

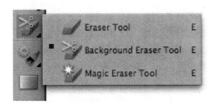

Figure 2-37
Select the normal Eraser in the pop-up menu if it isn't selected already.

The Eraser works in very much the same way as the brush that you're using to draw your lines, with similar controls governing how it works.

Before you use the Eraser you need to choose its shape and size (Again, this is something that's much quicker to do using other techniques once you're more familiar with the programme, so don't get too frustrated if you feel that everything seems just a bit too fiddly right now).

In the options bar click in the panel with the curved line, which represents a stroke of the Eraser (It's exactly the same as the panel in the Brush's options bar represents a brush-stroke, Figure 2-16). At the top of the panel that opens is a panel labelled Brushes (It's labelled Brushes rather than Erasers because the Eraser is essentially a brush that removes colour instead of applying it). Click the panel and choose Default Brushes from the pop-up list that appears, if it's not already selected.

Choose an eraser from near the top of the list. I'd recommend maybe the sixth one from the start of the list, which is a round one with the number 19 next to it.

You can change the size of the eraser by entering a different value in the Size panel, just as you can with the Brush tool.

Put the Mode setting in the options bar to Brush, and the Opacity to 100%, if they're not there already.

Now you can start erasing simply by holding down the button on your mouse, or by pressing on your graphics tablet, while passing the eraser over the areas of the image that you want to remove.

If you're using a graphics tablet there may be an additional eraser at the 'wrong' end of the pen (as there are with some ordinary pencils), allowing you to erase simply by turning the pen round rather than having to change tools in the Tools panel.

If you erase more than you intended to, use the Undo button to reinstate the work.

Making a Layer Invisible

While you're working on your new improved drawing you may find that the original rough sketch slightly distracts from your judgement of the drawing's progress, as the rough sketch is bound to interfere with the new drawing despite the fact that it's relatively dim.

To remedy this you can make the layer containing the rough sketch temporarily disappear from view, so that it doesn't confuse the rest of the image.

Do this by going to the Layers panel and clicking on the icon that looks like an eye (Figure 2-38) in the panel of the layer that you want to hide (in this case Layer 1).

 Figure 2-38 To hide a layer from view, click its eye icon in the Layers panel

The eye icon disappears when you click it, leaving the square that contained it empty. Clicking on the empty square will make the eye return, along with the image on the layer.

Removing a Layer

When you've finished tracing your drawing you can throw away the rough sketch that you've traced over.

To do this, go to the Layers panel and select the layer with the rough sketch on it, by clicking inside the panel containing the layer's name.

Hold the cursor down inside the panel and drag the panel down towards the trashcan shaped icon in the row at the bottom of the Layers panel (Figure 2-39). When the cursor is over the trashcan the background behind the icon will become darker, showing that you're in position. Then release the cursor.

Figure 2-39
To remove a layer from your document drag the layer's panel in the Layers panel into this trashcan

The rough sketch disappears, and you're left with only your finished drawing. Here's mine in Figure 2-40, on the next page.

Figure 2-40
The finished drawing with
the rough sketch removed

And that's it!
You can now draw on a computer. Have a coffee break while you take it all in.

Again I must apologize for some of the fiddling around that you've had to do, altering controls so that they're in their most useful settings. This is almost inevitably necessary when you use a new programme, but it has the compensations that you'll rarely have to alter them again, and that the programme now works more efficiently for your purposes. If you were to now repeat the exercise above you'd find that you could do it in a fraction of the time.

If you're relatively new to computers and you're finding the whole business a bit complicated it's most likely because you're not used to the various computer conventions involved, and it all just seems a bit alien. This will pass as you become more familiar with the programme. Using programmes like Elements is a bit like riding a bike. With a bike, to begin with you can't understand how anyone can balance on the thing at all, then after a little practice you find that you can hurtle along without holding onto the handlebars (which of course you should never do in real life). If you find riding a bike difficult, please ignore this analogy.

Altering Images

2

In this section:
How to manipulate parts of an image once the image has been created. This includes:
Moving
Duplicating
Changing the size
Rotating

Along the way, you'll learn how to rename layers, select parts of an image, cut and paste, duplicate a layer.

Moving Parts of an Image

Moving Parts of an Image that are on Separate Layers

The use of layers extends far beyond the functions described in the previous section, where one layer was used for creating a basic sketch and a second one was used for creating the finished artwork.

One of the main uses of layers is to hold separate parts of a single piece of artwork so that the individual parts can be worked on independently.

Here's a simple example of this in practice, where the different elements of an image on separate layers are moved relative to each other (Figure 2-41).

Figure 2-41 Separate layers can easily be moved relative to each other

41

If you want to follow this example using an image of your own, create a new blank sheet by repeating the steps from the previous section – making a sheet two inches (five centimetres) square at a resolution of 300ppi.

Then, as before, create a new layer on which to draw, so that you don't have to draw on the original background layer (Create the new layer by clicking the New Layer button (Figure 2-27), at the bottom of the Layers panel).

Using the brush, produce a quick drawing over to one side of the sheet so that there's room for another element alongside it (but don't draw the other element yet). Although I've drawn a tree as my first element you can draw what you want: just a squiggle will do.

Now you need to create another layer onto which to draw your second element, as shown below in Figure 2-42, where I've chosen to draw a sheep. Do this by clicking the New Layer icon at the bottom of the Layers panel, as before.

Figure 2-42
The two elements of the image
are each on their own layer

When you create a new layer it's automatically selected as the layer that your next action will apply to. This means that you can start drawing on it straight away.

Draw your extra element on this new layer. Don't be too fussy about putting it in exactly the right position, because that can be altered afterwards – in fact will be altered afterwards, as that's the whole point of this demonstration.

The drawing now has its two elements on separate layers.

The layers are called Layer 1 and Layer 2, however you can rename the layers so that the names reflect the contents of the layers rather than simply being impersonal numbers. This isn't too important when you've only got a few layers that you're working with, but when you've got more than half a dozen layers it may become useful in order to keep track of what's on each layer.

To rename the layers, in the Layers panel double click directly on the layer's current name, such as Layer 1. The name will be selected, in a little box, and you can type your new name over it (You don't have to delete the original name first, as it disappears as soon as you start typing).

In my case I've renamed the layers Tree and Sheep, logically.

So now you've got an image with its two components, but the second component is in the wrong position and needs moving (In my drawing, everyone knows that sheep live in the tops of trees rather than on the ground where I've stupidly put it, so I need to move it).

Here's how to move the second component to the correct position.

First, make sure that the layer containing the element that needs moving is the one that's active, by clicking on its panel in the Layers panel. The active layer is the one where the background of its panel in the Layers panel is a different shade to the rest of the contents on the panel.

Then go to the Tools panel and select the Move tool (Figure 2-43), at the very top.

 Figure 2-43 The Move tool

In the Move tool's options bar, turn off the three options, Auto Select Layer, Show Bounding Box, and Show Highlight on Rollover. Do this by clicking their check boxes to remove the ticks.

Press and drag your cursor anywhere on your drawing, and the image on the active layer will move around the screen as you move the cursor.

Release the cursor when you're happy about where the image is positioned.

Moving Part of an Image That's on the Same Layer as Other Artwork

You'll often want to move parts of images that are on the same layer as other parts of your artwork (rather than being conveniently on separate layers as in the previous example) (Figure 2-44). In such cases you can't simply slide the desired part of the image round, because the rest of the image on the layer would move with it.

You have to first cut out the part of the layer that you want to move, as though you were cutting it out of a sheet of paper with scissors. You can then move the cut portion independently.

Figure 2-44 The man in the image on the left needs moving up the stairs (centre). However both man and stairs are on the same layer (right),so the man needs to be cut from the layer

Here's what you do.

First, make sure that the layer that includes the artwork that you want to work on is the layer that's active. The active layer is the one in the Layers panel that is a different shade to the rest of the panel's contents (It may be darker or lighter, depending on whether you're using the darker or lighter version of the interface, as described on page 75). To select a layer click on its position in the Layers panel.

Then, in the Tools panel, choose a tool called the Lasso tool (Figure 2-45).

 Figure 2-45 The Lasso tool

If the Lasso's icon isn't visible in the Tools panel it's because it shares its space with a couple of specialized forms of the tool that have different icons, and one of these is visible instead. You can see these other icons in Figure 2-46 (they both look like bent wire coat hangers, and one seems to have a magnet attached to it). To find the Lasso, press and hold on the icon that's on display, which will open a panel that contains all three versions of the Lasso. Select the top one, which looks most like a proper lasso. Once you've done this, the Lasso will become the tool displayed in the Tools panel until you change it again, which you may do very rarely.

 Figure 2-46 The specialized lassos

Move the Lasso's cursor onto your image, near to the part that you want to cut out (in my case the man on the stairs), and press and drag the cursor. A thin line appears as you drag, marking the path of the cursor. This line isn't part of your image as such – it's just there on the screen to show you the path that the Lasso is taking.

Move the Lasso so that its path more or less surrounds the part of the image that you want to cut out and move.

When the line nearly surrounds your object release the mouse or pen and the two ends of the line will automatically join up, creating an unbroken loop (The beginning and end points of the loop will be connected by a straight line, no matter how far apart they are from each other).

When the loop is completed the line takes on a shimmering effect (See Figure 2-47, where you can see the line surrounding the man, but without the shimmering effect). This shimmering effect shows that the line is defining a specific area of the layer, and whatever you do next will only affect that particular area. Such an area is referred to as a selection area, or just plain selection.

Figure 2-47 The selection outline

There are several other ways of creating selections, but for now the Lasso tool is enough to be going on with.

Now you want to cut the selected area from the layer and place it onto a new layer (so that you can move it around independently).

In the menu bar at the top of the screen go to the Layer menu and choose New. This will open a submenu that contains a list of various ways of creating a new layer. Choose Layer via Cut. This automatically cuts the selection from its layer and puts it onto a new layer that's created specially for it. If you look in the Layers panel you'll see the new layer that has miraculously appeared, directly above the one that the selection was cut from.

Now that the desired part of the image is on its own layer you can move it independently of the rest of the image.

With the layer selected as the active layer in the Layers panel (which in this case it will be automatically, as the last thing that you did was to create it), go to the Tools panel and select the Move tool (Figure 2-43), as in the previous example.

In the Move tool's options bar turn off the three options Auto Select Layer, Show

Bounding Box, and Show Highlight on Rollover if they're on. Do this by clicking their check boxes to remove the ticks.

Press and drag your cursor anywhere on your drawing, and the image on the active layer will move around the screen as you move the cursor.

Release the cursor when you're happy with where the image is resting.

Cutting part out of an image like this often leaves holes in your original image that need fixing. For instance, in my example (Figure 2-48), cutting the man out left small gaps in the line of the stairs where the man was sitting, which had to be restored using the Brush tool. This is one reason why it's normally best to try to place different elements of an image onto separate layers to begin with, making such repairs less necessary.

Figure 2-48　Moving parts of images may require some repair work, as with the gaps in the stairs here

Duplicating Part of an Image

Figure 2-49　Part of an image duplicated (right) in order to create multiply copies

It's very easy to duplicate parts of an image so that you have several identical copies of the same object in the same image. You may want to do this for instance when you need

two versions of the same object in a picture, such as with the flamingos in Figure 2-49, or if you want to create a copy of an object so that you can modify it while keeping an unmodified version safe in case of mistakes.

If the object that you want to duplicate is the only thing on a layer, the easiest way to make a copy of it is to duplicate the whole layer.

Duplicating a layer is done by pressing the cursor on the layer's position in the Layers panel and dragging the layer down to the New Layer icon at the bottom left corner of the panel (Figure 2-27). When the cursor is above the icon, release it to create an exact copy of the layer. The copy will have the same name as the original layer but with the word 'copy' added.

If the object that you want to duplicate is on a layer with other objects that you don't want to duplicate you have to first isolate the object by placing a selection line round it, such as by using the Lasso tool described in the previous section.

Then go to the menu bar, and go to Layer>New>Layer via Copy.

The copy of the image on the new layer will be directly above the original layer, with the contents lined up exactly, so its existence may not be immediately obvious. However, if you look at the Layers panel you'll see that there's a new layer in it, which is now the active layer.

If you want to reposition the copy so that it's in a different position to the original image, making both images visible at once as with my flamingos, slide one of the layers across to place its contents in a new location by using the Move tool (Figure 2-43).

If you copied the image with the intention of altering one of the copies while leaving the other one unchanged, you need to make one of the versions invisible so that you can only see the one that you want to work on. Do this by going to the Layers panel and clicking the eye icon for the layer you want to hide (Figure 2-38).

Moving Part of an Image into a Totally Different Image

Sometimes you'll want to copy part of an image into a different image altogether, in a different file.

Here's one way to do this.

Open both images, the one that you want to copy the image from and the one that you want to place it into, so that they're both visible on the screen at the same time. Then, in the

image containing the object that you want to move, define the object by selecting it (for instance by tracing a line round it with the Lasso tool). Using the Move tool, press inside the selection and drag the selection across onto the other image (Figure 2-50). The area will automatically be copied onto a new layer in the second image (leaving the original in place and unaltered).

Figure 2-50 You can drag objects between images

Changing the Size of Objects

Sometimes you'll want to change the size of parts of your image.

You may want to do this if you need to resize a whole object, such as in Figure 2-51 where I've changed the size of one of the flamingos, or you may want to change the proportions of part of an image, such as in Figure 2-52 where I've changed the size of the man's head relative to his body.

Here's how to do it.

First make sure that the layer containing the object that you want to alter is active.

If the object that you want to alter is on a layer with other artwork you have to select the desired part of the layer so that the computer knows which part you want to alter. You

can do this by using the Lasso tool (described on page 44). If the object is the only thing on the layer no selection is necessary, as the computer automatically selects all of the artwork on the layer.

Figure 2-51 You can change the size of objects in Elements, such as here where I've changed the size of one of the flamingos

Figure 2-52
You can change the size of parts of objects.
Here I've altered the man's head while leaving his body the same size

To change the object's size, in the menu bar go to Image>Transform>Free Transform.

When you click on Free Transform a rectangle appears round the selected part of your image (Figure 2-53), with small squares at each corner and half way along each side.

Figure 2-53
The bounding box, with which you
can resize or distort an object

This rectangle is called a bounding box, and the small squares are called handles. By pulling on these handles with the cursor you can distort the shape of the box, which in turn distorts the object inside it.

When the cursor is outside the bounding box the cursor will appear as a curved line with an arrowhead at either end, but when you move it very close to the box the curved arrow will change into a straight arrow instead, which will be pointing in one of several directions depending on whether it's near a corner or a side. The direction of the arrow is a clue to which way you can move that particular part of the box. Press and drag the cursor to move the sides of the box.

When you drag on a corner handle the size of the box, and its contents, are changed, becoming either larger or smaller depending on the direction that you drag. When you drag on a side handle (or anywhere along a side of the box) the box is either squashed or elongated, making it tall and thin or short and wide, depending on the direction that you drag.

If you change the size of the box by exclusively dragging the corner handles the proportions of the box remains constant. However, if you drag on any of the side handles in the same operation the constraint on the corner handles is 'unlocked' and the proportions can be altered by using the corner handles alone. Once the proportion constraint has been unlocked in this way it's still possible to reapply the constraint temporarily – do this by holding down the Shift key on the keyboard while you're dragging the corner handles (The Shift key is a very useful key whenever you want to restrain the movement of something on the screen – it works in a similar way with lots of different tools).

Once you've resized your object you may also want to reposition it by moving it across the image (for instance in order to compensate for the size change). To do this, put the cursor inside the bounding box, where it will turn into a single arrowhead. Then press and drag to move the object.

When you're happy with the new size and position of your object, click the large tick in the box that hovers to the bottom right of the bounding box (Figure 2-54). However, if you're dissatisfied with the results, and would like to return to the original version of the object, click on the circle with the diagonal line through it instead, which cancels the alterations.

Figure 2-54
Accept or reject the alterations: the tick to accept or the circle to cancel

If you apply the alterations by clicking the tick, but then change your mind about it, you can use the Undo arrow (Figure 2-21) in the bar at the top of your screen to return the object to its previous unaltered state.

If you used a selection to define the part of the image that was resized (such as by using the Lasso), when you've finished altering your selection it will still have its selection line round it (although now the dotted line may have 'collapsed' to only surround the actual artwork within the selection rather than including any empty, transparent areas that were within the selection area – a small technical point).

When there's a selection area active, most things that you do to the image (such as painting or erasing) will only occur *within* the selection area, because that's the purpose of a selection area, so you need to cancel the selection before you proceed.

To do this, you can go to the menu bar, to Select>Deselect.

You'll find that going to the menu bar in order to deselect areas in this way can become quite tedious, because deselecting is something that you have to do a lot of. There's a much quicker method of doing it, by using the keyboard instead of the menu. If your computer uses Windows press the Control key and then the letter D, holding the two keys down together, or if you use a Mac press Command and D (The Command key has an enigmatic, mysterious symbol on it: ⌘. And possibly an apple as well). This action is known as a keyboard shortcut, as explained in more detail on page 78.

Rotating Parts of Images

As well as using the Free Transform command, described above, to change the size of objects, it's possible to use it to alter their angles too. In Figure 2-55 I've used it to change the angle of a man's head.

Figure 2-55
You can use the Free Transform command to rotate objects, such as this man's head

You do this using almost exactly the same steps that you use to change the size of objects, described previously.

If you only want to rotate part of an image (in my case the man's head) select the area using the Lasso tool. If everything on a layer needs rotating, no selection is necessary.

Now, choose the Free Transform command (In the menu bar at Image> Transform> Free Transform). A bounding box will appear, enclosing the selected area.

When the cursor is outside the bounding box (but not too close to any of the sides) it appears as a curved, double-headed arrow. This means that when you press and drag, the box and the object inside it will rotate.

When you do this, twirl the box round randomly just for the fun of it, then choose the correct position and release the cursor.

After you've rotated an object it often needs moving slightly horizontally or vertically to improve its position relative to the rest of the image. To move it, place the cursor inside the box, where it changes to a single arrowhead, then press and drag.

When you're happy with the position, click the large tick in the panel just beneath the bounding box to apply the alterations (Figure 2-54). If however you don't like the results, cancel the whole operation by clicking the circle with the diagonal line through it.

If you apply the alterations by clicking the tick, but then change your mind about it, you can use the Undo arrow (Figure 2-21) in the bar at the top of the screen to return the object to its previous unaltered state.

If you used a selection to define the part of the image that was rotated, remove the selection outline when you've finished by going to Select>Deselect in the menu bar, or use the keyboard shortcut of Control-D in Windows or ⌘-D on a Mac (as described in the previous section).

Once you've rotated your artwork you'll sometimes find that it doesn't quite join up to the rest of the image, as there may be discontinuities where you've altered the angle. You can tidy up the joins using the painting tools, such as the Brush and the Eraser.

And that is most of what there is to the art of drawing on your computer.

Except of course for the use of colour, which I'll deal with next. But in terms of the fundamentals of building up and manipulating the elements of your image, you're there.

You may be thinking that it all seems a bit complicated right now, but remember that it's a bit like learning to ride a bike – with a little practice it will become second nature.

Adding Colour

All that remains now in order to create images on your computer is to acquire an understanding of how to apply colour.

Of course the colour images in this section lose something reproduced here in black and white, but fortunately the actual use of colour is surprisingly unnecessary for these explanations. If you want to see the images in full colour, some are reproduced on the back cover, while more are on the web at www.chrismadden.co.uk/create.

In This Section:
Painting in colour
Changing colours after they've been applied

Along the way you'll be shown how to change brush sizes instantly, rearrange layers in the stack, select with the Magic Wand and sample colours using the Eyedropper.

Painting in Colour

The most obvious way to add colour to images is by 'painting' it directly onto the image with a brush, in very much the same way that you created the line drawing earlier in this chapter. All you need to do in order to do this is to change the black 'ink' that you were applying into coloured 'paint', and maybe choose a thicker brush with which to apply it.

Just follow this exercise to learn the basics of using colour in Elements.

Figure 2-56
This colourful dragon was created using the Brush tool.
Okay, okay. I know that it's in glorious black and white here on the printed page. Do you realise how much this book would have cost if it had been in colour?
To see a colour version of the image go to www.chrismadden.co.uk/create)

First, create a new sheet to work on, by opening a new document as described at the beginning of the chapter.

Give it a name, such as My First Colour Experiment, and set a size and resolution. The dimensions used in the previous section are fine (five centimetres or two inches square at 300ppi). Make sure Mode is set to RGB Color, and Contents to White.

When the sheet, or canvas, appears, create a new layer to work on, so that you don't work directly on the original background layer itself (As I mentioned earlier, it's best not to work on the background layer because the work's harder to manipulate later).

To apply your colours you'll need a suitable brush.

There are a very large number of brushes to choose from in Elements, that apply colour in a variety of different ways (as described later, in Chapter 6). However for now it's probably best to stick to a very straightforward brush – by simply using a larger version of the basic brush that I recommended for creating line drawings.

If the brush that you did your drawing with was the last brush that was used it'll be the one that opens when you click on the Brush tool.

Reopen the Brush tool by clicking its icon in the Tools panel. The brush size that I recommended for drawing lines with was in the region of five or nine pixels, but this will be too small for covering areas with colour, where a size of about 20 pixels may be better.

To increase the brush's size you can change the size in the Size box in the options bar, as described on page 24.

Alternatively, you can use the following method.

You can change the size of a brush without going back to the options bar at all, by simply pressing one or other of the square bracket keys on the keyboard (to the right of the letter P). These keys are keyboard shortcuts for increasing or decreasing the size of your brush in small steps: the left bracket reduces the brush's size while the right one increases it. Look at the Size box in the options bar and you'll see the size changing.

Now that you've got your layer to work on and your brush, you need some colours to use.

There are several ways to choose your colours: here I'll describe the simplest one, which is to use the Color Swatches panel (Figure 2-57).

The Color Swatches panel contains a set of squares of predetermined colours, called swatches. Choosing colours from these swatches allows you to avoid the complexity of having to 'mix' the colours yourself. If the exact colour that you want isn't available in the panel you can pick any other colour and alter it later, after you've applied it (as I'll explain soon).

To open the Color Swatches panel go to the menu bar, to Window>Color Swatches. If you've never opened the Color Swatches panel before, it will open in the Panel Bin, because that's where all panels appear the first time you use them. The Panel Bin, which will have suddenly and annoyingly incarnated itself down the entire right hand side of your screen, is, as I mentioned previously, a huge waste of space, so I'd recommend removing the panel from the bin, allowing you to place it somewhere more convenient. Slide the panel out of the bin by dragging on the panel's title bar (the gray band that includes the title Color Swatches). The bin will then close, leaving the much more modestly and sensibly proportioned panel free-floating on the screen.

Figure 2-57 The Color Swatches panel, with the colours unaligned (left) and aligned (right)

When the Color Swatches panel opens, the colours in the panel may seem to be randomly displayed rather than being arranged in any logical order (Figure 2-57, left). The colours can however be arranged in columns with similar colours stacked above each other (Figure 2-57, right), which makes the panel much easier to understand. To rearrange the colours, alter the panel's size by pressing and dragging on the bottom right corner of the panel, which represents a knurled fingerpad: the swatches will then 'flow' to fit the new space allocated to them. Adjust the size until the column-based layout is achieved. Why this isn't the automatic layout is beyond me.

Pick a colour to paint with simply by moving the cursor across to the Color Swatches panel and clicking the cursor when it's over the desired colour. If the colour that you want isn't there, pick a different but similar colour, as you can alter it later.

When the cursor is over the panel it will change into an eyedropper, indicating that it can 'suck up' colours. Move the cursor back to the canvas and it will turn into a brush again. When you use the brush it will paint with the new colour.

Arranging the Colours on Top of Each Other

When you apply different colours to an image it's generally best to paint different areas of colour onto separate layers, rather than applying them all to one single layer, especially if the colours abut each other or overlap. This is because a key feature of Elements is that you can manipulate and alter colours once you've applied them, as you'll see soon, and it's much easier to control which area of colour to alter if they're on separate layers.

Figure 2-58 shows how the different colours in my picture of a dragon are arranged on individual layers.

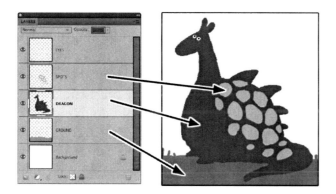

Figure 2-58
The different colours in an image applied to separate layers, so that they're easier to manipulate later.
See the image in colour at
www.chrismadden.co.uk/create

Applying Colours With Tonal Variations

Using the technique described above the colours that were applied to the image were all flat, with no variety of tone, because the brush applied the colours very uniformly. However, it's possible to produce brush-strokes that are softer and more varied, such as in the sky that I've added in Figure 2-59, by using the following method.

To produce tonal effects it's best to use a brush that produces a softer edged stroke than the one that you've been using up to now, so that the tones blend together more smoothly.

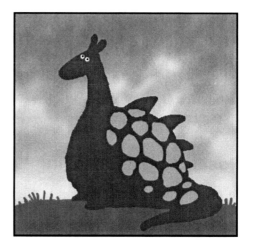

Figure 2-59 The sky here contains tonal variations

57

Go to the Brush panel to pick a new brush (by clicking on the curving brushstroke thumbnail in the Brush tool's options bar). Drag the bottom right corner of the palette to change its size and to thus reveal more brushes. You'll notice that the brushes in the panel are laid out in a certain order. The first six brushes increase in size (up to the one with the number 19 next to it), then the size drops down again and starts over. The first group of brushes are all hard-edged ones, while the second group are softer edged ones. It's one of these softer edged brushes that you need to pick now. I'd recommend the one at size 65 to start with. If that size isn't suitable choose a different one or use the square bracket keys to alter the size (described on page 55). When you've picked a new brush the thumbnail in the options bar will change to show the type of stroke made by the new brush.

You can produce variability in the tone of your brushstrokes by setting the Opacity control in the Brush tool's options bar below 100 percent. This makes the colour that you apply semitransparent, so that you can see through it and thus build up the colour with separate brushstrokes on top of each other. You have to apply *separate* brushstrokes to build up the colour, releasing the mouse or pen between strokes (as simply doubling back and going over the same spot twice in the same stroke doesn't produce the effect). The more transparent the colour, the more subtle the tonal variations that you can achieve, as the colour has to be built up more gradually using a larger number of strokes. I'd recommend using an opacity in the region of ten percent to start with.

If you're using a graphics tablet, you can also alter the opacity of your brush strokes simply by varying the pressure with which you apply to your pen to the tablet. If this feature doesn't seem to be working for your chosen brush it probably means that the facility is turned off. To turn it on go to the menu bar, to the (unnecessarily) insignificant-looking little downward pointing arrow that's after the Opacity control and the Airbrush button and before the brush-shaped button. Click on the arrow and in the panel that opens tick the check box for Opacity if it isn't checked already (This is a separate type of opacity to the one in the menu bar itself).

Positioning and Moving Layers in the Stack

In my example of the dragon in Figure 2-59, after I'd painted the dragon I painted the sky onto a new layer that I placed *beneath* the creature. It had to be beneath the dragon so that the colour of the sky wouldn't obscure the dragon itself. So far I haven't actually mentioned how to place layers under other layers, so I'd better do that now.

New layers are by default placed above the active layer, so the easiest way to create a

new layer at a particular position in the stack of layers is to first decide which layer you want to be positioned immediately *below* the new layer. Make this layer active, then create your new layer above it as normal.

You can move any layer in a stack of layers (other than the background layer) in order to change the order of the stack by pressing on the layer in the Layers panel and dragging it up or down to a new position. The other layers will move apart in order to accommodate the repositioned layer. As I mentioned, you can't move the backgrond layer, and you can't place layers beneath it, as by definition the background layer is the bottom layer (however it's possible to turn the background layer into an ordinary layer in order to overcome these inconveniences, as explained on page 214).

Changing the Colours in an Image

If you're not a hundred percent happy with the colours that you've chosen for an image (and who ever is?) you can alter them very easily. You can make subtle adjustments to them or you can change them to completely different colours from wildly different parts of the spectrum, all in a matter of moments (Figure 2-60). This is one of Elements' greatest strengths – you need never worry about applying the wrong colours, because they are all infinitely changeable.

Figure 2-60
Here I've changed all of the colours
in my image.
(To see a colour version go to
www.chrismadden.co.uk/create)

Here's how to change your colours.

First, as a precaution against anything going wrong, it's a good idea to create a duplicate of the layer that you're going to work on, so that you've got an unaltered copy as a back-up. Do this in the Layers panel by dragging the layer down onto the New Layer icon. Then hide the copy of the layer so that it doesn't get in the way, by clicking on its eye icon.

Then return to the layer that needs changing. If the layer contains areas of colour that

you want to leave unaltered as well as ones that you want to adjust you have to select the specific areas that you want to change (for instance by using the Lasso tool).

Next, in the menu bar go to Enhance>Adjust Color>Adjust Hue/Saturation.

A dialogue box opens with three sliding controls in it (Figure 2-61). This panel looks much more intimidating than it really is. All you need to concentrate on are the three sliders in the middle of the box, labelled Hue, Saturation and Lightness. These sliders adjust the values of the colour that you've chosen to alter.

Moving the top slider, the Hue slider, will alter the hue (or basic colour) of the selected area of your image. This means that as you slide it, the colour shifts through the entire spectrum, through red, orange, yellow, green and so on. No matter what your original colours were, you can change them to any other colour in the rainbow.

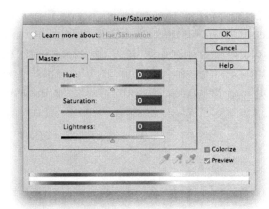

Figure 2-61
The Hue/Saturation dialogue
box: for altering the colours
in your image

The second slider alters the saturation, or the intensity of the colour. At one end of the scale the colour is at its most vivid and intense, while at the other end the colour leaches out completely, leaving a colourless grey.

The third slider changes the lightness (or darkness) of the colour, adding black as you move the slider right, or adding white as you move it left.

A particularly useful feature of this way of altering colours is that the tonal values of the original colours are retained when the colours are changed. Notice in Figure 2-60 that the tonal variations in the sky that give it a cloudy effect are unaltered, despite the fact that I've changed the colour (Actually, you probably wouldn't notice this by looking at the black and white image here, so have a look at the colour version at www.chrismadden.co.uk/create).

Flooding Areas With Colour Using the Paint Bucket

Up to now the colour that's been added to an image has been applied with a brush.

However it's possible to add colour to areas of an image automatically, without having to use the Brush tool at all. The only requirement is that the area that's going to be filled with colour has a well-defined boundary.

Here's the technique at it's simplest.

Figure 2-62
The area of the shape on the left was filled with colour with a single click (right)

First, create an area that has a well-defined continuous boundary, such as a loop formed by an overlapping line as in Figure 2-62. Alternatively choose part of an image that you think will serve the purpose.

Then select the Paint Bucket tool (Figure 2-63) from the Tools panel.

In the Paint Bucket tool's options bar, make sure that the check boxes labelled Anti-alias and Contiguous are ticked, and that the one labelled All Layers isn't.

 Figure 2-63 The Paint Bucket tool

Open the Color Swatches panel, if it isn't open already (In the menu bar go to Window>Color Swatches).

Move the cursor over the Color Swatches panel, and click on any colour that takes your fancy. Then move the cursor back to the image, and click inside the area where you want to apply the colour. Hey Presto, the entire area will fill with colour.

A small warning: when you're filling outlines (such as the one in Figure 2-62) make sure that the outline is completely closed, with no gaps in it, such as the one shown overleaf in Figure 2-64. If there are any gaps the colour won't be contained within the shape and will flow out through the gap, disconcertingly filling the area outside the shape too. Gaps in outlines are almost bound to occur occasionally, and are sometimes necessary, so this issue is covered in more depth on page 303.

Figure 2-64
If there are gaps in the outline, as here,
the colour floods out through the gap

That's the technique at its simplest.

Here's how to use it in a more sophisticated way – to add colour to a line drawing (Figure 2-65).

Figure 2-65 A line drawing, and the drawing filled with flat areas of colour

To follow this explanation using work of your own, first create a line drawing on a new transparent layer, making sure that any areas that you want to fill with colour have continuous boundaries, with no gaps (as explained on the previous page). The simplest sort of drawing that you can make for this purpose is a single squiggly line that crosses itself several times (Figure 2-66). Draw the line using one of the hard-edged brushes from the top of the Brush panel.

Figure 2-66
An easy way to draw a sketch that has
no gaps in it is to use one single line that
crosses itself several times

Starting with the line drawing on one layer, create a new layer on which to add the colours (so that the colours remain separate from the line drawing and are thus easier to alter later if necessary).

I'm going to put all of the different colours for this image onto one layer, even though earlier I said that it's best to put different areas of colour onto separate layers. This is because when you're working with well-defined areas of flat colour it isn't *quite* as important to keep your colours separate, as I'll demonstrate soon when I explain how to alter different colours that are on the same layer.

The new layer is automatically placed above the previously active layer, which contains the line drawing. Pull it below the line drawing's layer by going to the Layers panel and pressing and dragging on the new layer's name panel, placing it beneath the panel of the line drawing.

Then select the Paint Bucket tool from the Tools panel.

In the bucket's options bar make sure that the check boxes labelled Anti-alias and Contiguous are ticked, as before. This time tick the All Layers box as well – this makes the Paint Bucket take into account the artwork on all of the layers when it's working out the area that it will fill with colour, rather than only taking into account the active layer. Which is exactly what we want.

Set the number inside the box labelled Tolerance at the default setting of 32 (This isn't critical, but if it's wildly different it may affect your results).

Open the Color Swatches panel, if it isn't open already (at Window>Color Swatches).

Move the cursor over the Swatches panel, and click on a colour to select it.

Move the cursor back to the image, and click it on the white space in the area that you want to apply the colour. The area will fill with colour. In my example on the next page (Figure 2-67) I've clicked on the area of the head.

Figure 2-67
Filling a well-defined
area with flat colour
using the Paint Bucket

If you don't like the colour that you've chosen you can remove it by stepping back one stage using the Undo button (the left pointing arrow in the bar near the top of the screen). Then pick a different colour from the swatches and repeat the process.

Fill other areas of the image in the same way.

This method of applying colour is almost too good to be true, it's so easy.

There is, however, one small thing you need to watch out for.

You may notice sometimes that when you've filled an area with colour, especially a dark colour, there's a slight light fringe between the fill colour and the edge to which it's filled. One way to reduce this fringe is to increase the value in the Tolerance box in the options bar, which will make the colour fill a wider area. The cause of the fringe will be explained later (page 305) – along with ways of avoiding it.

Once you've applied your colours you'll almost inevitably want to alter some of them.

You can modify them, as in Figure 2-68, using the Adjust Hue/Saturation command that was introduced in the previous section (at Enhance>Adjust Color>Adjust Hue/Saturation).

Figure 2-68
You can easily change
the colours in your
image using the
Adjust Hue/Saturation
command.
(See this image in
colour on the back
cover)

In this image all of the colours are on the same layer (Figure 2-69), so to alter a specific area of colour you need to select that colour to isolate it from the other colours.

If you don't isolate the colour, all of the colours on the layer will be affected by the adjustment. (Try using the Adjust Hue/Saturation command on all of the colours to see what happens: moving the Hue slider will make all of the colours on the layer change quite bewilderingly. Then press Cancel so that the effect isn't applied.)

An easy way to select a specific colour on a layer is described next.

Figure 2-69
All of the different colours in this image
are on the same layer

Selecting Areas Automatically Using the Magic Wand

When you have several colours on one layer, as in Figure 2-69, in order to alter one specific colour you need to define the area of the colour by selecting it.

You can trace round the outline of the area that you want to select, using the Lasso tool described earlier, but this is a little difficult sometimes, and can be quite tedious too.

Fortunately, Elements includes several tools that can automatically select areas of similar colour without you having to define the areas manually. For now I'll explain how to use one of the most basic and easy to understand of these tools, called the Magic Wand (Figure 2-70).

To use the Magic Wand, click its icon in the Tools panel.

In the tool's options bar, tick the check boxes for Anti-alias and Contiguous if they aren't checked already. The check box for All Layers should be off.

Figure 2-70 The Magic Wand selects areas of similar colour with one click

Go to the image and click on the coloured area that you want to alter (in my example, the woman's hair).

A shimmering selection line (the same as the ones created earlier using the Lasso) will appear round the edge of the coloured area that you click on (Figure 2-71). This shows that the area has been defined as a selection.

Figure 2-71
An area of colour (the hair), selected
with the Magic Wand, showing the
marching ants

Because you've defined an area as a selection, whatever you do next will only apply to that particular area of the image.

What you want to do to this particular area is to change its colour (Figure 2-72) using the Adjust Hue/Saturation command. To do this go to the menu bar, to Enhance>Adjust Color>Adjust Hue/Saturation, which will open the dialogue box with its three sliding controls (Figure 2-61). To alter the colours move the sliders, as explained earlier.

Figure 2-72 Changing the colour of part of a layer. Left: The area is selected (the hair) using the Magic Wand. Right: The colour is changed, using the Adjust Hue/ Saturation command

That explains how to alter one area of colour in an image, but what if the colour that you want to alter is in several separate areas that each need changing? For instance, in my image, the woman's collar is in two distinct areas, so altering one part of the collar means that the other part needs changing as well.

To alter several areas at once you need to select them all at the same time, so that they'll all be affected together. To do this with the Magic Wand go to the options bar and go to the row of four icons depicting overlapping squares (Figure 2-73). Click the second icon along, which shows two squares of the same colour.

Figure 2-73 Click the second button to select several areas at once

Now when you use the Magic Wand you can click on several areas in succession and they will all become selected.

A word of warning: the wand will stay in this multiple selection mode until you deliberately return it to its normal mode – so after you've finished making your multiple selection I'd recommend that you click on the first button in the row (the single square) to return the wand to its normal mode, as otherwise the next time you use the wand it will make another multiple selection.

Going backwards and forwards to these square buttons is another procedure in Elements where the tedious need to make multiple visits to the options bar can be avoided by using a keyboard shortcut, which is a technique that I've only mentioned briefly so far. The only reason it's not mentioned these shortcuts in greater detail yet is that they are yet another thing to remember on a relatively steep learning curve, so they are explained later when things flatten off a bit, on page 231.

Sampling Colours Using the Eyedropper

What do you do if there's an area of colour in an image and you want to make another area the same colour? This would be the case, for instance, if in my image of the woman I'd failed to realize that her collar had two distinct areas, and I'd only coloured one of them with the correct colour (Figure 2-74, right). You don't want to tediously have to 'remix' the colour for the second area using the Hue/Saturation sliders in an attempt to get a perfect match.

Figure 2-74 How do you match the collars?

The simplest approach in cases like this is to sample, or pick up, the desired colour directly from the image, so that the same colour can be applied elsewhere.

You can do this by going to the Eyedropper tool in the Tools panel (Figure 2-75).

Figure 2-75 The Eyedropper, for sampling colours

Select the Eyedropper and move the cursor onto your image. Click on an example of the colour that you want to use elsewhere: this will make the top square in the overlapping pair at the bottom of the Tools panel change to that colour, indicating that it's now the colour that'll be used when you next apply colour.

Now you can apply the colour to your image, such as by using the Paint Bucket to flood an area with the colour or by using the Brush to apply the colour manually.

And that's about it!

You've now been introduced to about 90 percent of the techniques that I use when creating computer images.

Of course this has just been a taster to those techniques.

Some of the methods described so far are the simplest means of achieving results in their most basic form. More sophisticated and controlled results can be obtained once you're more familiar with the programme.

The next chapters cover ways of getting more out of the techniques that are available in Elements, such as by fine-tuning tools and by using features not covered so far. There are sections on tools and techniques that I haven't touched on at all yet, some of which are useful for specific purposes and some that you may never use at all. I've attempted to present these sections in the order of their relative importance, although this is inevitably partly a matter of personal preference.

But essentially, you're there already. You can draw and paint on a computer!

Congratulations!

The Essentials: Step by Step

Part II

Opening Elements and Dealing with Documents

Welcome to the Interface

3

When you open any computer programme a selection of panels, bars and other paraphernalia appears on your screen, giving you access to the features of the programme: this display is known as the interface.

Some of the items on the interface are essential for using the programme, and have to be left on view more or less permanently, while other components can be opened and closed as and when they're needed to avoid cluttering up the screen. This chapter will introduce you to all of these features.

In This Chapter:
The interface
The Menu bar
Keyboard shortcuts
The Tools panel
Application bar
Options bar
Panels
Project bin
Zooming

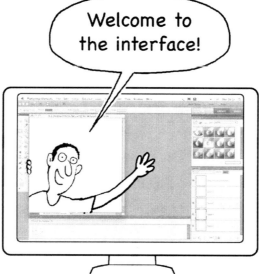

A Lightning Tour of the Interface

When you open Elements for the first time the display of panels and bars that makes up the interface looks awfully complicated (Figure 3-1), but it's very easy to simplify it and make it look much less intimidating (Figure 3-2).

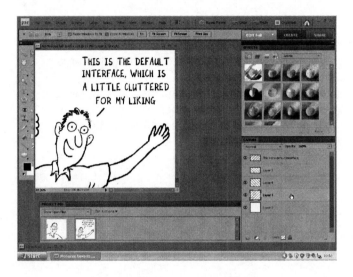

Figure 3-1
This is the appearance of the interface the first time you open Elements. It's all a little busy. Fortunately, it can easily be simplified so that it looks more like Figure 3-2

Two of the items on the original interface, the Panel Bin (down the right side) and the Project Bin (across the bottom) can easily be removed altogether, as described soon.

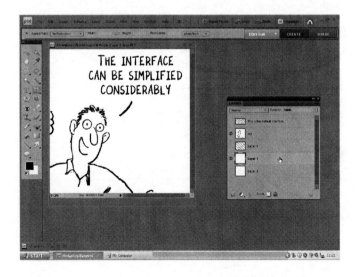

Figure 3-2
The interface laid out with only the most important panels on display, making it much less cluttered than the original layout

If the image on your interface seems to be floating in the middle of a neutral gray panel (Figure 3-3) rather than being bounded by a definite frame as in Figure 3-1 you've possibly got your interface set to a different mode, called tabbed mode. This isn't a particularly useful mode for working creatively, so I'll generally ignore it. It's easy to accidentally slip into tabbed mode when you move images round on your screen, which can be a little confusing.

If you want to see what your screen looks like in tabbed mode (so that you know what to expect if you accidentally slip into that mode later) go to Window>Images>Consolidate All to Tabs. You can get out of tabbed mode by going to Window>Images>Float All in Windows.

On a Mac you can avoid slipping into tabbed mode by going to Window>Application Frame, which will also remove the gray background from the interface (which I would recommend).

Figure 3-3
This is the
appearance of the
interface when it's
in tabbed mode

The interface can be displayed in a choice of two shades of gray - light or dark. You can choose between these shades by going to the Preferences panel and in the General section ticking the appropriate Interface Brightness button (near the bottom). The Preferences panel can be found in the menu bar – in Windows it's in the File menu, while on Macs it's under the Photoshop Elements menu. Both choices of gray are awful as far as I'm concerned, but that's all that's on offer unfortunately. If you're using Windows I'd recommend that you use the light interface, as it makes it easier to see the smaller, more obscure buttons that lurk in odd corners of the interface. On a Mac things are more difficult. The light interface is generally better except for the infuriating fact that any boxes into which you have to type

information (such as file dimensions, brush sizes and such-like) are so dark as to be unusable. On a Mac you may find yourself flipping between interface shades just so that you can see what's going on.

Here's a description of the various bits and pieces that you'll find on the interface.

The Cursor

The cursor is the small pointer that scurries around the screen as you move your mouse or pen, allowing you to interact with the items on the screen.

Pressing the button on your mouse or the pen on your graphics tablet while the cursor is in a particular position signals that you want to select the item that the cursor's over at the time or that you want to work on that particular part of the screen.

The cursor doesn't have a single, fixed appearance, but metamorphoses into a variety of different forms, depending on what it's being called on to do at any specific moment. For instance, if you're using the Brush, the cursor will look like a tiny brush (unless you deliberately choose to make it look different, as described on page 146), while if you're using the Eraser it will look like an eraser (again unless you choose to make it look different). The cursor only looks like the chosen tool while it's on the area of the screen that's occupied by your image (because that's where the tool will function). When you move the cursor off the image it will change form. On most of the rest of the screen it will take the form of an arrowhead, while if it's above various of the panels on the interface it may change into a form appropriate for that panel.

The Menu Bar

The menu bar (Figure 3-4) can be found along the very top of the screen. This is essentially the primary control strip of Elements, where you instruct the programme to carry out chosen functions or commands.

The menu bars in Windows and on Macs are slightly different. Both however share the same core feature, which is the row of categories in the left hand half of the bar, beginning with File and ending with Help.

Figure 3-4 The Menu bar. Top, on a PC: bottom, on a Mac

All of these categories contain lists, or menus, of commands – the menus that give the bar its name (Figure 3-5). These lists are usually referred to as drop-down menus because of the way that they open. The commands act on the work that you're doing by allowing you to alter it or process it in some way (except for the commands in the Help menu, which give you advice on how to use the programme). The use of the individual commands is explained in the appropriate sections of the book.

Moving the cursor down the commands in the list will highlight each command as you pass over it, indicating that if you click the mouse or pen at that point that command will be selected.

Once you've opened a drop-down menu by clicking on it you can move the cursor across the menu bar to the other menus, which will open automatically without you having to bother clicking on them. This is very useful when you're trying to find a command when you're unsure which menu it's in, which tends to be most of the time.

You can also open the drop-down menus by pressing and holding down the mouse button or pen rather than by clicking – which means that you need to click less (although you have to 'hold' more). Using this method a command is chosen when you release the mouse or pen while the command is highlighted.

Figure 3-5
The commands in a typical drop-down menu in the menu bar, including a typical submenu
The presence of a submenu is indicated by a triangular arrowhead alongside the menu item

If you're working on a task for which a particular command can't be applied, the command's name in the drop-down menu is displayed in faint gray letters rather than in black (or white if you're using the dark version of the interface in Windows), and when you move the cursor over the command it isn't highlighted, indicating that it's inoperative.

Alongside many of the commands' names are symbols indicating that you have more choices to make when you choose the command.

A small triangular arrowhead next to an item indicates that there is a further list, or submenu, of commands that will open automatically when you hover your cursor over the

command – there's one in Figure 3-5 alongside the Adjust Lighting command. Having these secondary lists hidden in this way keeps things neat, as otherwise the full menu may stretch for the entire height of your computer screen and all the way down to the floor. The drawback is that the submenus can make commands hard to find when you're unsure of where they are.

An ellipsis (three dots) next to a command's name indicates that when you click that command a dialogue box will open, into which you should enter relevant information in order to execute the command. For example, choosing Brightness/Contrast from the submenu in Figure 3-5 will open the dialogue box in Figure 3-6, where you have to enter a numerical value.

Figure 3-6
Three dots next to a
menu item mean that
a dialogue box such
as this will open

Alongside some commands are various letters and symbols. These are reminders of the keyboard shortcuts for those items, described next.

Keyboard Shortcuts for Commands

Many commands in the menu bar can be executed without the need to go to the menu bar in order to select them – by using keyboard shortcuts. This saves a lot of fiddling around. The keyboard shortcuts are a combination of a letter key and one or more of the small group of keys in the bottom left corner of the keyboard. The keys in this group are called modifier keys, because they don't produce any results when used on their own, but modify the action of other keys (For instance, the Shift key turns letters into capitals, but doesn't type letters itself).

Although the shortcuts displayed in the menus (and therefore in this book) show capital letters, the shortcuts themselves work using lower case letters (so Control-I should be Control-i). I suppose the capital letters are used for clarity. In Windows the + sign in the menus means 'plus this letter' rather than meaning that you have to press the + key as one of the keys.

To use a shortcut, hold down the appropriate modifier key or keys first, then press the letter key: when all of the relevant keys are down at the same time the shortcut will be executed (You have to press the modifier keys first, otherwise it doesn't operate).

For frequently used commands these keyboard shortcuts can save a lot of time and are well worth memorising. Once you're familiar with them, they're usually the easiest way of accessing commands.

On a Mac some modifier keys have symbols on them as well as, or instead of, names. The Command key has a funny four-looped symbol, ⌘, on it and on some keyboards an apple, while the Option key may have a ⌥ symbol and the abbreviation 'alt' (showing that it's the same as the Windows' Alt key, where Alt is short for Alternate).

Windows only apects of the menu bar

As well as the features described above which are shared by both Windows computers and Macs, the Menu bar in Windows includes the following features. Some of these are also featured on Macs but are situated in the Application Bar, discussed on page 81.

The button to the left of the Help menu, which shows a number of rectangles inside a square, is the Arrange button. This gives you a few options concerning the way that your images are displayed on the screen when you have several images open at once. Each configuration is indicated by an icon in the series that appears when you click the button. The configurations all involve displaying the images in what is known as 'tabbed' format. This isn't the ideal way to display images when you're working on them, for which the default 'floating window' format is preferable. If you do decide to display the images in tabbed format for any reason you can revert to floating format by clicking the Arrange Documents button and going to Float All in Windows.

Next comes a button labelled Reset Panels. Clicking this button returns the panels, such as the Layers panel, to their default positions – the positions that they were in when Elements first came out of its box. This button is particularly useful when you're first experimenting with panels and you become hopelessly confused about what you've done with them and you just want to start all over again.

The two curving arrows in the Menu bar, labelled Undo and Redo, are extremely useful features. These buttons allow you to move backwards and forwards through the stages of your work in order to correct mistakes.

The button labelled Organizer opens Elements' image cataloguing and retrieving system, known as the Organizer (See Chapter 19).

The house-shaped button opens the Welcome Screen, which the icon seems to imply is some sort of home page. From the Welcome Screen you can then open the Organizer or the Editor. I'm not quite sure why this button exists to be honest.

The final three buttons in the Windows Menu bar are the standard Windows' buttons for minimising and maximising the interface on the screen and quitting the programme. Minimising (the button that looks like a minus sign) makes the interface disappear into a small tab at the bottom of the screen. Clicking the tab reopens it. Maximising (the overlapping rectangles) makes the interface fill the available space on the screen. Quitting (the cross) closes down the programme completely, meaning that to reopen it you need to click on the Elements application icon or the name or icon of an Elements file.

The Tools panel

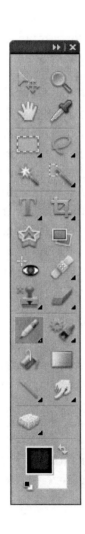

Down the left hand side of the screen is a raft of icons (Figure 3-7), which will be arranged in either one or two columns depending on the size of your screen and on how you've decided to display them. This is the Tools panel.

If you can't see the overlapping coloured (or black and white) squares at the bottom of the Tools panel when it's in single column mode this is because they've disappeared off the bottom of your screen. You need to shorten the panel by converting it to its shorter, stockier two column version. To change between the one and two column versions click the dark band that contains two tiny white triangular arrowheads at the top of the panel.

The icons in the Tools panel are the on-buttons for the tools that you use to create and edit your work in Elements. Clicking on a button opens the appropriate tool. Some of the buttons look reassuringly very much like paintbrushes, pencils, erasers and magnifying glasses, while others look completely indecipherable.

The tools are arranged in a vaguely logical order, with similar types of tool grouped together.

A little triangular arrowhead next to a button means that there are more tools, related to the visible tool, hidden away (Figure 3-8). Clicking and holding on the button will make the hidden tools pop into view.

Figure 3-7 (Left)
The Tools panel: a sort of super-powered pencil case. It will occupy either one or two columns, depending on your preference (and whether or not the single column version will fit on your screen)

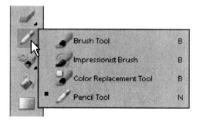

Figure 3-9
A small arrowhead next to a button in the
Tools panel means that there are hidden
buttons, revealed by pressing and holding
on the button

Each tool has a keyboard shortcut that allows you to activate the tool by pressing an appropriate letter on the keyboard rather than by clicking on the Tools panel icons. To help you to remember the correct letters they are revealed in a small box that pops into view when you hover the cursor over the tool in the Tools panel (Figure 3-10). If these boxes don't appear it's because you haven't got Tool Tips turned on in the Preferences dialogue box at Preferences>General. The keyboard shortcuts are also displayed alongside the tools in the boxes that pop open when you reveal hidden tools (Figure 3-9). Although the displayed letters are capitals, the shortcuts work just the same with lower case letters.

Figure 3-10
Tool Tips remind you of the keyboard shortcut for
opening tools (in this case the letter i for Eyedropper)

The Application Bar and Application Frame (Mac only)

If you're using a Mac you'll find that there are three bars along the top of the screen, rather than the two possessesd by the Windows version of Elements.

The extra strip is to be found immediately beneath the menu bar and is known as the Application bar (Figure 3-11). It's similar to what used to be known as the Shortcuts bar on earlier versions of Elements.

Figure 3-11 The Application bar (only found on a Macs), truncated here to fit the page

Amongst other things the Application bar contains a number of icons that act as buttons for executing some of the commands in the menu bar without you having to navigate through the menus in order to find them.

You may find that you never use the Application bar, in which case you can remove it

in order to free up a little bit of valuable screen space. To remove it go to Window>Application Bar (This only works when you're using floating image windows rather than tabbed image windows).

The Application bar may also contain a set of 'traffic lights' buttons (If they're not there it's because you're working without the Application Frame in place (which I recommend) – see the following section for details). These buttons contain symbols that only appear when you move the cursor near to them (an example of style over usefulness).

The first button – the red one with an x-shaped cross inside it (when the cursor is in its vicinity) – closes Elements. That is, it closes any open Elements documents and it makes the interface disappear from the screen. It doesn't acually *quit* from the programme altogether however, leaving it running in the background, so when you open Elements again (such as from the icon in the dock if you've put it there) the programme will pop straight back onto the screen without the delay that's inherent in opening the programme from scratch.

The second button – the amber one with the minus sign in it – makes the interface collapse down into an icon in the dock. If you're working in floating windows mode, which I'd recommend (go to Window>Images>Float all in Windows to achieve this), any open Elements images remain floating on the screen, as the button simply clears the interface itself from view to stop it from getting in the way of other things that you are doing. If you're working with the interface in tabbed mode, where the images are more intimately attached to the interface, the images disappear along with the interface. To make the interface reappear go to the dock and click the icon that will have appeared there – it looks like a tiny version of the interface and it'll be somewhere near the waste bin. The interface rather annoyingly appears in front of your images, obscuring them from view – to bring them to the front go to the Window menu and click their file names at the bottom of the menu. If you find that you're using this button a lot, because you frequently need to move Elements out of the way of other items on your computer, make sure that you read the following section about removing the Application Frame, where I explain how to get around this inconvenience.

The third button – the green one with the plus sign in it – maximises the size of the interface so that it fills the whole available space on the screen. This is useful if you've reduced the size of the interface for some reason (by dragging the bottom right hand corner inwards) or if you've moved the whole interface over to one side (by dragging in the Application bar).

Moving along the Application bar the next icon (which looks like a computer monitor with a star in its corner) is a button that allows you to create a new file without having to go to the menu bar or without having to remember the keyboard shortcut (command-N).

The next icon, with the letters Br in it, is a button that opens Adobe Bridge. Bridge is software that allows you to organise and index your images. It's used on the full price version of Photoshop and is used on Macs in place of the Organizer feature on the Windows version of Elements. There's more about Bridge in Chapter 19.

Next along is a button that allows you to save your work without having to go to the menu bar or having to remember the keyboard shortcut for saving (command-S). Despite the existence of this button it's generally a good idea to memorise the keyboard shortcut so that you can save your work almost without thinking whenever you pause during your work. The symbol looks like a floppy disk – a long redundant form of storage device.

Next comes an icon with a question mark in it. This opens the Elements Help Pages in your web browser (see page xviii).

The rest of the buttons are ones that on Windows computers are found in the Menu bar.

The first of these – a button which shows a number of rectangles inside a square – is the Arrange Documents button. This gives you a few options concerning the way that your images are displayed on the screen when you have several images open at once. Each configuration is indicated by an icon in the series that appears when you click the button. The configurations all involve displaying the images in what is known as 'tabbed' format. This isn't the ideal way to display images when you're working on them, for which the default 'floating window' format is preferable. If you do decide to display the images in tabbed format for any reason you can revert to floating format by clicking the Arrange Documents button and going to Float All in Windows.

Towards the left hand end of the Applications bar is a button labelled Reset Panels. Clicking this button returns the panels, such as the Layers panel, to their default positions – the positions that they were in when Elements was first installed. This button is particularly useful when you're first experimenting with panels and you become hopelessly confused about what you've done with them and you just want to start all over again from scratch.

Amongst the most useful buttons in the Application bar are the two curving arrows at the extreme left, labelled Undo and Redo. These allow you to move backwards and forwards through the stages of your work in order to correct mistakes.

Removing the Application Frame

Stylistically speaking, the interface in Elements leaves several things to be desired. One of its unfortunate and ill-conceived design features is that it has a solid, screen-covering, impenetrable gray background. This makes the interface look clean, but one of the consequences is that it completely obscures anything else that's on the screen such as work in other programmes. Fortunately, on a Mac you can remove this gray slab – by going to the

menu bar, to Window>Application Frame (Figure 3-12).

If you're a Windows user, I'm sorry but you don't have this option. You're stuck with the slab.

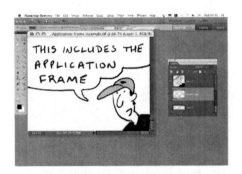 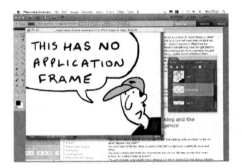

Figure 3-12
With and
without the
Application
Frame
(Mac only)

The Options Bar

Lowest amongst of the bars that span the top of the screen is a bar that displays different contents depending on which tool in the Tools panel is active.

This is the options bar. Figure 3-13 shows the appearance of the bar for the Brush tool. The bar is used to change the settings for the specific tool that's in use.

The contents of the bar change because different tools have different settings that need altering. For instance the Brush tool (for painting with) has options that include one for choosing the shape of a brush, while the Text tool (for typing with) includes one for choosing the size of the letters.

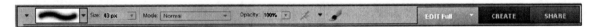

Figure 3-13 The options bar, which changes depending on which tool you're using: this one's for the Brush tool

Panels and the Panel Bin

Panels are boxes that contain information or options relating to your work.

A typical panel is the Color Swatches panel (Figure 3-14), which displays a selection of colours that you can use in your image.

Panels can be opened and closed when needed. They can also be moved round to different positions on your screen so that they are conveniently placed for easy access and so that they don't interfere with the display of the image that you're working on.

Panels can be stored in the Panel Bin if desired (described soon), although I wouldn't recommend it because the bin takes up too much space. You can see the interface with and without the bin in Figures 3-1 and 3-2 respectively. When they're in the bin the panels will always be stacked against the right hand edge of the screen, which is a bit restrictive. When you first open Elements the Panel Bin is set to automatically open with two panels in it: the Effects panel and the Layers panel.

Figure 3-14
A typical panel – here the
Color Swatches panel

To open a panel, go to the Window menu in the menu bar. The contents of the list that opens are divided into several sections, separated by fine lines. The panels are all in the long section in the list, starting with Adjustments and ending with Undo History (They are listed in alphabetical order, not order of importance or usefulness). Click on a panel's name to open it. Panels that are already open have ticks next to them.

If the panel that you're opening hasn't been opened before – or since you clicked the Reset Panels button – it will automatcally appear in the Panel Bin down the right hand side of the screen.

There are several ways to close panels that are open in the Panel Bin (or more accurately, to collapse the panels down to narrow strips that don't take up much room). The easiest way is to click on the gray title bar at the top of the panel (That's the bar that contains the panel's name, such as Color Swatches). Alternatively you can go to the Window menu and click on the panel's name, which will remove the tick from the name and will collapse the panel to its title bar.

The Panel Bin can be very much reduced in size by clicking the white double arrowheads in the dark bar at the top of the bin. This converts the panels that are in the bin into a series of small labels, which Elements calls icons. Like the bin, these icons cling to the right hand edge of your screen. Clicking on any of them opens the appropriate panel. The layout can be returned to the normal bin by clicking the arrowheads again.

Removing Panels From the Panel Bin, and Removing the Bin Itself

Personally I'm not a big fan of the Panel Bin, as it takes up a lot of space, and it doesn't display the panels to best effect. Fortunately it's a simple matter to remove the panels from the bin and place them elsewhere on the screen, thus allowing you to discard the bin altogether.

To remove a panel from the bin press and drag on its gray title bar (The bar that contains the panel's name, such as Layers or Color Swatches). This will detach the panel from the bin. See Figure 2-26 in Chapter 2.

The detached panel, known as a floating panel, will change its appearance slightly. It will acquire a dark bar across the top (similar to the dark bar across the top of the Panel Bin) and its height may change.

The panel will remain in the position that you drag it to until you deliberately move it again. To move the panel press and drag on the panel's name (i.e. Layers or Color Swatches). You can actually press and drag anywhere on either of the bars that run across the top of the panel, however if you *click* on these bars rather than pressing on them continuously the panel will shrink in size (Figure 3-15), which is a bit disconcerting if that's not what you're expecting to happen. If it does happen, clicking on the bar again will reverse the action.

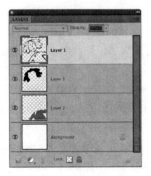

Figure 3-15
Panels can be collapsed to save space.

Right,top: clicking on the bar that contains the panel's name collapses the panel to a strip. Right, bottom: clicking the top bar collapses the panel to an 'icon'

Clicking on the bars so that the panels shrink, as just described, is what you do if you want to keep a panel conveniently accessible on the screen without it taking up too much space. The panel collapses in different ways depending on which bar you click. Clicking the lower, lighter bar makes the panel disappear apart from the top bars, while clicking the top, dark bar collapses the panel to what Elements describes as an icon (There's probably a reason for this seemingly unnecessary choice of collapsed modes, but I haven't managed to work out what it is yet).

To close a floating panel completely, so that it's taking up zero space on your screen, click the button in the dark bar across the top of the panel: in Windows it's a cross at the

extreme right hand end of the bar, while on Macs it's the dot at the extreme left hand end. When you reopen floating panels (by going to the Window menu) they reappear in the position they were in when you closed them.

A couple of final points about moving panels around the screen. If in the process of moving a panel the cursor crosses the edge of another panel or crosses the edge of the Tools panel or the Project bin or the left or right edges of the interface, a thin blue line will appear along the edge. This signals that if you release the cursor at this point the panel will 'glue' itself to the edge that has turned blue (as though the blue was glue). I'm sure that this is meant to be a convenient design feature, but in reality it's quite irritating, because it means that when you're moving panels you have to consciously try not to glue them to each other accidentally. If you do find that you've inadvertantly bonded panels together pull them apart by dragging on the panel's title bar. If you're using a Mac you can avoid these issues by using Elements without the gray background (so that you can see through to the desktop) as in Figure 3-12 – do this by going to Window>Application Frame.

Finally, if you move a panel and drop it while the cursor is above the title bar of another panel (that's the bar with the panel's name in it), the two panels will fuse together so that they occupy the same space, one on top of the other (so that only one of them is visible), The names of both panels will appear as tabs in the title bar. To reveal the hidden panel click its tab. To separate the panels again drag on a tab.

The Project Bin

Along the bottom of the screen is a panel called the Project Bin (Figure 3-16).

Figure 3-16 The Project Bin, containing thumbnails of images that are open in Elements

This panel displays thumbnail versions of any Elements files that are open at the time. Double clicking on a thumbnail will place the selected image in front of the other open images so that you can work on it.

Personally I don't think that this panel is particularly useful, and it takes up lots of

valuable screen space, so I'd recommend removing it from the screen.

You can remove/reinstate the bin by going to the menu bar, to Window>Project Bin.

The bin can have its characteristics altered in similar ways to the other panels that adorn the screen, such as by dragging its title bar (which detaches the bin from the bottom of the screen) and clicking its title bar (which will alternatively collapse or expand the bin).

Changing the Size and Position of Your Image on the Screen

The Zoom Tool

When you open an image in Elements it doesn't have to remain at a fixed size on the screen, but can be made larger or smaller, as shown in Figure 3-17.

You can magnify the image if you want to have a closer look at it, such as when you want to work on a particular detail, or you can reduce the size if you want to get an overall view of the whole image.

Changing the magnification in this way is called zooming, after the effect achieved by zoom lenses on cameras. Enlarging the image is referred to as zooming in, and making the image smaller is referred to as zooming out.

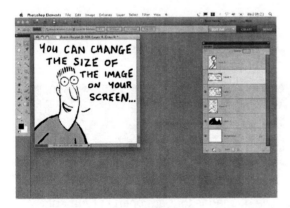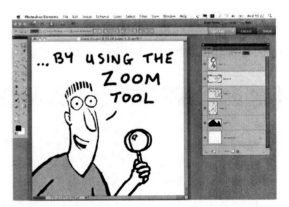

Figure 3-17 You can change the size of an image by zooming in or out

There are a number of ways to zoom in and out in Elements.

Perhaps the most straightforward method is to use the Zoom tool (Figure 3-18).

 Figure 3-18 The Zoom tool

When you click on the Zoom tool the cursor turns into a small image of a magnifying glass with either a plus or a minus sign inside it (depending on which mode it was last used in). The plus sign shows that the tool is set to make things bigger, while the minus sign shows that it's set to make things smaller. To change between the two go to the Zoom tool's options bar where you'll see two small circles at the left hand end, one with a plus sign in it and one with a minus sign. Click the one that you require.

To make the image zoom in or out place the magnifying glass on the image and click. The image will be magnified or reduced in size by a set amount, with the new view more or less centred on the spot where you clicked. Clicking again will repeat the operation.

This method of zooming in or out changes the size of the image in predetermined steps, however there are a couple of ways of imposing more control over the degree of zoom.

You can zoom in to a specific part of an image by placing the Zoom tool's cursor on the image, then pressing and dragging the cursor across the part of the image that you want to zoom in on (Figure 3-19). Moving the cursor will generate a dotted rectangle from the point that you start dragging. When you release the cursor the image will be enlarged by an amount that makes the selected area fill the image window.

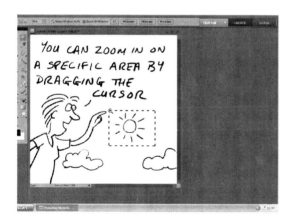

Figure 3-19 Here I've zoomed in on the sun by dragging the cursor over it

If your mouse has a scroll wheel you can zoom in or out in a continuous motion rather than in discrete steps by pressing the Alt key and then turning the scroll wheel (after having first gone to the Preferences dialogue box and ticked Zoom with Scroll Wheel).

The Zoom tool's options bar contains several check boxes that affect how the image is enlarged or reduced.

The check box labelled Resize Windows To Fit refers to the size of the frame that surrounds your image (and has nothing to do with Windows, the operating system). When this box is checked the frame around the image expands or contracts so that it's always a snug fit round the outside of your image, which is generally the preferred option. If you turn the box off, the frame will remain the same size – the result being that when you change the size of the image, the image may become smaller or larger than the frame (Figure 3-20). This is useful when you have several images open on the screen and you want to keep each one within a certain area (You can still adjust the size of the frame round the image by dragging on the knurled area in the bottom right corner of the frame).

Figure 3-20
Retain a constant window size when zoming by turning off the check box labelled Resize Windows To Fit

To zoom the image so that the whole image fills as much of the screen as possible, click the box labelled Fit Screen.

The box labelled Fill Screen changes the size of the image so that all of the available space on the screen is filled, even though as a result some of the image may disappear from view beyond the edges depending on the proportions of the image.

The box labelled Print Size will display the image at approximately the size that it will print out at. This is only an approximation because computer screens vary in the size that they display images, but it'll give you a clue as to whether or not your size is wildly out.

Zooming in and out is something that you'll inevitably do a great deal of, so after a while you'll find that going backwards and forwards to the Tools panel and the options bar in order to activate the Zoom tool will become a bit frustrating. Because of this, by far the most convenient way to use the Zoom tool is to use the keyboard shortcuts for the operations instead of the controls on the screen.

Pressing the shortcut keys temporarily gives you access to the Zoom tool without you

having to exit whichever tool you're using at the time. Releasing the keys returns you to your tool.

The shortcut for zooming in is Command-Spacebar on a Mac or Control-Spacebar in Windows. When you press these keys the cursor will change from that of the tool that's in use into the Zoom tool's small image of a magnifying glass with a plus sign inside it. You can then magnify areas either by clicking on them (in order to magnify them in predetermined steps) or by pressing and dragging to define an area that you want to enlarge so that it fills the available space on the screen.

To zoom out, the keyboard shortcut is Option-Spacebar on a Mac or Alt-Spacebar in Windows. This will turn the cursor into a magnifying glass with a minus sign inside it.

When you're using the shortcuts the settings that are checked in the Zoom tool's options bar apply, such as Resize Windows To Fit.

To begin with you may find these keyboard shortcuts hard to remember. However, if you forget them, all you have to do is to try pressing various combinations of the keys on the bottom row of your keyboard until the cursor changes into the appropriate magnifying glass. In the process, if you press the wrong keys the cursor will appear in other forms, but that doesn't matter as long as you don't click the mouse.

Changing the Size of the Image Window, and Moving Images Round Within it

You can change the size of the window, or frame, that contains the image, by pressing and dragging on the bottom right hand corner of the window (Figure 3-21). This corner has a knurled pattern on it, so that it looks like a thumb pad (which is a bit of a hint).

Figure 3-21 You can change the size of the window by dragging its lower right corner

When your image is larger than the available space in the window, part of the image is hidden from view, as in Figure 3-22. To move the image round behind the window, use the Hand tool on the Tools panel. Pressing and dragging the hand on the image moves the image.

Figure 3-22 Use the Hand tool (right) to slide your image round behind the window

The Interface

Opening, Saving and Closing Documents

4

In this chapter I'll explain the basics of administering Elements files on your computer.

A lot of the issues here apply to other software too, so if you're familiar with using a computer for tasks such as word processing you'll probably be aware of many of these techniques already – but be sure to read the Elements-specific sections about setting the size and other properties of Elements files.

In This Chapter:

Opening a document
Setting the dimensions and properties of the image
Saving your work to avoid losing it
Saving your work as another document
Closing a document

Opening a New Document

Before you can draw or paint on your computer you have to create a surface on which to work – the digital equivalent of a sheet of paper or an artist's canvas.

You do this by creating a new file, which will automatically open with a blank surface ready for you to work on.

When you open Elements an introductory panel called the Welcome screen appears. The Mac version is shown in Figure 4-1 (The Windows version is substantially different to this). When you open a pre-existing image in Elements the Welcome screen doesn't appear – it only puts in an appearance when you open Elements from scratch with no specific image.

The Mac Welcome screen

The Mac Welcome screen gives you immediate access to various ways of opening documents, allowing you to create new files, open files that you've already created, or import images from digital cameras or scanners.

Figure 4-1
The Welcome screen on a Mac.
The Windows version is
completely different to this

To create a new file, click on the button labelled Start From Scratch.

To work on an image that already exists, click Browse with Adobe Bridge, which will open Adobe Bridge, a sister programme to Elements that is used for organising and retrieving files (See Chapter 19). If the image that you want to open was worked on recently you may find it listed in the Recent Images list, in which case click its entry to reopen it.

You don't have to use the Welcome screen to open files, as there are several other methods, explained in a moment. The Welcome screen only appears when you turn Elements on, so when you need to create or open files once the programme's up and running you have to use one of these alternative methods anyway.

You may find that the Welcome screen becomes a little irritating after a while, in which case you can turn it off so that it stops appearing. To do this remove the tick from the box

in the bottom left hand corner of the screen, labelled Show at Startup. If you want to start using the Welcome Screen again go to the menu bar, to Window>Welcome.

The Windows Welcome screen

The main use of the Windows Welcome screen is to choose between opening Elements in its image creation and manipulation mode or in its image organisation and retrieval mode – respectively known as Edit mode and Organize mode. The buttons that allow you to make your choice are on the left hand side of the Welcome screen, labelled Edit and Organize. There's more about the Organize mode in Chapter 19.

You may find that the Welcome screen becomes a little irritating after a while. You can't turn the screen off in Windows, which s a bit of a shame, so if you want to circumvent it you have to create a simple bypass route. Do this by creating a desktop shortcut.

Go to C:>Program Files>Adobe>Photoshop Elements 8>PhotoshopElementsEditor (the application file for the Editor), or go to C:>Program Files>Adobe>Elements Organizer 8>PhotoshopElementsOrganizer (for the Organizer). Right-click on it and choose Create Shortcut. This will put an icon on your desktop that allows you to open the selected part of the programme directly.

Opening Files Without using the Welcome Screen

When you don't use the Welcome Screen, either because you've turned it off, by-passed it or you've already got an Elements file open, you can create a new file by using the keyboard shortcut of Command-N (Mac) or Control-N (Windows), or you can go to the menu bar, to File>New>Blank File.

On a Mac you can also create new files by clicking the New File button at the left end of the Applications bar. This is the button that looks like a computer monitor with a star in one corner (Figure 4-2).

 Figure 4-2 The New File button (Mac only)

Whichever route you take, a dialogue box will appear, called the New File dialogue box (Figure 4-3), into which you enter details of the new document that you're creating.

These details include the width and the height that you want your work surface to be. This is relatively easy to understand, hwever the exact purpose of some of the other settings will possibly elude you if you're new to Elements. These settings are all explained to some extent here, and are expanded on in the next chapter. They'll start to make sense after you've created a few documents.

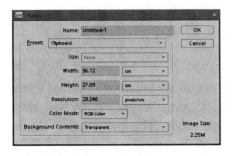

Figure 4-3 The New File dialogue box, where you enter the dimensions and other details of the image that you want to create

Give the document a title in the panel labelled Name, which will be displaying a default title of Untitled-1 (or, if there's already a file of that name, Untitled-2, and so on).

Then enter the settings for the image you're intending to create (Deciding on these settings is covered in more detail in the next chapter). The settings that are already in the dialogue box when you open it will usually be those for whatever item is on the Clipboard at the time (The Clipboard is part of your computer where you can temporarily store part of a document, as explained on page 274). If there's nothing on the Clipboard, which is unusual, the settings will be those of the last image used.

The meanings of the settings are as follows.

Preset

This box gives you access to a list of preconfigured (or preset) settings for various standard sizes and types of image which you can choose so that you don't have to bother entering the values yourself. Using these settings is far from essential, although they're useful if, for instance, you want to create an image to print at A4 size but you aren't sure what the exact dimensions of an A4 sheet are in inches or centimetres.

The name in the box when it first opens indicates the settings that are currently in use in the rest of the dialogue box, which will be those of the item on the Clipboard, or if there's nothing on the Clipboard, of the last image used (The word Clipboard in the box indicates a Clipboard image; the word Custom indicates an image that has values that you've entered yourself. Any other name is from the list of standard preset image settings).

Unless you want to use one of the specific standard settings you can ignore this box altogether and enter your own values directly in the panels beneath it (which will make the Preset panel automatically display the word Custom).

Quite usefully, at the bottom of the list of preset settings is a list of any images that are open at the time, so if you want to create a new image to the same values as one of these open images just click on the appropriate name.

The preset settings can be broken down into two groups: those for images intended for printing and those for images intended solely for on-screen use, such as for web pages. The significance of the settings will make a lot more sense after you've read the next chapter.

In the print category you can choose from such categories as International Paper sizes and US Paper sizes. When you choose one of these categories the actual choices of size appear in the Size box below (so for instance if you choose International Paper, the Size box will automatically display a list of sizes including A4, A5 and so on).

Width, Height and Resolution

You'll frequently want to set your own size for your images rather than choosing from the preset sizes that Elements offers. Here's how to go about it.

Images for printing

If you're intending to create an image for printing (as opposed to only for viewing on a computer screen), choose the units for the Width and Height that you want to use, such as centimetres or inches. You can change the units by clicking on the name of the units that are displayed, which will open a list of alternatives.

In the Width and Height panels enter the size that you intend to print your image. If you're not sure of your intended size, just use an estimate, as everything can be altered later.

Then enter a resolution. This is a value that determines the amount of detail in an image contains, by setting the size of the tiny dots, called pixels, that make up digital images.

There's more about exactly what resolution is, and what pixels are, in the next chapter, but for now it's simplest to assume that the safest resolution setting for most printed work is 300 pixels per inch (ppi), as this ensures that the image will print out at high quality (Resolution is usually measured in pixels per inch, even if you use metric units elsewhere).

Images for on-screen use only

If your work isn't intended to be printed and is destined solely to be viewed on-screen, such as on web pages, the dimensions of your image are measured purely in terms of the dots (pixels) that make up the image. This is all explained in the next chapter, in the section Sizing Images Solely for On-Screen Use, page 114.

For on-screen use set the Width and Height units to pixels (by clicking on the units displayed, which will open the list of alternative units).

You'll find more details about determining the dimensions of images for on-screen use in Chapter 5, but for now the following basic guidelines for determining their size should suffice.

The largest image that you'll probably want to create for on-screen viewing is one that

fills most to the available screen area of an average screen (after taking into account such things as menus and other screen paraphernalia that eat up space round the edges). This area is about 900 pixels wide by 600 pixels high, so as a rule of thumb that's probably the maximum size you should be aiming at for your final image. However, generally it's best to actually work with more pixels in your image than you need (so that you can work more accurately) and then reduce the number of pixels after you've finished. As I mentioned, this is all explained in the next chapter. So if you're aiming at an almost screen-filling image with 900x600 pixels, you should create the original image at maybe three times the size, which is 2700x1800 pixels.

The Resolution setting in the dialogue box plays no part in determining the size of on-screen images, as it's a factor that only applies to images on paper (where resolution is the measure of the size that the pixels print at). Whatever the value in the Resolution box, it won't affect the image on the screen.

Despite the fact that resolution isn't a factor for screen-only images, you'll frequently come across the figure of 72ppi being quoted as the resolution setting that you should use for them. This is generally unnecessary. Its only purpose is that it makes the centimetre or inch measurements that are shown in the dialogue box approximately the same as the size that the image will appear on screen. But it's only approximate, as screens vary.

Color Mode

In the Color Mode panel choose RGB Color if you're working on a colour image, or Grayscale if you're working in black and white.

Don't choose the Bitmap mode, as this is very limited in its use. It only uses pure black and white (with no grays), but it also disallows a huge number of very important functions of the programme (as a way of using less memory). So even if you only want to use pure black and white in your image use the Grayscale mode instead (and then convert the image to bitmap mode later if you really want to).

Background Contents

The Background Contents section of the panel allows you to select the colour of the surface that you're creating.

I'd recommend that normally you set this to White, which creates an opaque white sheet as a background for your image.

There are two other options: Background Color and Transparent. You don't really need to worry about using these options at the moment, as it's easy to modify your image once you've created it so that it has any of these backgrounds. Here's what these options do though.

Background Color: This creates an opaque sheet in the colour that's in the lower of the two squares at the bottom of the Tools panel. Often this square is white, but you can change it to any colour you want.

Transparent: This creates a transparent sheet, or layer, that allows other artwork on other sheets or layers to be placed beneath it and to be seen through it. This sounds like the best option to choose for some types of artwork, but it has a couple of drawbacks when you alter the tones in images using a feature of Elements called Adjustment Layers, introduced later, so is best avoided unless you know what you're doing.

When you've entered all of your settings, click OK.

The blank sheet or canvas will then appear on your screen, ready for you to work on.

Saving Your Work

After you've done a few minutes' work, you need to save the results of your efforts.

First I'll explain exactly what saving is.

When you're in the process of doing any work on a computer the modifications and additions that you make to the work appear on the screen as you're working, but they aren't automatically stored permanently on the computer as you work. The changes are only held in the computer's working 'short term' memory, where they stay until you specifically tell the computer that you want to keep them permanently. When you actually tell the computer that you want to keep them permanently they're recorded onto the computer's hard disk. This act of recording the work is called saving.

You should make a habit of saving your work quite frequently while you're in the process of doing it – definitely not only when you've finished working and want to close your document. The reason for this is that computers can sometimes seize up unexpectedly, or crash, especially if you ask them to do something particularly demanding. When they crash they lose any work that you'd done that hadn't been saved.

By saving your work every few minutes or so you can be sure that if the computer does crash only the work of the last few minutes is lost. Your computer may never crash at all, but it's still a good habit to save your work frequently, just in case – because if your

computer does eventually crash unexpectedly, you may lose hours of work. Saving your work eventually becomes second nature, and you tend to do it every time you have a natural 'thinking' break while you're working.

You can save files via the menu bar, by going to File>Save.

After a while, going backwards and forwards to the menu bar every few minutes in order to save your work becomes very tedious indeed, so it's much more convenient to use the keyboard shortcut for saving files. This is Command-S (Mac) or Control-S (Windows).

If you're using a Mac you can use the Save button in the Application bar (Figure 4-4), which shows a representation of a floppy disk (a type of storage device that's now obsolete).

Figure 4-4 The Save button (Mac only)

The first time that you save a piece of work you'll be given the choice of whereabouts on the hard disk you want to keep it. By clicking the panel labelled Save in (in Windows) or Where (on a Mac) a panel will open containing a list of the folders that exist on your computer, and into which you can place your file.

You can store your work just about anywhere that you like on the hard disk, but things can become awfully messy very quickly unless you apply a certain amount of discipline.

Here's an analogy with conventional storage systems.

Imagine that each document that you create on your computer is like a sheet of paper, and that the hard disk is like a filing cabinet. When you've only got half a dozen sheets of paper to store in a filing cabinet you can cope with them pretty easily by just shoving them all into a single pile in one of the drawers, because to find any one sheet in the pile you simply have to flick through them quickly. But as you acquire more sheets of paper the pile gets bigger and bigger, until there are hundreds of sheets, and finding individual sheets becomes more and more of a problem. You have to simplify your pile by putting related sheets of paper into specific folders, labelled with the contents.

This is exactly what you do on your computer too.

Once you've saved your file to a particular location it will stay there until you deliberately move it.

You can reopen any file to do more work on it. When you save the file again, it will be updated to include the alterations that you've made to it.

Having said that it's best to organize your files in some way, fortunately on computers your filing system doesn't have to be *too* precise, because there are ways of seeking out files no matter where they are on your computer. This is done by instructing the computer to search for files that have specific words associated with them. These words can be in the file's name, in the contents of the file, or in a special section of the file that's reserved for special background data and notes. To help you to find files on Windows computers check the box for Include in the Organizer. There's more on the Organizer in Chapter 19 at the end of the book.

Save As...

Sometimes you'll want to create a copy of a file, so that you can alter one version while leaving the original file unaltered. You can do this by using the Save As command, in the File menu in the menu bar.

Using the Save As command, a dialogue box opens (Figure 4-5), allowing you to choose a new name for the file and, if necessary, a different folder to keep it in.

Figure 4-5
The Save As dialogue box

If you save the new file in a different folder to the original you needn't change the file's name (although it may be best to do so, in order to tell the separate files apart), but if you want to keep it in the same folder as the original you have to alter the name, as two files with the same name can't be kept in one folder.

You can choose a different format of the file when you save it, in the Format panel. Formats are different ways of saving files, allowing them to be opened more efficiently in other software, and are explained in detail on pages 510 and 526 in Chapter 18.

In Windows you can automatically save a file as a new version (leaving the original file unaltered) by checking the box labelled Save as Version Set With Original. This saves the new file in the same folder as the original, giving it a suffix to distinguish it.

Closing Files

When you've finished working on a file you can close it.

Along the top of the image that you're working on is a strip, called the title bar, which contains the title of the file and a number of small buttons. One of these buttons closes the file when you click on it. In Windows it's the x button at the extreme right hand end, while on Macs it's the red circle at the extreme left hand end.

Figure 4-6 The Close button. Left, on a Mac: right, in Windows

The keyboard shortcut for closing files is Command-W on a Mac, or Control-W in Windows.

If you haven't saved your work before closing it, a panel will appear asking you if you want to. Normally the answer is yes, unless you've made changes that you don't want to keep.

Closing a file only closes the actual document – it doesn't close the programme itself, which remains open. This means that you can now open another document in Elements without the whole programme having to be restarted. The Elements menu bar, Tools panel and so on will remain visible on the screen (unless you open another programme, in which case they'll disappear, although the programme is still open so that you can return to it immediately).

When you've finished using Elements altogether it's best to close the entire programme, as leaving it open may slow the computer down when you move on to use other programmes.

To close Elements in Windows, go to File>Exit in the menu bar, or on a Mac go to Photoshop Elements>Quit Photoshop Elements. Alternatively, and more conveniently, use the keyboard shortcut of Control-Q (Windows) or Command-Q (Mac).

Opening, Saving, Closing

Sizing Images

5

In this chapter I'll describe the factors that you have to take into account when you're deciding on the size of your image, either for printing or for purely on-screen use.

To help explain some of these factors I'll introduce you to the way that Elements builds up its images and displays them on the screen.

Bits of this chapter are a little more technical than most of the rest in the book, but are worth reading because a little insight into how an image is created and displayed can make some aspects of using Elements much easier to understand.

If you're not of a technical or theoretical bent, don't worry. You can get by perfectly adequately without a lot of this knowledge, but it's definitely worth skimming through it to get a feel for the basics, possibly missing out the sections labelled as advanced by the dark band in the margin.

In this chapter:

How an image in Elements is built up of pixels
How images or displayed on your screen
How to decide on the size of images for print
How to decide on the size of images for on-screen use
How to change the size of images

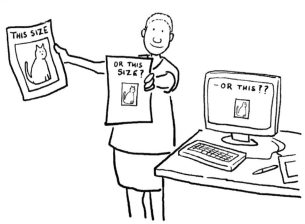

How an Image in Elements is Generated

Images in Elements are composed of a grid of tiny coloured squares or tiles, as shown magnified in Figure 5-1. These tiny coloured squares are called pixels, which is short for 'picture elements'. The pixels are too small to see with the naked eye, so they give the impression of a smooth, continuous image. The colour of each pixel in the grid can be changed almost infinitely – in fact changing the colours of the pixels is essentially all that you're doing when you create or alter an image in Elements.

A basic awareness of pixels is extremely useful for appreciating how Elements works.

Figure 5-1
A computer-generated image, and a magnified portion of it showing the tiny squares of colour of which it's composed

Resolution – the Size of Printed Pixels

When you create an image in Elements you can choose the size that the pixels in the image will print out at. This affects the amount of detail that there is in the printed image: the smaller the pixels, the more detail there is (Figure 5-2).

Figure 5-2
Different sized pixels produce different qualities of image. The image on the left is 300 pixels across, while the one on the right is only 50 pixels across. In other words, the pixels in the right hand image are six times larger

A Word of Reassurance about Resolution

Before I explain anything more about the choices of pixel size for printed images, and the reason that you have a choice, you can generally work to one size that'll cover most needs. This will keep things simple, and means that you don't actually have to understand the explanations that come after this box.

Pixel size isn't measured directly in terms of inches or centimetres, but is expressed in terms of how many pixels will fit into an inch on the paper, and is referred to as the resolution.

The recommended resolution for images that are destined to be printed is 300 pixels per inch (ppi), meaning that each pixel in the printed image is 1/300th of an inch across. (The resolution is almost always expressed in terms of inches, even if your other measurements are all metric.)

One of the few times that you may want to use significantly different sized pixels from this norm is when you're working on artwork that's going to be printed in pure black and white (with no grays), such as line drawings, where a resolution of 1,200ppi is sometimes more useful. For an explanation of why this is, see Chapter 7, page 186, The Definition of Line Art and Creating Very High Definition Pencil Lines.

When you're doing work that's only going to be viewed on-screen rather than being printed, such as images for a web page, you don't have to worry about pixel size or resolution at all. The reason for this is explained soon (page 114): essentially it's because with screen-only images each pixel in the image is usually displayed by one of the dots of light that make up the screen, so the pixels are automatically the size of these dots of light.

Don't lose too much sleep over resolution and over being absolutely accurate about getting it right.

If you stick to a resolution of 300ppi you can't go far wrong, and even if your resolution is out by twenty percent or more you probably won't be able to see the difference.

5

You may wonder why you have a choice the size of the pixels. Why, for instance, can't you just use infinitely small pixels, so that there's always enough detail in your image, and so that you never need to worry about getting 'blocky' images such as the right hand one in Figure 5-2.

One of the reasons is the power of your computer. which has the onorous task of keeping track of the colour of each and every individual pixel in your image separately.

A huge number of infinitesimally small pixels in an image would need a huge amount of processing power, as your computer would have to work very hard to keep track of them all. At the very least your computer would work very slowly because of the amount of effort it was having to put in, and at the worst it wouldn't be able to cope at all because it wouldn't have enough memory to remember what it was doing.

As a result you have to compromise and use a number of pixels that your computer can deal with.

One day in the future, when computers are even more powerful than they are now the consideration of pixel numbers will be a thing of the past. But until that day it's an inconvenience we have to put up with.

That explains why you can't use infinitesimally small pixels, but why do you have the choice of using different sizes rather than just one standard size, such as the 300ppi size that I've suggested you use as a standard for images that you intend to print?

This again is partly to do with processing power, in this case specifically at the stage where your work is being printed.

When an image is printed, each pixel in processed separately, so the more pixels in an image the slower the printing. This may not be important for the occasional printout on your desktop printer, but if your work's going to be printed in large quantities, such as in a magazine, newspaper or book, the cumulative effect of printing all those copies can be very noticeable.

As a result you want as few pixels as is reasonable in your image when it's being printed. To have fewer pixels you need to use larger ones. What you want to use are the largest pixels that you can get away with, without them being visible to the naked eye. The size of pixel that fits this criterium is one that's about a three hundredth of an inch across (which means that 300 of them fit into an inch of your printed image, which means that the pixels are at a resolution of 300 pixels per inch).

That may explain why you need a certain size of pixel, but it doesn't explain why you have a choice of sizes. After all, surely there's only one specific size at which pixels become visible when you print them?

Well, the answer is actually no, because it all depends on the quality of the printing.

For instance, a glossy magazine can print highly detailed images with pinpoint accuracy on its smooth expensive paper. In contrast, the cheaper, absorbent paper used in newspapers tends to make the ink spread and blur, making highly detailed reproduction impossible. As a result the detail in an image destined for a glossy magazine needs to be greater than for one destined for a newspaper. So the pixels in an image for a glossy magazine with its crisp, clean reproduction need to be smaller than those for a newspaper with its slightly fuzzy reproduction.

So what size should the pixels be for these different qualities of print?

For high quality printing it's recommended that the pixels be the smallest size that's necessary in practice – at a resolution of 300ppi (In other words, that the pixels are 1/300th of an inch across).

For lower quality print work, such as newspapers, a resolution somewhere round 150ppi will do (where the pixels are 1/150th of an inch across).

As I mentioned in the gray panel a few pages back, it's a good idea to create all of your work at a resolution of 300ppi (possibly apart from pure black and white work, as explained on page 185). This is because it's very easy to change the resolution of an image on the occasions that you need to do so (as I'll explain soon in the section on resampling). By using 300ppi as a standard resolution your work is always capable of being printed at high quality. Just because your work may be destined for the low quality printing of a newspaper today doesn't mean that you won't want to get the same image printed in a high quality glossy magazine in future, so it's best to play safe. Also, using a consistent resolution keeps things simple.

That's enough for now on the subject of getting the size of the pixels that compose the printed image right: now what about getting the printed image itself the right size in terms of centimetres or inches?

Setting the Size of Images for Printing

If you're about to create an image that you intend to print out it's best to know more or less the size that you hope to print it at, so that you can enter the values in the Width and Height settings in the dialogue box that opens when you first create the file. (If you're working on an image that's only ever going to be used on-screen, such as on a web page, these considerations don't apply, as explained in the section about screen-only images on page 114)

If you're not sure of the final size that you want your image to print at it's not crucial, as within reason it's easy to alter the size later. When you don't have an exact size, it's best

to make your image larger than you expect to need, as it's always better to reduce an image's size later than it is to enlarge it, as this ensures that it retains detail and means that you don't magnify any inaccuracies that are in the image. Also bear in mind that if you're working on an image that you're intending to use as, say, a greetings card today, but that you think you might possibly want to use as a poster tomorrow, make the image poster sized.

Here's how to set the print dimensions of a new image (as described in the previous chapter, but repeated briefly here to avoid page turning).

First, to create a new surface on which to work, in the menu bar go to File>New>Blank File. Alternatively you can use the keyboard shortcut of Command-N (Mac) or Control-N (Windows).

This will open a dialogue box into which you enter the appropriate values.

The Width and Height for prints can be measured in centimetres or inches, whichever you prefer. If the dimension boxes don't display the units you want, click in the units that are displayed to reveal the other choices (ignoring the units that mean nothing to you).

Then enter the size that you want your printed image to be.

Next, you have to enter a value for Resolution. As explained above, this is the measurement of the size that you intend to print the pixels in the image, and it can be varied to suit the quality of printing that you have in mind for your work. It's best to assume that your work is going to be printed at high quality (if not now, then maybe later), so it's best to use a resolution of 300ppi as your usual setting (unless you want to work in pure black and white, in which case a resolution of 1,200ppi is worth considering – see page 186).

Changing the Size of an Image for Printing

You'll often want to print out an image at a size that's different to the size at which you originally created it.

If you simply want to change the size of a printout on your desktop printer the easiest thing to do is to magnify or reduce the image at the printing stage by setting the printer to print it out larger or smaller. This method of changing the size of the printed image has the advantage that you don't have to alter the actual Elements image in any way, only the print setting. This is dealt with at the beginning of Chapter 18, which covers printing and other ways of outputting your work.

You can also alter the print size by changing the actual dimensions of the Elements file. You do this by using the Image Size dialogue box (Figure 5-3), in the menu bar at Image>Resize>Image Size.

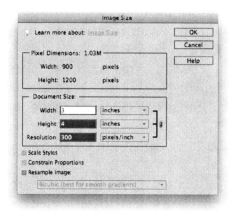

Figure 5-3
The Image Size dialogue box.
This is the Mac version, just for a change

To change the size of an image, first make sure that, for now, the check box at the bottom of the panel, labelled Resample Image, isn't ticked. When this box is ticked, not only does the size of the image change, but the number of pixels that it's composed of changes too, affecting the quality of the image (We'll come back to the significance of this box soon, and when it needs to be used, in the section on resampling, page 122).

Then look at the part of the box that's labelled Document Size. The term Document Size refers directly to the size of your image on a *printed* document or sheet of paper (so it should maybe be labelled Print Size instead). You can completely ignore the top panel, labelled Pixel Dimensions, which shows you how many pixels there are in your image.

Enter a new width or height for your image. Altering either one of these dimensions will automatically alter the other one, as the computer will keep the image's proportions correct (as long as the box labelled Constrain Proportions is ticked, which it normally should be).

If you want to alter the print size by a percentage rather than by a specific number of centimetres or inches click on the units box for the Width or Height and choose percent. Then for example, if you want to make the image twice the size, key in 200 percent.

And that's it. Apart, that is, from the subject of resolution, which you may or may not have to take into account, as explained now.

When you alter the height and width of an image as described above you'll notice that the value in the Resolution box changes automatically at the same time. This is because when you change the size of the image you change the size of the pixels as well, because after all, they are what the image is composed of (The link symbol to the right of the Width, Height and Resolution boxes shows that the three values are interdependent). So, for example, if you halve the print size of an image, you halve the size that the pixels will print at as a result.

Now, you may remember that not long ago I said that there's a recommended size for the pixels in a high quality printed image – 300ppi. But now you've changed their size, so if they'd originally been at 300ppi they're not at 300ppi any more.

If you've only changed the size of your image by say 20%, the size of the pixels will still be reasonably close to the size that they were originally, so you probably needn't worry. If your image had pixels at 300ppi and now it has them at say 350ppi or 250ppi it really doesn't matter too much.

But if you change the size of an image radically, then you have to take the size of the pixels into account.

For instance, if you reduce the size of an image to a quarter of its original size, you reduce the size of the pixels to a quarter of their original size too: so if you started with 300 pixels per inch you end up with 1,200 pixels per inch instead. This size of pixel is far too small for normal purposes, resulting in too many pixels packed into the image. It makes the image use a lot of memory, as it has to remember the colours of all of the pixels, and all with no gain in print quality, as 300ppi is the smallest size of pixel that you need for high quality printing.

What you need to do is to reconstruct the image out of new pixels that are the size of the original pixels. You do this by using a process called resampling, which I referred to briefly at the beginning of this section.

I'll explain the process of resampling soon (on page 122), but before I do so I'd like to move away from talking about the factors involved in creating images that are the right size for printing, and introduce the factors linked to creating images that are the right size specifically for on-screen display, such as on web pages or in emails. I want to deal with this before I look at resampling because resampling is a technique that's common to resizing both printed and on-screen images, so it's probably best if you're familiar with the basic principles underlying on-screen images first. If you're not interested in placing images on web pages or in emails, skip straight to page 122.

Sizing Images Solely for On-Screen Use

The size of images that are intended purely for viewing on-screen, such as for web pages, is determined in a different way to those that are intended for printing.

In order to appreciate the way that you measure the sizes of images for viewing on-screen you need to understand a little about the relationship between your Elements image and the way that it's displayed on the screen.

To do this you have to know very vaguely how screens display images in the first place.

How Computer Screens Work

At the beginning of this chapter I explained how images in Elements are composed of a grid of separately coloured tiny squares, or pixels (Figure 5-1).

This method of composing digital images out of very small units of colour is so useful that exactly the same method is used by computers to create the images on their screens.

Essentially, a computer screen consists of a grid-like array of spots of light, as in Figure 5-4. Each spot can change to any colour, so the overall effect of all of those little spots of coloured light is the image. The individual spots are almost invisible, but you can see them if you look very closely at your screen.

Figure 5-4
The image on your screen
is composed of thousands
of tiny dots of light

Because they work on a similar principle to the pixels in an image, the spots on the screen are also called pixels, however in this case they're known as screen pixels (while those in the Elements image itself are called image pixels, or just plain pixels).

When you're first confronted with the concept of pixels it can be a little hard to remember that the screen pixels are *not* the same thing as the pixels in your Elements image.

If you ever need convincing that the two types of pixel, image pixels and screen pixels, are different things, there's a simple practical demonstration that you can use as a reminder of the fact that they're independent of each other (Figure 5-5).

You can magnify an Elements image on the screen, using the Zoom tool (such as by going to the menu bar, to View>Zoom In), which magnifies the image pixels so that they

can be clearly seen. But you can't enlarge the *screen* pixels, because they're physically part of the screen. So when you see a magnified Elements image on-screen, with its image pixels magnified and clearly visible, those image pixels must be made up of lots of separate, tiny screen pixels.

Figure 5-5 A demonstration showing that the image pixels that make up your image are not the same thing as the screen pixels that make up your computer screen. On the left is an image at a 'normal' viewing size. On the right I've magnified the image so that only a *tiny* part of it (the centre of the snail shell's spiral) fills the screen, making the image pixels clearly visible (while the screen pixels, being part of the screen, stay resolutely the same size and almost invisible)

What Size Should the Image be for On-screen Use?

When you're working on an Elements' image on your screen, the issue of what size it is on-screen seems a bit irrelevant, as you can change the size effortlessly simply by using the Zoom tool to magnify or reduce it (see page 88) – so it seems that there isn't a single, definitive size on the screen that can be pinned down as the 'actual' size of the image.

While you're working on an image, this in indeed true – the size that you choose to display the image on-screen is purely a matter of convenience, depending on whether you want to see the whole image or a magnified portion of it.

However, when you want to display a finished image on-screen at a fixed size, such as on a web page, one particular size takes on a special significance. That's the size where each image pixel in the image is displayed by one screen pixel on the screen. The significance of this one-to-one ratio is explained in the panel on page 118, following an explanation of the general relationship between image pixels and screen pixels. Understanding these explanations isn't crucial, but remembering the importance of the one-to-one ratio of image pixels to screen pixels for displaying on-screen images is.

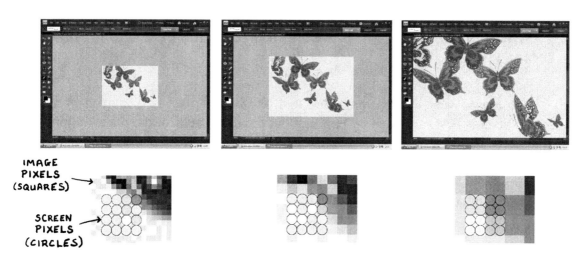

IMAGE
PIXELS
(SQUARES)

SCREEN
PIXELS
(CIRCLES)

Figure 5-6 When an image is displayed at different sizes on the screen (top row), its image pixels are displayed by different numbers of screen pixels (bottom)

In Figure 5-6 the left hand example shows an image displayed at a small size on the screen, where the image pixels are *smaller* than the screen pixels. As a result several image pixels 'fit into' each screen pixel. Each screen pixel has to represent the colours of all of the image pixels that are in its region of the screen, however each screen pixel can only display *one* colour at a time, so each screen pixel has to average out the colours of the image pixels that it represents and it displays that average. In the centre example above, the same image is displayed at the size where one image pixel is displayed by one screen pixel, allowing each screen pixel to display the colour of a single image pixel. Meanwhile, the right hand example above shows the image displayed at a large size, where each image pixel is *larger* than the screen pixels. In this case each image pixel requires several screen pixels to display it – in my example four screen pixels are needed in order to display each image pixel.

Now here's the important bit.

When an image is displayed on-screen at a size where *one* screen pixel displays *one* image pixel the image is at the most effective and efficient size for displaying on-screen, and this size can be thought of as being at its natural, full size in terms of being viewed on the screen. This fact is indicated in the image's title bar (the strip that runs along the top of the frame containing the image), where this size of one screen pixel per image pixel is expressed as 100% (Figure 5-8). When the image is displayed on the screen at other sizes the percentage difference in size is shown. For instance, if the image is displayed at twice this size the title bar indicates 200%, while if it's at half the size it's 50%.

Why one image pixel to one screen pixel is the best size for on-screen images

The reason why it's recommended that one image pixel is displayed by one screen pixel is best explained by pointing out the drawbacks of the other options.

Images where the image pixels are smaller than the screen pixels

This is the left example of the butterfly image in Figure 5-6.

Here you have to take into account that, because screen pixels are the individual dots of light that build up images on the screen, they are the smallest sized detail that can be displayed on-screen, with each dot being a single colour. As a result, because the image pixels in the Elements image are *smaller* than the screen pixels (Figure 5-7, left), each screen pixel has to represent the colour of several image pixels. It does this by averaging out their colours, resulting in the detail supplied by the image pixels being lost (Figure 5-7, right). In my example each screen pixel displays the averaged colour of four image pixels. The problem with this isn't to do with the resulting quality of the displayed image, but is because the image uses more memory than is necessary. Each image pixel uses memory, so this memory is being used in order to supply detail that can't be displayed on the screen. In my example four image pixels have to be displayed by each screen pixel, so the image contains four times as much detail as can be shown, and thus uses four times the necessary memory.

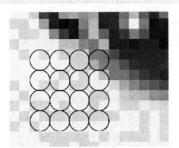 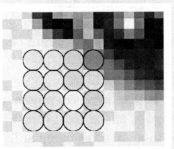

Figure 5-7 When image pixels are displayed smaller than screen pixels, the colours of several image pixels have to be averaged to form the colour shown by the screen pixels. Left: The positions of the image pixels (the squares) relative to the screen pixels (the circles). Right: The resulting averaged colours displayed by the screen pixels

Images where the image pixels are larger than the screen pixels

This is the right example of the butterflies in Figure 5-8.

Displaying an image where the image pixels are larger than the screen pixels doesn't cause any problems concerning memory as in the previous case. In fact the image uses relatively little memory for its size, as the image pixels are large and the image therefore uses fewer of them.

The problem here is simply that because the image pixels are large, the image quality is lower than the optimum.

Figure 5-8 The on-screen size of an image (@100%)

How big will an image displayed at 100% appear on-screen? That depends not only on the size of the image (that is, the number of image pixels across and down) but on the screen. Not all screens have the same number of screen pixels. Most modern screens have either 1024 or 1280 pixels across and between 768 and 1024 pixels down, while some have up to 1680 pixels or more across. Older monitors may have as few as 800 pixels across, although these are becoming rarer. The number of screen pixels that make up the screen display is known as the screen resolution.

When an image is viewed at one image pixel to each screen pixel, an image that's about 900 image pixels across will more or less fill the available width on a screen that's 1024 screen pixels across, while on a wider screen of 1280 screen pixels across an image that's about 1200 pixels wide will fit (The whole screen can't be used to display the image due to the various bits of screen furniture such as scroll bars etc that occupy space around the sides of the screen).

The number of screen pixels that a screen possesses isn't linked to the physical size of the screen – small screens merely have the screen pixels closer together.

There's a panel on your computer that will show you the number of screen pixels that your screen is using.

To find this panel in Windows, place the cursor on an area of free space on the desktop, rather than an area occupied by part of any programme that's open, and right-click on your mouse to open the Control Panel. Left-click on Properties. This opens the Display Properties box, where you select the Settings tab. In the box that appears is a panel containing an adjustable slider, with the words Less and More at the ends. Beneath the

slider is the current screen resolution, which can be altered by moving the slider (Changing the resolution may degrade the quality of the image, as the default setting gives the optimum quality).

On a Mac in OS X, go to the Apple menu at the extreme left end of the menu bar and choose System Preferences>Displays. This opens a panel containing a list of possible screen resolutions, with the one in use highlighted. To choose a different resolution, click a different setting from the list. Changing the resolution may degrade the quality of the image, as the default setting gives the optimum quality.

If you want your images to be viewed on different screens, such as is the case with web pages, you may need to take into account the fact that other people will have screens with different numbers of screen pixels, and that the image will take up different amounts of space on their screens. In Figure 5-9 an image that's 1150 pixels wide fills a screen that's 1280 screen pixels across, but fits a 1440 screen pixel monitor with room to spare. On an old screen with only 800 screen pixels across the image would disappear off the sides.

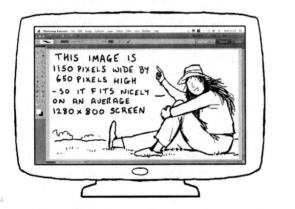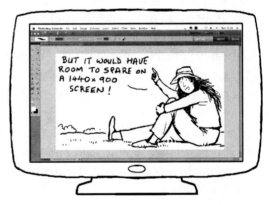

Figure 5-9 Exactly the same image will occupy different amounts of screen space on different monitors, depending on the number of screen pixels on the monitors. These screens are 1280 pixels wide (left) and 1440 pixels wide (right)

To some extent you have to decide what size of screen you think that your audience will be using when they are viewing your work. For an image to fit onto almost every screen in the world you'd have to set the size as suitable for old screens that have a screen resolution of 800x600, however that size of screen is becoming increasingly rare and requires images that are impractically small for most other screens. If you think that your audience will be using modern equipment you can safely set your image sizes for screens of 1024x768.

To give you a vague idea of the proportion of different screen resolutions that are used for web browsing at the moment, here's the percentage of different screen resolutions that were used to view my own web site recently (so it's not a scientific analysis).

1024x768	28%
1280x800	22%
1280x1024	12%
1440x900	9%
1680x1050	6%
800x600	2%
Other wider than 1280	14%

It's better to make the images for web pages smaller than full screen size, as the larger the image the more chance that it won't fit onto someone else's slightly different screen. On top of this, the more pixels that there are in an image the longer it takes to download by the person who wants to look at it. Remember that not everybody has broadband!

There's more about putting images on the web, and into emails, in Chapter 18.

Setting the Size of On-screen Images

As explained earlier, the big difference between setting the size of images for print and for on-screen use is that images on-screen aren't measured in centimetres or inches, but are measured directly in terms of the number of pixels that they're composed of. Centimetres and inches are irrelevant on-screen, because different screens display the same image at different sizes (just as a large television set displays the same picture at a different size to a small television set).

To create a new image for on-screen use, open a new file in the usual way, such as by using the keyboard shortcut of Command-N (Mac) or Control-N (Windows). Then, in the dialogue box that appears (Figure 5-3) click on the units of measurement that are displayed for the width and height, in order to show more options, and choose pixels from the list that appears.

Enter the number of pixels that you want for the width and the height of your image. Because the number of pixels in a screen image is very low, producing relatively little detail, it's often best to work on a version of the image that has more pixels than the final image needs, so that your working image is more detailed and accurate. It's advisable to work on an image that contains maybe three or four times more pixels than you finally

want, and to then reduce the number of pixels later by resampling (explained in a moment). Your original image will produce more detail than you need, which will be lost when you reduce the number of pixels for on-screen viewing, but this is usually preferable to working on the real-sized image which may be too blocky and crude for precise work – a bit like trying to draw a delicate spider's web with a magic marker pen.

Changing the Number of Pixels in an Image by Resampling

There are several circumstances in which you may want to change the number of pixels in an image: a process known as resampling.

Resampling is a technique that's generally used in order to reduce the number of pixels in an image, in order to make the image fit more efficiently into a given space on a web page or printed page without the image having a surfeit of pixels that are contributing nothing to the appearance of the image.

Excess pixels in an image means that the image uses an unnecessary amount of memory or processing power, increasing transmitting time for emails or on web pages amongst other things.

You'll rarely ever need to resample in order to increase the number of pixels in an image. Increasing the number of pixels doesn't improve the quality of an image by making it more detailed (as explained in the panel later in this section), it simply increases the number of pixels in the image, which has the counterproductive effect of increasing the image's file size.

One of the commonest uses of resampling is when you want to convert an image from one that's suitable for printing, which is composed of lots of pixels, into an image that's intended for viewing on-screen on a web page or suchlike, where it would need to be composed of many fewer pixels (A printed image that spans a page of this book needs about 2,000 pixels across its width, while the same image on a web page is more likely to need about 800 pixels).

Another common use of resampling is when you want to produce differently sized versions of the same image for a web site: perhaps a large image on one page and a small thumbnail version on another page.

You may also occasionally need to resample images in order to make them suitable for printing. For producing a few prints on your desktop printer this isn't really necessary, but if you need to send a piece of artwork off to someone else for professional printing you may

need to send it at a size stipulated by them (or then again, you may not have to, as they can usually apply any such adjustments themselves – after all, they know what they're doing).

Before I explain how to change the number of the pixels in an image, I'll explain the implications.

When you change the number of pixels, the detail and colour in the image have to be redistributed, or remapped, across the new pixels. One pixel is the smallest amount of detail that you can have in an image, so changing the number of pixels changes the size of the smallest detail you can have.

For instance, if you were to halve the number of pixels in an image, the detail in the image would halve too. This degrades the image, which is something that you have to approach with caution (Figure 5-10).

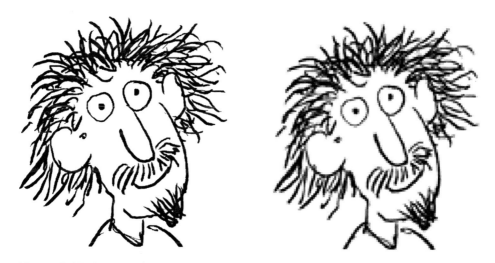

Figure 5-10 Left: A magnified view of an image that has pixels of a suitable size for printing. Right: A magnified view of the same image after it's been resampled so that it's suitable for a web page, where fewer pixels are needed. The resampled version is of lower quality

Because of this degradation of the image it's almost *always* best to save the resampled image as a copy, while keeps the original high quality image safe and unaltered. (This means that you end up with two versions of the image on your computer, the high quality original and the lower quality resampled copy. If you're got limited resources of disk space you may have to eventually jettison one version of the image. Usually you'd want to throw away the lower quality resampled version, so that you retain the superior one.)

Why Giving Images More Pixels isn't a Good Idea

I mentioned earlier that resampling is best used for reducing the number of pixels in an image, in order to make the image use less memory, and that it isn't really advisable to use resampling to increase the number of pixels in an image.

Basically, this is because increasing the number of pixels achieves nothing positive, only something negative.

Increasing the number of pixels won't increase the quality of an image but it will increase its file size, because of the extra pixels.

Adding pixels to an image doesn't add extra detail – basically because you can't miraculously produce detail where there wasn't any to begin with. In fact if anything increasing the number of pixels may make the image a little fuzzier as the colours are redistributed over a larger number of pixels (Figure 5-11).

Figure 5-11 Giving an image more pixels by resampling doesn't create a more detailed image, as these magnified images show. Left: The original image. Right: The resampled image – no new detail magically appears due to the smaller pixels, and any stepping in the original image (due to the larger original pixels) isn't smoothed out, it's just made slightly fuzzy

The upshot of this is that if, for example, you have a lowish quality image with largish pixels, say at 100ppi, and you want to print it out on a high quality printer where 300ppi would be more appropriate, it's best just to use it as it is and hope that people won't look too closely at the quality. They may need a magnifying glass to notice the difference anyway.

How to Resample

That's the theory of resampling covered. I hope it made at least a small amount of sense, as it's quite a tricky subject to juggle in your head when you first come across it. It'll all make sense with practise! Now here's how you actually go about resampling an image.

In the menu bar go to Image>Resize>Image Size. This opens the Image Size dialogue box (Figure 5-12).

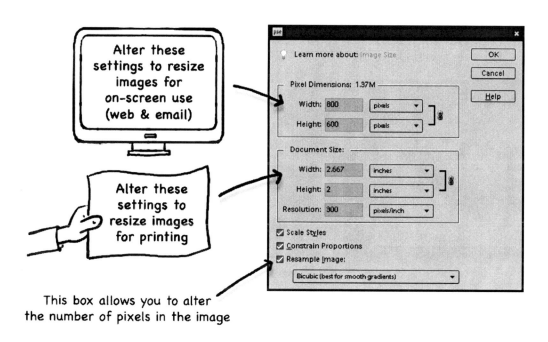

Figure 5-12 The Image Size dialogue box

Make sure that the check boxes for Resample Image and Constrain Proportions are both ticked. Constrain Proportions means that when you alter either the width or the height of the image, the other dimension changes at the same time in order to keep the image the same shape (You can see that the dimensions are connected because of the link symbol joining the dimension boxes).

If for some reason you want to change the proportions of an image, such as making it tall and thin or short and wide, leave the Constrain Proportions box unchecked.

There's also a check box labelled Scale Styles. This box is only significant if you use a type of special effect called a Layer Style on your image (page 451). It's generally best to keep it ticked, so that you don't have to remember to tick it when it's actually needed.

How to Resample for On-screen Images

If you're resampling an image in order to make it the right size for on-screen use, you should ignore the settings in the lower panel, labelled Document Size, as these are related to images for printing. All you need to do is to change the number of pixels that compose the image, by altering the values in the Pixel Dimensions panel (Figure 5-13). You may be able to remember that the Document Size section is irrelevant for on-screen use and can be ignored because it generally has units for 'real life' measurements in it, such as inches or centimetres – and such units are irrelevant on-screen, because different sizes of screen display the same image at different sizes, just as differtly sized tv screens do).

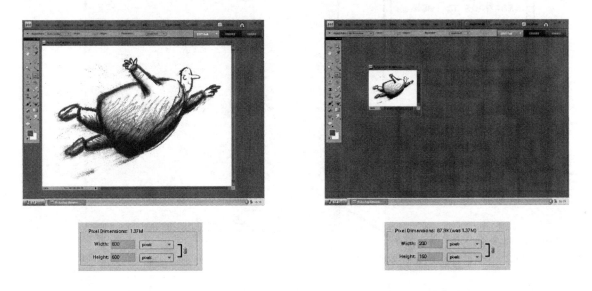

Figure 5-13 Left: When this image, which is 800 pixels across, is displayed at one image pixel per screen pixel it occupies most of the screen. Right: The resampled image, which is 200 pixels across, takes up a quarter of the width and height of the original

Resampling for Print

If you want to resample an image that's going to be printed (in order to change the size or the quality of the print), it's only the measurements in the Document Size panel in the dialogue box that you need to alter. Document Size refers to the size of the image on a printed document (so should maybe be called Print Size instead, as I mentioned previously). You may be able to remember that this is the box to concentrate on when you're working

on an image for print because it contains 'real' dimensions such as inches or centimetres which are what you generally apply to 'real' objects such as sheets of paper.

You can ignore the settings in the Pixel Dimensions panel, which are used for altering the size of images for on-screen use – you'll notice however that because resampling alters the number of pixels in the image, the figures in this panel will change to reflect the new values that you enter in the panel below.

Figure 5-14 shows the two main reasons why you'd probably want to resample an image before printing it. These are:

Centre: to make the image smaller while retaining the same quality. To do this, alter only the Width and Height measurements, leaving the resolution unaltered.

Bottom: to keep the image the same size but to lower its quality (often because it's going to be printed on low quality paper, so the memory used by all of the pixels in the original is unnecessary). To do this only alter the resolution value.

To change both the size and quality of the print, alter both sets of values.

Original Image

Resample to make image smaller

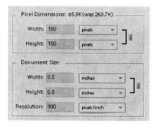

Resample to lower resolution

Figure 5-14
The two main reasons for resampling an image:
changing its size (centre) or
changing its quality (bottom)

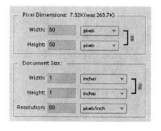

What Does the Box With Bicubic in it Mean?

Next to the Resample Image check box is a panel that displays the words "Bicubic (best for smooth gradients)". This is a pop-up menu containing a list of different ways in which Elements can redistribute the colours of the image when it spreads them over a new number of pixels during resampling (Figure 5-15).

The box always opens on its default setting of Bicubic, which is the best setting for photographic work. However some of the other settings produce better results for images that are more graphic in nature. I suspect that 99 percent of the time no one ever moves this setting away from its default of Bicubic, however it's worth familiarising yourself with the other options because for suitable images the improvement in quality of the resampled image can be significant.

Figure 5-15
The resampling modes compared when resampling the flat colours in the image on the left. Notice the slight fringing created in the default bicubic mode, especially against the background

| Original | Bicubic | Bilinear | Nearest Neighbor |

Bicubic

This is the best setting for images where the colours merge softly into each other, such as photographs (Even abrupt edges in photos are soft by this definition). It resamples by comparing the colour of all of the pixels surrounding a given pixel (See Figure 5-16). To help remember this, think of this square of pixels as one side of a cube, as in bicubic.

Bilinear

This setting works well on images that have a mixture of sharp edges (such as black lines) and soft transitions (such as diffuse areas of colour), making it very useful for resampling cartoons and other types of graphic work. This is because it doesn't produce the fringes that Bicubic sometimes creates along sharp edges. It averages pixels by comparing adjacent pixels that are in line vertically and horizontally with a given pixel (Figure 5-16). This sampling method is quite easy to remember because the pixels are in line, or linear.

Figure 5-16
Bicubic compares all of the pixels surrounding a pixel.
Bilinear compares only those in line (vertically and horizontally)

Nearest Neighbor

If you're resampling work that has predominantly flat colours and hard edges, such as work created using the Pencil tool, you get good results using Nearest Neighbor, as this doesn't average colours out (and thus create new colours), it just moves the existing ones round a bit. This means that no new mixes of colour are created at the transition between one flat colour and another, and it therefore avoids the blurring of edges that occurs using the other methods (In continuous tone work, such as photographs, this blurring is useful because it helps to ease transitions). This makes this method of resampling particularly good for some types of very flat graphic artwork.

If you attempt too large a size change using Nearest Neighbor the pixel shifts will become blocky, in which case using Bilinear may be better.

If you're resampling an image in order to put it on a web page it's not a good idea to use the Nearest Neighbor setting. This is because with screen-based images you usually need a degree of softening of edges in order to make images look acceptable (otherwise they're too jagged and blocky).

Bicubic Smoother

This setting is intended to be used when you increase the number of pixels in an image – however, it's generally not a good idea to do this, as explained earlier, because all it does is increase the file size with no increase in quality.

Bicubic Sharper

This setting is similar to Bicubic, but produces sharper edges at colour transitions. Sometimes these edges may be too sharp, in which case use the normal Bicubic setting.

5

Changing the Canvas Size

The Crop Tool

To cut unwanted areas from the edges of an image (known as cropping), or to add extra canvas on which to extend your image, you can use the Crop tool (Figure 5-17).

 Figure 5-17 The Crop tool

To crop an image, drag the Crop tool's cursor across your image to define the area that you want to retain. As you drag, the defined area will be shown by a dotted rectangle. When you release the cursor the rectangle will acquire square handles on the edges (Figure 5-18) and the area outside the rectangle will be partly masked by a coloured overlay that helps to 'frame' the area that you intend to retain. After defining the area you can adjust it by dragging on the handles of the crop frame. When you're happy with the results click the tick that is attached to the bottom of the crop frame, which will activate the actual cropping process. If you're not happy, click the circle with the diagonal line through it instead.

Figure 5-18 The Crop tool defines the area of the cropped image with a dotted rectangle.
Left: The uncropped image. Centre: The crop area defined. Right: The cropped image

When you're using the Crop tool to extend the canvas (in order to add an extra area to an image) it's often a good idea to enlarge the window frame that contains the image (That's the frame that comtains the file's title bar), allowing the image to float well within the window. This allows you to manipulate the area more easily, as you can see the area that the extended canvas is going to occupy. Increase the size of the window by dragging the knurled triangle in the window's bottom right corner.

It's possible to drag the edge of the cropping frame completely out of the side of the window that's displaying the image. When this happens the handles of the frame become inaccessible, which could be a problem should you need to adjust them further. To gain access to the handles again you can either enlarge the window manually (by dragging the bottom right corner) or by using the little-known shortcut of pressing Command-zero on a Mac or Control-zero in Windows – that's zero, not the letter O. (This is a special use of this shortcut combination, which in most other circumstances is used to change the size of your image on the screen in order to make it fit snugly into the space available).

If you know the dimensions that you want to crop the image to, and the resolution that you want the image to be, you can enter them in the boxes in the Crop tool's options bar. This will constrain the cropping frame to the desired proportions as you drag the cursor to create the frame, and will resize the final area to the dimensions entered.

If you want to crop an image so that it becomes the same size and shape as another image, open both images together, with the image that's already the desired size as the top, active image. Open the Crop tool and in its options bar open the menu labelled Aspect Ratio. Choose Use Photo Ratio. This will enter the image's dimensions into the size boxes. Now click on the image that you want to crop. When you drag the Crop tool's cursor across the image the crop frame will be constrained to the proportions of the other image, and when you commit the crop the image will be resized to that of the other image.

Any values that are entered in the Crop tool's Width and Height fields remain there until they are deliberately removed.To remove them go to the Aspect Ratio menu and choose No Restriction or simply delete the values directly in the fields.

Canvas Size Command

Another way to change the size of your canvas is to go to Image>Resize>Canvas Size.

In the dialogue box, enter the desired width and height for the canvas in the boxes provided, and choose the units of measurement from the drop-down lists alongside.

Activating the check box labelled Relative allows you to enter the dimensions of the extra canvas required rather than those of the whole canvas. For instance, entering one inch for the width would add an inch to the total width of the canvas (Half an inch on each side).

Extra canvas is applied equally to opposite sides of the original canvas in the default setting – in other words, increasing the canvas size by one inch would add half an inch to either side of the canvas. To add canvas only to selected edges go to the Anchor button and move the 'canvas' from the centre by clicking on the arrows that surround it. The new canvas will be applied only on the sides that retain their arrows.

Part III

Working on Images

Brushes (& Erasers)

6

In this chapter, I'll introduce you to the many brushes that are available in Photoshop Elements. I'll show you how to change brushes, how they're stored and how you can organize them to suit your own working methods. I'll also show you how you can create your own personalized custom brushes, in almost any shape you want.

Finally, I'll introduce the Eraser tool, with which you can rub out your brush-strokes should they go astray.

In This Chapter:

The Brush and the Pencil
Should you draw with the Pencil or the Brush?
The Brush panel
Using brushes
Changing brushes' properties
Creating new brushes
Customizing sets of brushes
Erasers

Figure 6-1
A selection of
brushstrokes
created using
different
brushes

The Brush and the Pencil

Elements supplies you with the digital equivalents of a multitude of brushes and pencils with which to paint and draw images. They're called brushes and pencils only to give you a rough idea of how they work, as they can perform feats that their real-life counterparts can only dream of.

Painting and Drawing in Colour

While you're experimenting with using brushes you'll undoubtedly want to try your hand at applying different colours. If you haven't read anything about how to use colour yet, which is covered in Chapter 11, here's the simplest method of choosing different colours to use with the Brush.

Open the Color Swatches panel, which displays a range of colours in small squares (called swatches), by going to the menu bar, to Window>Color Swatches.

While you're using the Brush, just go over to the panel and click on the square that's the colour that you want to use for your next brushstroke. Repeat the action whenever you want to change colours.

The Brush

Figure 6-2 The Brush tool (top left) produces soft-edged strokes

The Brush tool (Figure 6-2, top left) is the most commonly used tool for applying strokes of colour to an image. It produces strokes with slightly soft edges.

You'll find the Brush's button about a third of the way up from the bottom of the Tool panel. (Your Tools panel may also be displaying another brush-like button nearer the top, with a curved dotted circle behind it – don't confuse this with the Brush, as it's a totally different tool called the Quick Selection tool).

If you can't see the Brush tool in the Tools panel this is because the brush shares its place in the Tools panel with three other tools – two types of specialist brush and the Pencil tool. Whichever of these tools was last used will be the one that's on display. You can see their buttons in the panel in Figure 6-3. To find the normal Brush, press and hold on the icon that's visible, which will open this panel, then select the Brush from the list. This chapter deals almost exclusively with the standard Brush tool.

Figure 6-3
If a different button is occupying the Brush's space in the Tools panel, press and hold on the button to open the panel where you will find the Brush tool

The Brush tool gives you access to a huge selection of different brushes, producing a very diverse range of marks (a few of which are shown in Figure 6-1).

The quickest way to open the Brush tool is to use the keyboard shortcut, which is simply to press the letter B.

If you find that pressing the letter B several times in succession makes the brush jump from one version of the tool in Figure 6-3 to the next (which is very annoying as it means that you end up with the wrong version of the tool), go to the Preferences panel (by pressing Command-K on a Mac or Control-K in Windows) and in the General Preferences check "Use Shift Key for Tool Switch".

The Pencil

Figure 6-4 The Pencil tool (top left) produces hard-edged strokes

The Pencil, which shares the same space in the Tools panel as the Brush, is superficially similar to the Brush except that it produces hard-edged strokes instead of soft-edged ones (Figure 6-4).

These hard-edged strokes are excellent for creating sharp and crisp black and white drawings, but before you plunge into using the Pencil there's one question you should ask.

Should you Draw with the Pencil or with the Brush?

Your automatic response to this question would probably be – the Pencil!

But it's not quite as straightforward as that on a computer.

This is because of the way that computers produce their images in small squares, or pixels. In standard digital images the hard edges of lines produced by the pencil may appear jagged or stepped due to the fact that the pixels are *just* large enough to be visible with the naked eye (See Figure 6-5). For this reason, on a normal image the Brush is generally a more sympathetic instrument for drawing, as its soft edges result in smoother strokes.

Figure 6-5
Magnified views of the same bird
drawn with the Pencil (left) and
the Brush (right), in a standard
300ppi image for printing. The
hard edge of the Pencil's line
appears harsh in comparison to
the softer edged Brush line

At first sight the Pencil seems to be a very clunky and crude tool, but it comes into its own when it's used to produce pure black and white line images for print, such as the redrawn version of the bird here in Figure 6-6. This is because pure black and white line images are a special case, where the pixels can be much smaller than in standard print images. Explaining the reasons for this is a bit of a departure from the rest of this chapter, so there's a special chapter dealing with working in pure black and white following this one.

Figure 6-6
The Pencil is perfect for producing pure black and
white line images like this one, where very fine
lines and a very high degree of detail is possible,
as described in the next chapter

If you produce pure black and white line art you really *must* read that next chapter, as it explains how the Pencil can be turned into a precision instrument, and one that I personally use very frequently indeed.

An Introduction to the Brush Panel

When you click on the Brush tool's button in the Tools panel the brush that opens is the last brush that you used from the multitude of different brushes that are available to you.

The individual brushes are stored away in separate groups of (relatively) related brushes that share similar characteristics, as visualized in Figure 6-7. One group contains brushes that create strokes that give the effect of watercolour painting, another contains brushes that act like 'dry' media such as charcoal, pastels and crayons, while another contains brushes that lay down special effects such as flowers or stars.

6

Figure 6-7
The brushes are stored in the computer equivalent of a cabinet made up of several drawers, each containing a set of brushes that have relatively similar characteristics

I'll explain how to gain access to all of these different brushes in a moment, but if you think that the sound of these myriad brushes in their many groups seems quite intimidating here are a few words of reassurance.

Firstly, if you only want to create relatively straightforward work the default selection of brushes – the one that opens when you first open Elements – is the most useful, and it contains the simplest and easiest brushes to use.

Secondly, even though there are lots of brushes in lots of sets you'll probably find that you only need to use a limited number of brushes from a very limited and manageable number of sets. There are some brushes that you'll never use at all. How often, for example, would you want to use a brush that scatters tiny rubber ducks across your image? Yes, such a brush really does exist, and here it is in Figure 6-8 to prove it.

Figure 6-8
Although there are a huge number of brushes available, there are some that you'll probably never use, such as this 'rubber duck' brush

Later I'll explain how you can rearrange the groups of brushes so that brushes that you use frequently are easy to find, while the ones that you never use, including perhaps the rubber duck brush, are hidden away.

Opening the Brush Panel

To open the Brush panel in order to gain access to the different brushes, go to the Brush's options bar, which will have opened automatically when you clicked the Brush tool's button in the Tools panel.

In the options bar is a box containing a curved sample stroke of the currently chosen brush, with a downward pointing arrowhead next to it (Figure 6-9, top left). This box is called the Brush Sample box. Click either the sample brushstroke or the arrowhead, and the Brush panel will open (Figure 6-9), displaying one of the sets of brushes available (This will be the set that contains the currently chosen brush, unless you previously changed panels but then didn't get round to choosing a brush from the newly opened panel).

Figure 6-9
Left: The Brush Sample box, showing a stroke of the brush in use
Below: The Brush panel. It can display the brushes that it contains in several different ways, depending on your preference

The contents of the panel can be displayed in one of several different formats, some of which are shown above.

One format displays the brushes as long curving strokes, which gives you an idea of what the actual strokes look like. To the left of each stroke is an image of an individual 'dab' of the brush tip.

Another version of the panel shows the brushes only as individual dabs, so that more brushes can be displayed in the same amount of panel space.

Yet another version of the panel displays the brushes as a list of names alongside the individual dabs. These can be useful for indicating what sort of mark to expect (such as 'Hard Pastel on Canvas'). When you're using the other versions of the panel, where the names aren't on display, the names pop into view in little boxes when you move the cursor over the brushes, as in Figure 6-10 (as long as Tool Tips is turned on in the Preferences).

Figure 6-10
The name of the brush will appear in a small panel when you hold the cursor on a brush

To change the version of the panel, go to the small double arrowhead near the top right corner of the panel. This opens a pop-up menu (Figure 6-11), where you can choose the display option from the list (starting with Text Only and ending with Stroke Thumbnail).

Figure 6-11
The Brush panel's pop-up menu

In the panel, the number next to a brush indicates the brush tip's size in pixels. For small brushes the mark representing a single dab of the brush is the actual size of the tip, while for large brushes (that are too big to fit into the limited space available for the sample) the size is standardized.

When you select a brush, the brush's position in the panel is surrounded by a thick line (if you're using a panel with a display of thumbnails) or becomes highlighted (if you're using a text-based list). This is a useful reminder of which brush you're using should you want to check. Unfortunately, if you alter any of the characteristics of the brush (described soon), this reminder disappears, which can be very irritating.

To change the set of brushes displayed in the panel go to the box at the top of the panel, labelled Brushes. This opens a pop-up list of the other sets available (Figure 6-12).

Figure 6-12
The pop-up menu with which
you change brush sets

That's the basics of how to find your way around the Brushes panel. I'll go into more detail about how to use the panel later, but first here's how to use the brushes themselves.

Using Brushes

To select a brush in the panel, just click on the brush.

When you start using the brush that you've selected the panel closes automatically so that it doesn't take up valuable space on your screen.

To change brushes the standard method is to reopen the panel and click on a different brush.

Alternatively, if you want to gain access to the Brush panel while you're drawing or painting, and you don't want to break your concentration by going to the options bar, you can press the Control key and click (on a Mac) or right click (in Windows), which will make the Brush panel conveniently manifest itself right next to your cursor. If you're using a graphics tablet you can open the panel by pressing the button on the side of the pen.

Changing the Size of Brushes

If you're using a graphics tablet you can vary the thickness of brush strokes by applying different amounts of pressure on the tablet – however, the thickness of the resulting strokes is still dependant on the size of the brush tip that you've selected in the Brush panel. A small brush tip will never produce a thick brush stroke for instance, no matter how hard you press on your tablet. Whether you're using a tablet or just a mouse it's inevitable that you'll want to change the size of your brush tips, often at frequent intervals.

Fortunately, you don't have to keep making frequent return trips to the Brush panel in order to choose a new brush tip at a different size, even thought the brushes in the panel are all of specified sizes. No matter which brush tip you're using, you can *override* its set size so that it can produce a different thickness of stroke. You can do this in a number of different ways.

By far the quickest and most convenient way to change the size of your brush is to use the keyboard shortcut for the operation. The shortcut is simply to press either of the square brackets keys on your keyboard (You'll find them to the right of the letter P). Press the left bracket key to make the brush smaller and click the right bracket key to make the brush larger.

These keys enable you to change the size of your current brush incrementally. As you press the bracket key the brush size changes in steps. You can see the size changing by looking at the size displayed in the options bar. If you've got your preferences set so that the brush's cursor reflects the size of the brush (which I'd recommend), the cursor will change size too.

The size change of each step is dependent on the size of the brush that you're altering – small brushes change in small steps while large brushes change in large steps.

If you only ever use the simple brushes that are found in the top half of the default set of brushes (all of which are perfectly circular and are called either 'hard round' or 'soft round'), you may hardly ever need to open the Brush panel at all in order to change brushes This is because all of the brushes of each type in the default set (hard round or soft round) are essentially the same brush apart from their size. As a result you can simply alter the brush sizes using the square bracket keys rather than having to choose differently sized brushes from the set itself. You may only need to go to the panel if you want to move from a hard brush to a soft brush, or vice versa.

Alternatively, but less conveniently, you can change the size of a brush by altering the value in the Size box in the options bar, which overrides the brush's original size setting. Go to the box and type in a new value, representing the number of pixels that you want the brush's width to be.

There's another way to change brush size using the Size box. Move the cursor up to the options bar and place it above the word Size (That's above the word itself, not above the box next to it). The cursor will change into a pointing hand with a double-headed arrow beneath it. Move the hand along the options bar, to the left or the right, and the size of the brush will change, as though the whole options bar was a sliding scale for altering the size.

Changing the Size of 'Artistic' Brush Tips

Changing brush sizes by overriding the original brush size (by using the keyboard shortcut or by entering a new size in the Size box as described on the previous page) works perfectly on many brushes, but with some of the brushes – the ones that create realistically 'artistic' brush strokes – the strokes may become slightly fuzzy and ill-defined, for reasons that I'll explain now.

If you use the simple round brushes in the top half of the default set you can alter their size as much as you want, and the resulting brushstroke is perfect, because changing the size simply produces a differently sized circle. The same applies to brushes that have tips that lay down tiny images of objects, such as the ones in the default set that lay down grass or leaves (or the one that produced the rubber ducks in Figure 6-8).

There are many brushes however where the quality of the brush's marks degrade if you increase the size of the brush by overriding the original size (See the lower brushstroke in Figure 6-13). This applies especially to the brushes that lay down strokes that strive to emulate the appearance of real brushes (by doing such things as including stray brush hair marks) or ones that attempt to mimic the textures of chalk, charcoal or similar media. With these brushes, which can usually be identified because their tip is a cluster of dots or a textured blob, it's better to choose an alternative size of the same brush from the Brush set rather than to greatly increase the size by overriding its original setting.

This is because the tips of these brushes are actually created from tiny images composed of clusters of pixels (explained on page 149, in the section How the Brushstrokes are Generated), and like all pixel-based images their quality is reduced when you increase their size drastically (The brushes composed of hyper-realistic images such as the 'rubber duck' brush don't suffer from this blurring effect, because their images are generated in a different way, that doesn't use pixels).

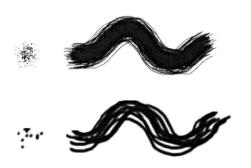

Figure 6-13
Increasing the size of the 'artistic' brushes via the keyboard shortcut or the Size box in the options bar makes the textures in the stroke (such as brush hairs) slightly fuzzy.
Top: The Stipple brush at its 43 pixel size. A single dab of the tip is shown at the left.
Bottom: The 12 pixel version of the Stipple brush enlarged to be the same size as the 43 pixel brush, showing the degradation in definition

Choosing the Appearance of the Brush Cursor

Like all tools, the Brush has a cursor that indicates the location on the screen that you're acting on. You can change the appearance of the cursor by opening the Display & Cursors preferences panel (Figure 6-14). In Windows do this by going to Edit>Preferences>Display & Cursors (or by using the keyboard shortcut Control-K), or on a Mac by going to Photoshop Elements>Preferences>Display & Cursors (or shortcut Command-K).

Figure 6-14
You can change the appearance of cursors in the Preference panel. The thumbnails in the panel showing the appearance of the cursors of your choice

Here are your choices for the Brush cursor.

Standard: This displays a cursor that looks like a small paintbrush. This is good for reminding you what the tool does, but otherwise it's not as accurate as the other versions for showing how the brush is going to apply the paint. It's a good choice for beginners.

Precise: Creates a cross hair shaped cursor that accurately shows the position of the centre of the brush tip.

Normal Brush Tip: Perhaps the most useful of the cursors, this displays a cursor that indicates the shape and size of the brush mark that'll be applied.

Full Size Brush Tip: Similar to the Normal Brush Tip cursor, except that it shows the full size of the entire brush tip. With brushes that apply colour that fades away to nothing towards the edge this means that the cursor indicates the outer limit of the faded colour, making the cursor larger than the obvious coloured parts of the brush mark.

Show Crosshair in Brush Tip: Ticking this box will place a crosshair at the centre of the two Brush Tip cursors above. This is useful for pinpointing the centre of large brushes.

The Other Cursors panel changes the cursors for tools other than those that use brush tips, such as the Lasso and Paint Bucket (I'd recommend that you set this to Precise).

While you're in the middle of painting you can toggle between the Brush Tip or Standard cursors and the Precise cursor by pressing the Caps Lock key (If you're ever in the middle of working and you find that the wrong cursor is being displayed for no apparent reason, the first thing to do is to check that you haven't accidentally activated Caps Lock).

Changing How the Brushes Apply Colour
- The Brush Options 6

There are various ways in which you can vary the appearance of your bru.
altering the manner in which your brush lays down paint. These features are accessible v..
the Brush's options bar.

Some of these options are very useful when you're using a mouse, with which brush-strokes would otherwise be flat and uniform. Other options are essential when you're using a tablet, in order to control the ways in which the pressure of the pen alters the brushstrokes.

Opacity Control

Figure 6-15 Opaque and semitransparent brushstrokes. Left: A cloud created using strokes of a single opaque colour results in an area of flat, solid colour. Right: This cloud was created using the same colour and brush, but with semitransparent strokes. Because you can see though the colour, objects beneath it are visible. Overlaid brushstrokes build up to create tonal variation

Many brushes lay down solid, opaque colour by default, so that anything beneath the stroke is totally hidden (The cloud in Figure 6-15, left). You can however make your brush lay down semitransparent colour rather than opaque colour by altering the Opacity setting in the options bar, allowing colour beneath to show through (Figure 6-15, right).

To change the opacity of your brushstroke you can type a number into the box labelled Opacity in the options bar or you can click on the small triangle in the box to reveal an adjustable slider. You can also click on the word Opacity itself and then move the cursor along the options bar to change the opacity without the opening an actual slider panel.

If you're using a graphics tablet you can also vary the opacity of colours using the tablet, described later.

Using semitransparent strokes you can build up tonal effects by applying separate strokes on top of each other. A single stroke that crosses itself doesn't build up the tone in this way, remaining flat (Figure 6-16).

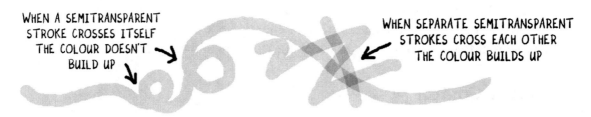

WHEN A SEMITRANSPARENT STROKE CROSSES ITSELF THE COLOUR DOESN'T BUILD UP

WHEN SEPARATE SEMITRANSPARENT STROKES CROSS EACH OTHER THE COLOUR BUILDS UP

Figure 6-16 Semitransparent strokes build up tone where separate strokes cross

By using a low opacity to build up tonal variation, subtle effects can be achieved even with a mouse (as in Figure 6-17).

Figure 6-17
The shading on these balloons was done with a mouse, not with a pressure sensitive graphics tablet.
The colour applied was black, with the opacity in the options bar set below 10%. Using a low opacity allowed the subtle build-up the tone by the repeated application of separate strokes on top of each other

Altering Brushes and Creating New Ones

Although Elements has a large stock of brushes, if there isn't one that's the shape that you want you can create new ones. You can do this either by tweeking the characteristics of existing brushes or by creating totally new ones from scratch – all in a matter of seconds.

To understand how to alter existing brushes or to create completely new ones it helps to know a little about how Elements generates its brushes in the first place.

How the Brushstrokes are Generated

Different styles of brushstroke are produced by dragging differently shaped brush tips across the surface of your image. Elements uses several distinct types of brush tip, generated in different ways. There are simple brushes where the tip is a single circular blob (Figure 6-18), and there are complex brushes where the tip is textured or variable in some other way (Figures 6-19 and 6-20).

Figure 6-18
A simple circular brush tip and the
stroke it produces

The circular brush tips not only look simple, but they're simple for the computer to generate. The computer only needs to know where the centre of the brush is, and what the radius of the circle is, and it can produce the tip using a simple mathematical formula.

These brushes include all of the ones in the top half of the default set – those that include the word 'round' in their titles –and all of the brushes in the Basic Brushes set.

Figure 6-19
A complex, textured brush tip
and the resulting stroke

The complex, textured brush tips (Figures 6-19 and 6-20) are totally different. These tips aren't produced by using a few simple mathematical coordinates in the way that the circular tips are, because the shapes of the tips are too complicated to be broken down into simple formulæ. They are in fact composed of tiny images.

With some brushes these images are clusters of pixels that replicate the effect of real brushes and other media, such as charcoal or chalk (Figure 6-19). The image creates the impression of brush hairs or textures as the tip is 'smeared' across the canvas.

With other brushes the image of the tip isn't smeared in a continuous stroke, but is laid down in distinct 'dabs' along the length of the brushstroke (Figure 6-20), making the image composing the tip more visible. These brush tips are usually of quite realistic objects, such as the spheres here (or the rubber ducks earlier). The images look so realistic because they are created by a method that is independent of the pixels that the rest of Elements images are dependent on (although once the brushstrokes have been laid down they are rendered as pixels, as usual).

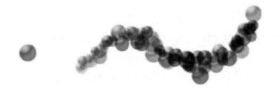

Figure 6-20
Some brushes create their strokes
in the form of repeated 'dabs' of
the image that forms the tip

Customizing Brushes

As well as being able to change the size and opacity of a brush, described earlier, you can customize other settings – such as the softness of the brush's edge, its shape and the way that it applies colour.

If you customize a brush and find that its new settings are particularly useful to you, you can keep the brush, along with its settings, for future use by adding it to the other brushes that are stored in the sets in Elements. Do this by saving it, as described in the section Customizing Your Brush Sets (page 168).

If you don't save a customized brush, the brush's modifications are only available while the brush is still active – as soon as you change to a different brush the customized settings are discarded and the modified brush reverts to its original form.

To customize a brush, follow these steps.

With the brush that you'd like to modify chosen, go to the Additional Brush Options button in the Options bar. That's the button that's the final item in the Options bar (not counting the Edit, Create and Share tabs), that's shaped like a paintbrush. You can see it in Figure 6-21, next to the cursor.

When you click this button a panel opens displaying the various characteristics of the brush that's in use (Figure 6-21).

By modifying these settings you create a new customized brush that temporarily

Figure 6-21 The characteristics of your brush are revealed when you click the Additional Brush Options button in the Options bar

overrides the current brush.

Any settings that are faded can't be applied to the specific brush in use.

As mentioned above, the new settings will disappear as soon as you change to a different brush, unless you deliberately save them as a new brush, explained on page 168.

Here's a rundown of the properties in the panel, and how to change them.

I won't introduce them in the order that they appear in the panel, but in the order that's hopefully easiest to understand.

For clarity, the images of brush strokes that I use to illustrate the properties are all produced with a simple round brush from the default set, and are produced using a mouse (so that there's no possibility that any of the effects illustrated are due to the use of a graphics tablet).

Hardness

The Hardness control determines the degree of fuzziness or softness at the edge of a brush stroke (Figure 6-22).

A hardness of 100 percent is a well-defined edge (although not completely razor sharp like the edge of a line produced with the Pencil), while zero percent is very diffuse and soft.

The harder edges are generally best for drawing and line work, while the fuzzier ones are more suited to painting.

Figure 6-22
Different Hardness settings.
Left: 0%.
Right: 100%

Fade

Figure 6-23
Making strokes fade
away at different rates.
Top: 250
Middle: 100
Bottom: 50

The Fade control allows you to create strokes that fade away, eventually disappearing altogether, simulating the effect of a brush running out of paint (Figure 6-23).

You can set the rate at which a stroke fades. A value of one makes the stroke fade in just one step, which is practically instantaneous, while at the other extreme the maximum value is 9999, which is practically meaningless. Higher values are best when you want strokes to fade slightly but not to disappear completely.

The values of the steps indicates the number of dabs of colour that the brush tip lays down as it fades, described in the descriptions of Spacing and Scatter in a moment.

Setting the Brush's Roundness and Angle

Figure 6-24
Left: A standard round brush tip and the stroke that it produces.
Right: The same brush tip squashed into an ellipse

It's possible to squash brush tips so that they are flatter and to rotate them in order to change the angle at which they're applied (Figure 6-24).

To do this go to the circle that looks a bit like a telescopic sight at the bottom of the Additional Brush Options panel (Figure 6-25). Press on one of the little handles (the black dots) where the cross hairs join the circle, and drag it towards the centre. The circle flattens into an ellipse.

Notice that the value in the box labelled Roundness alters when you do this. If you know exactly what value you want, you can just type it the straight into the box.

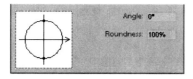 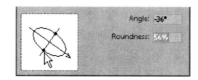

Figure 6-25
Changing the
roundness of
a brush tip

With a flattened brush the angle at which the brush makes a mark on the image is important, so you can rotate the brush by pressing and dragging anywhere inside the box, which will swivel the brush round. If you know the precise angle that you want you can type the value into the box labelled Angle.

Spacing, Hue Jitter and Scatter

To understand these values – Spacing, Hue Jitter and Scatter – you have to know a very small amount more about how Elements creates its brush strokes.

When you draw a line with your brush in Elements the stroke isn't continuous as with a conventional brushstroke on paper. It's made up of many closely spaced dabs, each one in the shape of the brush tip (Figure 6-26). These dabs are normally too close together for you to notice the individual dabs, making the line for all practical purposes continuous.

However, you can alter the way that the dabs are laid down, and thus change the nature of the brushstrokes, using the Spacing, Hue Jitter or Scatter controls.

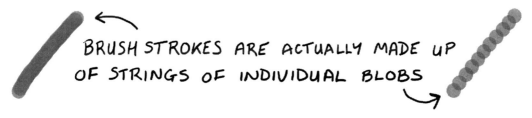

Figure 6-26 All brushstrokes are composed of a series of very close blobs or dabs

Spacing

The Spacing control alters the distance between the dabs described above.

Figure 6-27
Different Spacing settings.
Left: 25% (the default setting)
Centre: 75%
Right: 150%

For smooth, continuous brushstrokes you'll usually want the dabs to be close enough together to ensure that you can't see them individually, but for some effects you'll find that spreading them out is more effective.

Occasionally you may be able to see the individual dabs that are laid down by the brush even when you want a smooth, continuous stroke. This is most likely to happen when you're using a very large brush or one with an unusual shape. To overcome this effect you can make Elements place the dabs closer together by reducing the number in the Spacing box in Figure 6-21. The default setting for most brushes is 25 (The meaning of the numbers is explained in the panel below).

The Measurement of Spacing

If you want an explanation of the numbers involved in the Spacing box, here it is. Refer to Figure 6-27.

The Spacing value shows the percentage of the brush's diameter that separates the centres of the individual dabs. So the default setting of 25 means that the centres of the dabs are separated by 25 percent (a quarter) of the dab's diameter, which normally makes them overlap enough to look like a continuous line. At 100 percent the centres of the dabs are separated by exactly their diameter, so the individual dabs are just touching and look like a string of beads. Above 100 percent the dabs appear as individual blobs with space between them.

If you put a very low number in the Spacing box, so that the dabs are extremely close together, the computer has to work very hard at laying all of the dabs down while you're creating the brushstrokes. In this case you may experience a time lag between the movement of your mouse or pen and the stroke actually appearing on the screen. If this happens, increase the number in the box slightly so that the computer can keep up with you.

Spacing is a matter of compromise. In an ideal world the spacing value would be so low that the brushstroke would be almost continuous, but until computers become even faster than they are now, they just can't cope with that amount of work.

Hue Jitter

Normally when you apply a brushstroke the colour that is laid down is the foreground colour (The colour in the top one of the two overlapping squares at the bottom of the Tools panel). This creates a uniform colour in a single hue.

Using the Hue Jitter control you can make the colour vary by adding a certain amount

of the background colour (the lower square at the bottom of the Tools panel) to the dabs of your brushstroke (Figure 6-27). The colour is added randomly, in greater or lesser amounts, to individual dabs. This gives a more paint-like and natural effect to the stroke.

Moving the Hue Jitter control varies the amount of the background colour that's added to the stroke. A low value means that only a slight amount of the colour is added, while 100 percent produces a stroke that's equal parts foreground colour and background colour.

For subtle colour effects make the background colour similar to the foreground colour.

Figure 6-27
Hue Jitter mixes the background colour with the foreground colour in your brushstroke, as here (right) with the Drippy Water brush from the Wet Media brush set.
(See a colour example on the back cover, or at www.chrismadden.co.uk/create)

Hue Jitter generally works best with brushes that don't produce marks that are too regular, so that the mixing of the coloured dabs doesn't look too mechanistic. Try using it with brushes in an 'irregular' set, such as the Wet Media Brushes set – the Drippy Water brush at the top of the list is a good choice.

Having said that, to actually understand how Hue Jitter works it's best to experiment with it in a way that creates unnatural mechanistic effects rather than subtle naturalistic ones (Figure 6-28). Try it with a simple brush, such as a large round brush from the top of the default set (perhaps increased in size using the right square bracket key), and using wildly different foreground and background colours, such as yellow and blue. Set the Hue Jitter value to near a hundred percent. That way you'll see the separate dabs of colour along the length of the stroke, creating a very interesting tube-like effect. It's good fun – give it a go.

Figure 6-28
Hue Jitter mixes the background colour and foreground colour in different degrees along your brushstroke.
Left: No jitter
Right: 100% jitter
(See a colour example on the back cover or go to www.chrismadden.co.uk/create)

Scatter

Scatter works by spreading the dabs that form a stroke out on either side of the line of the brushstroke (Figure 6-29). In other words, it scatters them.

The percentage of scatter affects how far from the line the dabs are spread.

Figure 6-29
Scatter: The first stroke has no scatter, the second has 12%, and the third 25%. I've set the Spacing for these brush-strokes high, so that you can see the individual dabs better

Adding scatter to a brush can turn the lines produced by even the simplest of brushes into complex strokes – just look at the hair in Figure 6-30.

Figure 6-30
The hair in this image was drawn with the same brush as the rest of the image, but with Scatter activated. The brush was a simple round one from the default set, and it was drawn with a mouse, so the only factor that's making the lines in the hair non-uniform is the Scatter setting

Giving a brush both a high Scatter and a high Hue Jitter value can transform even the most precise and uniform of brushes into a brush that produces a nebulous stream of speckles (Figure 6-31).

Figure 6-31
The same image drawn twice, both times using only an ordinary round brush from the default set. In the second image the stroke for the plane's trail was given high Scatter and Hue Jitter values to spread the dabs out

The Airbrush

Another way in which you can alter the quality of brushstrokes is to turn the brush into an airbrush.

To activate airbrush mode click the Airbrush button in the Brush tool's options bar (Figure 6-32).

Figure 6-32 The Airbrush button in the Brush tool's options bar

It has to be said that describing this tool as any sort of equivalent to an actual airbrush is stretching it a bit.

The Airbrush differs from the normal Brush in that it keeps laying down colour continuously, even when the cursor is held in a stationary position on the image. With a lot of brushes the effect of this is simply that the brush mark increases in thickness as the cursor is held in position, which isn't really an effect that warrants a whole tool. Some brush tips create slightly more spectacular effects when applied in Airbrush mode, although these tips tend to be ones at the novelty or gimmicky end of the brush tip spectrum. Try the Airbrush with the Azalea tip in the Special Effects Brushes list to see what I mean (and compare it with the Azalea tip when not in Airbrush mode).

Using a Graphics Tablet with Brushes

When you use a graphics tablet you can make the thickness, opacity and several other properties of your brushstrokes vary by changing the pressure with which you press the pen on the tablet.

A tablet is essential for any sort of artistic work. If you don't possess a tablet, put this book down and go and buy one this minute.

You can choose which properties you want to be responsive to pressure variations. For instance you may want a brush's thickness to vary with pressure changes but its opacity to remain constant, or you may want both thickness and opacity to change together.

Some brushes are preset so that some of their properties respond to pen pressure automatically. For instance the round brushes at the top of the default set of brushes are preset to change thickness as you vary the pen pressure, but if you want any other property of these brushes, such as opacity, to be responsive you have to activate them yourself. To activate

the properties of the brush go to the Options bar and click the downward pointing black arrowhead that's nestling between the Airbrush button and the brush-shaped Additional Brush Options button. This opens the Tablet Options panel, Figure 6-33.

The options can be changed by clicking on the appropriate check boxes.

Figure 6-33
The options in the Tablet Options panel allow you to control the characteristics of brushstrokes

Here's a small warning concerning the Tablet Options panel.

You'd think that when you open the panel the settings that are displayed in it would be those for the brush that's in use at the time (So if you're using a brush with its unaltered default settings you'd expect the panel to be displaying those default settings). But they're not. The settings seem to be an amalgamation of default settings and settings carried over from the settings for the previous brush. Don't ask me why. It's all very confusing, at least to me.

What's more, once the panel has been opened the settings in the panel will be applied to the current brush, even if you just open the panel for a quick look. The upshot of this is that if you open the panel out of curiousity to see what settings are in place (perhaps on the mistaken assumption that the settings are operating on the brush already) they are suddenly applied to your brush and it may start acting differently. To return your brush to normal, choose a different brush momentarily and then return to your original brush, when you'll find that it's back in default mode.

Brushes that you've altered revert to their default settings when a different brush is selected.

If you want to keep the settings that you apply to a particular brush so that the brush automatically opens with the desired tablet options activated (rather than you having to reset them every time you select the brush) you can store the settings. Do this by saving the brush as a new brush (described later, in Saving New Brushes, page 168). Give your new brush a different, suitable name, such as its original name followed by the tablet options that you've applied to it.

If you find this technique useful, you can create a whole set of new brushes with their tablet settings permanently active.

The options for the tablet are as follows.

Size: Using this option, the width of the stroke changes with varying pressure: the harder you press, the wider the stroke (Figures 6-34 and 6-35).

Figure 6-34
The Size option in Tablet Options makes a stroke's width vary with pressure

Figure 6-35
All of the strokes in this image were produced using one brush with Size activated

Opacity

The opacity of the stroke changes with varying pressure: the harder you press, the more opaque the stroke (Figure 6-36).

Figure 6-36
The smoke in this image is applied above the man. You can see him through it because the smoke is semitransparent, with its opacity varied by varying the pen pressure

Scatter

Scatter works by spreading the dabs in a stroke out on either side of the line that you draw (see the explanation of these dabs in the Additional Brush Options section, immediately before this one).

With Scatter activated in the Tablet Options, the degree of scatter is increased with increased pen pressure (Figures 6-37 and 6-38).

Figure 6-37
Scatter spreads the dabs in a stroke
according to pen pressure

The maximum spread of the scatter is dependent on the Scatter setting in the Additional Brush Options panel (click the brush shaped button in the Options bar). If no value is entered in this panel the tablet option won't have any effect, and you may think that it's not working properly.

Figure 6-38 Each tree in this image was drawn with a *single* brushstroke using a simple round brush tip with Scatter and Size activated. The harder the pen was pressed, the larger and more scattered the dabs

Roundness

With the Roundness setting activated the stroke is flattened when you apply light pressure with your pen (so for instance a round brush becomes elliptical). With increased pressure the stroke widens out towards its normal shape (Figure 6-39).

Figure 6-39
With Roundness activated, light pressure produces flattened dabs, while greater pressure produces normal dabs.
(I've applied wide spacing to show the dabs)

Hue Jitter

This setting mixes the foreground colour and background colour in different proportions, depending on pen pressure (Figure 6-40). When you press hard the colour is predominantly the foreground colour, while if you press lightly it's predominantly the background colour. Intermediate degrees of pressure produce varying mixes of the two colours, as demonstrated in Figure 6-41.

For many brushes the tablet's Hue Jitter option needs to be kick started by operating the other Hue Jitter control, in the Additional Brush Options panel (the brush-shaped button in the Options bar), otherwise you get no effect. To do this, open the Additional Brush Options panel and set the Hue Jitter to any value: a very low value is advisable (because this control creates a different version of the jitter effect to the tablet's jitter – as explained in a moment). Once you've set a value in the Additional Brush Options jitter you can immediately return it to zero again if you want, as the simple act of setting a value is what activates the tablet's Hue Jitter option.

If you save new brushes with Hue Jitter activated, as described earlier in this section on tablet options, the option is automatically active, without the need for kick starting in this way.

Figure 6-40
With Hue Jitter a stroke's colour moves between foreground and background colour as you vary pen pressure
Top: Hue Jitter activated.
Bottom: Hue Jitter and Size activated, making the colour and the size vary together.

As mentioned above, the Hue Jitter option in the Tablet Options isn't exactly the same as the Hue Jitter option in the Additional Brush Options panel. The Additional Brush

Options version applies random mixes of colour to the stroke, producing speckly effects rather than gradual colour changes, and is unaffected by pen pressure. If both of the Hue Jitter options are in use at once the two jitter effects work together, although for many effects it's best to just use one at a time.

Figure 6-41 This entire black and white image was drawn in *one* single brushstroke – yes, one – without the pen leaving the tablet.
Hue Jitter in the Tablet Options panel was active, so the tone of the stroke moved between black and white with pen pressure

Creating Your Own Image-based Brush Tips

If there isn't a brush available to suit your needs you can make one very easily by designing your own brush tip.

All you need to do is to create a suitable image and then ask Elements to convert it into a brush.

You can create brushes that mimic real brushes or you can create ones with recognizable images as their tips.

First I'll demonstrate how to create a brush out of a recognizable image, because it's more fun than making a brush that mimics a 'proper' brush, and it's easier to visualize. For my demonstration I'm going to use a drawing of a flower as a brush tip (Figure 6-42). If you want to see a more typically brush-like type of brush tip see Figure 6-49 at the end of this section.

Figure 6-42 The flower that I'm going to convert into a brush tip for the purposes of my demonstration

Once the brush has been created it can be used to produce brushstrokes that are composed of the image, as shown in Figure 6-43.

Figure 6-43 The Brush that's shaped like an image can be used to produce strokes composed of the image

It can also be used to lay down individual 'dabs' instead of continuous strokes (Figure 6-44). Used this way the brush works something like a rubber stamp, but with the great convenience of allowing you to change the size of each dab separately, such as by using the square bracket keys (or by pressing with different pressures on a tablet).

Figure 6-44
An image-based brush tip can be used as a 'rubber stamp' to apply multiply versions of the tip. Each flower here is an individual dab of the brush

Here are the stages in creating an image-based brush tip.

1: You can create a brush tip from any image. It can be a drawing specially created for the purpose (such as my flower) or it can be part of a pre-existing image such as a photograph.

The brush tip is created in black and gray, even if the original image is coloured. Don't produce or choose a multicoloured image as a brush tip and expect the brush to include the colours in the brushstrokes. No brush ever contains colour itself – you always have to add the colour later, as with a real brush. Black areas of the brush lay down solid colour, while gray areas lay down semitransparent colour dependent on the shade of gray. Any white in the image lays down no colour at all, so it's best to think of such areas as being transparent – definitely not as being white (For instance in my flower the white inside the petals will become transparent, allowing colours behind to show through).

2: If you design your own image for a brush on a white canvas Elements will automatically select only the image itself as the brush tip, trimming away the excess white that's surrounding the image. If you want to use part of an image as your brush tip you need to select the part that you want to use by defining the area as a selection (Figure 6-45). The brush tip is created from all artwork visible within the selection area, even if it's on different layers, so if any artwork on other layers intrudes into the selection area, and you don't want it in your brush tip, hide the layers temporarily.

Figure 6-45
Select the area that you want to use as a brush tip, unless it's the only object on an otherwise white or empty canvas, in which case it will be selected automatically

You can remove any unwanted detail from within the selection area by either erasing it or by applying white paint to it.

3: Elements will create a brush tip the same size as the image you've chosen, so if your image is larger than a sensible brush size you should shrink it down to the right size, such as by using the Transform command (Chapter 13).

4: When you've created and/or selected the image for the bush tip open the Brush tool (if it's not open already).

5: In the menu bar, select Edit>Define Brush (If it's a selection that you're turning into a brush it'll be Define Brush from Selection). The Brush Name dialogue box will appear (Figure 6-46).

Figure 6-46
The Brush Name dialogue box

You can check that you've chosen the right piece of artwork for your brush by looking at the thumbnail image of the new brush. If the image of the thumbnail doesn't more or less fill the space in the box it probably means that you've accidentally included other areas of artwork in the brush, effectively making the part of the image that you want as the brush become just one part of the brush (This will make sense if you actually do it). The thumbnail of the brush always expands to fill the square panel both horizontally and vertically no matter what the proportions of the actual brush, often making the thumbnail appear out of proportion – this won't affect the actual brush itself.

6: Enter a name for your new brush in the Name text box.

7: Click OK.

Your new custom brush is now ready for use, and is placed at the bottom of the set of brushes that is open in the Brush panel.

Despite the fact that you can see the brush sitting at the bottom of the list it's only stored there *temporarily*. You need to *save* the brush in order keep it there permanently (or at least until you decide to throw it away).

Before you save the brush permanently you need to decide whether you want to keep it in the set that's currently open, and in which it's currently residing at the bottom of the list of brushes, or whether you'd prefer it to be in a different set.

You can't permanently store new brush tips in the Default set, because it's a special case (Nor can you, for some reason that eludes me, add to the top two sets in the rest of the list which are the Assorted Brushes or Basic Brushes unless you alter the sets). If you want to store new brushes in these top three sets you need to create new versions of the sets as duplicates, explained on page 169.

If you're happy with the set that the new brush was placed in when you first created it, all you need to do in order to save the brush there permanently is to go to the double arrowhead near the top right of the Brush panel and click Save Brush (not Save Brushes at the bottom). A name panel will appear that displays the name that you chose for the brush earlier, now followed by a number. Don't bother to change the name or remove the number – just click OK. You'll now notice that bizarrely there are two copies of your new brush at the bottom of the list of brushes – the one that was placed there originally and the one that you've just saved. You don't really want to have two identical brushes in your set, so you need to remove one of them. Select the brush that you want to remove (probably the one with the number after it), go to the pop-up menu via the double arrowhead and click Delete Brush. That's it. This seems to be an odd way to have to go about things, but that's how it is for some reason (or perhaps for no reason).

If you'd prefer the new brush to be in a different set to the one that it first appears in, navigate to the desired set of brushes via the panel at the top of the Brush panel (Before you do this check that the new brush is the highlighted brush in the open set – this is because to move it from one set to another it has to be 'out of the set and in your hand'. If it isn't, click on it.) When you leave the original set, a panel will appear asking you if you want to save the set as a new set with the new brush in it. Click Don't Save. Then when you've opened the desired set click the double arrowhead near the top right of the Brush panel to open the pop-up menu, and choose Save Brush (at the top of the list – not Save Brushes at the bottom). A name panel will appear that displays the name that you chose for the brush earlier, but now followed by a number (probably 1). Remove the number if you want, then click OK. The brush is then placed in the set.

Here's a tip about image-based brush tips of the type discussed in this section.

If you use an image-based brush tip repeatedly to make multiple copies of objects, along the lines of a rubber stamp (described earlier and illustrated in Figure 6-44), the end result can often be far too uniform. Look at Figure 6-47 for instance. Here I've use a drawing of a dandelion seed as a brush tip, and to be honest the effect is quite monotonous despite the fact that I've applied the seeds in a variety of sizes.

Figure 6-47
A single
repeated
image looks
monotonous

The fact that you're using the same brush tip for a series of marks can often be concealed simply by rotating the tip slightly when you're applying some of the marks (Rotate the tip in the Additional Brush Options panel in the options bar). In Figure 6-48 the exact same brush tip as in the previous figure was used at only three different angles, but it gives the impression of a series of completely individual dandelion seeds.

Figure 6-48 The same brush tip that was used in the previous figure applied at different angles to add variety to an image. At first sight you don't notice that there is only one repeated dandelion seed here, at only three different angles

If you want to create brush tips that produce more conventional brush-like effects, rather than drifts of floating dandelion seeds or suchlike, here are a few hints.

For a conventional brush effect that simulates blobs of paint a brush tip is typically composed of an array of black and grey smudges that become more diffuse towards the edge to avoid hard edges (Figure 6-49). There may be separate dots round the sides of the image to give the effect of the stray hairs in a conventional brush.

Figure 6-49
A suitably indistinct brush shape to avoid obvious repeating forms

To create a convincing paintbrush effect you need to take into account the fact that computer generated brushes aren't flexible in the way that conventional brushes are – you can't twist them in your hand and splay the brush hairs to vary their effect in the way that you can with a real sable (or nylon) brush. As a result a degree of repetitiveness may creep into your brushstrokes if there's anything in the brush's design that is too regular or well-defined. For instance, if you use a brush with an image that has 'stray hairs' that are too obvious you'll notice that these hairs are always in the same position relative to the rest of the brushstroke.

This is one of the reasons why Elements' brushes work much better with a graphics

tablet than with a mouse, because the variation of thickness and opacity of stroke that's achievable with the tablet mitigates greatly the mechanical properties of the brushes (although, as you can see in Figure 6-50, a mouse can produce quite naturalistic results when you're using a suitable brush tip).

Figure 6-50
A few strokes with the brush in Figure 6-49, done with a mouse. Variation was achieved by painting with the brush at less than 100% opacity to let the lower strokes show through those laid on top

Customizing Your Brush Sets

In the next few sections I'll explain how to add brushes to, and remove brushes from, a brush set. While you're experimenting with this you may find yourself worrying about the fact that you seem to be producing a totally chaotic brush set containing random new brushes and with some of the original brushes discarded.

Fear not. None of the alterations that you make will be saved unless you make the very conscious and deliberate effort of saving the altered set of brushes as a new set. As long as you don't do this the set that you're using will revert back to its original form the next time you change sets. Phew!

Saving New Brushes

When you modify the characteristics of a brush by changing its properties in the Additional Brush Options panel the modified brush is only held temporarily and the modifications will vanish as soon as you change to a different brush – unless you specifically and deliberately save the modified brush as a new brush in one of the sets of brushes.

(The exception to this is if you click the check box at the bottom of the Additional Brush Options panel, labelled Keep These Settings For All Brushes, in which case all of the brushes will have the new settings applied to them automatically. They'll revert to their previous settings when the check is removed.)

Similarly, if you want to make a brush react to a graphics tablet's options automatically, rather than by having to go to the Tablet Options panel to activate them, you need to specifically place a version of the brush that has the tablet's chosen options activated into a brush set.

Here's how to save a new brush in a set.

While using a customized brush that you want to keep, click the Brush Sample box in the options bar (containing the curved brushstroke), to reveal the Brush panel.

Using the pop-up list at the top of the panel, go to the set of brushes in which you want to place you new brush. (There are a number of sets that you can't add new brushes to. These include the Default set, because it's hard-wired into the programme, and for some reason the top two sets in the rest of the list – the Assorted Brushes set and the Basic Brushes set. If you want to add brushes to these sets you need to duplicate the whole set and save it again.)

Click the double arrowhead near the top right corner of the panel. The panel pop-up menu will appear.

Select Save Brush, the command at the very top of the pop-up menu (*not* Save Brushes, the command at the very bottom, introduced soon). This will open a dialogue box, into which you can type a name for your new brush (otherwise it will have the default name that appears in the box). Your new brush is added to the end of the selection of brushes in the set that you're in.

Saving a New Set of Brushes

There are times when, rather than adding a new brush to a pre-existing set, you'll want to create a totally new set. This may happen if you want to deposit copies of your favourite brushes into one convenient set so that you don't have to go searching around for them in separate sets or if you want to create a whole batch of new brushes to your own specifications.

It isn't possible to create a new set of brushes from scratch by creating a new empty set and then filling it with brushes. You have to save a copy of a pre-existing set by making a duplicate with a different name, and then you have to remove unwanted brushes from it (described in a moment).

To create your new set open a suitable set of brushes to duplicate. Ideally this should be a set that contains a few brushes that you want to have copies of in your new set.

Open the pop-up menu via the double arrowhead at the top right of the Brush panel. Select Save Brushes at the bottom of the list (*not* Save Brush at the top, as used in the previous section).

A panel then opens which shows a list of any sets of brushes that you've created. The list doesn't show any of the original sets that are preinstalled in Elements. If you have previously created any new sets you'll notice that all of their names in the folder are followed by the suffix abr. This shows that the files are special ones that store sets of brushes.

Before you save your new set type a name for the set into the box provided. By default

a name of Untitled Brushes will be displayed in the box. There's no need to type the suffix .abr, as this is added automatically when the set is saved.

Then press Save.

If you give the new set the same name as a set that you've already created, a panel will open asking you if you want to replace the previous set that had that name. If however you give the new set the same name as any of the *preinstalled* sets *both* sets will be retained, so you'll have two sets with the same name. The new set will appear further down the list (The preinstalled sets are in alphabetical order at the top of the list, followed by any new sets in alphabetical order themselves).

Any new set that you create won't appear in the pop-up list of available sets in the Brush panel until you quit Elements and restart it again.

Because of the fact that Elements' own preinstalled sets appear above any sets that you create yourself (and thus demote your own sets to the bottom of the pile), and because the preinstalled sets don't appear in the preset manager list, there's a case for copying all of the preinstalled sets (with their original names or with new names) and then removing the original sets. The new copies (Figure 6-51) will then have the same status as your own, self-created sets – which will mean that they'll appear in the preset manager and that you can do things like place your own sets above them alphabetically (After all, Assorted Brushes and Basic Brushes aren't important enough to occupy the top spot in the menu list, are they?) You can influence the order in which sets appear in the list by adding blank spaces befor the first letter of a set's name.

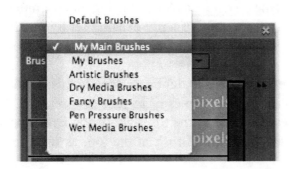

Figure 6-51
The Brush Presets list as it might appear once the original presets have been removed and replaced with your own selection of presets.
The top entries in the list have got spaces preceeding their names so that they jump the alphabetical queue.
This is the Mac version

Here's how to remove the original preinstalled presets from the list.

You can't remove them from within Elements itself – what you have to do is go to the folder on your computer that holds the actual preset files, and then move the files to another location so that they are out of the way. In the Applications folder on your computer go to

the Elements 8 folder, in which you'll find a folder labelled Presets. In that folder go to the folder labelled Brushes (which contains all of the original presets, apart from the Default set which is a special case). Drag the folder anywhere convenient on your computer, as long as it's no longer in the Presets folder (If you want to find it later, but you've forgotten where you've put it, simply do a search for 'brushes'). Then quit and relaunch Elements, when you'll find that the original presets are no longer in the preset list.

Removing Unwanted Brushes From Sets

Among the vast number of brushes available to you in Elements there are almost bound to be ones that you never use (such as the rubber duck brush). To prevent these brushes from cluttering up your brush list and making it hard to find the brushes that you actually need you can remove them, thus creating slimmed down brush sets. You can save the slimmed down sets with new names (perhaps by putting the word 'My' in front of them, such as 'My Pen Pressure Brushes').

Here's how to create a slimmed down set.

First open the set that you want to alter. Consider whether or not you want to create a new set based on the set before you start removing brushes.

To remove a brush from the set, select the brush you want to remove.

Open the panel submenu via the double arrowhead at the top right of the panel and select Delete Brush.

Alternatively, and more easily, you can also delete brushes using a keyboard shortcut. Press and hold down the Option key (Mac) or Alt key (Windows). The cursor turns into a pair of scissors to indicate that you've pressed the correct key. Then just click on the brush that the scissors are hovering over.

Repeat this for each unwanted brush.

Rearranging the Brushes on the Panel

The arrangement of the brushes in the Brush panel can be altered so that the most frequently used brushes are at the top of the panel, making them much more convenient to find (In some of the original sets the brushes are simply arranged in alphabetical order, regardless of the usefulness of the brushes).

With the appropriate set open in the panel, go to the panel pop-up menu via the arrowhead at the top right of the panel.

Go to Preset Manager.

The Preset Manager's dialogue box that opens will be displaying the contents of the set of brushes that is open in the panel. If you want to change the way that the brushes are displayed (thumbnails or lists), go to the More pop-up menu near the top of the dialogue box.

To change the order of the brushes, simply press on the appropriate brush in the panel and drag it to a new position. The brushes in the region where you release the cursor will move apart to accommodate it.

When you've finished press Done.

When you go back to the main brushes panel you'll find that the brushes have changed positions to reflect the alterations that you've made.

When you next change brush sets you will be prompted to save the set with the brushes in their new positions. If you've rearranged an original preinstalled set you have to save the set as a new set. It's a good idea to give the set its original name but prefixed with the word 'My'. If you've rearranged one of your own sets you'll be prompted to replace the earlier version. In this case click on the name of the set from the list of sets that appears in the dialogue box.

Finally, relaunch Elements so that the new versions of the sets are loaded.

Merging Two Sets of Brushes Together as One Set

It's possible to join several sets of brushes together in order to make a single set.

You may want to do this once you've slimmed down your sets so that you have sets that only hold the brushes that you use, and you want to rationalize things further by joining several sets together as one.

To do this, first open one of the sets that you want to merge, then go to the Preset Manager (via the double arrowhead near the top of the Brush panel).

In the Preset Manager's panel click the word Load.

This opens a panel containing a list of any sets of brushes that you've created previously (followed by the suffix .abr). The list doesn't include any original preinstalled sets – in order to make these sets appear in the list you need to resave them as duplicates.

Click on the set that you want to merge with the open set. In the confirmation panel that opens confirm that this is the set that you want to add to the other one by pressing the word Load.

Then press Done in the Preset Manager panel.

The brushes from the second set are added to the first (while leaving its original version unaffected in the list of sets).

If you want to keep the extended set with its extra brushes as a new set go to Save

Brushes in the pop up menu, otherwise the set will revert to its original version when you change sets again. As always with saving sets, once you've saved the set it isn't loaded into the list in the Brush panel until you restart Elements.

Delete Brush Sets

After you've been experimenting with Brush sets for a while you'll probably find that you've created a few new sets of brushes that you can do without and that are no good for anything but causing confusion in your list of sets. A cull may be called for.

Here's how to delete superfluous sets from your collection.

If you're using Windows, open the Brush panel and then open the pop-up menu via the double arrowhead. It doesn't matter which set of brushes is open. Click on Load near the bottom of the menu, which will open a list of sets that you've created (This panel has opened with the expectation that you're going to add, or load, a set from the list to the open set, however the reason that you've actually opened it is purely to give you access to the list). In the list, right click on the set that you want to delete. In the pop-up menu that appears click Delete.

On a Mac the process is more longwinded for some reason. Open the Brush panel and then open the pop-up menu via the double arrowhead. It doesn't matter which set of brushes is open. Click on Load near the bottom of the menu, which will open a list of sets that you've created. Unfortunately, on a Mac you can't simply select a set from the list and delete it as you can in Windows. You have to find the actual file containing the brushes and delete that. Here's how to do it. Click on the field that's displaying the word Brushes, near the top of the panel. This field shows the folder that you're looking inside, and when you click on it a list appears showing the folder that that folder is in, and which that folder is in and so on – the nesting order of the folders. So you'll see that the Brushes folder is inside a folder named Presets for instance. This particular Presets folder isn't the one that was referred to previously, containg the preinstalled brush sets – this one contains only your own self-created sets. Make a note of the order of the folders up to a point where you recognise a folder that you'll be able to find easily. Once you've made this note you've finished with the Load panel, so you can close it by clicking Cancel. Now navigate to the Brushes folder by using the notes that you made of the nesting order of the folders. In the folder are separate files for each Brush set that you've created. Select the one that you want to delete and drag it to the trash. Phew!

That's it for manipulating the brush sets, you'll be pleased to hear. Personally I feel that the whole process could be streamlined somewhat, but there you are.

Using Blend Modes

When you click on the box labelled Modes in the Brush options bar a long list of strange names appears. Names such as Color Burn, Linear Burn and Hard Light. These are called Blend Modes.

Blend Modes are different ways in which the colours of the brushstrokes you're producing can be made to interact with the other colours on other layers of your image.

It sounds confusing, and by and large it is.

Fortunately Blend Modes can be applied to your work independently of the Brush, after you've finished laying down your colours, which is definitely the easier way to use them.

So I'm going to by-pass Blend Modes for now. However, you can learn all about them on page 463 in Chapter 16.

Erasers

Figure 6-52
If your artwork goes
wrong, you can use the
Eraser to correct it

In the process of creating an image you're bound to want to remove colour as well as apply it.

To do this, Elements includes the digital equivalent to a conventional eraser – but of course, being digital, it has a few tricks up its sleeve.

(The pens that come with graphics tablets often have their own erasers at the top end, which can be used by reversing the pen. In practice you may find that you rarely use this feature, as Elements' own built-in Eraser is more convenient and useful.)

The Eraser

 Figure 6-53 The Eraser

You can open the Eraser by clicking its icon in the Tools panel (Figure 6-53).

The Eraser shares its space in the Tools panel with two specialized erasers, described soon. If the Eraser icon has a small pair of scissors or a star next to it, it means that one of these specialized erasers is the one that will be selected. To choose the normal Eraser, press and hold on the icon that's displayed to reveal the icons for the other erasers.

The most convenient way to open the Eraser is to use its keyboard shortcut, rather than its Tools panel button, which you do by simply pressing the letter E. This shortcut allows you to change from the Brush (or any other tool) to the Eraser instantaneously without any tiresome scuttling back and forth to the Tools panel. (Make sure that in the Preferences panel 'Use Shift Key for Tool Switch' is checked, as otherwise the Eraser will switch between the specialized erasers if you accidentally press the Shift key while the Eraser is already selected.)

The Eraser works just like the Brush except that it removes colour rather than adding it. In fact in some ways it's easier to think of the Eraser more as a form of negative Brush than as a positive block of rubber. The Eraser's tip uses the same shapes of tip as the brushes – which are chosen by opening the same type of panel that you pick brushes from – and you can change the Eraser's size in the same way that you change the brush's size – either via the Size panel in the options bar or by clicking the square brackets keys (which is the more convenient method).

You can give the eraser a light touch so that it doesn't erase all of the colour that you pass it over in a single pass (similar to rubbing softly with a conventional eraser). Do this by setting the opacity in the options bar below 100 percent. Strokes of the eraser will then make the colour that's being erased fade slightly. Repeated strokes will make it fade more with every pass.(It's a good idea to return the opacity setting to 100 percent after using the Eraser in this way, unless you specifically want to leave it at a low setting, as otherwise you may wonder why the Eraser isn't rubbing images out very efficiently next time you use it.)

The Eraser can be used with either a soft edge or a very hard edge, by selecting its mode in the options bar.

If you want to give the Eraser a soft edge, set the Mode to Brush (the default), while for a hard edge set it to Pencil.

The Brush mode is generally the more useful, except when you're working on completely hard-edged images (such as those created with the Pencil itself, as described in the next chapter).

As well as having a Brush and a Pencil mode, the Eraser also has a mode called Block. This is the least useful of the Eraser's modes, as it uses a very crude and square eraser that can't be adjusted in any way. In fact I'm not sure why it's there at all – maybe it's a fossilised relic from prehistoric versions of Photoshop. You can't change its size, you can't modify its softness, and you can't alter its opacity. When you select it in the options bar, all of the controls in the bar go blank – you can't adjust anything.

If you erase work from the background layer the Eraser will reveal the colour that's in the background colour swatch (the lower of the two squares at the bottom of the Tools panel). If you've changed this colour at all, so that it's a different colour to the background layer, this gives the disconcerting effect of seeming to apply paint with the Eraser.

The Background Eraser and the Magic Eraser

Sharing the same space in the Tools panel as the normal Eraser are two specialized erasers: the Background Eraser and the Magic Eraser. Press and hold the cursor over the Eraser icon to reveal the pop-up menu that contains them.

Both erasers are essentially shortcut methods of achieving results that can be equally or better obtained using other, very slightly more lengthy techniques, so they're not really essential tools, although the Background Eraser works in a very interesting way, and is very convenient when you're in a hurry.

In their own different ways both erasers work by being selective about which colours they erase.

These erasers will be better understood if you've read about the Quick Selection tool (page 225) or the Magic Wand (page 241), which can automatically select different areas of colour in an image so that only those selected colours are affected by an operation.

Erase up to the Edge of an Object and Leave the Object Untouched – the Background Eraser

Figure 6-54 To isolate this Chinese junk from its background I passed the Background Eraser round the edge of the junk, overlapping onto the junk itself. The Eraser automatically ignored the colours of the junk and erased only the colours around it. This made it much easier to then remove the rest of the background separately (final image)

With this photo of a Chinese junk (Figure 6-54) I wanted to isolate the junk from the background quickly.

I could do this using the normal Eraser or some of the selection techniques described later in Chapter 9, but it'd take a little while, especially because I'd have to be careful to avoid losing the narrow lines of the boat's rigging.

This is where the Background Eraser comes in useful.

It's called the Background Eraser because its most obvious use is to remove backgrounds from around objects – such as in my photo of a junk. The term background here has nothing to do with Elements' usual uses of the word, as in background layer and background colour – this time it literally means the background detail on a photograph.

Because it's useful for isolating objects in images, the icon for the Eraser includes a pair of scissors, as if to show that it's cutting the object from the rest of the image.

Here's how it works.

When you use the Background Eraser the cursor takes on the form of a circle with a cross in the middle (Figure 6-55, left).

Figure 6-55
Far left: the cursor for the Background Eraser
Left: A magnified view of the cursor in action, erasing only colours that are similar to the colour under the central cross

The circle shows the size of the area over which the Eraser will erase. Within that circle however, the Eraser will only erase any colour that is similar to the colour that is directly beneath the cross at its centre.

In the close-up of the Chinese junk in Figure 6-55 you can see the position of the cursor on the water. Most of the water within the circle has been erased, because it's the same colour as the colour directly beneath the cross, but you can see that the junk, the small boat and the rope between the two have been left untouched, because they are a different colour. Preserving detail like the rope is one of the tool's strong points.

Be careful though. If you move the cross at the centre of the circle onto the object that you're erasing round, such as the junk here, the object will start to be erased instead of the background. It's whatever colour is under the cross at the time that gets erased, as the computer itself doesn't 'know' what's background and what isn't.

This last point may sound annoying, but it's actually a major strength of the tool. It means that you can erase backgrounds that vary in colour quite effectively, as the colour that's selected to be erased can be changed instantaneously, just by moving the cross onto a new colour. For instance, in my image of the junk, by moving the Eraser down the side of the junk's sail the sky was erased while the cross was on the sky, but as soon as the cross reached the land it started erasing the land instead. So the different colours in the background are all erased in one smooth operation, as the cross in the cursor moves from sky to land and then to water, erasing the colours of each in turn. Meanwhile the junk stays totally unaffected, because the cross never rests on the particular colours of the junk itself.

Moving the Background Eraser round the junk took maybe half a minute. Using other methods of isolating the boat, with its rigging and other ropes still intact would have taken much longer.

The Background Eraser has several options to help fine-tune its performance.

Tolerance: This sets how similar to the colour under the cross the colours have to be for them to be erased. Zero percent only erases exactly the same colour, while 100 percent would erase everything.

Contiguous: Contiguous means that the only colours to be erased are those that are actually touching the colour that's under the cross at the centre of the circle. Discontiguous means that similar colours anywhere in the circle will be erased – touching or not.

Because the Background Eraser is selective about which colours to erase it's almost bound to leave a few stray colours behind in the areas that you're erasing, and it may also remove a few colours from the areas that it's supposed to ignore. As a result you may have to tidy up your image after using the eraser. For accurate work, or on the wrong sort of image, this can make the tool less convenient than other methods of isolating an area, although it's very effective when speed rather than accuracy is an issue.

Erasing Similar Colours with One Click - the Magic Eraser

You can find the Magic Eraser in the same compartment of the Tool panel as the standard Eraser. Press the cursor on the current eraser to reveal the other erasers.

When you click the Magic Eraser on an area of colour, that whole area of colour will be erased from a layer instantly.

This sounds very convenient, but the tool's ability to decide where one colour ends and the next one starts leaves something to be desired.

Exactly the same job can be done using the Magic Wand (which is used to select areas of colour automatically, and is dealt with in detail on page 241 in Chapter 9), with the addition of only one keystroke (pressing the Delete key).

So it's an unnecessary tool, and it's just one more thing to remember in a programme that's got plenty to remember already. I'd forget it if I were you, at least until you're familiar with everything else.

The Magic Eraser's relationship to the Magic Wand is indicated by its name, and by the starburst-like object in its icon, which represents the twinkly magic end of the Magic Wand.

If you do decide to use the Magic Eraser here are a few points about it.

In the Options bar the Tolerence setting dictates how similar colours have to be in order for them to be selected for erasing – the higher the tolerence the more colours are selected. The Anti-alias checkbox lets you choose whether or not the edge of the area that's erased is sharp or slightly diffuse (or anti-aliased). Ticking the Contiguous check box will make the Magic Eraser only erase colours that are touching, while with the box unticked all similar colours anywhere on the layer will be erased. Ticking the Sample All Layers check box allows you to choose the colour to be erased based on the colours on any layer, not only the active layer – although the selected colour will only be erased from the active layer. The Opacity setting allows you to erase a colour to a percentage of the original opacity.

Brushes and Erasers

Working in Black and White for Print

7

When creating pure black and white artwork that's destined to be printed (rather than being used solely on-screen), images can be produced with much more detail than is possible with images that contain colour or shades of gray. This is all because of technical aspects of the printing process, descibed later.

This chapter describes some techniques that can be used specifically to produce highly detailed pure black and white artwork.

These techniques aren't essential – indeed you can produce perfectly acceptable black and white artwork by ignoring this chapter altogether and by simply using the standard methods that you'd employ for other work. However, the increased quality obtained using the methods outlined here makes reading this chapter well worth the effort.

Remember that these techniques are specifically for creating images for printing, and can be totally ignored for screen-only work, where the amount of detail obtainable by these methods is totally unnecessary.

In this chapter:
The difference between line art and continuous tone art
Using the Pencil on high resolution images
Transforming line art
Adding text to line art
Creating Pencil tips specially for line art

The Definition of Line Art

Because work that contains only pure black and white, without any shades of gray, is usually made up of black lines, it's often referred to simply as line art. Images that include colours or shades of gray are known as continuous tone images (Figure 7-1).

Figure 7-1
The difference between
pure black and white line art
and continuous tone art

The techniques described in this chapter produce extremely high definition images compared to the results obtainable using the techniques for producing standard artwork. You can see the difference illustrated in Figure 7-2.

Figure 7-2

Top:
A line art image produced using the high definition techniques described in this chapter.
The detail obtainable can be seen in the magnified view of the hair.

Bottom:
An image almost identical to the one above, produced using the standard techniques described in the rest of the book. Although this image is perfectly adequate for most uses, the magnified section shows the relatively low quality compared with the top figure

The techniques described in this chapter are specifically for creating line art *for print* – if you want to produce line art solely for on-screen use these techniques don't apply. This is because the quality obtained using these techniques is unnecessarily high for screen-only images (Figure 7-3). For such screen-only work you can create your artwork using the same methods that you'd use for other types of artwork.

Figure 7-3
A screen-only image, such as one for a web page, magnified to show the low quality of the image, making the high definition technique described in this chapter totally unnecessary

If your work is intended for *both* print and on-screen use you should perhaps create the work at printing quality as explained in this chapter, and then make a copy of the image and resize it so that it's suitable for the screen (by resampling, page 122).

If you scan work in to use as line art rather than creating the work from scratch on the computer make sure that you also read the section on Scanning Black and White Line Art and Pencil Drawings in Chapter 17, page 489.

Creating Very High Definition Pencil Lines

To produce high quality line art for printing it's best to use the Pencil tool (Figure 7-4), which works in very much the same way as the Brush tool except that it produces absolutely hard-edged strokes instead of soft-edged ones.

The Pencil shares the same space in the Tools panel as the Brush. To open it using its keyboard shortcut press N.

Figure 7-4
The Pencil tool

Images produced using the Pencil are best created at a different resolution to those produced using other methods. While the standard resolution that's recommended for most artwork is 300ppi the recommended resolution for Pencil work is a whopping 1,200ppi.

To understand the reason for this it's useful to know a little about the subject of resolution, or the size of the pixels in a printed image, explained in more depth in Chapter 5.

To understand the reason for this it's useful to know a little about the subject of resolution, or the size of the pixels in a printed image, explained in more depth in Chapter 5.

At the standard recommended resolution of 300ppi the pixels in a printed image are normally too small to see with the naked eye, which is how it should be, but when the pixels produce a very high contrast sharp edge as they do with the Pencil the edge is so well defined that the pixels may become visible, producing a jagged effect (Figure 7-5). To avoid this jagged edge the solution is to produce pencil lines with much smaller pixels than usual, at a resolution above 1,000ppi (with the standard recommendation being 1,200ppi).

Having said that, you can get away with printing pencil images that were created at 300ppi (which I do accidentally more times than I care to admit), especially when the printing isn't of the highest quality (because with low quality printing the ink tends to spread and blur the jagged edges anyway). However, if you do create images this way, there isn't much tolerance for enlarging the image should you need to print it larger or at higher quality at some time in the future.

Figure 7-5
Enlargements of images drawn at 300ppi (left) & 1200ppi (right). Notice the more obvious stepping of the pixels in the 300ppi image

When you're working on a line art image you should set the mode to Grayscale, which is the recommended mode for images that contain only black, white and shades of gray. Do this either in the New File dialogue box when you first create the file, or convert your work later in the menu bar at Image>Mode. There is a special mode in Elements, called Bitmap, which only uses pure black and white in its images. You may think that this sounds like the mode that you should use, however this mode is very limited in what it will allow you to do in the way of image manipulation, so it should be avoided while you're producing your work (although in certain circumstances you may want to convert an image to this mode once it's finished, such as in order to place it into a page layout in which it's going to be printed at high resolution – the printer will only know it's high res if it's in bitmap mode).

Working in Black and White

If you're interested in the technical aspects of creating and printing line art images using the method described in this chapter, here's some background information.

If you've read the chapter that deals with resolution, and you were paying particular attention, you may remember that I said that 300ppi was the recommended maximum resolution for creating images because printers can't print more detail than there is in a 300ppi image. So how come the Pencil tool can be used at 1,200ppi?

The reason is to do with the way that printers produce their images. There's a more detailed explanation of how printers work in Chapter 18, but here's a basic explanation of the relevant points.

When an image that contains colours or areas of gray is printed, the image is usually broken down into dots (Figure 7-6). This is so that the image can be printed using the very limited number of colours available to the printer (typically four, although your desktop printer may use a few more in order to enhance the colours in the print). For instance, to produce shades of gray, printers print small black dots of varying sizes, which against the white of the paper give the illusion of gray. When an image is broken down into these dots for printing, some of the detail in the image inevitably disappears – look at a photo in a newspaper to see the effect. It's pointless putting more detail into an image than the printing process can reproduce, and to accommodate the maximum amount of detail that's printable a resolution of 300ppi is generally more than enough.

Figure 7-6
Left: A continuous tone image is broken down into small dots in order to reproduce the tones or colours.
Right: A close-up view of the dots

Images that are created using pure black lines are different however.

All printers use black ink, so as a result they can reproduce black line art directly, without it having to be broken down into dots at all. This means that there's no loss of quality, so the amount of detail in a pure line art image can potentially be much higher than that in an image containing colour or shades of gray.

In the chapter that deals with resolution, Chapter 5, I mentioned that the higher the resolution of an image the more memory the image consumes. So you may think that an image with a resolution of 1,200ppi would use a gargantuan amount of memory compared to one at the standard 300ppi.

In the case of black and white line art this isn't so. This is because the image is only composed of two colours, black and white, with no grays or other colours in it to complicate things, so your computer has relatively little to remember. The file size may seem large when the image is open on your screen (as shown at the bottom of the image window), but when you close the file it's automatically compressed, or simplified, for storage purposes. The closed file will be smaller than that of a colour image that has the same dimensions and a resolution of 300ppi.

Using the Transform Command on Line Art

In the step-by-step introduction in Chapter 2 I explained how you can change the size or shape of parts of your image using the Transform command (explained at greater length in Chapter 13). When you use this technique on a line art image there's a small consideration you have to take into account.

Figure 7-7
The head of the figure on the right has been rotated using the Transform command.
See the effect on the detail below in Figure 7-8

In Figure 7-7 I've used the Transform command to rotate part of a piece of line art. Now look at the *hugely* magnified view of the pupil of the man's left eye (Figure 7-8). You can see an unwanted consequence of the transformation – when the lines have been transformed their crisp black edges have acquired a gray fringe.

Figure 7-8
These seemingly meaningless blobs are ridiculously magnified views of the pupil of the left eye in each of the images above

Here's the cause of this fringe.

Figure 7-9 How gray fringes are produced when black and white images are transformed.

Refer to Figure 7-9 for this explanation.

Left: This diagram represents a close-up of part of an image, showing some black pixels and some white pixels. The grid that I've superimposed shows the layout of the pixels in the image.

Centre: When an image is transformed the colours are shifted. The underlying pixel grid however remains static, as the grid is the 'physical' structure of the image. Notice how the altered image doesn't align exactly with the underlying pixel grid.

Right: Each pixel in the image can only be *one* colour, therefore when black and white areas of a transformed image overlap on an individual pixel on the underlying pixel grid the tones are averaged out, producing grays. The exact shade of gray of a pixel is dependant on the proportion of black and white that it has to represent.

As a result of these gray fringes you lose the pure black and white of your original image. The gray fringes on the lines make the lines lose their sharp, crisp quality, making them look as though they were created with the Brush instead. It seems that you may as well have used the Brush in the first place.

But it's a simple matter to get the sharp edges back.

You do this by using the Threshold command. This converts the image to pure black and white, which it does by turning dark grays into black and light grays into white (The threshold in the command's name is the value of gray that marks the boundary between grays that turn black and grays that turn white).

The easiest way to use the Theshold command is as follows.

Wait until you've finished your artwork before you use the command, rather than removing all stray shades of gray as you go along.

Then you need to place your artwork on an opaque white layer, if it isn't on one already. You have to do this because the Threshold command doesn't affect the gray fringes when they're on transparent layers (The reason is explained in the following box if you're interested).

> The reason you have to place your artwork onto an opaque white layer before applying the Threshold command is because the command 'sees' the gray fringes on transparent layers as being composed of semitransparent black rather than actual gray. As a result the command interprets them as already being black and leaves them as they are. For the command to work, the grays have to be the result of an opaque mixture of black and white rather than being 'diluted' black.

The simplest way to place the artwork onto an opaque white layer is by merging all of the layers of the image so that they're placed on the background layer. This process is called flattening, and to do it you go to the menu bar, to Layer>Flatten Image (If you're not sure whether or not you've actually finished your work, make a copy of the file before you flatten it, so that you can work on the unflattened version later).

Once your artwork is on an opaque white layer you can apply the Threshold command by going to the menu bar, to Filter>Adjustments>Threshold. A dialogue box will open. You can usually simply leave this box in its default setting, and press OK in order to apply the Threshold command.

Adding Text to Line Art Images

When you add text to most types of image using the Type tool (covered in detail in Chapter 15), it's best if the letters have slightly soft edges (Figure 7-10, left). This soft-edged effect, called anti-aliasing, is important at normal image resolutions as it stops the lettering looking jagged and crude. In high resolution, pure black and white artwork this soft edge is unwanted, as it adds gray to the image. What you want is aliased text.

Anti-aliased type Aliased type

Figure 7-10 Left: Normal text in Elements, greatly magnified to show the soft edges produced by anti-aliasing. Right: Hard-edged text, produced by turning off the anti-alias option

To apply text without a soft, anti-aliased edge click the Anti-alias button in the Type tool's options bar (Figure 7-11).

 Figure 7-11 The Anti-alias button in the Type tool's options bar, allowing you to choose between soft-edged and hard-edged letters

You can apply this option to the lettering at any time, not necessarily when you first enter the text – just select the layer containing the text and click the button.

It's usually best to return the button to its normal, anti-aliased mode straight after you've finished using it, as the setting remains active until altered, meaning that you may find yourself inadvertently typing with hard edged aliased type where you require soft-edged anti-aliased type.

Creating New Tips for the Pencil

Although you can use any brush tip from the Brush panel as a tip for the Pencil, the Pencil doesn't give you the option of altering the characteristics of the tip, such as the spacing or scatter, in the same way that the Brush does, as it doesn't have the More Brush Options panel in its options bar. It also lacks the Tablet Options panel that allows you to alter the way that the tip responds to the use of a graphics tablet.

This is possibly because in the general run of things most normal Elements users would only want to use the Pencil as a very simple instrument for producing straightforward lines that vary in no way other than perhaps their width (Figure 7-12). For such uses the basic tips from the top of the default brush set would be perfectly adequate. But due to the fact that you're reading at this very moment the chances are you're not a normal Elements user.

Figure 7-12
A standard pencil stroke varies only in its width (when used with a tablet)

Sometimes, for creative work, you may want to use a pencil that produces a more varied stroke, such as the one shown in Figure 7-13.

If you choose a tip from the more artistic parts of the Brush panel you'll find that many of these tips produce disappointing results when used with the Pencil, as their settings are optimized for creating effects with the slight fuzziness of the Brush tool. What's more,

because the Pencil lacks the More Brush Options and Tablet Options controls, it seems at first sight that you can't alter the tips to make them more appropriate for the Pencil.

Figure 7-13
It's possible to create new tips for the Pencil, despite the fact that the Pencil lacks options in its options bar

However this isn't the case. It's easy to create new settings for the pencils, exploiting the fact that the Pencil uses exactly the same set of 'brush' tips that the Brush uses, all accessible in the Brush panel.

To create a new pencil tip with different characteristics you have to change the characteristics of the tip when it's being used as a brush rather than as a pencil (See Chapter 6). This gives you access to the More Brush Options and Tablet Options panels.

Then you have to save the modified tip as a new tip in the Brush panel (see the section, Saving New Brushes, page 168, in Chapter 6).

It's a good idea to save any tips that you create for the pencil in a new brush set specially created for pencil tips, perhaps called 'Pencils'. This makes the tips easier to find when you need them.

You can then go back to the Pencil tool, from where you can access the new tip and use it as a pencil.

In Figure 7-13 I've changed the characteristics of a simple round brush tip from the top of the Default Brushes set by altering the Scatter setting – so that instead of producing a regular line it produces scattered dots.

When you're setting the More Brush Options and Tablet Options for brush tips that are going to be used for creating line art you shouldn't normally use the opacity, fade or color jitter options. These create shades of gray in the strokes, which line art doesn't use. For the same reason you shouldn't use the tips that normally produce variable gray strokes, such as some of those in the Pen Pressure set.

There are some techniques that are used in line art that cry out for the use of a specific type of brush tip rather than the standard round ones.

One such technique is stippling – the application of large quantities of small dots to create a tonal effect, such as the smoke in Figure 7-14.

Figure 7-14
The stippling effect
of this smoke was
created using a
brush that laid
down multiple dots
(see Figure 7-15)

There are brush tips available in Elements that can produce stipple-like and other effects when used with the Pencil, however these tips are all geared towards creating continuous tone images at resolutions such as 300ppi. When these brush tips are used on a high resolution, 1,200ppi line art image they have to be enlarged, which enlarges the component parts of the tips (usually dots or blobs), sometimes making the resulting strokes crude.

The remedy for this is to create new brush tips specifically for use with line art, such as the one shown in Figure 7-15. This tip produced the smoke in Figure 7-14.

See the previous chapter to find out how to create brush tips (page 162).

Create tips for use with the Pencil from images that are pure black and white, as you don't want to produce any shades of gray in a line art image.

Another hint – it's best to create your brush tips from images that are at or near the same resolution that you use to produce your line art images, otherwise they may be too small.

Figure 7-15
The brush tip that I created in order to
apply the stippled effect in Figure 7-14

Layers
8

Layers are one of the most important and blissfully easy to understand features of Photoshop Elements.

They act like the computer equivalent of stacked sheets of completely transparent tracing paper or plastic film. By placing different parts of your artwork on separate layers you can build up images out of independent components.

Just as with sheets of tracing paper, you can move layers around, add new ones, or throw them away. But of course, being digital, you can do much more as well.

In this Chapter:
Introducing layers
Manipulating layers, such as changing their opacity or their stacking order
The special case of the background layer

Introducing Layers

Figure 8-1
Layers are the computer
equivalent of sheets of
tracing paper or plastic film

When you create a new document in Elements an opaque surface is automatically created on which you can work – a surface that can be likened to the digital equivalent to a sheet of paper. This sheet is called the background layer. (It is actually possible for you to specifically create a document without this background layer if you want to, as explained overleaf on page 198.)

Above this background layer you can add new, transparent layers. These can be likened to the digital equivalent to sheets of completely transparent tracing paper or plastic film.

Layers are extremely easy to use. You can pile as many layers as you need on top of each other and then reshuffle them into any order you like. You can create different parts of an image on separate layers, which makes it easy for you to alter separate parts individually without interfering with the rest of the work. You can trace, improve and develop drawings from one layer onto another. You can duplicate layers so that you can experiment with one copy while keeping another one safely untouched. You can try out an effect on a layer and if it doesn't work you can throw the layer away. The list is almost endless.

And the number of layers you can have in a single document is almost endless too, being in the thousands. The memory capacity of your computer will probably make this theoretical upper limit unreachable, as your computer will slow down as you create more and more layers. The memory capacity of your brain may be a limiting factor too. Fortunately, you can reduce the number of layers by merging the contents of several layers onto one single layer in order to keep things manageable.

Layers

Introducing the Layers Panel

The layers in your document are all stacked on top of each other in a neat pile.

In the world of conventional media, where the layers would be real sheets of transparent film or tracing paper, to select one of the layers from such a stack you'd have to flick through the actual sheets in order to find the one that you wanted to work on. You obviously can't do that on your computer, so instead you go to a panel that displays a list of the layers and you select the layer that you want from that list.

This list is called the Layers panel (Figure 8-2).

Figure 8-2 The image (left) is composed of layers, displayed in the Layers panel (right)

In the panel the layers are displayed in the order in which they are stacked on your work surface, with the background layer at the bottom and the uppermost layer at the top.. To work on a specific layer, all you need to do is click on the layer's position in the panel.

When you first open Elements the Layers panel can be found in the Panel Bin, down the right hand side of your screen, however you can remove the panel from the bin and allow it to float freely anywhere on the screen, which is what I'd recommend (See page 31).

The various icons and boxes in the Layers panel control the state of the layers.

The box next to a layer's name is a small thumbnail version of the image that's on that particular layer. In the default setting, the thumbnail for each layer in the panel will have a checkered pattern inside it showing areas of the layer that are transparent. Notice that the background layer doesn't have this checkered effect – this is because the background layer

is always opaque, like a sheet of paper. I like to think of the checkered effect as being like a checkered tablecloth on my work surface that can be seen through the transparent parts of the layers (as in my illustration in Figure 8-1).

If you find the checkered effect distracting you can remove it by going to Preferences>Transparency>Grid Size>None (In Windows, Preferences is in the File menu, while on a Mac it's in the Adode Photoshop Elements menu). You can also change the size or colour of the checks in the same panel. The checks do have their uses, as I'll explain later, so don't be too hasty in getting rid of them.

Best Drawing Practice Concerning the Background Layer

When you create a brand new blank document in Elements it will only have one layer. In the default setting this layer is opaque and white, not unlike a blank sheet of paper.

You don't have to start with a blank white sheet however. There are several other options to choose from. Before you start worrying about which of these options may be best for your purposes, it's worth bearing in mind that once you've opened a file in any of these formats it can very easily be altered to make it like any of the others. Generally the default blank white sheet is the most useful option, so I'd recommend plumping for that one.

Chose your option in the Background Contents section of the New File dialogue box.

Here are the different types of layer that you can choose from.

White: The default option mentioned above. It produces an opaque white layer, like a sheet of paper. This is normally the best option to choose.

Background Color: This produces a layer of opaque colour, like a sheet of coloured paper. The colour is the one that's in the background swatch square (the lower of the two squares at the bottom of the Tools panel – see page 285).

Transparent: This produces a layer that's totally transparent, like a sheet of clear plastic.

If you choose one of the opaque versions of the layer – either the white or the coloured versions – the layer is called the background layer. If you choose the transparent version there is no background layer at all – just an ordinary layer.

The background layer is best described as being like a sheet of paper that's firmly taped to a drawing board. All of the other layers that you add to the document as you work on an image are like loose sheets of transparent film placed on top of it.

I find that it's normally best not actually to create artwork directly on the background layer itself, but to treat the layer as a sort of backing sheet for the work that's all done on

transparent layers above it. This is because work done on the background layer is harder to manipulate afterwards, mainly because of the fact that the layer's opaque. This will all be made more evident as you read this chapter.

If you choose the Transparent option for the original layer, you dispense with the background layer and create a standard transparent layer as your initial layer instead. This layer has none of the unique and slightly limiting properties of the background layer – it's not opaque and it's not taped down to the work surface. It's simply an ordinary transparent layer, like all of the other ones that you create while producing your artwork. Although this sounds like a nice simple option to choose, it has a few drawbacks. Chief amongst these is that due to the transparency of the layer that's created you can see the underlying checkered effect through it, which is quite distracting. You can remove this effect in the Preferences panel if you want, but the checkered effect is actually quite useful for some purposes, so it's generally best to keep it but to have it hidden behind an opaque layer – such as the default white background layer.

When you open files such as images from digital cameras or scanned images, the image will automatically be on the background layer. It's very simple to remove such images from the background layer in order to work on them more easily if you need to (see page 214).

For the rest of this section I'll assume that you're using the recommended choice of a white background layer.

You can rearrange the order of any transparent layers that you add to your document, just like shuffling sheets of tracing paper. However, the opaque background layer itself is 'taped down' to the work surface, so you can't shuffle it or put any of the other layers behind it. It is however possible to 'untape' the background layer from the base, effectively turning it into an ordinary layer so that you can move it around.

As you can probably tell, the background layer is a bit of a special case (and quite why it exists I'm not sure – perhaps it's something left over from earlier and less efficient versions of Photoshop). Rather than confusing things by mentioning any more about this slightly odd layer now, I'll leave it for a special section of its own later in the chapter (page 214) – that way you can concentrate on how to work with the other layers on which you create all of your work, while leaving the background layer well alone. As I mentioned earlier, it's generally best not to create work directly on the background layer anyway.

Changing the Size of the Layers Panel

As you create more layers, described in a moment, the list of layers in the Layers panel gets longer and longer, and will eventually disappear out of the bottom of the panel so that you can't see the lower ones without scrolling down the list. Similarly, as you remove layers, the panel can be left unnecessarily long, with empty space below the list taking up more of your valuable screen space than is convenient.

To change the length of the panel so that it's a sensible length for your list of layers press on the knurled triangle in the bottom right corner of the panel and drag down to make the panel longer, or up to make it shorter.

To collapse the panel so that it's still on the screen but is taking up the minimum amount of space click either of the dark gray bars that run along the top of the panel. The top darker bar makes the collapsed panel slightly smaller than the lower lighter bar. To expand the panel click the bar again.

Adding New Layers

With almost every piece of work that you do in Elements you'll want to add layers onto which you can place different parts of your artwork. Here's how to do it.

To create a new layer click the New Layer icon (Figure 8-3) in the row at the bottom of the Layers panel – it looks like a sheet of paper with the corner turned over revealing a sheet beneath it (This symbolises one sheet of paper above another – a clue to the icon's function). New layers will automatically be given the name Layer 1, Layer 2 etc.

 Figure 8-3 The New Layer button

New layers are automatically placed directly above the layer that's active at the time. To automatically position a layer *below* the active layer instead, hold the Control key (in Windows) or the Command key (on a Mac) while you click the New Layer icon. If you forget which key to press, it's easy to move the layer later, as described in the section Changing the Order of Layers (page 202).

Naming (and Renaming) Layers

Elements automatically names new layers by number: Layer 1, Layer 2, and so on. This is very logical but also very impersonal, and it doesn't help in indicating what's on each layer. It's a simple matter to change these names to something more appropriate. Normally

you'd probably want to give your layers practical names that give you a clue as to what's on the layers: names such as Line Art, Rough Sketch, Cat, Dog, Tree, Stegosaurus or whatever.

You're not permanently committed to the names that you choose for your layers. You can change them at any time.

To change a name, double click on the layer's current name in the Layers panel. This will surround the name with a small box, into which you can type your chosen name. If you accidentally don't quite double click on the name and simply double click inside the layer's panel instead a separate dialogue box opens into which you can type a new name for the layer. It's the same thing by a slightly different route.

Alternatively you can go to the menu bar, to Layer>Rename Layer.

If you double click on the background layer in order to change its name something totally different occurs, as you aren't allowed to change the name of the background layer (another strange property of this layer). Double clicking it converts it into an ordinary layer, which will be explained in more detail in the section specifically about the background layer, on page 214.

Using Layers

To demonstrate the uses of layers I've specially created a document with several layers, and on each one I'll drawn a person (Figure 8-4). Each person is holding a board telling you which layer they're on, so that you can keep track of which layer's which.

I've drawn a man with the letter B on the background layer, a woman with the number one on Layer 1 and a child on Layer 2. (I've drawn on the background layer here, even though I recommended earlier that normally it's best not to draw directly onto it due to its limitations. These limitations will become evident during this demonstration.)

Figure 8-4 Three layers, each with a person on it, to help demonstrate the use of layers. The man is on the background layer, the woman is on Layer 1 and the child is on Layer 2

Selecting Which Layer to Work on

To draw or paint onto a particular layer, or to do almost anything else with it, you have to first select the layer, which is known as making it 'active'. This is the equivalent of choosing which sheet of paper in a stack to work on.

You can recognise the active layer in the Layers panel because its section of the panel is highlighted in a different shade of gray to the rest of the panel (either lighter or darker, depending on your setup). See Figure 8-5, where Layer 1, containing the woman, is active.

To make an inactive layer active, just click anywhere in the part of the panel that contains the layer's name and thumbnail. You can only work on one layer at a time, so the layer that was active up until then stops being active.

Figure 8-5
Here Layer 1 is active, so that it can be worked on (such as by being drawn on, as here).
In the Layers panel the panel for Layer 1 is highlighted, showing that it's the active layer

Changing the Order of Layers

It's possible to rearrange the layers in a stack so that you can place an element of an image above or below other parts of the image (Figure 8-6).

Figure 8-6
Rearranging layers
Left: The layers in their original order
Right: Layer 1 moved in front of Layer 2

In the Layers panel press and hold the cursor on the layer that you want to move. Then drag the cursor up or down the stack of layers to choose a new location for the layer. As you

move the cursor a rectangle representing the layer's panel will move along with the cursor, indicating that the layer is being moved (although the layer's panel itself will stay in its original position until you finally 'drop' it into its new resting place). Drop the layer into place simply by releasing the cursor – the layer will drop into position between the two layers nearest to the cursor's position.

You can't reshuffle the background layer, or place other layers behind it, because by definition it's the bottom-most layer in the pile. If you want to move the background layer you have to convert it into an ordinary layer first, described on page 214.

A layer doesn't have to be the active layer (the one that you're working on) in order to be moved. Just press and drag on any layer and it'll move – as long as you don't release the cursor before you've actually moved the layer the computer will realize that you're just moving a layer rather than selecting it to make it active.

Hiding the Image on a Layer

Figure 8-7
Making the image on a layer
disappear.
Left: The original layers
Right: Layer 1 hidden

You'll frequently want to temporarily hide individual layers from view, for instance in order to hide rough versions of an image that you're tracing from, or maybe so that you can study the other layers without distraction, or to avoid all of the layers being printed out at the same time.

To hide a layer, go to the Layers panel and click on the eye icon (Figure 8-8) alongside the layer that you want to hide.

Figure 8-8 The eye icon, used to make layers appear and disappear

When a layer is hidden the eye in the box is hidden too. To bring your hidden layer back click the empty box, which will make both the layer and the eye reappear.

You can't work on a hidden layer, so if you hide the active layer, you won't be able to paint on it until you reveal it again. If you do try to paint on it a message appears informing you of the fact. Of course, obviously you wouldn't want to work on a hidden layer, because you wouldn't be able to see what you're doing, but you may try doing so by mistake.

Changing a Layer's Opacity

Figure 8-9
Lowering the opacity of a Layer makes its colours fainter and allows the layers behind to show through.
Left; The original layers
Right: The opacity of Layer 1 lowered

When you apply totally opaque colour to a layer the colour that you apply completely obscures any work on the layers below. Applying semitransparent colour obscures the layer below partially.

If you want to be able to see through opaque colours on a layer – allowing you to see work that's on the layers beneath – you can make the whole contents of a layer semitransparent by reducing the opacity of the layer (Figure 8-9). You may want to make layers semitransparent permanently as a deliberate effect in your image or you may want to do it temporarily just as a convenient way of seeing what's where on different layers.

To alter the opacity, in the Layers panel go to the box at the top labelled Opacity, and click the triangular arrowhead at the right-hand end. This will open an adjustable slider (Figure 8-10, left). Drag the pointer to the left along the slider to make the layer fade away – into nothingness if you go the whole way to zero percent. The percentage opacity is indicated in the numbered box above the slider.

Figure 8-10
Two ways to operate
the Opacity control

The Opacity control has a second, hidden form of slider that can be used instead of the one above. If you place your cursor above the word Opacity itself, rather than over the box, the cursor will turn into a pointing hand with a double-headed arrow beneath the extended finger (Figure 8-10, right). Pressing and dragging this cursor to the left or right will alter the opacity. There isn't an actual slider visible when you do this, but the changing value is displayed in the box.

You can also adjust the opacity by directly typing a value into the box.

You can't change the opacity of the background layer, because it always has to be 100 percent opaque. If you click on the background layer in the Layers panel you'll see that the controls across the top of the panel go gray. This is their way of telling you that they won't do anything. If you want to use the Opacity control on the background layer you have to convert the layer into an ordinary layer first, described on page 214.

Don't confuse the opacity control in the Layers panel with the one in the Brush tool's options bar. The Brush's opacity control affects the transparency of brushstrokes as they are being applied, while the Layer panel's control affects the transparency of a whole layer (The brushstrokes' opacity can't easily be altered after the colours have been applied, while the opacity of a layer is always adjustable).

Sliding the Contents of Layers Around

 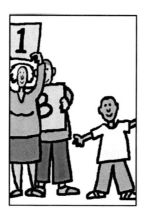

Figure 8-11
The contents of a layer can be
moved relative to the other
layers.
Left: The original layers
Right: Layers 1 and 2 moved

As with sheets of conventional tracing paper, you can take hold of a layer and move it around on your work surface so that the work on the layer changes position relative to the rest of the work (Figure 8-11).

To do this, first make the layer that you want to move active, by clicking its position in the Layers panel. Then go over to the Tools panel and pick the Move tool (Figure 8-12).

 Figure 8-12 The Move tool

For the simplest method of moving layers, go to the Move tool's options bar and turn off Auto Select Layer, because you don't want to use it right now, and turn off Show Bounding Box and Show Highlight on Rollover because they are irritating distractions. Then go back to the image, and move the layer by pressing the cursor anywhere on the image and dragging.

A slightly different but very convenient way to move layers with the Move tool is to activate the Auto Select Layer option in the tool's options bar. With this option activated, a layer is automatically chosen when you click on any part of the image that's on the layer itself rather than you having to select the layer in the Layers panel in order to make it active (So in my image above I would click on the boy in order to move the boy). Usually this is a very simple procedure, but there are a few complications in certain circumstances, which are covered in more detail in the section devoted to the Move tool (page 280).

When you move a layer, any parts of the image that disappear off the edge of the canvas area aren't lost – they're simply hidden from sight as though they are behind a frame. They can easily be dragged back if you move the layer again. Think of the layer as extending beyond the bounds of the visible image area on the screen, as illustrated in Figure 8-13.

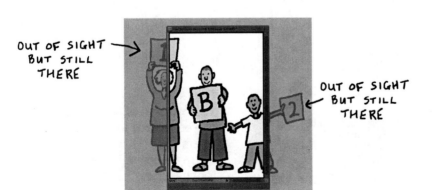

OUT OF SIGHT BUT STILL THERE

OUT OF SIGHT BUT STILL THERE

Figure 8-13
When you move a layer, the parts of the image that are moved outside the canvas area are still there, but are hidden from view

You can't move the background layer, because it's 'taped down'. To move the contents of the layer you first have to turn the background layer into an ordinary layer, described in the section about the background layer on page 214.

Moving Layers Together – Selecting Several Layers at Once and Linking Layers

Often you'll want to move several layers at the same time, especially if their contents have to remain lined up correctly (for instance if you've drawn a person and you've placed the head on a separate layer to the rest of the body).

To make this easier Elements gives you several ways of selecting multiple layers together so that they can be moved as though they're attached to each other.

The simplest method is to select several layers at once. First select one of the layers, then select more layers by clicking on their panels while holding down the Command key (Mac) or Control key (Windows). The panel for each layer that's clicked on will become highlighted.

If you want to select multiple layers that are next to each other one above the other you don't have to select them individually. Select one of the end layers, hold down the Shift key, then select the layer at the other end of the series. The whole series will be selected.

When you select several layers in these ways none of the individual layers is active while they're selected (so you can't draw or paint on them). As a result, after you've finished moving them you need to click on the panel for the layer that you want to be active – this will activate that layer and deselect the other layers at the same time.

The one drawback to this method of moving several layers together is that every time you want to move them you need to reselect each layer again individually. There is however a way of selecting several layers so that they can be united semipermenantly, allowing you to automatically move them together whenever you move any one of them. The process of joining the layers together in this way is called linking.

To link layers, first select the layers as described above (by clicking on their panels while holding down the Command key on Macs or the Control key in Windows).

Then go to the bottom of the Layers panel and click the button that resembles a chain link. This links the selected layers.

You can recognise the linked layers because of the chain link icon that appears in their panels (Figure 8-14). (These chain link icons are only visible when one of the linked layers is the active layer. Why, I don't know.)

The process of selecting several layers in order to link them deactivates the active layer,

so that no layer is specifically selected as the active layer – so when you've finished linking your layers you need to click on the layer that you want to be active.

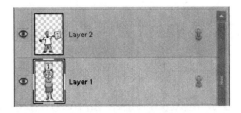

Figure 8-14
The chain icon indicates that a layer
is linked to the active layer

Now when you move the active layer using the Move tool any linked layers will move with it.

The linked layers will remain linked until you deliberately uncouple them. To delink a layer from other layers make the layer that you want to uncouple active and then click the link button at the bottom of the Layers panel. To remove the links from several layers at once select the layers by holding down the Command key (Mac) or Control key (Windows), then clicking the link button.

Layers will remain linked even if you reshuffle them or hide them.

If you throw a layer out that's linked to other layers, the link to the layer will break automatically – the discarded layer won't drag other layers into the bin with it.

Copying Layers

Figure 8-15
Copying layers.
Left: The original layers
Right: Layer 1 copied.
(The layer has then been
moved across, simply so
that you can see it)

You'll often want to create a duplicate of a layer so that you have multiple copies of the same image (Figure 8-15). For instance you may want to have two versions of the same

element in an image (as with the two women in the figure), or you may want to experiment with part of an image by working on a duplicate while leaving the original layer safe.

To create a copy of a layer, in the Layers panel drag the layer's panel down onto the New Layer icon (Figure 8-16) at the bottom of the panel. The New Layer icon resembles a sheet of paper with a corner turned up above another sheet, representing layers.

 Figure 8-16 The New Layer icon

The layer you're copying will stay in its original position in the panel (even though you may have had the impression that you were dragging it down the panel when you moved it down to the New Layer icon). A second version of the layer will appear directly above the original one. The new layer will have the same name as the original, but with the word 'copy' after it. Subsequent copies will be suffixed with a number indicating the number of copies, such as 'copy 2'.

The keyboard shortcut for copying layers is Command-J (Mac) or Control-J (Windows). You can also copy layers via the menu bar by going to Layer>Duplicate Layer, or by opening the Layers pop-up menu by clicking the preposterously insignificant little button that's nestling at the right end of the mid-gray band near the top of the Layers panel – it looks like a downward pointing arrowhead with four short horizontal lines next to it (These lines represent the list in the menu that opens). In the pop-up menu select Duplicate Layer from the list.

You'll probably have noticed in this chapter that for most of the possible actions that you can apply to layers there's one layer, the background layer, that's stubbornly uncooperative and won't respond – however this time it's different. You can indeed make a copy of the background layer. The copy will just be an ordinary layer that you can then treat like the other layers.

Merging Layers

When you're working in Elements it sometimes doesn't take long for the number of layers in your document to multiply out of all control. Keeping track of lots of layers can become quite difficult, so it's sensible to reduce their numbers occasionally by turning several layers into a single layer. Turning a number of layers into one layer is called merging.

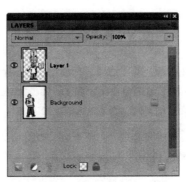

Figure 8-17
Merging layers.
Left: The Layers panel
with three separate
layers
Right: The number of
layers reduced by
merging Layers 1 & 2

A word of warning though - merging layers overrides any locked layers (see page 212). Locking layers is generally a procedure that's used in order to protect the layers' contents from being accidentally altered, so merging them thus neutralising the protection of the lock (so you have to reapply the lock if you want to).

There are four different commands that you can use to merge layers, described now.

Merge Down

This is the easiest way to merge layers, as it doesn't involve you having to select multiple layers. You can use it in order to merge any two layers that are directly next to each other.

First, make the upper one of the two layers active, then go to the menu bar and choose Layer>Merge Down (or open the Layers panel submenu from the button in the mid-gray bar at the top of the panel, and select Merge Down from there instead). The active layer merges with the layer below it, and the new layer retains the name of the lower layer.

The keyboard shortcut for merging down is Command-E (Mac) or Control-E (Windows). This shortcut is actually the same shortcut that is used for all merging operations listed below too – it activates the different operations depending on the context.

Merge Layers

Here's how to use the basic Merge Layers command.

First, select all of the layers that you want to merge. Do this by making one of the layers active, then selecting the others by clicking on them while holding down the Command key (Mac) or Control key (Windows).

Then in the menu bar choose Layer>Merge Layers (or you can also choose Merge

Layers from the Layers panel submenu, via the insignificant button at the right end of the mid-gray bar near the top of the panel).

The keyboard shortcut for merging layers is Command-E (on a Mac) or Control-E (in Windows).

The selected layers all turn into one single layer, in the same position as, and with the same name as, the top layer that was selected (unless one of the selected layers is the background layer, in which case the layers merge onto the background layer).

Merge Linked

You can choose to merge only layers that are linked (See page 207 for more on the subject of linking).

First, make one of the linked layers active by clicking its position in the Layers panel. Then in the menu bar choose Layer>Merge Linked (or you can also choose Merge Linked from the Layers panel submenu, via the insignificant button at the right end of the mid-gray bar at the top of the panel). Alternatively, and best of all, use the keyboard shortcut for merging layers, which is Command-E on a Mac or Control-E in Windows (As I mentioned earlier, this is the same shortcut for all versions of merging. Elements can tell which type of merge you have in mind due to the state of your selected layers).

The linked layers all turn into one single layer, in the same position as the one that was the active layer amongst the linked layers (Before you merge layers you can change your mind about which of the linked layers you want to be the active one, simply by clicking on a different layer).

The resulting merged layer keeps the name of the active layer.

If one of the linked layers is the background layer the linked layers are merged down onto the background layer no matter which layer was active to begin with. To prevent this happening you have to convert the background layer into an ordinary layer, as you do with many other types of layer manipulation concerning the background layer, as described on page 214.

Merge Down, Merge Layers and Merge Linked all share the same spot in the menu bar. Only one of them is ever accessible at any time, depending on the way that the layers are selected.

Merge Visible

Merge Visible merges all layers that are visible, leaving any hidden layers unmerged.

Find it in the menu bar at Layer>Merge Visible, or in the Layers panel submenu (via the button in the mid-gray bar near the top of the panel).

Throwing Layers Away

After you've been working on an image for a while you'll inevitably end up with the Layers panel full of layers that contain failed attempts at ideas, discarded reference material and other 'junk' artwork that you no longer need, all making it hard to find the layers that you actually want to use.

When this happens it's time to throw some of your redundant layers away. To do this, just grab hold of a layer in the Layer panel and drag it to the little bin at the bottom of the panel (Figure 8-18).

Figure 8-18 Throw away unwanted layers by placing them in this bin

If you suddenly realize that you've thrown away a layer that you really should have kept, use the Undo command to move back through your actions, such as by using the keyboard shortcut of Command-Z (Mac) or Control-Z (Windows).

Needless to say, you can't throw away the background layer. If you want to, first you have to convert it into an ordinary layer, described on page 214.

Locking Layers to Protect Their Contents

If you have a layer that's so perfect that you don't want to change it any more you can protect it from any unintentional alterations by locking it.

With the layer active, click on the padlock button at the bottom of the Layers panel (Figure 8-19). This locks all of the pixels on the layer, so that you can't erase, paint on, or move the contents of the layer. A padlock icon will appear in the layer's panel to indicate that it's locked.

A word of warning though – locking a layer doesn't protect it from being merged with other layers or from being cropped, so it's not infallible!

Figure 8-19 The Lock button

To turn the lock off, select the locked layer as the active layer and click the Lock button again.

There's a second button near the word 'Lock' at the bottom of the Layers panel, with the appearance of a checkered square (Figure 8-20). Its appearance doesn't suggest that it's a lock button in the way that the padlock does, but the fact that it's sandwiched between the

word Lock and the padlock may be a clue. The checkered design of the icon actually represents the checkered effect of the 'tablecloth background' that you can see behind transparent areas in the layer thumbnails in the Layers panel (if you have the effect turned on) and in transparent areas of your image when you hide the background layer (if you have the effect turned on in Preferences).

 Figure 8-20 The Transparency Lock button

This button locks only the levels of transparency of the pixels in the layer.
This needs a little explaining.

A normal layer is like a transparent sheet of plastic film to which you apply colours in varying degrees of transparency. Often the colours on a layer are completely opaque, such as when you paste a photographic image onto the layer, however semitransparent colours can be applied to layers by using brushes or by fading the colours in various ways. This means that a single layer can contain pixels that display differing degrees of transparency. Activating Lock Transparency means that the pixels on the layer will retain the degree of transparency that they have at the time that you apply the lock. Then, when you alter the colours on the layer, such as by painting over them with the Brush or by filling areas with the Paint Bucket, the new colours that are applied will acquire the degree of transparency that is locked into the pixels. In other words, even if you apply a completely opaque colour to a layer, any completely transparent pixels on the layer will remain completely transparent and any semitransparent ones will retain their level of transparency.

When Lock Transparency is activated the Eraser acts slightly oddly, at least at first sight.

Normally when you use the Eraser on a layer (without Lock Transparency activated) the Eraser erases colour from the pixels, making the pixels transparent (or semitransparent if the Eraser's opacity setting is below 100%).

This isn't the case with Lock Transparency activated. Now the pixels retain their degree of transparency rather than becoming completely transparent. The erased colour is replaced by the background colour. This effectively means that the Eraser paints the background colour onto the layer, more like a brush than an eraser.

If you cut an area from a layer that has Lock Transparency activated, the resulting 'hole' is completely transparent, as usual. It doesn't retain the transparency values of the colours that were cut from the area.

The Background Layer

Why it's Best Not to Work on the Background Layer

As I mentioned at the beginning of this chapter, it's best not to actually work directly on the background layer.

If you've read the sections in the rest of this chapter about the various ways that you can manipulate layers you'll have noticed how few of the processes can be applied to the background layer – because of the way that it's 'taped down' to the work surface.

This isn't actually a major problem because it's very easy to 'untape' the background layer and turn it into an ordinary layer at any time (explained in a moment), allowing you to move it just like any other layer.

But if you do untape the background layer and move it up through your stack of layers you come across a particular problem. The background layer is always opaque, like a sheet of paper, so if you place it above other layers those layers become hidden from view, as shown in Figure 8-21.

There are however ways of making it transparent, described in the next section, so it's not the end of the world.

Figure 8-21
Moving the background layer.
Left: The original layers
Right: The background layer has been detached and moved in front of Layer 1 (but still beneath Layer 2). Because the background layer is opaque, it hides Layer 1 from view

Turning the Background Layer into an Ordinary Layer

Although I suggested that you don't actually work directly on the background layer, sometimes you will inevitably find that you have artwork on it. This will be the case when you use a scanner to import an image, when you open a digital photograph, or when you

just find that you've absent-mindedly worked on the background layer by mistake.

Depending on what you want to do with your work it may be fine to just leave it on the background layer, but for many purposes it's best to untape the layer and turn it into a normal layer.

To do this all you need to do is to double click the background layer's position in the Layers panel.

A dialogue box will appear asking you if you want to give the new layer a name (because it can't really be called the background layer anymore). If you don't give it a name it'll automatically be given the default name of Layer 0, which has a pleasantly irrational ring to it.

Click OK and the process is complete.

Because the background layer was opaque, like a sheet of paper, the ordinary layer that it's been converted into will be opaque too, meaning that if you move it up the stack of layers it'll hide any layers beneath it, as in Figure 8-21.

There are ways of making the layer transparent. You can for instance use the Magic Wand (described on page 241), with which you can select any unpainted, opaque white areas on the layer, and then delete them, although this is sometimes a little on the crude side depending on what's on the layer. Alternatively you can use the Multiply mode in the Blend Modes (introduced next, and dealt with specifically on page 467), which will make the white on a layer transparent and other colours (other than black) semitransparent. Black remains opaque.

Blend Modes

Near the top of the Layers panel is a box that by default has the word Normal displayed inside it. If you click this box a whole list of strange terms is revealed. These are known as Blend Modes.

Blend Modes are different ways in which the colours on the separate layers of your image can interact with each other (by reinforcing each other, cancelling each other out and such like).

Apart from the Multiply mode, which can be useful for making the white in opaque layers transparent, they generally fall very much into the realm of special effects, rather than Elements essentials, so they're dealt with in more detail later, in the chapter that deals specifically with special effects (Find them on page 463, with the most useful one, Multiply mode, dealt with on page 467).

Changing the Size of the Thumbnails in the Layers Panel

The Layers panel can take up an awful lot of space on your monitor when there are more than just a few layers in it. You can modify the amount of space it needs by altering the size of the thumbnails of the layers' images (Figure 8-22).

To do this, open the Layers panel pop-up menu by clicking the tiny, ludicrously obscure button in the mid-gray bar near the top right of the panel (it looks like a downward pointing arrow with four horizontal lines next to it, symbolising a list), and in the list of commands that opens go to Panel Options.

The panel that appears has four different thumbnail options in it – small, medium, large and no thumbnail at all.

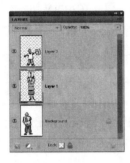 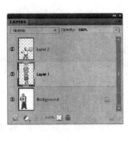 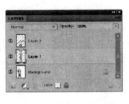

Figure 8-22
You can alter the size of the thumbnails, making them smaller so that the Layers panel takes up less space or larger so that you can see their contents better

Click on either the button or the icon representing the thumbnail size to make your choice.

Very soon you'll realize that the big thumbnail is far too large for any list of more than about three layers (and with three layers you hardly need a thumbnail to show what's on which layer anyway) so there's little point in using it. The No Thumbnail option squeezes more layers onto the same sized panel by discarding the thumbnails altogether. The thumbnails are so useful however that I'd recommend the small or medium thumbnail options as the best choices in most circumstances.

Checking the box labelled Layer Bounds will magnify the artwork on a layer so that it fills the thumbnail (Figure 8-23). This is *very* useful if a layer contains only a tiny part of an image which would be very hard to see on a thumbnail of the whole layer (such as the man's head in my example). Using this setting may mean that you don't have to bother giving your layers special descriptive names, as you may be able to see their contents well enough in the thumbnails. The main time that you *will* need descriptive names using this thumbnail display is when several layers have similar artwork on them so that their thumb-

nails are hard to tell apart (For instance, if two layers have nothing but a red circle on them their thumbnails will be exactly the same - a thumbnail-filling red circle - no matter where on either layer the circle is or what size it is).

 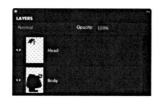 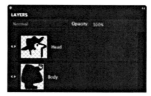

Figure 8-23
Selecting Layer
Bounds in the
Panel Options
makes the
contents of a
layer fill its
thumbnail (right)

If you find that the check effect for transparent areas in the thumbnails makes the thumbnail images difficult to see, you can remove the effect by going to Preferences>Transparency>Grid Size>None (In Windows Preferences is in the File menu, while on a Mac it's in the Adode Photoshop Elements menu). This also removes the check effect from the background that lurks beneath your stack of layers (Hide the background layer by clicking on its eye icon to see it).

Selections

9

You'll frequently want to do something to only a particular part of the image on a layer – such as removing it or changing its colour – rather than to the whole of the layer. You can define a specific part of a layer, so that the actions that you take will only affect that portion, by creating a selection area.

In This Chapter:

I'M SURROUNDED BY MARCHING ANTS! WHAT CAN THAT MEAN?

What is a Selection?

A selection is a localized area on a layer that's been specifically defined so that you can operate on it in isolation from the rest of the layer.

Here's an example.

Imagine that you're working on the picture of an Easter Island statue at the left in Figure 9-1, and you want to have some fun doing something to the statue. Perhaps you may want to change the statue's size or position, or make multiple copies of it (I've done all of these in Figure 9-1, centre), or you may perhaps want to move the statue into a totally different image altogether (Figure 9-1, right).

Figure 9-1
Left: An image of Easter Island
Above: The statue altered in various ways

If the statue was on a separate layer to other parts of the image you'd simply go to the layer containing the statue and apply any alterations or operations to that layer (As I've mentioned before, this is a major reason for putting separate parts of your artwork on their own individual layers as you create them).

However, with this image everything is on one layer, as though it's been painted onto a conventional canvas or single sheet of paper (Figure 9-2). This is the situation that you'd find yourself in if for example you'd scanned in a piece of work or if you were using a photographic image.

Because everything's on one layer, in order to alter only the statue you have to specifically define the statue so that it's isolated from the rest of the image, allowing you to treat it independently.

Figure 9-2
If your artwork is all on one layer,
as here, you have to isolate the
part you want to change

An area of an image that's selected for individual treatment in this way is called, in refreshingly non-jargonistic language, a selection.

There are various tools and techniques that you can use for creating these selections. The methods range from manually tracing over the image with a cursor through to letting the computer automatically define an area based on its colour. These will all be dealt with in this chapter.

When you've made a selection, the edges of the selection area are shown on your screen as a line which has an unearthly shimmering effect, poetically known as 'marching ants' (Figure 9-3). This line itself isn't part of your artwork – it's a type of 'virtual' line that floats above the image (so that if, for instance, you printed an image while the line of marching ants was there, the line of ants wouldn't appear on the print).

Figure 9-3
Left: The statue defined
as a selection area,
surrounded by
'marching ants'
Right: The selection
outline shown on its
own (simply so that you
can see it better)

Because making selections is a meaningless activity unless you alter the resulting selected area in some way, as I've done with the versions of the Easter Island statue in

Figure 9-1, you'll come across a small number of rudimentary operations in this chapter – cutting and colouring for example – that will be dealt with in more detail later, in their own chapters.

Cancelling a Selection

Before I go into any detail about how to select areas, I'll first tell you how to cancel selections once you've made them. There's nothing worse than creating selections on your image and then forgetting how to get rid of the things (When there's a selection area on the image the only part of the image that you can work on – such as by adding colour to it – is the part that's inside the selection area, so being able to cancel selections is important).

There are three ways to cancel selections. (These methods don't work if you're using the Quick Selection tool, described on page 225, unless you finish using the brush and move to a different tool – the Quick Selection tool works in a slightly different way to the other selection tools.)

The easiest way to cancel a selection is to use the keyboard shortcut, which is to press the two keys, Control-D (Windows) or Command-D (Mac). The D stands for Deselect.

If you forget this keyboard shortcut you can use the slightly longer route of going to the menu bar and choosing Select>Deselect.

You can also deselect a selection area just by starting another selection somewhere else on the image, as long as the starting point of the new selection area is outside the area that's currently selected. If you want to start a new selection area from a point that's *inside* an area that's already selected you have to cancel the active selection area first. This is because if you put the cursor down inside a selection area, and drag, it will move the selection outline instead of starting a new one. This moves only the selection outline (the marching ants), not the actual artwork inside it, so the ants will move while the image remains stationary. (When the cursor is inside a selection area it changes its shape to an arrowhead with a dotted rectangle next to it. The arrow is a visual clue to the fact that the cursor is in a mode to move something, while the dotted rectangle symbolizes a selection area, which is a clue that it's the selection area that will be moved).

Selecting the Whole Area of Your Canvas at Once

Perhaps the simplest selection method is to select the whole active layer of an image right up to the edge of the canvas, without you having to make any decisions about which parts of it to choose.

You do this by going to the menu bar, to Select>All. The keyboard shortcut for this

operation is Command-A (Mac) or Control-A (Windows). That's A for All.

A word of warning though!

Although the word 'All' sounds very clear-cut, the term isn't quite as all embracing as it implies.

Firstly, remember that it refers only to the layer you're actually working on, not to all of the work on all of the layers.

That's not too difficult to understand, but even on the layer that you're working on the word All is slightly misleading.

The reason for this is to do with the fact that you can slide a layer round so that parts of the image disappear off the edge of the actual canvas, as I mentioned in the previous chapter (see Figure 8-13). The Select All command only selects the parts of the image that are on the canvas area itself (Figure 9-4). You can tell that this is the case because when you use Select All you can see the marching ants round the canvas's edge. The consequence of this is that any parts of the image that have been moved outside this area aren't selected.

Figure 9-4
On this image (left), part of the Easter Island statue's head has been moved off the actual canvas area (and would therefore be out of sight).
If you used Select All on the layer containing the statue, the part of the statue that's outside the canvas area wouldn't be selected – so if, for instance, you then copied the statue the top of its head would be missing (right)

The Different Selection Tools – an Overview

In order to create a selection area you have to define the outline of the area by using one of several different tools specifically designed for the task.

Exactly which tool is the best one for the task in hand will be determined by the nature of the area that you want to select, such as whether or not it's an easily defined shape or is all one colour.

Before I describe the individual selection tools in any detail, here's a quick reference section with a breakdown of the different tools.

This information won't all make sense until you've used the tools, but it's here to refer back to later, to remind you of which tool does what.

The tools are listed in approximate order of usefulness or ease of use.

Quick Selection tool

Use this tool to 'mark' areas of colour that you want to select, by dabbing or scribbling on them. The edges of the marked colours then become the edge of the selection.

Lasso

Use this tool to draw free-form selections manually, tracing round the shape that you want to define using the cursor.

Magic Wand

Automatically selects regions of similar colour in an image. Just click in the area of colour that you want to define, and the edge of that colour becomes the edge of the selection area.

Rectangular Selection Tool (Marquee Tool)

Makes rectangular and square selections. Just drag the cursor across the canvas to define the opposite corners of the rectangle.

Selection Brush

Use this to 'paint' a selection area onto your image.

Elliptical Selection Tool (Marquee Tool)

Makes circular or elliptical selections by dragging the cursor.

Polygonal Lasso

Draws selections with straight sides, where each corner is defined by clicking on the image with the cursor.

Magnetic Lasso

Draws selections that automatically hug the edges of well-defined objects as you trace round them with the cursor.

The Selection Tools in Detail

Many of the selection tools share similar characteristics in the way that they work, so I'll cover these characteristics in detail while introducing the two most useful of the tools, the Quick Selection tool and the Lasso.

The Quick Selection Tool

Perhaps the easiest selection tool to use is the Quick Selection tool (Figure 9-6). It shares its place in the Tools panel with another tool, the Selection Brush (see page 248).

 Figure 9-6 The Quick Selection tool

The icon for the Quick Selection tool is meant to look like a magic wand with a selection outline eminating from its tip. This is because it works by magically applying selection outlines to areas of your image that you 'wave' the tool across (Figure 9-7).

The tool's icon is similar to that of the Magic Wand tool that's adjacent to it in the Tools panel (described on page 241), to which it's related. In fact the two tools are so closely related that you'd expect them to share a place in the Tools panel (but they don't do so for historical reasons relating to earlier versions of Elements).

Figure 9-7
Moving the Quick
Selection tool's cursor
across an object (the fish,
left) will automatically
select the whole object if
the various colours that
are crossed are clearly
part of the object

To select an area on an image (usually in the form of an object, such as my fish here) all you have to do is to drag the cursor so that it crosses the dominant colours of the object. Elements will then use its judgement to automatically select the object. It does this by assuming that any colours that are similar to those over which you've moved the cursor, and that are in the same vicinity, are probably part of the same object, and so it selects them all

up to their edges. If you dab the cursor rather than dragging it the tool may select either a small dab-sized area of colour or a larger area, depending on the colours involved and the settings of the tool. To extend a selection all you need to do is to dab or stroke the cursor on the extra areas that you want to add.

The tool isn't infallible of course, and sometimes it will include too much or too little of the image in its selection. In my fish example below for instance (Figure 9-8), a light part of the fish's side hasn't been included in the selection, while some of the vegetation below the fish has been included by mistake.

Figure 9-8
The Quick Selection tool
sometimes gets it wrong.
But you can easily put it right

It's a simple matter to correct these errors of judgement.

If you look in the Options bar you'll notice a series of buttons that allow you to modify your selection area (Figure 9-9).

 Figure 9-9 The selection modification buttons in the options bar

After you've made your first selection stroke the tool automatically moves to the button with the plus sign on it, on the assumption that the next thing that you're likely to want to do after making your initial selection is to add to the selection.

To remove an area from the selection (such as the water weed in my fish example in Figure 9-8) go to the selection modification button that has a minus sign next to it. Alternatively, use the keyboard shortcut of holding down the Alt key (Windows) or Option key (Mac) – this has the advantage of allowing you to remove selection areas without having to move away from the modification button with the plus sign in it.

The tool uses a degree of intelligence when defining selection areas, and works on the principal that any smallish areas of different colour that are embedded within the chosen

colours are probably part of the object too, and these are included in the selection. You can see this with my fish, which has an eye that's a *totally* different colour to any of the colours that I dragged the cursor across, but which was selected nonetheless.

You can fine-tune the selection edge that's generated by the tool by clicking the Refine Edge button in the Options bar. This allows you to smooth out rough edges, modify the size slightly or soften the edge of the selection. The Refine Edge command is actually independent from the Quick Selection tool, with the button in the Options bar simply being a shortcut to allow you to open the command more conveniently. The Refine Edge command can also be found in the Select menu in the Menu bar, along with a number of other commands that allow you to modify selections. These features are all dealt with together in the section about modifying your selection, with the Refine Edge command on page 252.

The Auto-Enhance button allows you to smooth out any rough edges of selections automatically (rather than manually as with the Refine Edge command). As a consequence you sacrifice a degree of control over the result compared with the Refine Edge command.

You can alter the size of the area that the tool's cursor covers (and thus analyses). Go to the Options bar and click on the button with the dot and number in it that's to the right of the word Brush (The tip is called a brush because of its brush-like characteristics). A panel opens that contains some characteristics that you can alter. Moving the Diameter slider will alter the tips size. Alternatively, and more conveniently, use the keyboard shortcut of pressing the left or right square bracket keys (just as you would to alter the size of a paintbrush tip). The size of the tip can be varied when you use a graphics tablet – make sure that the Size box at the bottom of the Brush panel is set to Pen Pressure.

The Quick Selection tool is excellent for a lot of standard selection tasks, especially because of the way that it attempts to be intelligent in its choice of selections, but it does have a few limitations that come to light when you try to use the tool on non-standard artwork (which includes a lot of artistic and other non-photographic images). These limitations are caused because the Quick Selection tool is designed as a 'point and shoot' semi-automatic selection tool, with few facilities for fine-tuning the selection process.

Here are the Quick Selection tool's shortcomings.

The most obvious limitation of the tool is that it works best on images in which the elements are reasonably easy to differentiate from each other. In Figure 9-10 the tool would easily be able to select the moth in the image on the left, but would find itself struggling to

select the same moth in the image on the right. To select the camouflaged moth on the right a manual selection tool such as the Lasso (descided next) or the Selection Brush (page 248) would be more suitable.

Figure 9-10
The Quick Selection tool can easily recognise the well-defined moth in the sky on the left, but it would have a hard time isolating the same moth on a tree trunk

The Quick Selection tool can be unreliable when selecting areas composed of semi-transparent pixels, as it doesn't always distinguish properly between degrees of transparency, treating semitransparent colours and opaque colours as being the same (In other words it'll select a transparent red and an opaque red at the same time because they are both the same red). There is a way to get round this however, by ticking the Sample All Layers box in the Options bar. The tool will now treat semitransparent colours differently, as it 'sees' them as being mixed with colours on layers beneath. A setback with this is that any artwork on layers underneath will now affect the selection, which may actually complicate things further. This complication can be remedied by temporarily putting a new layer beneath the one you're wanting to select semitransparent colours on, and by filling the new layer with solid white, thus hiding any artwork beneath. The Quick Selection tool will now see the semitransparent colours as being mixed with the white on the layer below, and it can now distinguish between different shades. For instance it will now see a pale red as 'red with a lot of white added' rather than as pure – but thinly applied – red.

The Quick Selection tool produces a soft, or anti-aliased, edge to its selections, to help to avoid obviously abrupt or jarring edges. (The only exception to this is when you're selecting hard-edged areas, such as pencil lines, that are bounded by transparent pixels.) Other selection tools, such as the Magic Wand (page 241), allow you to create crisp edged selections by turning off the anti-alias option.

With the Quick Selection tool it's not possible to alter the tolerance level of the selection process (Tolerance alters the amount of variation in colours that are selected, described on

page 243). In most cases the intelligence that the Quick Selection tool uses in order to make its selections more than compensates for its inadequacy in this department. If you need to control the tolerance you should consider using the Magic Wand.

The Lasso

You use the Lasso tool (Figure 9-11) to manually sling a 'rope' round the part of an image that you want to select. You do this by drawing a freehand line using the cursor, as I've done in Figure 9-13. The Lasso is an excellent tool for selecting areas that are hard to define using any of the semi-automatic selection tools such as the Quick Selection tool, mentioned above. A perfect subject for the Lasso would be the moth in the right hand panel in Figure 9-10.

Figure 9-11 The Lasso tool

The Lasso tool shares the same space in the Tools panel, with the Magnetic Lasso and Polygonal Lasso tools (both of which have icons that look like bent wire coathangers). If the Magnetic of Polygonal Lasso is occupying the space you can open the normal Lasso by pressing and holding on the lasso that's present, which will open a panel in which you can select the Lasso. The Lasso will then become the tool that's displayed in the Tools panel.

Figure 9-12
The Lasso tool uses a hand-drawn line to select part of an image (here the man)

In my example here, of a man sitting in a tree, I'm selecting the man because I want to cut him from this image and place him on a grassy bank (Figure 9-13).

Figure 9-13
A typical reason for making a
selection is to cut an object
from an image in order to
place it in a different image

To use the Lasso, select the tool in the Tools panel, then press and drag the cursor on your artwork to trace round the edge of the area that you want to select. A thin line shows the edge of the selected area as you make it. When you release the cursor the two ends of the line join up automatically to complete the shape. The line then takes on a shimmering 'marching ants' appearance to show you that it represents a selection area.

If you're working on a complex image where there's lots of detail surrounding the object that you want to select, your lasso line will have to be relatively accurately drawn, hugging the edge of the area being selected so as not to incorporate other parts of the image.

This need for accuracy can be avoided if you keep different elements of your artwork on separate layers, in which case you just have to throw a line round your object rather loosely, as long as it doesn't enclose other bits of artwork that are on the same layer.

In my example here, the selection line was traced relatively casually round the areas against the sky where there was no extraneous detail, and only had to be accurately drawn where the branch and the bird had to be taken into account.

While you're trying to create accurate selection lines round objects your line is bound to stray slightly in places, either selecting too much of your image or too little of it. Don't worry about this – you can modify your selection area after it's finished, described next.

Modifying the Shape of a Selection

Unless you get things right first time, which will be pretty unlikely, you'll want to alter the area covered by your selection in order to make it either larger or smaller. Often you'll want to alter your outline in order to fine-tune a selection's shape because the original selection line went slightly astray, while sometimes you'll decide that you want to add or subtract large areas, as in my examples in Figure 9-14.

Figure 9-14 Modifying a selection outline. Left: The area selected by my original selection outline in Figure 9-12. Centre: The selection area expanded to include the bird. Right: The selection area decreased to exclude the extended arm

There are two ways of increasing or decreasing the area covered by a selection: by using keyboard shortcuts or by using buttons in the options bar (Figure 9-15).

 Figure 9-15 Use these buttons to modify the area of a selection

The keyboard shortcuts are by far the better method to modify selection areas, once you've remembered them – once you have done you'll never use the buttons in the options bar again. Here's a quick reference to the keyboard shortcuts, before I describe the different options in more detail.

The keyboard shortcuts for modifying selections

Add to a selection:	Shift
Subtract from a selection:	Alt (Windows)
	Option (Mac)
Leave only the overlapping portion:	Shift-Alt (Windows)
	Shift-Option (Mac)

There's a small warning needed about using the buttons in the Options bar.

After you've used a button to alter the shape of a selection, that particular button remains active until you deliberately change it again. It's best to return to the standard selection button (the first one, with the simple, single square in it) as soon as you've finished using one of the others. The setting of the buttons is retained even when you close Elements down. So when you turn it on again the last button selected is still active. Whenever you start selecting, and you find that the selection tool is acting strangely, one of the first places to look for the reason is at those buttons.

When you use the keyboard method rather that the buttons, only the operation in progress is affected, and the selection option returns to its default setting as soon as you've finished. This is one reason why the keyboard method is by far the better method to use, once you've remembered which keys to press.

The squares in the modification buttons' icons represent selection areas: the way that the squares interact in each icon shows the effect that the button will have.

The first button, showing a single rectangle on its own, represents the normal, single selection mode – the mode that you'll use most of the time. The other modes are described next.

Adding to a Selection

Figure 9-16
Left: The original selection.
Right: The selection extended to include the bird

Use this mode when you want to add an extra part of a layer to your selection. You may for instance want to add a thin slither to a selection in order to correct an imprecisely drawn outline, or you may want to add a large area to incorporate more of the image, such as the

bird in Figure 9-16 (See Figure 9-12 to see the original selection area). The area being added doesn't have to be adjacent to the original selection area – it can be absolutely anywhere on the layer that's active.

The keyboard shortcut for adding to a selection is to hold the Shift key as you start to make the additional selection (You can then release the key once you've started).

Using the modifier buttons in the options bar (Figure 9-15), click the second button along – the one with the icon showing two equally shaded overlapping squares (indicating that they are merged together).

When you extend a selection area the original selection area remains selected and the new area is added to it (Figure 9-17). While you're extending the selection area you can tell that you're adding to it because a little plus sign appears next to the cursor. When you release the cursor to finish the selection process the marching ants change their route to encompass the new area.

By repeating the process you can add as many extra selection areas as you like, all in one operation.

Figure 9-17
Left: The cursor tracing the additional area.
Right: The resulting marching ants

You don't have to stick to the same selection tool to modify your selection. For instance you can create your original selection area using the Lasso, then alter it using the Rectangular Marquee tool, described soon. Just choose your new selection tool, then press the appropriate keys or click the necessary button in the tool's options bar before you apply the new selection.

Subtracting from a Selection

Figure 9-18
Left: The original selection area.
Right: The selection area reduced to exclude the arm

Use this method to remove areas from your selection, either in order to shave thin slithers from the edge of an inaccurately defined selection area or in order to remove whole areas such as the arm in Figure 9-28.

On the keyboard, use the Option key (Mac), or the Alt key (Windows). Press the key before you commence the modification, then release it once you've started.

Using the modifier buttons (Figure 9-15), it's the third button along – that's the one with the icon that represents a second selection area taking a chunk out of a previous selection area.

A minus sign appears next to the cursor to show that you've put the tool into subtracting mode.

Using this method you can also make holes right in the middle of selection areas, so that 'islands' inside the selection area become unselected.

Selecting Overlapping Sections of Selection Areas

You can choose to select only areas where a second selection outline overlaps the first.

This is useful when you want to keep only a small part of a large selection area. An example would be if you only wanted to keep the man's head selected in Figure 9-12, rather than keeping the whole selection

The keyboard shortcut is to press both the Shift and Option keys (Mac), or the Shift and Alt keys (Windows), at the same time.

Using the modifier buttons, it's the last of the set: the one that shows only the overlapping parts of the squares shaded.

Other Modifications to the Selection Outline

If you look at the Options bars of any of the selection tools in Elements you'll see a variety of options that modify how the tool works. The options that are displayed in the Lasso tool's Options bar are also found in the Option bars of several other selection tools as well. Any options that are possessed by a specific tool other than the Lasso are mentioned in the section about the tool itself.

The Anti-alias Option

The prize for the option with the strangest name in the selection tools' options bars goes to the Anti-alias option. With a name like that, Anti-alias sounds like an extremely geeky option, possibly best ignored. In fact it's the option that you ought to usually use, so it really should be given a more user-friendly name.

The Anti-alias setting produces a slightly soft-edged selection, so that when you cut the selection, or add colour to it, or modify it in any other way, the resulting edge isn't too sharp and harsh (Figure 9-19).

The main time you'd turn this check box off is when you're producing sharp-edged work using the Pencil, such as black and white line work, as described in Chapter 7.

Figure 9-19 To show the effect of anti-aliasing, here's a magnified portion of an image (so that you can see the individual pixels). Left: A small selection area on the image, shown by the marching ants. Centre: The selection cut from the image, with Anti-alias turned on, giving a soft edge. Right: The same selection cut with Anti-alias turned off, creating a sharp edge (notice the stepped effect visible at this magnification,where the edge follows the pixels' edges)

The Feather Option

The Feather option is similar to the Anti-alias option in that it softens the edge of a selection, but it does so to a much greater extent. With the Feather option you can alter the amount of softening considerably, while Anti-aliasing confines the effect to a narrow band on either side of the selection line. See Figure 9-20 for comparisons between the two.

Change the degree of feathering by entering a value in the box or by sliding the cursor over the word Feather.

A word of warning! The value that you enter remains in place until you actively remove it, which means that the feathering will be applied to future selections. Therefore it's generally a good idea to return the setting to zero when you've finished using it. Whenever you notice that your selection edges are inexplicably fuzzy the first place to look for the reason is in the Feather option box.

The Feather option is best used for specific effects, because for general purposes it produces too soft a selection edge.

Feathering is covered in more detail on page 254.

Figure 9-20
Left: An anti-aliased
selection cut from
an image,
Right: A feathered
selection cut from
an image

The Refine Edge Option

The Refine Edge button in the Options bar allows you to fine-tune the selection edge that you create. It allows you to smooth out rough edges, to modify the size slightly or to soften the edge of the selection. The Refine Edge command is actually a command that's independent from the Lasso tool, with the button in the Options bar simply being a shortcut to allow you to open it more conveniently. The Refine Edge command can also be found in the Select menu in the Menu bar, along with a number of other commands that allow you to modify selections. All of these commands, including the Refine Edge command, are dealt with together in the section Modifying Your Selection Using the Select Menu (page 251), with the Refine Edge command on page 252.

Selecting with Straight Lines – the Polygonal Lasso

Objects that have very straight edges are hard to select using the freehand line created with the Lasso tool.

For example, in Figure 9-21 you'll see that buried inside the image is the shape of a star. The star is too similar to the background to allow it to be selected using a semi-automatic selection tool such as the Quick Selection tool, so it really needs a manual tool for the task. To select along the straight edges of the star the perfect selection tool would be one that creates straight edges itself – which is exactly what the Polygonal Lasso tool does.

Figure 9-21
The Polygonal Lasso tool is used for manually outlining selections with straight edges.
Here I've selected and cut out a star

Figure 9-22 The Polygonal Lasso tool's button

The Polygonal Lasso's button (Figure 9-22), which looks like a bent clothes hanger, shares the same space in the Tools panel as the normal Lasso. To reveal it hold down the cursor on the Lasso's icon in the Tools panel, which will open a small panel containing different types of lasso. Drag the cursor to choose the one you want. (By the way, you can tell that there's something else hidden behind any tool in the Tools panel when there's a small triangular arrowhead beside the icon.)

The Polygonal Lasso doesn't create a selection outline by freehand dragging, as with the ordinary Lasso, but by clicking and releasing the cursor at intervals. The points where you click are automatically joined up by straight lines that act as the edges of the selection. To close the selection, just double click (If you create the selection outline too quickly you may accidentally double click half way round, thus closing the selection area prematurely).

You can also close the selection by putting the cursor near the first point on which you clicked, next to which a little circle will appear (symbolizing that the selection is now complete), and then clicking.

Here's a good trick. You can alternate between the normal Lasso and the Polygonal Lasso in mid operation by pressing and holding Alt (Windows) or Option (Mac). Hold the key rather than just pressing it briefly. While the key is depressed, pressing and dragging the cursor creates Lasso lines and clicking creates Polygonal Lasso lines.

Holding the Shift key down will constrain the lines that you produce to horizontal, vertical or 45 degrees (The Shift key constrains many operations to these directions).

Making the Lasso Line Stick to the Edge of an Object as You Select it – the Magnetic Lasso

There's a special version of the Lasso tool, the Magnetic Lasso, with which the selection line that you create semi-automatically sticks to the edge of any well-defined object as you trace around it, as if it's attracted by static electricity.

Sounds too good to be true?

Yes, indeed it is. It doesn't make quite the perfect selection edge that you might have hoped for. It's not as useful as you'd expect, but it's interesting all the same, so here's its description.

Its button (Figure 9-23), resembling a wire coat hanger with a magnet attached to it, shares a space with the ordinary Lasso in the Tools panel, along with the Polygon Lasso.

 Figure 9-23 The Magnetic Lasso

To use it you click on the screen at the point where you want to start your selection – just click, don't hold and drag. The cursor then moves as you move the mouse or pen. Keep the cursor close to the edge that you want selected, and a selection line will automatically travel along the edge.

Close the selection by clicking once when you return to the starting point, or by double clicking at any time in mid selection, in which case the selection area will close with a straight line between the start and end points.

You can alter the sensitivity of the Magnetic Lasso by changing the values in its Options bar, described now.

Width: This determines how far from your object the cursor can drift without the selection line veering off course and detaching itself from the edge of the object. High contrast shapes are best traced round with a high width value in the box (because you don't

have to be too accurate with your tracing – the lasso takes care of that), while low contrast shapes require a smaller width because you need to keep the cursor near to the edge of the object. The circle that forms the cursor reflects the width (The lasso may still stick to the edge of your object when the edge is outside the cursor's circle, but it's less likely to do so).

The width can be changed while you're moving the cursor, by clicking the square bracket keys: the left bracket key for down, the right one for up.

Contrast: This determines the tool's sensitivity to the degree of contrast that there is at the edge of the object that's being traced round. Set this high for high contrast elements, and low for lower contrast ones. Quite understandably the tool doesn't work as well with low contrast artwork, as boundaries are much more difficult to define.

Frequency: As you move the cursor you'll see that the Magnetic Lasso deposits squares at intervals as it creates the selection outline. These are anchor points, which are where the lasso line changes direction. Higher frequency settings create more points. As a rule complex shapes need more anchor points than simple ones, and so need a higher frequency.

Pen Pressure: (The icon showing a pen tip creating a ripple-like effect.) This only works with graphics tablets. As you press harder, the width value (see above) decreases – you can see the cursor getting smaller on your screen. When you press the pen, the keyboard method of altering the width value (above) doesn't work.

Making Rectangular Selections (and Elliptical Ones)

Figure 9-24
Top: Selections made with the Rectangular & elliptical Marquee tools

Bottom: The selections cut

You can create rectangular or elliptical selections (Figure 9-24) by using the Rectangular Marquee tool or the Elliptical Marquee tool respectively.

Apparently they're called Marquee tools because the shimmering effect of the selection outlines look slightly like the displays of flashing lightbulbs that you sometimes see at the entrances of circuses and other places of entertainment that use very large tents, or marquees. Why they're not simply called selection tools is a bit of a mystery to me.

Several of the features mentioned in the section about the Lasso tool work for the Marquee tools too: adding to and subtracting from selections, and feathering. Refer to the Lasso tool for explanations of these features.

The Rectangular Marquee Tool (Rectangular Selection Tool)

Figure 9-25 The Rectangular Selection (or Rectangular Marquee) tool

The more useful of the two Marquee tools is the rectangular one (Figure 9-25).

The tool creates a rectangular selection when you press and drag the cursor on your image. As soon as you press the cursor one corner is defined, then when you release the cursor the opposite corner is defined. You can see the rectangle being generated as you drag.

If you want to make a square selection, hold down the Shift key while dragging.

To make the selection move out from the centre instead of the corner, press the Alt key (Windows) or the Option key (Mac). For a square from the centre press the Shift key too.

You can restrain the proportions of the rectangle as you drag by going to the Options bar, where under the Mode heading you can choose Fixed Ratio. Choosing this will activate the Width and Height boxes in the Options bar. Put the proportions for the width and height in the boxes: for example, putting two in the width and one in the height will ensure a rectangle with sides to the proportions of two to one.

If you want to produce a rectangle to exact dimensions, in the Mode box choose Fixed Size, then type the dimensions into the boxes. Follow the numbers by the units of your choice, such as cm, in, px (pixels) or percent, and the units will automatically be applied.

You can't use the Anti-aliasing option with the Rectangular Marquee tool. If you want soft-edged selections you need to use the Feather option instead (which produces a softer edge than you'd get with an anti-aliased option).

The Elliptical Selection Tool (Elliptical Marquee Tool)

Figure 9-26 The Elliptical Marquee tool

This tool shares the same space on the Tools panel as the Rectangular Marquee tool. To move between tools hold the cursor down on the icon that's occupying the slot in the Tools panel, which will open a panel displaying both buttons.

It works in almost exactly the same way as the Rectangular Marquee tool, creating elliptical selection areas by pressing and dragging the cursor.

To create circles, press the Shift key as you drag.
For circles from the centre, use Option-Shift (Mac) or Alt-Shift (Windows).
For ellipses from the centre press Option (Mac) or Alt (Windows).

You can make anti-aliased selections with this tool, unlike the Rectangular Marquee tool. Turn the option on or off by using the check box in the Options bar.

As with the Rectangular Marquee tool the porportions of the ellipse or its actual size can be set in the Mode drop-down panel in the Options bar.

Wave the Magic Wand to Select an Area in an Instant

Figure 9-27 The Magic Wand tool

With the Magic Wand tool (Figure 9-27) you click on a colour in your image and the entire area of that colour is automatically defined as a selection area. The selection area can be set to include other colours that are similar to the colour that you click on, with the degree of similarity being adjustable in the tool's options bar.

The wand is a bit like a less intelligent version of the Quick Selection tool (page 225). It's slower to use than the Quick Selection tool, so when you're working on straightforward images such as photographs the Quick Selection tool should probably be your first choice of selection tool. However the Quick Selection tool doesn't work well on some types of image, mainly because it's not as intelligent as it thinks it is. For instance it can be rather imprecise when trying to select areas on layers (depending on the nature of the artwork on the layers) or when selecting delicate areas of artwork such as fine lines. In such cases the Magic Wand may be a better option (The wand knows that it's not as intelligent as the

Quick Selection tool, so it sticks to what it's asked to do and doesn't try anything fancy).

The wand is a very good tool for selecting well-defined objects that have clear-cut edges, such as the moth against the sky in Figure 9-10.

It's less useful when selecting areas that involve subtle changes of colour, where the edges aren't easily definable, such as the moth on the tree trunk in Figure 9-10. In instances like this a better choice of selection tool would be one where you define the area manually, such as the Lasso (described earlier) or the Selection Brush (page 248).

Used in its basic mode the wand doesn't take into account any degrees of transparency in a colour on a layer, and will select all of a colour regardless of its transparency. There's a simple way round this however, and the whole matter is described in more detail soon, in the section Selecting Transparent Colours, on page 246.

The wand is particularly accurate when you're working in pure black and white using the Pencil (see Chapter 7), as the complete lack of nuance in the colours means that the wand has no difficulty at all in selecting exactly the areas that are wanted.

Here's how the wand works. I'll use this image of a cat, Figure 9-28, to demonstrate.

Figure 9-28
I'll use this image of a cat to show
how the Magic Wand works

Clicking on a colour on the cat's body will automatically select all of that particular area of colour, along with adjoining areas of very similar colour (Figure 9-29). Any colours that are noticeably different to the original colour aren't included in the selection.

Figure 9-29
One click of the Magic Wand on the cat selects all of the colour that's similar to the colour at the point where the wand was clicked

To alter the range of colours that will be selected – either to widen or to narrow the range – change the tolerance setting in the wand's Options bar.

With a low tolerance only colours very close to the one you originally click on will be chosen, while if you pick a high tolerance a wide range of colours are included in the selection (Figure 9-30). At the lowest extreme, a tolerance of one will only select pixels that are exactly the same colour as the one that's clicked on.

You can alter the tolerance value by typing directly into the Tolerance box. Alternatively, if you place the cursor above the word Tolerance the cursor will turn into a sliding hand which you can move to the left or right to alter the value (you'll see the value in the box change as you do this, even though the cursor isn't actually moving over a control panel of any sort).

The default tolerance is 32.

Figure 9-30
Changing the tolerance alters the range of colours selected.
Left: a tolerance of 44 selects more tones than were selected in Figure 9-29 (where the setting was 32). Right: a tolerance of 66

You can modify the selection created by the wand by adding or subtracting areas using the same buttons or keyboard shortcuts explained under the Lasso tool.

For instance to add other parts of the cat to the selection you can hold down the Shift key and click on any parts of the cat that are different areas of the same colour, such as the head (notice that the head is separated from the body by a light collar), or that are totally different colours, such as the eyes and the whiskers, until you've got the whole cat selected (Figure 9-31).

Figure 9-31 The whole cat selected by holding the Shift key and making multiple selections to include separate areas of colour

If there are any features in an image that are just too fiddly to click on (such as perhaps the black in the cat's eyes in my example), the easiest way to incorporate these parts into the whole selected area is to abandon using the Magic Wand and to choose a different selection tool, such as the Lasso (while holding down the Shift key in order to add the selections together) or the Selection Brush, described on page 248 (with which – uniquely – you don't need to hold down the Shift key when adding areas).

If the wand incorporates areas that you didn't want including into a selection, you can use the Lasso tool to remove them by setting it to subtract mode, either by using the button in the options bar or by pressing the Option key (Mac) or the Alt key (Windows). Trace round any unwanted selected areas and they'll be deselected when you release the cursor. Alternatively you can use the Selection Brush (page 248) while holding down the Option key (Mac) or the Alt key (Windows).

You can alter the tolerance and other settings while making additions to the selection, so that each new addition uses different values.

Selecting all the Areas that are the Same Colour, all at Once

In its usual setting the colours selected by the Magic Wand have to be touching each other – the wand's selection won't leap over gaps. But this can be altered so that all similar colours are selected across the whole layer (Figure 9-32). Do this by turning off the tick in the check box labelled Contiguous (which is another word for adjoining or touching).

Figure 9-32
Using the wand with Contiguous turned off will select all examples of a colour on the layer. Here the cat's body and head, which are separate areas of colour, are selected together

Selecting Areas Using Colours on Other Layers

In it's normal mode the Magic Wand creates selection areas based only on colours on the active layer.

It can also select areas based on colours no matter which layers the colours are on, by ticking the Sample All Layers check box in the options bar.

The selection area thus defined will be based on all of the visible areas of the colour, as though the whole image was all on one layer.

As always though, the selection area outlined will operate on only the active layer. So for instance, if you have an image that has a particular shade of blue on several different layers, you can click on any of the blue, and marching ants will appear surrounding all of the blue no matter which layer the blue is on – then if you decide to fill the selection area with red, the red will be applied only to the layer that's active at the time, not to the different areas of blue on their separate layers.

Selecting Semitransparent Colours

The wand automatically selects areas of the same colour, but it doesn't take into account any degrees of transparency in the colour unless you're using the Sample All Layers mode.

I'm talking here about colours that have been applied semitransparently, such as by using a brush at lower than 100% opacity. Don't confuse these semitransparent colours with colours that are made semitransparent by lowering the opacity of the layer that they're on, (in this case the colours retain their opacity but the layer itself becomes semitransparent).

To explain how to select semitransparent colours look at the smoke coming out of the volcano in Figure 9-33.

Figure 9-33 Left: The smoke here was created using strokes of semitransparent black to produce the shading. Right: A 'perspective' view, showing that the image is on a transparent layer

The smoke is composed of brushstrokes of semitransparent black, built up to give a variety of shades of gray. If you click on any one of these shades of gray with the wand (with Use All Layers *off*) you'd expect the wand to limit the selection that it makes to just the small area of the smoke that's that particular shade of gray. But it doesn't: it selects *all* of the smoke, in all of the shades of gray (Figure 9-34).

Figure 9-34
If an image is on a transparent layer, the wand in normal mode will select all degrees of a semitransparent colour that's clicked on, no matter how faint, because it treats it all as the same colour

To make the wand select separate shades of semitransparent colour (Figure 9-35) you have to activate the Use All Layers check box.

Figure 9-35
In Use All Layers mode the wand will recognize each shade as a different colour

And here's the reason why.

The volcano's smoke is composed of overlaid strokes of black that are laid down semi-transparently – a bit like using thin, watery black watercolour in conventional media. So it's best to think of this smoke as being diluted black, rather than actually as shades of gray. This is the reason why the wand selects the whole area in one go – because it interprets all of the shades as being one thing – black.

For the wand to recognize the different shades of gray in the smoke, the grays have to be formed by mixing the black with white, so that each shade is actually a different gray rather than just a differently diluted black.

By employing the Sample All Layers mode the wand analyses the colours on all of the layers in the image as though they're all mixed and merged onto one layer. This means that the semitransparent blacks are mixed with the opaque white of the layer beneath, creating the shades of gray that the wand will recognize.

You'll often find it useful that the wand *can* select all of a semitransparent colour in one go by the way. An example would be when you want to select all of a soft-edged brush-stroke where the soft edge is formed by semitransparent colour (Figure 9-36). In such cases not selecting all of the colour may leave a thin unselected fringe round the edge.

Figure 9-36
The stroke at the left selected with Select All Layers off (centre left) & on (centre right).
Right: the fringe that is left unselected using Select All Layers

9

Paint a Selection Area with the Selection Brush

 Figure 9-37 The Selection Brush

Possibly the most intuitive way to create a selection area is to just 'paint' it onto your artwork.

You can do this with the Selection Brush (Figure 9-37). The brush's button shares the same place in the Tools panel as the Quick Selection tool (page 225). If the Quick Selection tool's button is being displayed press and hold on it to reveal the Selection Brush.

When you apply strokes to the image with the Selection Brush the areas are defined as a selection area (rather than being coloured in, as they would be with an ordinary brush).

The brush can be used in two modes, Selection mode or Mask mode (Figure 9-38). Make your choice in the Options bar. Selection mode is the more intuitive of the two modes.

In Selection mode the strokes that you make are transparent, with the edge of the strokes being indicated by the dotted line of marching ants that typically signifies the boundary of a selection area. Overlapping strokes merge together, with the marching ants circumnavigating the merged strokes. Mask mode is described in a moment.

The Selection Brush is good for defining small or fiddly selection areas. For larger areas the task of 'painting' over the whole area becomes a little tedious, so other methods such as the Quick Selection tool or the Lasso are better. After you've defined a large area using a different selection method you can pick up the Selection Brush and use it to fine-tune the selection area – just choose the brush and start 'painting' the areas where the fine-tuning is needed. You can create multiple selection areas by applying strokes to separate parts of your image. If you want to remove areas from a selection rather than add them, hold down the Alt key (Windows) or the Option key (Mac).

As with many operations, if you want to constrain the direction of the strokes to the cardinal directions hold down the Shift key.

You can alter the tip of the Selection Brush by choosing any brush tip that's in your brush sets, via the Brush panel in the options bar. The characteristics of the brush are reflected in the selection that it produces, meaning that quite complex selection areas can be created. Soft-edged brushes produce soft-edged selections and hard-edged brushes produce hard-edged selections, but what's more, semitransparent brushes produce semi-

transparent selections, fancy brushes produce fancy selections and so on. The easiest and most accurate brushes to use are the simple round brushes at the top of the Default Brushes set. Complex brushes produce complicated selection areas that are harder to predict. When you're using Selection mode the resulting marching ants that show the outline of the selection don't really indicate the selection area in its full intricacy. Fortunately, there's a way of dispensing with the marching ants and of displaying the selection area in a much more accurate way – using the Mask mode (Figure 9-38).

You'll find Mask mode in the box labelled Mode in the options bar.

In this mode the unselected area of the image is overlaid with colour, leaving the selected areas clear (rather than surrounded by ants). The overlaid colour is a mask, or stencil, rather than being part of the image itself, and is there only to indicate which areas of the image are not selected. You can choose the colour of the mask in the options bar (Click the coloured square). You can choose the mask's opacity, which controls how much you can see through it to the image below – the more opaque it is the better you can see the shape of the selection area, but the worse you can see the image beneath the mask's colour).

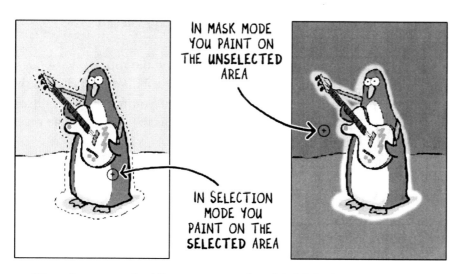

IN MASK MODE
YOU PAINT ON
THE **UNSELECTED**
AREA

IN SELECTION
MODE YOU
PAINT ON THE
SELECTED AREA

Figure 9-38
The Selection
Brush's two
modes.

Left: Selection
Right: Mask

There's a very significant manner in which Mask mode operated differently to Selection mode.

When you're in Mask mode the brush 'paints' the *unselected* area rather than the selected one.

This may seem confusing, but the logic behind it is that you're defining the mask, or stencil, rather than the selection area itself. Think of the coloured area that the brush lays

down as the 'solid' part of the stencil. As with an ordinary stencil it's the holes in the coloured areas that are the areas that will be worked on (such as by having colour applied).

Here's in Figure 9-39 is an example of the Selection Brush's in Mask mode in use.

Figure 9-39 Mask mode being used to create an irregular vignette. Left: An image of a bird. Centre: Using the Selection Brush in Mask mode, a mask or stencil is painted over the bird. Right: Using the Delete command the unmasked areas are removed, leaving only the bird.

In this image, here's how I made a misty vignette of the bird on the roof.

I set the Selection Brush's mode to Mask mode and chose an irregular brush (I used the Smoke brush from the Pen Pressure brush set, which works well if you're using a mouse).

Then I used the brush to apply a mask to the area that I wanted as the vignette. The mask can be seen as a coloured overlay.

When the mask was completed I then removed the unmasked areas by deleting it.

Think of the coloured area of the mask as the solid area of a stencil, meaning that whatever action is taken after the stencil has been put into place will affect the areas that aren't coloured. In this case I deleted them, leaving the masked area behind, untouched.

You may occasionally forget the fact that the Mask mode defines the unselected areas of an image rather than the more usual selected areas: if you find that you've used the tool the wrong way round just go to the menu bar, to Select>Inverse, and the selection will be reversed (see next section).

That's the end of the various individual selection tools.

Next are a number of modifications that you can make to your selections once you've defined the selection areas.

Modifying Your Selection Using the Select Menu

Most of the modifications to selections mentioned so far – such as adding to them or subtracting from them – have been made via either the selection tools' options bars or by using the keyboard. There are however further modifications that can be made by using the Select menu in the menu bar.

Selecting the Opposite of What You've Already Selected – the Inverse Command

This is one of the most useful commands in the Select menu.

It reverses the selection that you've made, so that the area that you originally selected becomes unselected, and the previously unselected area becomes selected in its place.

It's very useful when the part of an image that you *don't* want to select is easier to define than the part that you do want.

Here's an example to show what I mean, in Figure 9-40.

Selecting the vase of flowers in this image would be very tedious indeed using any of the methods outlined earlier in this chapter, due to its complex shape.

However, the whole vase of flowers is well defined against a very simple background. This means that a couple of clicks with the Magic Wand on the background, or a quick drag across it with the Quick Selection tool, will select the entire background easily, leaving only the vase of flowers unselected.

Using the Inverse command will then flip the selection areas so that the vase and flowers are selected instead of the background.

Figure 9-40 The Inverse command in use. Left: The background is selected because it's easier to select than the vase & flowers (Notice the selection line around the edge). Centre: The Inverse command is used to flip the selection. Right: The selection can then be worked on

In images one and two of the vase of flowers you can tell that in each case the opposite areas of the image are selected because, although the selection lines round the vase are exactly the same in both, the first image has a selection line round the perimeter of the image too, showing that it's actually the background that's selected.

The Select menu contains other ways of affecting the selection area, described next.

Refine Edge

This command can also be opened via a button in the Options bar of all of the selection tools that allow you to create irregular selections apart from the Selection Brush. For the Selection Brush and selection tools that create regular selections (the Rectangular and Elliptical Marquee tools) you need to go to Select>Refine Edge.

The command allows you to adjust the edge of a selection in three ways: by altering the smoothness of the selection, by applying a diffuse feather effect to it or by expanding or contracting it slightly, as described below.

The effect of the alterations on the selection boundary can be observed on the image as you alter the settings and before you finally apply them (as long as the Preview check box is ticked). There are two different preview modes, accessible via the two buttons below the adjustable sliders – one button's blue and one's red and both contain the image of a looped tube-like object for some bizarre reason. The blue button activates the normal 'marching ants' depiction of the selection outline. The marching ants will change their route as you make adjustments. The preview that's generated by the red button shows the selection area by applying a coloured overlay to the unselected areas, leaving the selected area clear. This overlay is a form of mask (You can see a visualisation of a mask in Figure 12-7). You can change the colour of the overlay by double clicking the red button. This also allows you to change the overlay's opacity – a low opacity allows you to see the image that's beneath the overlay, while a high opacity hides the underlying image and makes the edge of the selection easier to analyse.

The settings that you enter into the Refine Edge dialogue box will remain there until you change them. This can be useful as it means that you can apply the same settings to separate selections one after the other simply by opening the Refine Edge dialogue box and clicking OK. Each selection tool retains its own individual settings, so when you open Refine Edge via the Options bar of a specific tool the last settings for that particular tool are displayed. When you open Refine Edge via the Select menu a different group of settings are displayed – these settings remain unaltered when you switch between any of the selection

tools. This means that if you want to apply the same settings for selections created with different tools open Refine Edge via the Select menu, and if you want separate settings for the different tools open Refine Edge via the Options bar. Clear?

The refinements that can be made to the selection outline are labelled as Smooth, Feather, and Contract/Expand. The Smooth and Feather commands can be accessed as separate, independent commands elsewhere in the Select menu. For brevity I'll bundle the Refine Edge versions of those commands in with the independent versions in a moment, pointing out areas in which the two differ.

The third refinement that can be achieved with the Refine Edge command, labelled Expand/Contract, is slightly different to the superficially similar Expand and Contact commands found elsewhere in the Select menu (and dealt with soon), so I'll detail that command now to avoid confusing the two versions.

Expand/Contract: This setting isn't the same as the stand-alone Expand and Contract commands that are elsewhere in the Select menu. This version moves the edge of the selection inwards or outwards by a relatively small amount – usually just a few pixels. It's essentially a means of fine-tuning the edge of selections in cases where a selection tool has either slightly fallen short of or slightly overshot the very edge of an object. The degree of expansion or contraction isn't necessarily uniform all the way round a selection – it depends to some extent on the subtlety of the colour differences in the vicinity. The selection edge won't expand onto transparent pixels (in other words it'll stop at the edge of the coloured pixels) unless there is a degree of feather applied to the selection. The amount of expansion or contraction varies depending on how much feather is applied (see below). The greater the amount of feather, the greater the amount that the selection can contract of expand. When you contract a feathered selection the degree of feathering is reduced.

The Refine Edge command includes versions of the Smooth and Feather commands, described next.

Smooth

This option smooths out jagged edges of selections (Figure 9-41).

The stand alone version of the command is found in the Select>Modify submenu, which is immediately beneath the Refine Edge command, mentioned immediately above.

The Refine Edge version of the command is similar to the stand-alone Smooth command, but it's not exactly the same. The values that define the degree of smoothing for

each version work on different scales (for instance, 25 on the Refine Edge version is similar to 5 on the stand-alone version). The Refine Edge version always adds a feathered edge (see next) to the smoothed selection outline, whether you want a feathered edge or not, even with feathering set at zero. One advantage of the Refine Edge version of smoothing is that it allows you to see the degree of smoothing change as you alter it, whereas with the stand-alone version you have to apply the smoothing before you see the result (It's best to use the blue preview buuton to observe the degree of smoothing applied by the Refine Edge command, which allows you to see the marching ants rather than the coloured overlay).

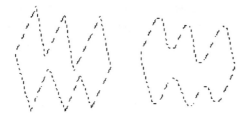

Figure 9-41
The Smooth command rounds off
the corners of selections.
Left: Before smoothing
Right: After smoothing

Feather

Feathering creates a very soft-edged selection boundary in comparison with the highly localized softening created by anti-aliasing (Figure 9-42).

Figure 9-42 A circular selection (left) used to create a sun effect by filling it with colour.
Centre: With no feathering. Right: With feathering

The Feather option in the Refine Edge command is the same as the stand-alone Feather command in the Select menu and the Feather option in the Option bars of some of the selection tools. The Refine Edge version has the advantage over the other routes in that it

provides a preview of the feathering effect before you actually apply it. To do this set the preview mode to overlay mode (the red button). The colour of the overlay shows the actual fading of the feathered edge (The marching ants mode, in contrast, doesn't indicate the gradation of the feathering at all).

Even using the preview the effects of feathering can be hard to judge. If you don't like the effect that you've created after you've actually applied the feathering, go back one step by using the Undo arrow or by using the keyboard shortcut of Command-Z (Mac) or Control-Z (Windows).

Figure 9-43
The amount of
feathering of a
selection edge
can be varied

It's best not to use too much feathering on a selection. If you apply a lot of feathering to a small selection the feathering from each side overlaps in the middle, with results that can be very dull indeed.

The Feather option is very useful when you want to cut a section out of an image and give it a soft edge or vignette effect (Figure 9-44).

Figure 9-44 The Feather command is particularly useful for creating vignette effects

Expand

This command moves the edge of your selection outwards, by the number of pixels that you type into the dialogue box (Figure 9-45). You'll find it in the Select>Modify submenu.

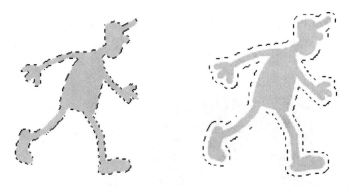

Figure 9-45
The Expand command
moves the edge of a
selection outwards

Don't confuse it with the Contract/Expand option in the Refine Edge command, which allows selections to expand to a lesser degree and in a less controlled manner (page 252).

The command can be useful as an aid to increasing the thickness of lines in line drawings that are too thin (Figure 9-46).

Figure 9-46 You can use the Expand command to increase the thickness of lines in line art. This is done by selecting the lines, expanding the selection, and then filling the new selection with black (centre). To add variety to a thickened lines (right), erase parts of them to allow the thinner lines on the original image (which is on a separate layer) to show through

To increase the line thickness, first select the black lines in the image, such as by using the Magic Wand (with Contiguous unchecked so that it selects all of the black with one click). Then use the Expand command to move the selection lines out by a small amount.

Next, on a new layer above the original one, fill the new selection area with black (Use a new layer so that the original image is unaffected).

Using this technique some of the resulting lines can sometimes be too thick, giving the image a crude appearance. To remedy this, erase some of the thicker lines in areas where they appear too weighty. As a result the thinner lines of the original on its separate layer will be revealed, creating the effect of a varied line (Figure 9-46, right).

This technique is particularly useful for thickening the lines of scanned drawings where the original lines are too thin and faint (Figure 9-47).

Figure 9-47
Left: a sketch
with thin lines
Right: the lines
thickened

Contract

The Contract command works in the same way as the Expand command, except that it makes the selection smaller rather than larger (Figure 9-48).

You'll find it at Select>Modify. Don't confuse it with the Contract/Expand option in the Refine Edge command (page 252), which allows selections to contract to a lesser degree and in a less controlled manner.

It won't affect selection lines that run along the edge of your canvas: they'll stay attached to the edge rather than shrinking inwards, which is usually the way you'd want it.

Figure 9-58
The Contract command.
Left: Before applying
Right: After applying

Grow

This command makes a selection area larger by adding extra colours to a selection that are similar to the colours that are already in the selection. The extra colours have to be touching the original selection in order to be included. A typical time when you'd use this is when you make a selection using the Magic Wand, and the wand doesn't select as many shades of a colour as you were hoping. Here in Figure 9-59 I've used the command to increase the number of shades of green selected in a tree.

The command works on multiple colours at the same time. So if your original selection contains say red and green, the enlarged selection area will encompass adjoining areas of different shades of red and green.

Don't confuse the Grow command with the Expand command, which increases a selection by a preset width all round its edge rather than by 'flowing' into adjacent areas of colour. Also, don't confuse it with the Similar command, described next.

Figure 9-59 The Grow command, here applied to the leaves on the tree, expands the selected area to include more colours at the edge of the selection area. Use the command several times to expand the selection further. Here the final selection includes most of the leaves

The amount that the selection area expands depends on the Tolerance setting for the Magic Wand. A low tolerance only selects very similar colours, while a high tolerance selects more diverse ones. You can use the command to expand a selection made using any tool, not just the wand, but it's always the wand's tolerance level that applies to the amount of growth.

If you find that you've selected too much using the command, use the Undo command to return to the previous position and set a lower tolerance.

Similar

This command increases the area covered by a selection in the same way as the Grow command, by encompassing colours that are similar to the original colours in the selection. The difference is that it selects colours that are anywhere on the whole active layer, including areas that aren't adjacent to the initial selection area. It's essentially the Grow command in non-contiguous mode.

It chooses similar colours using the tolerance value of the Magic Wand. The higher the value, the more colours are chosen.

Don't think that the Similar command is the same as using the Magic Wand in non-contiguous mode (where you select the *same* colour across the whole canvas rather than a wider range of colours) The clue is perhaps in the fact that the command is called Similar – not Same.

Border

Using this command, the original selection line is discarded and two new selection lines are created on either side of the old one, a little like tram lines (Figure 9-60). The area between the lines forms a band or border that can be filled with colour (or cut from the image). You can fill the border with whatever artwork you want: a single colour, a series of brushstrokes, a texture or part of a photograph.

Any shape of selection outline can be used to generate a border – it doesn't have to be a traditional rectangular or oval border (for which you'd use the Rectangular or Elliptical Marquee tools to create your original selection shape).

Set the width of the border in the command's dialogue box.

Figure 9-60 The Border command. 1: The original selection outline. 2: The selection outline after using the Border command. 3: The selection filled with an image. 4: The selection line removed, leaving the final border

This command isn't as useful as it sounds, unfortunately. This is because the edges of the border are soft and fuzzy, and nothing you can do can make them sharp. The reasoning behind this eludes me.

If you want to create a *hard-edged* border from a selection outline (Figure 9-61), you can use the following method instead – using the Stroke command.

Figure 9-61
A sharp-edged border can be produced by using the Stroke command rather than the Border command

Create your original selection outline, then go to Edit>Stroke (Outline) Selection.

In the box labelled Width enter the width that you want your border to be. In the panel labelled Location click where you want the border to be relative to the selection line (along the inside edge, centred on the line, or along the outside edge).

Next, click the rectangle labelled Color and choose a colour (any colour) from the Color Picker that opens. If you want your border to be a particular colour you can choose it now or you can make that decision later. Then click OK. A broad stroke forming a border will be created in the colour and the width that you chose.

That's it – your border.

If it isn't the colour that you want it to be, or if you want to fill it with artwork rather

than flat colour, click on the colour of the border using the Magic Wand in order to select the border. Then delete the colour inside the border. This leaves you with the two parallel selection lines that are defining the border.

You can now fill the space between the lines with whatever colour, artwork or brush-strokes you want (Figure 9-61). To fill the border with brushstrokes simply paint across the border with the Brush tool – the colour will only be applied between the 'tramlines' (It's probably best to create a new layer on which to do your painting. The selection outline will stay active and will operate on whichever layer is active). You can also paste part of a pre-existing image such as a photograph into the border. If the image is on a layer in the file that you're working on just make the layer active and copy the area that's inside the border's outline, by pressing Command-J (Mac) or Control-J (Windows. If the image that you want to include in the border is in a different file, open the file and drag the image across to the file that you're working on.

Reselect

This reinstates the last selection outline that you used on an image. Elements remembers the last selection outline that you made – until you close the file or you alter the image's width, height or resolution, when it's forgotten.

See also the Save Selection command, next.

Save Selection

Use this command if you want to retain the shape of a selection in order to use it later. It saves a copy of the selection outline in a list of outlines that can be reapplied. It's particularly useful if there's a complicated outline that you know you're going to need to define more than once, as it saves you the trouble of having to tediously redefine the outline from scratch each time.

To save a selection, first make the selection, then click on the command to open the Save Selection dialogue box. Type in a suitable name for the selection. To use the saved selection later, go to Select>Load Selection.

To modify a saved selection, such as to add to it or subtract from it, create a new selection outline to define the area that you want to add/subtract then in the Save Selection dialogue box find the selection that you want to modify by clicking in the box labelled Selection on the arrowhead next to the word New. Then click on one of the options for modifying your chosen selection.

The Magic Extractor

The Magic Extractor is used to semi-automatically separate (or extract) part of a layer from its surroundings. It does this by selecting the desired area and then erasing the surroundings. This leaves behind only the selected area on an otherwise transparent layer.

I have to admit that I've never used the Magic Extractor, other than to see how it works.

It doesn't do anything that can't be done using other, simpler techniques. It works in a different way to the rest of Elements, and has the feel of being something that's been grafted on. In previous editions of this book the explanation of how to use the extractor ran to six pages. Who needs six pages of explanation for a tool that you don't really need, in a programme that's top-heavy with other gadgetry that has to be mastered anyway? So I'm going to bypass it for this edition of the book. I have a hunch that by the time the *next* edition comes out the tool will have been greatly modified and simplified (just as its cousin in earlier versions of Elements, the Magic Selection Brush, has been modified into the much more streamlines Quick Selection tool).

Making Selections

Cutting, Copying, Pasting and Moving

10

You can cut an area out of a layer in very much the same way that you can cut a piece out of a sheet of paper with a pair of scissors .

The cut part of the image can then be discarded, or it can be placed back into an image – either into the original image from which it was cut (perhaps in a different place or at a different size), or into a totally different piece of artwork altogether.

You can also copy parts of images, leaving the original part of the image in place, thus creating duplicates that can be placed back into the original artwork or into other artwork.

In this Chapter:

Cutting an area from an image in order to discard it
Cutting an object from one layer and pasting it onto a new one – the easy method
Copying objects onto a new layer
Copying objects into a different image or file
The separate Copy, Cut and Paste commands
The Clipboard
Moving objects
Automatically selecting layers using the Move tool
Moving artwork on the background layer
Be careful using 'Select>All'

Figure 10-1
Objects can be
cut from images
just as though
you're using
scissors on
paper

Cutting an Area from an Image to Discard it

Elements supplies you with a number of ways of removing unwanted parts of images so that you can throw them away completely (rather than removing them in order to use elsewhere, which of course you can also do, as described soon).

To discard small areas from an image the simplest methods are to eraser them or to paint over them, depending on the artwork, as described in Chapter 6.

To remove larger or more complex areas it's better to delete them.

To do this, as shown in Figure 10-2, first define the desired area using an appropriate selection tool (see the previous chapter), then press the Delete key. The selected part of the image will disappear, leaving the area of the layer empty.

Figure 10-2 The steps involved in deleting part of an image.
1: The original image
2: Part of the image selected (The rabbit)
3: Pressing the Delete key makes the selected area vanish

Cutting, Copying, Pasting and Moving

When you cut an object that's 'embedded' in other artwork it will leave a hole in the image, which may need repairing (Whenever possible you should compose artwork with different elements on separate layers, which may help to avoid this being necessary). If your artwork is on the background layer the area that was deleted will be filled with the colour in the background swatch (the lower of the two squares at the bottom of the Tools panel).

With simple artwork you can fill holes by painting over them or by filling them with the appropriate colour using the Paint Bucket (after perhaps using the Eyedropper tool to sample the surrounding colour in order to get a perfect colour match). With more complex artwork it's often necessary to patch the hole with a sample of artwork moved from another part of the image, either by using the cutting and pasting techniques described in the rest of this chapter, or by using the Clone Stamp tool, described on page 337.

Cutting an Object from One Layer and Pasting it onto a New One: the Easy Method

You'll often want to remove part of an image from a layer and then place it back into the image on its own separate layer, a process known as cutting and pasting. This is often the best way to isolate an object so that you can alter it in some way independently of the rest of the image. You may for instance want to move an object to a different part of the image, alter its size or colour, or temporarily hide it from view. In Figure 10-3 I've cut the wind-blown hat from the image on the left and I've then moved it so that it's in its proper place on the man's head (and then I removed the 'movement lines' that indicated that the hat was moving, using the Eraser tool).

Figure 10-3
The hat in the left image is cut from its layer and placed on a new layer so that it can be moved to a different position on the image – onto the man's head (right)

Because cutting and pasting is such a commonly used technique there's a special command that cuts an object from its layer and places it onto a new layer all in one action (Figure 10-4). The command is called Layer via Cut.

Figure 10-4 The Layer via Cut command cuts an object from a layer (here the hat) and places it on its own layer, all in one action

To use Layer via Cut, first select the part of the image that you want to cut and paste, using an appropriate selection tool (see the previous chapter).

Then cut and paste the selected area by going to Layers> New> Layer via Cut.

You'll find that going backwards and forwards to the menu bar every time that you want to use this command is slightly cumbersome and extremely irksome, because you'll probably use the command quite frequently, so it's best to memorize the keyboard shortcut of Command-Shift-J (Mac) or Control-Shift-J (Windows). To remember that it's the letter J that's involved it may be useful to think up some form of association between the letter and the action, although I haven't managed to think of one yet.

When you've execcuted this command your image on the screen won't appear to have changed, other than that the marching ants that defined the selection area will have disappeared. This is because the cut and pasted part of the image remains in exactly the same position relative to the rest of the image – if you look at the Layers panel however you'll see that the object that you selected is now on a new layer all of its own.

Because the object is on its own layer you can then easily alter it in any way you want, such as by moving it. Moving objects is described in detail later in the chapter (page 277), but for the purposes of experimenting with the commands described here, here's a box describing the very basics of moving objects.

Cutting, Copying, Pasting and Moving

The Very Basics of Moving Objects

Here's the simplest method of moving an object on a layer.
Open the Move tool in the toolbox (Figure 10-5).

Figure 10-5 The Move tool

Turn off the check boxes in the Move tool's options bar for Auto Select Layer and Show Bounding Box and Show Highlight on Rollover.

Make the layer that contains the object that you want to move the active layer (which it will be automatically if pasting the object onto the layer was the last thing that you did).

Press and drag the cursor anywhere on the image area.

The contents of the layer containing the pasted object will move as you drag the cursor.

Creating Two or More Versions of an Object – Copying

Copying onto a New Layer

Sometimes you'll want to duplicate part of an image so that you have several copies of it. You may want to do this so that you have two or more copies of the same object repeated in the image, such as in my picture of penguins in Figure 10-6, or you may want to copy part of an image so that you can experiment with altering one version while leaving another one safely untouched as a back-up.

If the object that you want to duplicate is the only object on a layer all you need to do is to duplicate the layer, however if there's other artwork on the layer you'll have to copy and paste the object instead.

Figure 10-6
Create multiple
versions of objects
by copying them
onto separate
layers using the
Layer via Copy
command

The easiest way to copy part of an image is to select the area (using an appropriate selection tool) then to use the Layer via Copy command, at Layer>New>Layer via Copy. The keyboard shortcut for Layer via Copy is Command-J (Mac) or Control-J (Windows).

The command automatically copies the selected area of your image and places the copy on a new layer directly above the original. You won't see any difference in your image, as the copied artwork is directly above the original artwork. You'll see a new layer in the Layer panel however. You can then move or otherwise alter the copy of the artwork that's on this new layer.

In my picture of penguins, I selected the original penguin and used Layer via Copy several times to create more penguins, each on its own layer. I then moved each penguin across the image using the Move tool (described in the box above).

Copying Part of an Image into a Different Image

It's possible to copy part of an image onto a different image altogether, rather than just onto a new layer in the original image (Figure 10-7).

Figure 10-7 Copying an object from one image to another

Cutting, Copying, Pasting and Moving

There are several ways of doing this – here's maybe the simplest method (Figure 10-8).

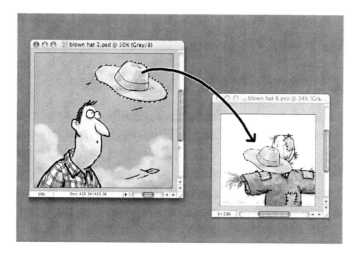

Figure 10-8
You can drag a selected object from one image to another if both images are open on the screen at the same time

Open both the image that contains the object that you want to transfer and the image that you want to transfer it to, so that they're visible on the screen at once (One way to open a second image is to use the keyboard shortcut of Command-O (Mac) or Control-O (Windows). You don't have to be able to see the whole of each image – all you need to see is the object that you want to copy and any part of the image that you want to move it to. If necessary, adjust the size of the images using the Zoom tool (The Zoom tool is usually easiest to use if the check box for Resize Windows to Fit is ticked, so that the windows containing the images don't need adjusting manually every time you zoom. The box can be found in the Zoom tool's Options bar or in the General Preferences panel, at Command-K (Mac) or Control-K (Windows), where it's labelled Zoom Resizes Windows). There's more about zooming on page 88.

Select the area of the image that you want to move by using an appropriate selection tool, dealt with in the previous chapter, Chapter 9.

Then use the Move tool (described briefly on page 269, and in more detail on page 277) to drag the object across the screen, dragging it off the original image and onto the other, where it will automatically be copied onto a new layer (leaving the original object still in place).

While you're in the act of moving the object a hole may appear in the image from which you're dragging it, but this is only temporary. As soon as you've dragged the object off the image the computer realizes that you're copying the object to another image, rather than just moving it to a new position on the original image, and the hole disappears.

If you want to copy a whole layer from one open file to another, rather than just copying a selection, you can use the same method as described above, by dragging on the whole layer. You can also copy a layer by dragging its individual panel from the Layers Panel across and onto the other image.

The Separate Copy, Cut and Paste Commands

The methods of copying, cutting and pasting described above are often the most convenient ways to execute these processes when you're working in Elements, as they work semi-automatically – however copying, cutting and pasting can also be done by using separate commands for each stage. Using the separate commands is particularly useful if you're transferring an object between images and you don't have both images on the screen at the same time, as you can copy or cut an object from one image before you open the other one to paste it into.

Although using the individual commands sounds more complicated than the previous methods, it's basically just a matter of pressing a few shortcut keys, which after a few attempts will become a semi-automatically process itself.

Cut or copied objects can be pasted into other programmes that accept images, such as word processing programmes like Microsoft Word or web design software, by using that software's paste command.

The Copy and Cut Commands

The Copy and the Cut commands are both ways of extracting a selected area from an image so that you can use it elsewhere, either in the same image or in a different image. The difference between the two is that the Copy command makes a copy of the object and leaves the original in place, while the Cut command removes the original, leaving an empty space (Figure 10-9). If you're in doubt about which one to use it's safer to copy an object rather than cutting it, as this leaves the original unaltered.

To extract part of an image using the Copy or Cut commands, first define the area that you want to extract by using an appropriate selection tool (see Chapter 9).

Having made your selection, decide whether you want to copy it (therefore leaving the original in place) or cut it (which will remove the original).

To copy an object go to Edit>Copy in the menu bar or use the keyboard shortcut: Command-C (Mac) or Control-C (Windows). That's C for Copy.

Cutting, Copying, Pasting and Moving

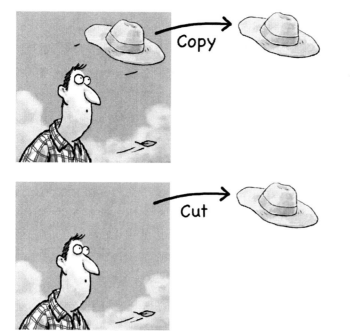

Figure 10-9
The difference between copying and cutting.
(If the cut hat had originally been on the same layer as the sky it would leave a hole in the sky)

To cut an object go to Edit>Cut in the menu bar or, more conveniently, use the keyboard shortcut, which is Command-X on a Mac or Control-X in Windows. That's possibly X for extract, or maybe the X looks like a pair of scissors. Using this method of cutting, the selected object disappears from the image. If it leaves an obvious empty space in a layer this will need filling.

When you copy or cut part of an image the relevant item is placed on part of your computer called the Clipboard, which is a sort of temporary holding area (described in more detail on the next page) from which it can be pasted into another image (or back into the same image).

Pasting Objects into an Image

Once you've copied or cut an object you can paste it onto an image, as in Figure 10-10, by going to Edit>Paste or by using the keyboard shortcut of Command-V on a Mac or Control-V in Windows. I don't know why it's V, but you may remember it because V looks like a pointer indicating that you're going to place something somewhere.

273

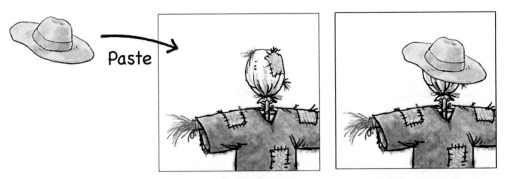

Figure 10-10 The hat pasted into a different image

When you paste an object into a different image the object is pasted into the position at the centre of the visible part of the image (unless there's a selection area active on the image, in which case it'll be pasted at the centre of the selection area).

If you copy an object and then paste it straight back onto the image that it's copied from, the copy will normally be pasted directly above the original object from which it was taken. This is because the selection area that you used in order to define the object remains active when you make a copy, and, as mentioned in the previous paragraph, if there's an active selection area, objects are pasted into the middle of it.

Sometimes however, the pasted object seems to 'just miss' the area that it's copied from, and is pasted into a slightly offset position. This often happens when there are transparent pixels in the selection area that was copied as well as coloured ones. The reason for this displacement is that when Elements is centring the pasted object on the original selection area it only takes into account the coloured pixels in the object – any transparent pixels that it contains are ignored. The consequence is that if the copied object has an uneven distribution of coloured and transparent pixels, with most of the coloured pixels over to one side, the object is displaced.

The Clipboard: Where a Cut or Copied Object is Held

When you cut or copy an object – such as the hat in my example – it's temporarily put to one side and is placed on something called the Clipboard, from where you can take it and place it into any image of your choice (When you use the Layer via Cut or the Layer via Copy commands, described earlier, the object isn't placed on the Clipboard, as it's moved directly in the image). You can even place it into a document that's in a totally different programme, such as Microsoft Word.

Imagine the Clipboard as you would an actual physical clipboard. It's where you attach

a loose piece of paper to keep it safe. The loose piece of paper in this case is the bit of the image that you've cut and which you want to hang on to before you use it again.

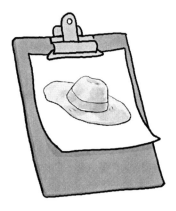

Figure 10-11
A cut object on the Clipboard

There are a couple of things you have to be careful about with the Clipboard though.

Firstly, it will only hold *one* item at a time. So if there's something clipped to it already, and you cut anything else from an image, the clipping that was already there gets discarded – and if you want to get it back you have to take extra steps to retrieve it (such as by using the Undo arrow).

Another point to watch with the Clipboard is that it's shared by different programmes on your computer, so think of it as part of the computer itself rather than as part of Elements.

This is very useful, because it means that if you place anything onto the Clipboard you can paste it into a document created in a different programme. For instance, you can place an image onto the Clipboard in Elements, then open Microsoft Word and paste the image into a Word document.

As a consequence of this, if you place an image onto the Clipboard, and then you get briefly diverted into doing something in a different programme, you may find that when you return to Elements the object on the Clipboard has been replaced by something that you cut from the other programme (such as by a piece of text if you were diverted into doing a spot of word processing).

So, to put it simply, it's best to use the Clipboard as a temporary holding space for an object while you're in the process of moving it, rather than using it as a place to store a valuable piece of artwork.

By default, when you create a new file in Elements, the image has the same dimensions as whatever is on the Clipboard at the time. This is useful when you want to paste an object

from the Clipboard into a new file, as the file will automatically be the right size to accommodate the object, which can them be pasted into it by using Command-V (Mac) or Control-V (Windows).

You can create a new file that already has the contents of the Clipboard on it, by going to File>New>Image from Clipboard.

Copying Everything in a Selection Area when it's on Separate Layers

The standard method of copying objects in Elements only selects artwork from the single layer that's active at the time. However there are a couple of ways of copying the artwork from several separate layers simultaneously.

If you want to copy several entire layers from one image to another, use the following method.

Open both images – the one that contains the artwork that you want to copy and the one that you want to copy it onto (or open a new, empty image file if you want to copy the art to a blank document) – so that they are both visible on the screen together.

With the image that you want to copy from as the active image, select the individual layers that you want to copy by clicking on their individual panels in the Layers panel while holding down the Command key (Mac) or Control key (Windows). The separate panels will become highlighted. If you select a layer by mistake, a second click will deselect it.

Drag the panels across onto the image that you want to copy them to.

The copied artwork will appear on the image as new layers.

If you want to copy a selected portion of an image that's spread across several layers you can use the following method. This method has a drawback though, as it automatically merges the copy of the artwork onto a single layer.

First create a selection outline using whichever method is most appropriate for your work, then go to Edit>Copy Merged.

Everything visible within the selection area is copied onto the Clipboard as a single piece of artwork, no matter which layer it was on (as long as the layer is visible). This piece of artwork can then be pasted back into the image (or into a different image) by using the Paste command (Command-V on a Mac, or Control-V in Windows).

Unfortunately there's no command that cuts (rather than copies) selection areas from multiple layers.

Moving Objects

Moving Selections Across an Image

You'll frequently want to slide images or parts of images around your canvas in order to reposition them.

You can do this by using the Move tool (Figure 10-12).

You'll find the tool at the top of the toolbox, but the easiest way to open it is to use the keyboard shortcut of pressing the V key (That's V as in moVe. Alternatively you may be able to remember that it's this key because it looks like a pointer that you press on the artwork in order to move it).

Figure 10-12 The Move tool

When you press and drag the Move tool's cursor on an object, the object slides across the surface of your image.

Unlike many tools, where you have to specifically choose which layer you want to work on by making the layer active in the Layers panel, the Move tool can automatically select and activate a layer itself (Figure 10-13).

Figure 10-13 Auto Select Layer automatically chooses the layer containing the artwork that you click the tool's cursor on

To allow it to do this, tick the check box for Auto Select Layer in the Options bar. Now when you click the cursor on any particular part of the artwork in a stack of layers, the layer containing that artwork automatically becomes the active layer. This is extremely useful, as it means that you don't have to work out which layer your artwork's on beforehand.

You can even select several layers together, so that they can be moved in unison. To do this hold down the Shift key while clicking on the desired areas of artwork.

In my example in Figure 10-13 there are five layers each containing a different butterfly, so using the Auto Select Layer option here would save me the trouble of sifting through these five layers to work out which is the layer containing the butterfly that I want to move, as it allows me to simply click on the butterfly I want. That's quite convenient, but the principle works just as well if there are 500 butterflies on 500 layers (Figure 10-14): you can home in instantly on any individual layer by clicking on the butterfly on it. This is more than just convenient – it's essential to your sanity.

Figure 10-14
The Auto Select Layer
option becomes more
useful the more layers
there are to choose
from – here each
butterfly is on a
separate layer

Because of the Move tool's ability to automatically select layers without the need to go to the Layers panel you can use the tool as a convenient way of selecting layers even when you don't want to move them (using it as a separate Automatic Layer Selection tool rather than as the Move tool). Temporarily accessing the tool using the keyboard shortcut of Command (Mac) or Control (Windows) while you're still using another tool is particularly useful for this.

As with most things, there are a few caveats that apply when using the Auto Select Layer option, and these are mentioned on page 280.

Cutting, Copying, Pasting and Moving

The Move tool's Options bar also contains a check box labelled Show Bounding Box. This provides access to another feature of Elements called transforming, with which you can distort the shape of an object by moving the corners of a box that surrounds the object (the Bounding Box of the title). There are other ways of gaining access to this feature, explained in Chapter 13 which is dedicated to the subject of transforming. When used with the Move tool this feature is a bit of an unnecessary complication, so I'd recommend that you leave the box turned off.

The other option in the Options bar, Show Highlight on Rollover, is so annoying that it should be reMoved from the programme entirely.

The Move tool moves artwork in the following way.

To move a whole layer you just make the layer active (either manually or by using the Auto Select Layer option), then press the Move tool's cursor on the layer and drag it.

To move part of a layer you first have to define the area you want to move by using a selection tool, then press and drag the Move tool inside the selection area. The selected part of the image on the active layer will then move.

When you place the Move tool cursor inside a selection area the cursor appears accompanied by a pair of scissors (which is a clue as to what it will do next). When you press and drag inside the selection, the selection is cut free and is slid across the layer. When you move a selection in this way you're moving it without actually removing it from the layer that it's on: as a result the repositioned selection will replace the image on the part of the layer that it's moved to. If you don't want to lose that part of the image, cut and paste the selection onto another layer before you move it (explained earlier in the chapter), rather than simply dragging it across its original layer.

If you press and drag outside the selection area the whole layer moves, including the selection outline – unless you're working on the background layer, which won't move.

If you press and drag in Auto Select Layer mode and you happen to press on a region of transparent pixels, the next layer down that has coloured pixels will be chosen. If this happens to be the background layer nothing will move.

The Move tool can be activated temporarily from the keyboard while you're in the middle of using a different tool (with a few minor exceptions) – you don't need to exit the other tool first.

Do this by pressing Command (Mac) or Control (Windows). It's just the one key – no actual letters are involved.

When you use this keyboard shortcut, the Move tool picks the object that it's going to move based on the current setting of the Auto Select Layer button in the Options bar. So if

Auto Select Layer is off it'll move the object on the currently active layer, and if Auto Select Layer is on it'll move the artwork that you press on. If you find that it's on the wrong setting, open the Move tool in the toolbox in order to gain access to the tool's options bar and change the setting.

If you're using the Move tool via the toolbox, the same keyboard shortcut, Command (Mac) or Control (Windows), has a different function, because it's not needed in order to access the tool itself, which is already open. The shortcut temporarily toggles the Auto Select Layer setting while the key is depressed (and then returns to the entered setting when the key is released) – so if Auto Select Layer is turned on the key temporarily turns it off, and vice versa. This can cause temporary confusion.

A Few Factors When Using the Auto Select Layer Option

The Auto Select Layer option is extremely useful, but there are a few circumstances in which it won't select the correct layer.

● Sometimes, if several layers of an image have the same colour on them in the same area it can be difficult to tell which layer has the top-most colours. This sometimes happens when you deliberately match a colour on one layer with the same colour on another layer, especially if the match is there to hide something on the lower layer.

● There's a way of making white pixels on a layer become invisible, by changing the layer's Blend Mode to Multiply, at the top of the Layers panel (page 467). Auto Select Layer can't select through a layer like this, because although you can't see the white pixels yourself, they're still there and are detected by the cursor, so the layer will be selected.

There's a way round this though. What you have to do is to lock the layer by clicking the padlock button an the bottom of the Layers panel (page 212). The Move tool will then ignore the locked layer and will select a lower layer instead

● If you try to use Auto Select Layer on semitransparent pixels that are less than 9% opaque the selection will be made through them to the next appropriate layer, as the pixels are too faint to register with the tool. This only applies if the pixels are semitransparent because they've actually been applied with that degree of transparency (such as with a brush with the opacity control in the brush's Options bar set below 9%). It doesn't apply to pixels that have been made semitransparent by altering the opacity of the layer itself (Indeed in such cases the opacity can be set at zero and the layer will still be selected).

● As mentioned earlier, the Auto Select Layer option of the Move tool ignores layers that are locked (Locking layers is explained on page 212). To select them you have to unlock the layer by clicking the padlock shaped button at the bottom of the Layers panel.

Cutting, Copying, Pasting and Moving

Moving Artwork on the Background Layer

You can't move the background layer as a whole layer, because it's 'taped down' to your imaginary work surface, but you can make selections of parts (or even all) of the background layer and move them, as though they've been cut out of the taped down layer.

However, if you move a selection on the background layer by sliding it (rather than by cutting it and putting it onto a new layer first) be careful of moving it 'off the edge' of your image. This is because as soon as you deselect the selection, any part of the selection that has been moved outside the image area is cut off and lost. This isn't the case with ordinary layers, where the parts of objects that you move outside the image area remain present though out of view as illustrated with the balloon in Figure 10-16. Imagine that ordinary layers extend indefinitely beyond the boundaries of the visible image, but that the background layer, being the 'canvas' itself, is of a fixed and finite size. If you want to move the background layer so that part of its contents are outside the visible area of the canvas, convert it into an ordinary layer first (by double-clicking its name in the Layers panel). If you only want to move a selected part of the background layer, paste the selection onto an ordinary layer before you move it – using Layer>New>Layer via Cut or the keyboard shortcut of Shift-Command-J (Mac) or Shift-Control-J (Windows).

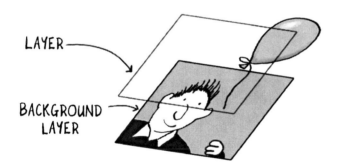

LAYER

BACKGROUND LAYER

Figure 10-16
Ordinary layers overlap the canvas, and their contents can be moved in and out of view, as here with the balloon.
The black line shows the edge of the canvas area, not of the layer

Don't Use 'Select>All' to Move a Layer's Contents

Don't be tempted to use the command Select>All to select the contents of a layer if you want to move the entire contents of the layer . This command only selects the parts of the image that are within the bounds of the canvas area, which means that any parts of the image that are hidden from view outside the canvas area – such as parts of the balloon in Figure 10-16 – aren't selected, and will be left behind. To move a whole layer all you need to do is to make the layer active and then use the Move tool: this will move the entire contents of the layer, including areas that are outside the visible canvas.

Adding Colour

11

So far little mention's been made of the use of colour in Elements. Everything up to now could have been done quite satisfactorily in black, white and gray.

However, adding and altering colour are amongst the core techniques of using the programme, and at their simplest they take almost no skill at all.

In this Chapter:

Setting an image so the it will accept colour
Colour and printing
Foreground and background colours .
How to choose colours
The Color Swatches panel
Sampling colours with the Eyedropper
The Color Picker
Applying colours
Automatically filling areas with flat colour
Pouring colour onto well defined areas of your image with the Paint Bucket
The Gradient Fill

Setting an Image to Accept Colour

When you create a brand new document in Elements (by going to File>New> Blank File for instance) you can dictate whether the image that you're going to create is going to be in colour or black and white (If you open colour photos in Photoshop you don't have to bother with this, as the documents are automatically in colour).

Creating a new document that will accept colour is simplicity itself. Indeed, if all of the images that you work on are in colour you don't need to do anything, as the colour settings for any new document will take their cue from the previous one. When you create a new file the New File dialogue box opens. In the box set the Color Mode to RGB Color.

RGB is short for Red, Green and Blue, and refers to the component colours of an image. These are the three primary colours from which all other colours are produced on your computer screen, by mixing them in different proportions.

If there's going to be no colour in your artwork – just black, white and grays – it's best to create your image in Grayscale mode, as this uses much less of your computer's memory.

If you've got a black and white, or grayscale, image to which you want to add colour, you can convert it so that it will accept colour by going to Image>Mode>RGB Color (Ignore the Index Color option, which is a special mode that uses only a limited number of colours).

If you want to add colour to an image that's in Bitmap mode (which is a specialized mode that only allows pure black and white, with no shades of gray) you have to convert the image to Grayscale first, before you can convert it to RGB Color.

Colour and Printing

When you create prints of images from Elements files you may notice that some colours are muted or have shifted slightly in colour compared to their screen counterparts.

This is because the RGB colour mode that Elements uses in order to create its images is specifically designed for displaying images on-screen. A screen is capable of displaying many more colours than a printer can print (due to the limitations of the inks used in the printing process), so a printer prints the closest approximation to the colours that it can manage.

Some programmes, such as the full version of Photoshop, include an alternative colour mode, CMYK, which is specially geared towards displaying printable colours. CMYK is short for cyan, magenta, yellow and black (where K stands for black, because the letter B is used to represent blue). These are the colours of standard printing inks.

If you want to produce professional quality work in which the accuracy of the printed colours is absolutely paramount you should consider investing in a programme that handles CMYK colours, although such programmes are much more expensive than Photoshop Elements (The full price Photoshop is six or seven times more pricy than Elements). However, before you lose too much sleep worrying about colour accuracy, the RGB colours produced by Elements are more than accurate enough for most purposes. For one thing, desktop printers such as the type that you may have sitting next to your computer at home are configured specifically to accept and interpret RGB images. Most photographic images are perfectly adequate in RGB mode (as the colours in them are generally naturalistic) – it's only when you start adding excessively zany bright colours to images that you may run into trouble.

Foreground and Background Colours

Before I introduce you to the different methods of choosing colours I'd like to draw your attention to the overlapping squares at the bottom of the Tools panel (Figure 11-1).

If you can't see these squares in your Tools panel it's probably because the Tools panel has extended itself off the bottom of your screen. Click the double arrowhead in the bar at the top of the Tools panel in order to make it shorter (and dumpier).

Figure 11-1
The foreground and background colour swatches, containing black and white (left) and different colours (right)

Think of these squares as your paint pots, or inkwells, as in Figure 11-2

Figure 11-2
You can think of the colour swatches as paint pots, or inkwells

Technically these squares are known as the foreground colour and background colour swatches.

You can change the colours in these squares to any colours that you like, just like changing pots of paint. I'll explain how in a moment.

The foreground colour is the more important of the two colours, as it's generally the colour that will be applied as 'paint'.

The background colour has two uses.

It can be used as a second source of colour that can be applied to your image as paint. For this purpose it's a good idea to think of the background colour as a secondary colour that you keep in reserve, or in the background, in a paint pot behind the main colour that you're using (as with the pots in Figure 11-2).

The other use of the background colour is to apply colour to the background layer, which is possibly where the background colour gets its name from.

You can apply the background colour to the background when you create a new file, by choosing Background Color in the list labelled Background Contents in the New File dialogue box.

Once you've created a file, changing the colour of the background colour swatch doesn't automatically change the colour of the background layer – at least not in any way that you'll notice superficially. You'll see that the background layer appears unchanged whenever you alter the background colour. However, at a deeper level the colour of the background layer has indeed changed. A possible way to think of it is that the colour displayed in the background color swatch is the colour of the actual 'paper' or 'canvas' that underlies any colours that are already applied to the background layer. Whenever you change the colour in the background colour swatch this *underlying* background layer of paper or canvas changes colour, it's just that you can't see it because of the overlying layer of 'paint' that's covering the canvas. If you use the eraser on the background layer the paint will be erased and will reveal the colour of the surface beneath. (As soon as part of the underlying layer is revealed it becomes part of the surface, so if you change the background colour again the area of revealed colour will remain unchanged. Does that make sense? You really have to try it.)

The most commonly used colours for the foreground colour is black and for the background colour white. You can switch the swatches automatically from any other colours to these colours by clicking the miniature version of the icon that sits alongside the swatches. Alternatively, and more conveniently, press the letter D on the keyboard (D for default setting, or possibly even for Drawing in black and white).

To swap the foreground and background colours round, click the double-headed arrow at the top right of the swatches, or press X on the keyboard (X for cross the colours round). This is a particularly useful technique when you want to paint with two different colours alternately, because you can store one colour out of the way as the background colour while you use the other one, then flip the two as required.

How to Choose Colours

Photoshop Elements has three principal ways in which you can choose the colours that you want to apply to your artwork.

The two simplest methods to use are the Color Swatches panel or the Eyedropper, described next. Both of these work by using pre-existing colours: the Color Swatches panel picks colours from a ready-made selection, while the Eyedropper picks colours by sampling them from any open image on the screen.

Neither of these methods allows you to directly create new colours from scratch, although you can alter them once you've applied them. To create brand new colours you have to use the third method – the Color Picker – which I'll come to later.

The Color Swatches Panel

The Color Swatches panel displays a selection of swatches, or preset colour samples, from which you can choose an appropriate colour (Figure 11-3).

Open the panel in the menu bar at Window>Color Swatches.

Figure 11-3
The Color Swatches panel
(minus the colour)

You pick a colour simply by clicking on the swatch of the desired colour.

You can pick a colour in this way no matter which tool you're using in the Tools panel. Just move your cursor over the swatches and the cursor will temporarily turn into an

eyedropper – for sucking up the colour of your choice. That colour then becomes your new foreground colour, which is the colour that you usually paint with. The foreground colour swatch at the bottom of the Tools panel changes it reflect this. When you move the eyedropper away from the panel and back onto your artwork it turns back into the cursor of the tool that you're using. If you're using a tool that applies colour, such as the Brush, you can then apply the colour immediately.

It's as easy as that, and very fast and convenient to use.

Occasionally you'll want to alter the background colour rather than the foreground colour, such as when you want to have a second colour to paint with. Do this by pressing Command (Mac) or Control (Windows) while you click a colour swatch.

If you forget which key to use in order to change the background colour you can cheat by choosing a new colour as the foreground colour then flipping the foreground and background colours' positions (by clicking on the curved arrow beside their swatches). Using this method you lose your original foreground colour unless you flip the colours beforehand to place the foreground colour onto the background colour swatch. You have to do a lot of flipping when you use this technique!

There are two ways of displaying the Swatches panel – either as a block of coloured squares (Figure 11-3), or as a list of the names of the colours with the squares alongside (shown in Figure 11-5). To choose the version you prefer, click on the obscure little button at the right hand end of the dark bar at the top of the panel (the bar with the words Color Swatches at the opposite end) – it shows a downward pointing triangular arrowhead and four horizontal lines (symbolising a menu list). This will open a pop-up menu where you should go down to the group of four entries that starts with Small Thumbnail. You can choose to have the coloured swatches either large or small by choosing the appropriate size from the list.

When you're using the usual Small Thumbnail view the names of the colours appear in little flash-up boxes when you hold the cursor over the swatches. If this feature isn't working on your computer you can turn it on by going to Edit>Preferences>General (Windows), or to Photoshop Elements>Preferences>General (Mac), and putting a tick in the box for Show Tool Tips.

You can add new swatches to those already in the Swatches panel, in order to increase the choice of colours that are available, and you can even create completely new sets of swatches containing specific colours that you use regularly or for particular projects, as explained soon.

If the exact colour you want isn't among the available swatches you can pick a swatch that's approximately the right colour and then alter the colour before you apply it.

The colour of the swatch that you've picked will be displayed as the foreground colour swatch at the bottom of the Tools panel (or the background colour swatch if you specifically choose to change the background colour – see previous page). Clicking on the swatch in the Tools panel will open the Color Picker, described later in this chapter, on page 295, which you can then use to modify the colour.

How the Swatches are Laid Out

The swatches in the default panel are arranged in a logical order (Figure 11-4, left).

If the colours on your panel aren't displayed in columns, but seem to be fairly random or to have a certain ill-defined diagonal order about them at best (Figure 11-4, right) it's probably because the panel is too narrow or too wide for the swatches to be laid out logically. The swatches flow to fit the total width of the panel, which is a bit silly, because as a result they easily become misaligned.

You can line them up by altering the width of the panel. To do this, press and drag the knurled thumbpad at the bottom right hand corner of the panel and move it in or out.

Figure 11-4
The logical order of the colour swatches (left) can be disrupted if the panel is the wrong width (right). To re-impose order, adjust the panel's width

The top left colours in the Color Swatches panel are the primary and secondary hues, red, yellow, green, cyan, blue and magenta. These are followed by white and then a steadily darkening procession of grays, culminating in black.

Next come variations of the colours, generally with different versions of the same colour in columns, one above the other. So, for instance, there's a column of different reds, a column of different yellows, and so on.

Finally, there's a row of browns.

Opening Different Sets of Colour in the Swatches Panel

There is a choice of different sets of colour swatches that you can display in the Color Swatches panel. When you first open the panel it will be displaying a set called the Default set, which is the most useful of the preinstalled sets.

To replace it with a different set click the panel above the top left of the swatches (which will contain the word Default unless you've changed sets). This opens a pop-up list of all of the stored swatch sets.

Move down the list and choose the set you want.

The chosen set will open and replace the one that was on display.

There are a number of preinstalled sets of swatches that you can use, or you can create your own sets of colours as described next.

Make Your Own Personalized Sets of Colours for the Swatches Panel

The default Swatches set contains a useful but limited number of colours. If you find that its range of colours doesn't fit your requirements you can create your own customized sets of colours to display in the panel.

Such personalized sets of colours are useful if, for example, you use the same colours in every frame of a strip cartoon (Figure 11-5). Personalized sets are also useful to reflect the colours needed for different genres of work: for instance you could create a set of different blues for using in seascapes, or one of different greens and browns for landscapes.

Not only can you select the colours that are in the set, but you can name them so that their names reflect their use. In the cartoon strip shown in Figure 11-5 the colours are named after the parts of the image that they're used on.

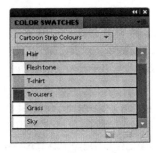

Figure 11-5 A set of repeatedly used colours, here displayed in the panel as a list so that their names can be seen

Here's how you create a new set of colours.

You can't create a new set from scratch, so what you're going to do is to create a duplicate set of swatches using one of the sets that's already available, then you're going to remove unnecessary colours from the set and add a few new ones of your own.

First, open the Color Swatches panel.

Next, decide which set of swatches you want to use as the starting point for your new set (by going to the pop-up list at the top of the panel, which will be displaying the word Default unless you've chosen to use a different set previously). The Default set is probably the best set to use as your starting point anyway, unless you've previously created a different set that you would like to build on.

Saving a New Set of Colours with a New Name

To duplicate a set of colours (so that you can then modify the contents of the duplicate) and save it with a new name, go to the panel commands by clicking the ludicrously insignificant button at the right hand end of the strip at the top of the panel that contains the name Color Swatches. Then, from the pop-up menu that opens, choose Save Swatches.

A dialogue box opens, asking you to name the new set of swatches. The name will be suffixed by the letters aco, which identifies the file that you're creating as a set of swatches.

Your new set of colours is then placed in a special folder named 'color swatches' in which the different sets of colors are all stored. (Make sure you put it in the folder at Applications>Adobe>Photoshop Elements 9>Presets>color swatches. You *don't* want the similarly named folder that's in Library>Application Support>Adobe>Adobe Photoshop Elements 9>Presets>Color Swatches. You can tell when you've got the right folder because it will already contain all of the preinstalled sets – and its name will be no capital letters in the name (it'll be color swatches rather than Color Swatches).

Then click Okay.

Now you need to open the set of swatches that you've just created, so that you can modify its contents (It isn't automatically displayed as the active set in the Swatches panel).

Normally to display a set you simply go to the pop-up list at the top of the panel, but for some reason when you create a new set it isn't loaded into this pop-up list until Elements is turned off and restarted again, so that's what you should do next.

When Elements has been restarted, go to the pop-up menu at the top of the Swatches panel and choose your newly created set which will now be in the list.

Removing Colours From a Colour Set in the Swatches Panel

You can remove a swatch from the set by pressing on the swatch and dragging it to the trashcan at the bottom of the Color Swatches panel. Or you can click the swatch while holding the Options key (Mac) or Alt key (Windows). The cursor becomes a pair of scissors to let you know that you've pressed the correct key.

Do this to all of the colours that you don't want to keep (If you remove all of the swatches from a set you have to add at least one new one before you save the new set, as you can't save totally empty sets).

Adding New Colours to a Colour Set

You can pick new colours that aren't already in a set by either sampling them from an image using the Eyedropper or by mixing them yourself using the Color Picker. Both methods of selecting colours are covered in the next few pages.

When you've picked a colour by either method it becomes the new foreground colour, shown at the bottom of the Tools panel.

To add the new colour to the set in the Color Swatches panel all you have to do is move the cursor to the empty area of the Swatches panel below the swatches, and click. The colour will automatically be added as a new swatch, next to the last one (The cursor will have turned into a paint bucket when you moved it onto the empty space, which is a clue to the fact that you can then pour the colour out of it as a new swatch). Adding a colour to the set in this way is actually too easy I think, as you may find yourself adding colours inadvertently just by accidentally clicking the cursor while it's on the empty space in the panel.

A dialogue box opens when you create a new swatch, in which you can give the colour a name if you wish (or leave the default name). You can go for straightforward names like 'light red,' or if the colour is for a specific purpose something like 'John's blue jacket.'

You can change a swatch's name at any time by double clicking the swatch to open the name dialogue box.

Rearranging Swatches in the Panel

To rearrange the order in which the swatches are displayed in the panel, go to the ludicrously insignificant button at the right of the bar at the top of the panel (the downward pointing triangle and the stack of four horizontal lines), and from the list that appears click on Preset Manager. This will open a display of the contents of the panel, very similar to the panel itself.

Press and drag on any swatch to move it to a new position.

Sampling Colours with the Eyedropper

The Eyedropper (Figure 11-6) allows you to sample any colours that are visible on your screen, either from within the image that you're working on or from anywhere else on-screen. It's so easy to use that it seems like cheating.

Imagine for instance that you want to paint a picture of a daffodil, and you want it to be a shade of yellow that's very daffodil-like. All you need to do is to open a photograph of a daffodil and then use the Eyedropper to sample its colours.

 Figure 11-6 The Eyedropper tool

To sample a colour, select the Eyedropper from the Tools panel, and move the cursor over the image that you want to sample from. Click on a colour, and you'll see that the foreground colour swatch, at the bottom of the Tools panel, changes to that colour.

Alternatively, if you press and drag the cursor on the screen, the Eyedropper samples whichever colour it's over as you drag: you can see the colour in the foreground color swatch changing dynamically to reflect this. When you release the cursor the colour at that point is selected.

You're not limited to sampling colours from images that are open in Elements: you can sample from images in any programme, or in fact from anything that's displayed on the screen, such as menu bars or panels. To do this, press and drag the Eyedropper while it's on your Elements image, then drag the cursor off the image and onto the part of the screen you want to sample.

If you're painting using a lot of sampled colours, you'll soon get fed up of having to pop back and forth between the Eyedropper and the painting tools in the Tools panel as you move between selecting and applying different colours.

There's a way of avoiding this.

When you're using a painting tool, you can temporarily turn it into the Eyedropper by pressing the Option key (Mac) or the Alt key (Windows). When you release the key your painting tool will return.

You have a choice between selecting either the exact colour that's directly beneath the cursor or of selecting a colour that's averaged over a small area, to allow for minor local variations in colour (Figure 11-7).

To choose the option that you want, go to the tool's Options bar, to the box labelled Sample Size (It's the only box there – the Eyedropper is a refreshingly uncomplicated tool). Choose Point Sample for pinpoint sampling of a single pixel, 3 by 3 Average for a wider sample range covering an area of three pixels square, or 5 by 5 Average for the widest range of five pixels square.

Figure 11-7
Magnified images of the different numbers of pixels that the Eyedropper can sample: Point Sample, 3 by 3 and 5 by 5

The reason that you have this choice of sample size is because unless your colour is a totally flat one the pixels in your image are almost bound to create a slightly mottled finish. By choosing the Point Sample option, and thus only sampling one pixel, you'll possibly pick up an unrepresentative pixel. Using 5 by 5 sampling by contrast may be unrepresentative by sampling too wide an area if the area of colour that you're sampling is quite small or restricted. 3 by 3 is probably the best choice for most purposes.

By default, the colour that the Eyedropper samples becomes the foreground colour. To sample a colour as the background colour, open the Eyedropper tool (as this doesn't work when you're using a different tool) and press the Option key (Mac) or Alt key (Windows).

If you use the Eyedropper on an image that doesn't have a background layer, or on one on which you've hidden the background layer, there are a couple of extra considerations that you have to take into account.

If you sample colours where the pixels on a layer have been made semitransparent (by either lowering the opacity of the layer or of the brushstroke), and there are no other opaque pixels beneath them, the Eyedropper will sample the semitransparent colour at its 100% opacity value – which is more intense than it appears on the screen. This can be very disconcerting if you don't realise what's going on.

Also, if you try to sample an area of completely transparent pixels, no colour will register, so the colour in the foreground swatch will remain unaltered.

In both of the above cases you can tell when you're working on areas with no opaque pixels because you'll be able to see the checkerboard effect that lies behind your whole image (The checkerboard effect can be turned off in the Preferences dialogue box if you find it distracting, but it's worth leaving in place for instances such as this).

The Color Picker

For the greatest control over choosing the colours that you apply to your image, use the Color Picker (Figure 11-8).

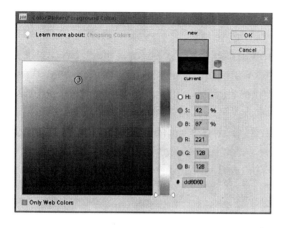

Figure 11-8
The Color Picker

Despite its slightly imposing appearance you'll be pleased to hear that the Color Picker is actually quite easy to use.

It operated by altering the three components that make up any specific colour: hue, saturation and brightness. This is very much what you do when mixing conventional paints for use on paper, but possibly without you realizing it.

I'll briefly explain these three components before explaining how you can alter them with the picker.

Hue. This is the pure unadulterated colour. Think of it as one of the colours of the rainbow, or as a specific wavelength in the spectrum. For instance, it's the red in red, whether it's light red or dark red (whereas orangey-red is a different hue).

Saturation. This is the amount of the hue that's in the colour. At one extreme you have the pure hue at its most intense. At the other extreme all of the hue has leached out (similar to the way that colour leaches out of an old T-shirt or pair of jeans), leaving white or gray.

Brightness. This is the amount of black that's been added to the original hue (so it should maybe be thought of as 'darkness' instead).

Here's how you alter these three components using the Color Picker.

To open the Color Picker click on the foreground colour swatch (or the background colour swatch if you want to change the background colour), at the bottom of the Tools panel.

If the Color Picker doesn't look similar to Figure 11-8, your computer has opened the picker that's built into your computer rather than the one that comes with Elements – either an Apple or a Windows colour picker. To replace this with the superior Photoshop version, go to the menu, to Preferences>General (It's in the Edit menu in Windows, or the Photoshop Elements menu on a Mac). Click on the box labelled Color Picker and choose Adobe.

As I mentioned, the picker isn't quite as intimidating as it looks at first sight.

You can ignore the list of letters and the numbers in the boxes for a start. So that's about 80 percent of the intimidation factor out of the way in one go. Also, notice that the huge coloured square that dominates the panel is actually quite simple in its internal structure.

I'll describe the picker in its default state first, with the button next to the H (for hue) in the column of letters selected (Figure 11-9). The same principles can easily be applied when any of the buttons next to the other letters are selected, should you ever choose to use them (which you may not).

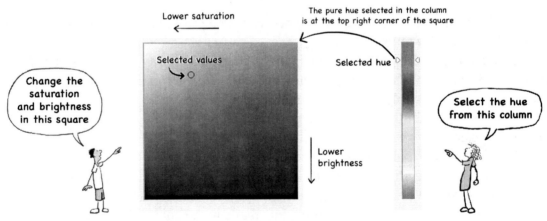

Figure 11-9 How the controls on the colour field and the column work

The tall, thin column of colour to the right of the big square is a spectrum of all of the hues, or pure colours of the rainbow. To choose the hue that you want to use, just click on it and slide the cursor up or down the column. The pair of triangles will move with the cursor.

The big square, called the colour field, is filled with the hue that is chosen in the column. The hue in the square changes dynamically as you move the cursor up or down the column.

The square shows how the hue appears when it has different values of saturation and brightness applied to it. In other words, the square shows the relationships between the three colour values.

The pure hue is the colour in the top right corner of the square. That's the pure red in red, blue in blue and so on. The colour gets less intense as you move across the square, as though the colour is being leached out, showing the different saturation values (The top left corner shows pure white, where all of the colour has gone). The colour gets darker as you move down the square, showing the brightness value, or how much black has been added to the colour (It ends with pure black across the bottom of the square).

To select the values in the colour field, click on approximately the desired colour in the field, then fine-tune the position by pressing and dragging the cursor (which is in the shape of a circle). Moving the cursor horizontally across the square alters the saturation, and moving it vertically alters the brightness.

While you're doing this, notice the two swatches at the top right of the Color Picker. The upper swatch shows the colour that the cursor is pressing on, and the lower one shows the colour that's currently being used as the foreground (or background) colour. When you drag the cursor over the colour field the colour in the upper swatch changes dynamically to reflect the colour under the cursor, while the lower swatch remains static as a comparison.

When you're happy with your choice of colour, click OK and the colour is transferred to the foreground (or background) colour swatch, ready for use.

And that's more or less it. You should now be able to use the Color Picker without having to read any further.

One last thing though. You might have noticed the check box in the bottom left corner of the Color Picker, labelled Only Web Colors, and you may have wondered what it's for, especially if you're doing work specifically aimed at the web. Ticking this box will reduce the colours available in the Color Picker to the two hundred or so colours that are viewable accurately on older computer screens. The subtle tonal variations in the colour field will be replaced by a blocky pattern that indicates the reduced palette of colours available. Screens that can only show these colours are now as rare as black and white television sets, so this check box is probably destined for the trashcan of oblivion soon. The small cube icon that appears alongside the new and current colour swatches is a warning that the currently chosen colour isn't one of the 'web safe' colours. You'll probably notice that this icon is displayed almost permanently. One day soon I expect this icon will be in the trashcan of oblivion too.

Different Ways of Choosing from the Color Picker

There are a number of slightly different ways in which you can choose your colours with the Color Picker. These methods produce the same colours – the only difference is the route that you take.

In the previous section, you chose hues from the vertical column, and saturation and brightness from the large square, or colour field.

You can change which of the three attributes is represented by the column – hue, saturation or brightness – by pressing the buttons next to the letters, H, S and B. Whichever of the three attributes you choose to have in the column, the other two are then represented by the colour field.

Hue is the most useful component to display in the column, and most users will never bother with the other options. However, should you want to alter the saturation of the colour that's in use as the foreground (or background) colour, a simple way is to open the Color Picker and to make saturation the component in the column (by clicking the button alongside the S). Then to alter the saturation just slide the cursor up or down the column (while leaving the square colour field well alone). Similarly, if you want to change the brightness of a colour open the Color Picker and put the brightness component into the column, by clicking the button for B. Then slide the cursor up or down the colum (again while leaving the components in the square colour field untouched).

You can also choose the display using the R, G or B buttons, which stand for red, green and blue. The interrelationships between the colours in the slider and the colour field are a bit harder to grasp when you're using these options. The column is filled with the currently chosen foreground colour mixed with the colour of the button (such as R for red) in varying amounts. The colour at the top of the column contains the maximum amount of the button's colour, and at the bottom none. The colour field's square shows the variations of the other two colours (so with the red button, these will be green and blue). The amount of one colour increases horizontally, from left to right, while the amount of the other increases vertically, from bottom to top.

If you know the exact numerical values for the colour you want, you can enter these into the boxes in the Color Picker rather than by using the column and square.

The long row of numbers and letters next to the hash sign is the code for the chosen colour in html (the code that is used for the construction web pages). This number can be inserted into the appropriate point in the code in order to generate the colour (such as for the background of a web page, the colour of the text and so on).

Applying Colours

So far this chapter has dealt with ways of choosing colours. Now it's time to find out how to actually apply them.

The closest that Elements comes to conventional, real world methods of colour application is to apply the colours by using the Brush tool, described in detail in Chapter 6. Just choose your colour and start painting by moving the cursor on your image.

As well as this relatively conventional method of applying colour Elements puts other, very convenient, methods of colour application at your disposal. One of the most convenient of these methods allows you to colour whole areas of your canvas using just a few clicks, as described next.

Automatically Filling Areas with Flat Colour

You can add flat colour to areas of an image almost instantaneously, with the only task involved being to define the area that needs filling.

One of the most straightforward ways to do this is to create a selection area to fill (Figure 11-10). Making selections is described in Chapter 9.

Figure 11-10
You can 'pour' flat colour onto your image to automatically fill selection areas

To create the selection area use whichever selection method is most suitable for the job in hand.

Once the selection area's been created it can be instantly filled with colour using the Fill command. This can either be done via the menu bar or by using a keyboard shortcut.

Because it's a task you'll probably find yourself doing quite frequently it's a good idea to learn the keyboard shortcut in order to avoid unnecessary trips to the menu.

The shortcut is Option-Delete (Mac) or Alt-Delete (Windows). Using the delete key in order to add something seems rather counter-intuitive, but there you go.

To fill with the background colour instead of the foreground colour, press Command-Delete (Mac) or Control-Delete (Windows).

If you can't remember the keyboard shortcut, you can fill the selection area via the menu bar by going to Edit>Fill Selection (If you go to this command without having made a selection first the command reads Fill Layer instead, and will fill the entire layer with colour). This will open a dialogue box (Figure 11-11) that gives you several options for how to fill your selection with colour. Using the keyboard shortcut this dialogue box is bypassed – which isn't a problem because it's a dialogue box that you hardly ever need to use anyway.

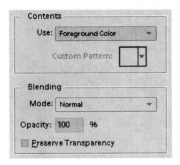

Figure 11-11
The main panels in
the Fill dialogue box,
in the Edit menu

If you do decide to alter any of the options in the dialogue box here they are in brief. Skip to the next section if you're not particularly interested.

In the Contents panel the usual setting for the pop-up list is Use: Foreground Color. This will fill the selection with the foreground colour, which is by far the most likely colour that you'll want to use.

You also have the choice of using the background colour, black, white, mid-gray, a colour from the Color Picker or of using a pattern (See the section about patterns on page 473 if you're interested in this).

The Blending panel, which you need never alter, should be left with all of its settings in their default positions (as in Figure 11-11). This is because this panel offers less versatile ways of achieving results that are better done in other ways (See page 309, about preserving transparency, to understand the Preserve Transparency check box, and see the section about Blend Modes, page 463, to understand the list that's labelled Mode).

Then just click OK.

Adding Colour

Pouring Colour onto Well Defined Areas of Your Image with the Paint Bucket

If you want to fill an area of an image that has a clear-cut boundary you may not have to bother creating a selection outline to define it as above, because clear-cut areas define themselves (Figure 11-12). They are perfect for filling with colour using the Paint Bucket tool.

Figure 11-12
The Paint Bucket tool (above) can be used to 'pour' flat colour onto your image (right) to automatically fill well defined areas

At its simplest, all you have to do to use the Paint Bucket is to click the cursor within an area on a layer that's got an obvious border, and the area is flooded with colour. You don't have to define the boundary at all, as the computer does that for you.

The Paint Bucket is perfect for adding colour inside black outlines, such as in cartoons (Figure 11-13), as the well-defined boundaries make the tool relatively simple to control, and the flat colours that are produced lend themselves very well to this type of work.

Figure 11-13
Despite its complex outline, image on the right was filled with colour in four seconds flat by using the Paint Bucket

The Paint Bucket doesn't work well on areas that have subtle colour variations. It's quite a rough and ready tool, as its name implies. It's hard to control exactly where the colour fill is going to end if the edge of the area is anything other than a reasonably sharp boundary. In fact defining where the fill colour stops is the trickiest part of using the tool.

The Paint Bucket is best used for adding colour to areas that up till then contain no colour at all (apart from perhaps white). Once an area is coloured it's often best to change the colour to a different one by using an alternative method that gives you more control (the Hue/Saturation command, page 320), rather than by repeatedly applying new colours to the same area using the Paint Bucket.

Filling areas that contain no colour can sometimes result in pale fringes along the edge of the fill: see the section on page 305 to find out how to avoid these.

In its simplest setting the Paint Bucket only takes into account boundaries created by artwork that's on the same layer as the one that the fill colour is added to. As a result, when you apply a fill to a layer the fill colour may blend slightly with the colour that creates the boundary of the fill, marginally degrading the edge, and also making it difficult to separate the colours should you want to alter them later (Because of reasons such as these it's always best to make a copy of a layer before you work on it). Fortunately, there's another method of using the tool, where the fill can be applied to a separate layer, independent of the rest of the artwork – described next.

How to Add a Fill Based on Artwork on Other Layers

There's a very useful setting that you can use with the Paint Bucket that allows the bucket to define the area to be filled by taking into consideration all of the artwork rather than only artwork on the active layer. The fill is still only applied to the active layer – it's just that the other layers are taken into account when the fill area is being defined.

One of the happy consequences of this is that fill colours can be applied to a totally separate layer to the rest of the artwork (Figure 11-14).

To use this feature, go to the Paint Bucket's Options bar and check All Layers.

The technique works best when the image that you're working on has a background layer or other layer of opaque pixels underlying the artwork. Otherwise, when you fill areas where the pixels are transparent right through to the 'work surface' (so that you can see the underlying checkerboard effect, if it's turned on) the fill often stops short of the desired edge, leaving a fringe (See the section, Avoiding Fringes Along Fill Edges, page 305).

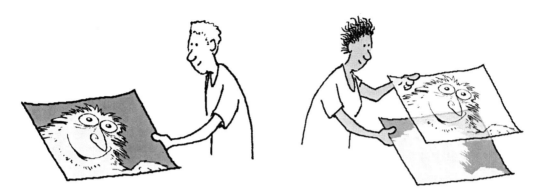

Figure 11-14 Left: In the normal fill mode the boundaries that contain the fill colour have to be on the same layer as the fill. Right: In All Layers mode boundaries can be on any layer

Although it's relatively simple to use, there are a couple of things that you have to watch out for when you're using the Paint Bucket, as I'll explain now.

Leaking Fills

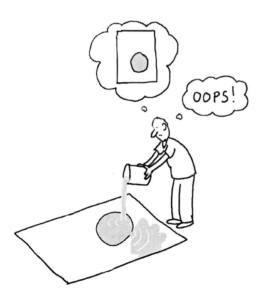

Figure 11-15
If the outline of the shape
that you're filling isn't closed,
colour can flood out onto the
rest of your image

Here's a factor that you especially have to watch out for when you're applying colour to areas that are bounded by drawn lines. This is particularly relevant to cartoons and similar graphic forms of artwork – so pay attention if that's the sort of stuff you do.

When you use the Paint Bucket to fill areas that are surrounded by lines, the lines form an excellent natural boundary with which to contain the fill, but unfortunately it only takes a tiny gap in that boundary for the colour to leak out and flow into other areas, often dramatically filling large parts of the image area (Figures 11-15 and 11-16).

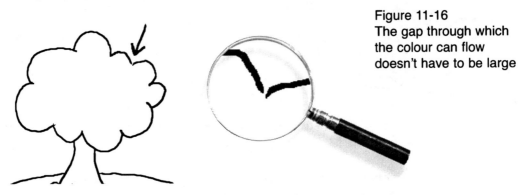

Figure 11-16
The gap through which
the colour can flow
doesn't have to be large

Here's how to fix such breaches when they happen.

When a breach occurs, undo the fill that you've applied by jumping back a step using the Undo command – by either pressing the left pointing arrow in the bar at the top of the screen or via the keyboard shortcut of Command-Z (Mac) or Control-Z (Windows).

Then seek out the offending breach. It may be very small indeed, as in Figure 11-16, so you may have to zoom in to find it.

You then have two ways of removing the breach, depending on the nature of your artwork. If the breach is caused by a gap that's a genuine mistake you can remove it completely by using Method 1 below. If the gap is a deliberate part of the design, and you want to retain it, use Method 2.

Method 1: Accidental gaps

When you've found your gap, remove it simply by painting over it with the Brush, making sure that you're adding the colour to the same layer as the line (If you're using the All Layers option, where the fill colour is applied to a different layer to the one containing the boundaries, you'll have to go to the layer containing the boundary in order to fix it – otherwise you'll add the repair to the wrong layer). Use the same colour as the line (so if it's a gap in a black line, paint over it with black).

Then apply the fill colour with the Paint Bucket again. If you're using the All Layers option don't forget to go back to the layer that you previously applied the fill to, otherwise you'll add the fill to the wrong layer.

If the colour still floods outside the area, the chances are there's another gap somewhere, so you'll need to track it down and repeat the process.

Method 2: Deliberate gaps

Sometimes you won't want to actually remove a gap in a boundary line, because it's an integral part of your design, such as with the hairline of the man in Figure 11-17.

In cases like this you should block the gap using a different method.

This time you need to fill the gap with the same colour that you intend to use as a fill.

If you're using the All Layers mode to do this, so that the boundary of the fill is determined by the artwork on all visible layers, paint the colour onto the layer that's going to contain the fill, rather than onto the layer containing the boundary. Because you're using the All Layers option this repair will serve to define part of the boundary for the fill, even though it's on a different layer to the rest of the boundary. Then when you apply the fill the repair colour will be incorporated into the fill (as in the case of the man's hair in my example), which is very convenient if you decide to change the fill colour later, as you won't have to change the repair colour separately.

If the colour still pours outside the area, there's probably another gap somewhere, so you'll need to find it and repeat the process.

Figure 11-17 Fixing a gap in a line without removing the gap. Left: Here I want to fill someone's hair with colour, but the hairline isn't continuous. Centre: The gaps are blocked using the same colour as the intended fill. Right: After filling, the colour that's blocking the gaps and the fill colour merge as a single area of colour

Avoiding Fringes Along Fill Edges

When you're using the Paint Bucket you'll sometimes notice a fringe between a fill colour and the boundary colour next to it (Figure 11-19). This is particularly noticeable when you're using dark colours.

This fringe is caused because the Paint Bucket has to decide on the position of the

boundary at which it's going to stop filling, and it's chosen to stop too soon.

Figure 11-18
Left: A fringe along the
edge of a fill.
Right: A fill with no fringe

To remedy this, first remove the fill that's leaving the offending fringe. If you've just applied the fill do this using the Undo command, either via the left pointing arrow in the bar at the top of the screen or by pressing Command-Z (Mac) or Control-Z (Windows). If you're removing a fill that's been there for a while you'll have to remove it using a different method, such as by selecting and deleting it.

Make sure that the box labelled Anti-alias in the Paint Bucket's options bar is checked (Anti-aliasing softens the edges of coloured areas and makes colours at boundaries merge together better). If it wasn't checked, check it and try filling again.

If that doesn't improve things, try increasing the tolerance setting in the options bar (explained in more detail soon).

If neither of these steps seems to have much effect, or indeed any effect, the fringe may be caused by the presence of transparent pixels.

Here's how to deal with this issue. The instructions sound rather complicated written here, but actually the process is relatively simple when you actually do it.

In my explanation I'll describe how to avoid fringes when you're adding the fill to the same layer as the fill's boundary. If you want to add the fill layer to a different layer, the process is almost the same apart from the slight complication of having to take an extra layer into account.

First, check whether or not the area of your proposed fill contains transparent pixels. That's basically any area of a normal transparent layer that hasn't specifically had colour applied to it already. You can sometimes recognise an area that contains transparent pixels by looking at the Layers panel (rather than the image itself) and studying closely the thumbnail image of the layer that you're working on. If you can see a checker board effect in the area that you're intending to fill, the area is transparent. Of course, this thumbnail is

rather small, so if you can't see the effect properly you'll have to look on the actual image itself, in which case you'll have to hide any opaque layers such as the background layer that are between the layer that you're working on and the underlying checker board. If you find that you are indeed trying to fill an area that contains transparent pixels the trick is to set the Paint Bucket to All Layers mode (even though you're applying the fill to the same layer as the boundary). You're now more or less ready to fill the area, but due to the fact that you're using the bucket in All Layers mode you need to ensure that there's no artwork on other layers that will interfer with the fill by intruding on the intended boundary of the fill, thus modifying the boundary. If there is any intrusive artwork on any layers that are above the layer that you're working on, hide the layers by clicking the eye icon in the Layers panel. Similarly, you don't want any artwork that's beneath the layer interfering with the fill area either – in fact what you want ideally is a layer of opaque white pixels beneath the layer that you want to apply the fill to (I'll explain why in a moment). Often the easiest way to conceal underlying artwork is to temporarily place a layer directly beneath the layer that you're working on and to fill it with white (You'll then delete this layer once you've applied your fill). If you've got a white background layer with only a few layers above it you can simply hide the layers containing the artwork instead, allowing the layer that you're working on to 'rest' above the white of the background layer. Don't hide the background layer though you want white pixels, not the checker board effect.

Phew – you're very nearly there.

Now all you have to do is to go back to the layer that you want to add your fill to, and add the fill! It'll be perfectly fringeless (hopefully).

The reason that you should use the All Layers mode to fill transparent pixels, even when you're only working on one layer, is this.

When you fill areas that are composed of transparent pixels the fill colour stops abruptly at the edge where the transparent area meets the coloured pixels that are bordering it. The fill colour won't fill any of the coloured pixels that form the boundary of the transparent area, no matter how faint the colours of the boundary are. It's as though the difference between 'no colour at all' and 'any colour at all' is just too wide for the fill to cross.

Employing the All Layers mode gets round this because the Paint Bucket then makes its judgements by treating the whole visible image as though it was all merged onto one layer. This 'removes' the transparent pixels by mixing them with the opaque pixels beneath them.

Other Paint Bucket Options

As well as the features in the Paint Bucket's options bar that have already been introduced, there are a few more settings that you can alter.

Tolerance

This option controls how much difference there must be between the colour that you click on and the colour where the fill stops. The values range from 0 to 255, with the default value being 32. A low tolerance will fill across a small range of colours, and a high tolerance will fill across a wide range of colours (Figure 11-19).

Figure 11-19 How Tolerance works. At higher tolerance settings the Paint Bucket fills a greater range of shades of colour in the original. The fill colour here is black

Contiguous

The word Contiguous means touching or sharing a boundary. With the check box for Contiguous ticked only pixels that are touching each other are filled with the fill colour. If you want all examples of a colour in the active layer to be replaced, regardless of whether they're touching or not, uncheck Contiguous (Figure 11-20).

Figure 11-20
How the Contiguous option works.
Left: In Contiguous mode only adjoining pixels are filled, meaning that only one area is affected (here part of the head).
Right: With Contiguous unchecked, all similarly coloured pixels on the same layer are filled, adjoining or not

Anti-alias

This creates a slightly soft edge to the fill colour. Keep this option ticked unless you specifically want a very hard edge.

Opacity

This setting allows you to use a semitransparent colour as your fill. The colour is overlaid onto the original colour, allowing the original colour to show through, thus creating a mix of the two colours.

A better and more versatile way to create the same effect is to place the fill on a separate layer, at full opacity, and to then adjust the opacity of the layer instead (which has the advantage that you're not committed to your original choice of opacity in the way that you are with the setting for the Paint Bucket's options bar).

On the subject of opacity, see the next item too.

Retain the Degree of Transparency of Colours when Filling with a New Colour

When you fill an area with colour using the fill methods described above, the new colour is applied flat (although as I've just mentioned, it can be semitransparent rather than opaque, allowing colour and shade variations to show through). When you fill areas that contain shading created by using semitransparent colours this shading will be obliterated by the flat colour of the fill (as shown in the central image in Figure 11-21).

Figure 11-21 Left: The smoke from this train is composed of semitransparent colours. Centre: When the smoke is filled with flat colour the semitransparent shading is obliterated, and the colour becomes flat and opaque. Right: Filling with colour when the transparency of the pixels is locked (via the Layers panel) retains the degree of transparency

Examples of semitransparent colour don't only include specially created areas of colour such as the smoke in my example here: they include most soft and anti-aliased edges that are on a transparent part of a layer, such as the soft edges of any brushstrokes and the anti-aliased edges of objects that have been cut and pasted.

Fortunately there's a way that you can apply a fill while retaining the degree of transparency of the pixels that are being filled so they don't become a uniform opaque colour.

To retain the degree of transparency click the Lock Transparent Pixels button at the bottom of the Layers panel – the checkered square next to the word Lock (Figure 11-23).

 Figure 11-23 The Lock Transparent Pixels button in the Layers panel

If you use this technique, take into account the fact that if there are any areas of white in the area that you're filling, they may fill too. The white areas may be invisible if they are against a white background, so you might not realize that they are there until they are disconcertingly replaced by the new fill colour. Solid white is replaced by solid fill colour, so you can't miss it.

The Gradient Tool

Figure 11-24
Left: The sky filled with flat colour.
Right: The sky filled with a gradient fill

You can fill areas with colour so that the fill colour changes tone smoothly and seamlessly, such as in the sky in Figure 11-24, by using the Gradient tool in the Tools panel.

 Figure 11-25 The Gradient tool

In its usual mode the start and end colours of the fill are the foreground colour and background colour respectively. So if, for example, you wanted to produce a fill for a fading sky, you'd choose a dark blue as the foreground colour and either a light blue or white as the background colour (or perhaps a pink or an orange if you wanted a dramatic sunset).

Define the area that you want the fill applied to by creating a selection area. If you want to add a fill to a whole layer, such as to make a background for a whole image, just make the desired layer active without bothering to create a selection area.

To apply a gradient fill, press and drag the cursor. The change of colour of the fill will start where you first press, and end where you release the cursor. The direction of the colour change will be based on the direction that you drag the cursor.

You can choose different ways in which the colours will change. The most useful and simple setting is where the colour changes uniformly in one direction (as in the sky in Figure 11-24), however you can also make it change in much more dramatic ways, such as by making the colours change from a central point or in alternating rings (Figure 11-26).

Figure 11-26
Gradients can radiate out from the centre, and can change colour in different ways

Choose the direction of the gradient, such as whether it will be linear or radiating, from the row of five buttons in the options bar (Figure 11-27).

Figure 11-27 Choose the direction of the colour change here

Click the gradient panel or the Edit button immediately alongside it (Figure 11-28) to open a dialogue box in which you can edit the effects of the gradient.

Figure 11-28
Edit the gradient effects by clicking this panel or the word Edit

Altering Colours
12

Once you've applied colours to an image you'll almost inevitably want to change at least some of them because they're not quite right.

In Elements it's very easy to alter colours.

You can alter them subtly, such as by changing a yellowy orange into an orangey yellow, or you can alter them drastically, such as by replacing a green with a red.

You can also change the tones in your image, making them lighter or darker, or changing the contrast.

In This Chapter:

Alter colours without affecting your original artwork: Adjustment Layers
Changing colours by using the Hue/Saturation command
Changing the tones of an image
Altering small areas of colour using the edit tools

The Two Routes to Altering Colours

It's extremely easy to alter the colours of images in Elements – changing blues to reds, greys to greens, dull colours to bright colours, dark colours to light colours – in fact the ease with which it's possible to do so is one of the major strengths of the programme.

I'll describe how you make actual adjustments and alterations to colours in a moment, but first I need to explain that Elements gives you a choice of two different routes that you can take in order to apply these alterations.

One route applies the alterations permanently, so that all changes that you make are committed to your image straight away. The other route applies alterations provisionally, allowing you to revert back to the original values at any time.

Because of its versatility and flexibility I'd recommend the second, provisional route whenever possible. This route involves the use of an amazing feature of Elements called adjustment layers.

Adjustment layers are so useful that I'm going to describe them right here, right now, before I explain in detail how you actually make any alterations to the colours in an image. I'd recommend that you read the first half of this description now, so that you get an introduction to the concept of adjustment layers, and then come back to the more esoteric second half later, once you're more familiar with the basic principles involved (and by which time you'll realize how incredibly useful adjustment layers are).

Alter Colours Without Affecting the Actual Artwork – Adjustment Layers

Adjustment layers are such amazing things that you really should read at least the beginning of this section so that you can try them out.

In a nutshell, an adjustment layer is a special type of layer that allows you to alter the appearance of the colours and tones in the layers that are beneath it, without you having to lay a finger on the actual artwork itself – thus leaving the original untouched.

Think of an adjustment layer as being like a sheet of special material, a bit like a photographic filter, that modifies the colours of your image as you view your work through it (Figure 12-1). For example you can use an adjustment layer to make the reds in an image turn green when viewed through the adjustment layer.

What's more, you can alter the settings of the adjustment layer at any time, to change the appearance of your colours, all without modifying the actual artwork at all. And you can do this endlessly until you're happy with the results. So you can change the reds in an image

to green, then to blue, then to yellow and back. You can change them endlessly until you're happy with the results.

And all of the time, if you don't like the alterations you've made, you can dispense with them altogether by just throwing the adjustment layer away – leaving the original, pristine artwork, which has remained unaffected throughout the whole process.

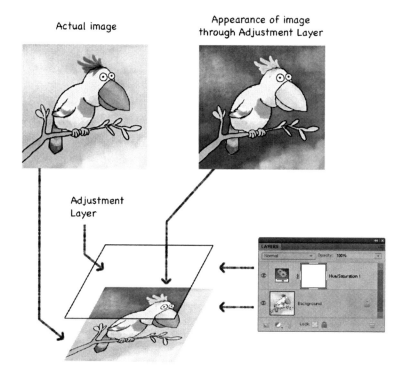

Actual image

Appearance of image
through Adjustment Layer

Adjustment
Layer

Figure 12-1
An adjustment layer
changes the appear-
ance of the image
below it without physi-
cally altering the image
itself.
Here I've used an
adjustment layer to
alter the hue of the
image.
To see it in colour look
on the back cover of
the book

Creating and Using an Adjustment Layer

When you create an adjustment layer it affects all of the layers beneath it (unless you deliberately limit it to affecting only the layer immediately beneath, as described later).

You should therefore create the adjustment layer directly above the highest layer that you want it to affect. Adjustment layers are automatically created directly above the currently active layer, so make the top layer that you want to affect the active layer (If you find that you've placed the adjustment layer in the wrong place you can move it up or down your layer stack afterwards, just like any other layer).

To create the adjustment layer click on the circular icon at the bottom of the Layers panel (Figure 12-2). To remember that this is the adjustment layer button I like to think of

this icon as representing some sort of filter over a camera lens, because camera filters modify what's seen through them just as adjustment layers do. You can also open adjustment layers in the menu bar at Layer>New Adjustment Layer.

 Figure 12-2 The adjustment layer button at the bottom of the Layers panel

Clicking the button opens a pop-up menu showing a list of different adjustment layers that affect your artwork in different ways. The most useful of these are those for Levels, Brightness/Contrast and Hue/Saturation: some of the others you may use very rarely. Or possibly never.

Select the type of adjustment layer that you want to use. If you're experimenting with adjustment layers for the first time the most interesting and fun one is Hue/Saturation, so I'll use that as my example (Use it on a colour image, not a black and white one – or it won't seem so remarkable).

The new adjustment layer appears in the Layers panel, directly above the layer that was active at the time (Figure 12-3). At the same time a dialogue box in which you make your adjustments appears on the screen (Figure 12-4). The particular dialogue box that opens will be dependent on the type of adjustment that you've chosen to make. The box here is the one that opens when you choose the Hue/Saturation Adjustment Layer.

Figure 12-3
An adjustment layer in the Layers panel

The adjustment layer's panel in the Layers panel contains an icon and a thumbnail instead of the usual single thumbnail that you get with a normal layer. The icon is a symbol that indicates that the layer is an adjustment layer. The thumbnail alongside it is an image of something called a mask, which is a form of stencil-like device for defining any specific areas of your image that you want the adjustment layer to affect, described later. When you're not using a mask this thumbnail will be blank (white).

When you move the controls in the dialogue box the image changes its appearance in response. For instance, if you're using the Hue/Saturation box, moving the top slider shifts

the hues in the image. This will change red into yellow, then into green and so on. This will look quite spectacular and more than a little perplexing when you first try it, especially if your image has several colours, which will at first sight all seem to change colour randomly.

Figure 12-4
An adjustment layer dialogue box.
This one's for the Hue/Saturation
adjustment

Nestling at the bottom of the dialogue box are a number of buttons that aid your use of the adjustment layer.

The first button, allows you to limit the effect of the adjustment layer to only the layer directly below it (see next section).

The eye button allows you to turn off the effect of the adjustment layer so that you can compare before-and-after images.

Use the button that looks like an eye with a curved arrow alongside it when you've reopened an adjustment layer in order to re-adjust settings that you've made previously. Once you've made any re-adjustments the button allows you to temporarily revert to the effect that you started with, for the purposes of comparison. Hold the button down rather than clicking it. If you use this button when you're making adjustments to a new adjustment layer (rather than one that you've reopened) the effect will be to show the initial state of the layer, where no settings have been altered (thus having the same effect as hiding the adjustment layer using the eye button alongside it).

The circular arrow button allows you to reset the adjustment layer to the state that it was in when you last opened it. In other words, if it was a new adjustment layer the default settings will be reinstated, while if it was an adjustment layer that had previously been altered the settings that were in place when it was reopened will be applied.

Finally, at the extreme right of the row of buttons, and sitting somewhat in isolation, is a trashcan button. Press this if you want to throw away the adjustment layer completely.

That's the fundamentals of using adjustment layers covered. You should now be able to open them at the very least. How you actually change the appearance of your image using the dialogue boxes of the various different types of adjustment layer is described soon.

The rest of this section about adjustment layers explains how to use them to only affect specific parts of an image – very useful but not crucial. If you think that you know enough to be going on with, skip to page 320, then come back here later.

Limiting the Effect of an Adjustment Layer to One Layer

When you first create an adjustment layer it will affect all of the layers beneath it, but it's possible to make the adjustments apply to only the individual layer that's immediately below the adjustment layer itself.

The easiest way to do this is to click the double circle button in the bottom of the adjustment layer dialogue box (Figure 12-5). When the button is clicked a right-angled arrow appears in the adjustment layer's position in the Layers panel (Figure 12-6), pointing from the adjustment layer to the layer below – indicating that the adjustment layer is only acting on that one layer. The icons in the panel shift slightly to the right to accomodate the arrow.

 Figure 12-5 The linked circles button that you use to group layers

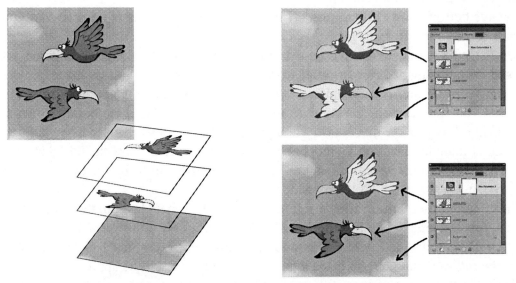

Figure 12-6 Left: Each bird in this image is on a separate layer. Right, top: An adjustment layer affecting all layers beneath it. Right, bottom: An adjustment layer affecting only one layer

An alternative way to make an adjustment layer affect only the single layer beneath it is to hold down the Alt key (Windows) or Option key (Mac), and in the Layers panel place the cursor on the boundary between the adjustment layer and the layer below it. The cursor will turn into a version of the two interlinked circles in Figure 12-5. Clicking the cursor on the boundary will group the layers together. You can ungroup them by repeating the action. If you can't remember which shortcut key to press, try them all in turn until the correct cursor appears. This method is quite useful when the adjustment layer's dialogue box isn't open, as it saves you the bother of having to open the box in order to gain access to the buttons at the bottom.

Limiting Which Parts of the Layer are Affected by the Adjustment Layer

Adjustment layers are often used to modify the colours across the entire surface of an image, however it's very easy to limit the effects to specific localised areas.

To limit the areas affected by Adjustment Layers you use a technique called masking.

In conventional art, masking is achieved with devices such as stencils – an opaque sheet of card with a hole in it (Figure 12-7). This stencil hides – or masks – most of the surface beneath it, so that whatever you're doing to the image, such as applying paint, only affects the part visible through the hole.

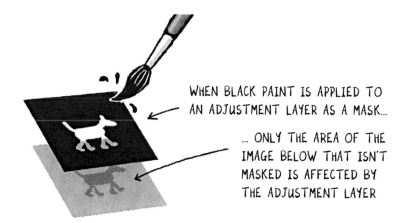

WHEN BLACK PAINT IS APPLIED TO AN ADJUSTMENT LAYER AS A MASK...

... ONLY THE AREA OF THE IMAGE BELOW THAT ISN'T MASKED IS AFFECTED BY THE ADJUSTMENT LAYER

Figure 12-7
A mask is a form of stencil. Changes are only applied to the parts of the image visible through the hole in the mask. Here it's a dog-shaped hole

When you apply a mask to an adjustment layer you have to paint black onto parts of the adjustment layer in order to make those parts opaque, a bit like applying black paint to glass or to transparent plastic film. The effect of the adjustment layer won't be applied to the underlying image in the regions that are covered by the opaque areas because the effect is

blocked, just like with a stencil – the effect is only seen through the transparent areas. The black that's being painted onto the mask shows up in the white thumbnail representing the adjustment layer in the Layers panel, indicating which areas are masked.

To add the black, make the adjustment layer the active layer by clicking on its position in the Layers panel, then with the Brush from the toolbox paint onto your image with black. What you're actually doing now is painting the black onto the adjustment layer itself. The black won't appear as a black brushstroke on the image as you'd expect, because it's being painted onto an invisible layer – the adjustment layer – so the black is invisible too. Interestingly though, if you've already made any adjustments with your adjustment layer you may see the resulting effect as you apply the 'invisible' black – the areas over which you paint (and which have previously been modified by the adjustment layer) will miraculously revert to the unaltered version of the artwork before you applied the adjustments. This is because the black is being painted on as a mask and is shielding these areas from the effects of the adjustment layer.

You can remove excess black either by using the Eraser or by painting over it with white.

If you paint with gray instead of black the masking effect works partially, allowing for subtle changes of effect.

You can also apply the black (or gray) to the mask by using any of the selection tools to define the area, which can then be filled.

If you define a selection area before you create an adjustment layer, the selection area will automatically define the region of the artwork where the adjustments will apply. In other words, it'll become the hole in the mask, while the rest becomes the black area.

Changing the Colours in an Image: the Hue/Saturation Command

One of the most useful features of Elements is that it allows you to change the colours in an image from whatever they are to whatever you want them to be. You can change reds to blues or yellows to greens or whatever to whatever (Figure 12-8). You can change anything to anything else. The most versatile way to do this is by using the Hue/Saturation command.

There are two ways of using the Hue/Saturation command. One is to apply the command directly on the layer that you want to alter, and the other is to work indirectly on

an adjustment layer, described in the preceding pages. The adjustment layer method is recommended hands down, as its effects are reversible, while the other method makes permanent changes to the colours on the layer.

Figure 12-8 Realizing that using black and white images to illustrate changes in colour means that I'm on a hiding to nothing, I thought I'd make the most of an already hopeless situation by using a colour blindness test as my illustration (See the back cover for a colour version though). On the left, the circle contains a number that is hard to separate from its background by people with colour deficient vision (who can't distinguish between reds and greens). Hopefully no one can see the number in this black and white version of the image, as in black and white we're all colour blind. On the right, the colours have been changed using the Hue/Saturation command. For instance the greens that make up the number have been turned to blue, and their intensity has been increased. As a result the number leaps off the page, even in black and white.

You can use the command either on a whole layer, or you can alter only part of a layer by making a selection first.

If you're using an adjustment layer to apply the effect, press the circular, half black, half white button at the bottom of the Layers panel, and from the list that opens choose Hue/Saturation.

If you want to use the much less versatile, but very slightly simpler route of using the command directly on the layer, open the command via the menu bar, at Enhance>Adjust Color>Adjust Hue/Saturation.

Using either method a dialogue box opens containing the Hue/Saturation controls (Figure 12-9). The adjustment layer's version of the dialogue box also contains buttons that are only relevant to the workings of adjustment layers, as described in the previous section about adjustment layers.

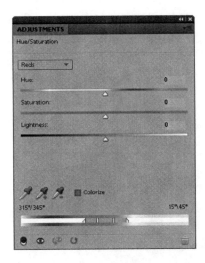

Figure 12-9
The Hue/Saturation dialogue box

I'll walk you through this dialogue box in a way that introduces the easiest bits first. The more difficult bits aren't actually difficult, but they're easier to follow once you know the underlying concepts involved.

The dialogue box shows three sliders, labelled Hue, Saturation and Lightness.

Here's what they do.

First, look at the Lightness control, which is probably the easiest control to understand.

When you move the slider one way the colours in the selected part of your image become darker, eventually turning black, while when you move it the other way they lighten, eventually turning white.

You can see the effect on your image. (If you're using the command via the Menu bar rather than as an adjustment layer make sure that Preview is checked. The alterations aren't actually applied to the image until you press OK. In the adjustment layer version there is no OK button, as the effect is never actually applied to the image but stays on the separate and infinitely alterable adjustment layer.)

While you're moving the slider, notice the two strips of colour at the bottom of the dialogue box. They both show a bar of rainbow colours, but when you move the Lightness slider the bottom of the pair goes light or dark, reflecting the position of the slider. The top bar remains unaltered, as it's a static reference bar.

Now look at the Saturation slider. When you move this to the left, the colour leaches out of the selected part of your image, eventually leaving it in shades of gray. Move the slider to the right and the colours become more saturated and intense.

The effect is reflected in the lower colour bar at the bottom of the dialogue box.

The Hue slider, which is the most interesting of the controls, needs a little more explanation, which is why I've left it till last.

If you move the Hue slider while you've got a multicoloured area of an image selected, the colours in your image will alter in a seemingly random manner. It's quite impressive, and a little disconcerting.

Despite appearances, the shifting of the colours isn't random at all: they're shifting along the spectrum in very strict order. If you look at the colour bars at the bottom of the dialogue box you can see a representation of this actually happening, as the colours in the bottom bar are all shunted along. What the bars are showing is the way that the colours in the image (represented by the top bar) are being replaced by the colours directly below them in the bottom bar. So when blue in the top bar is above red in the bottom bar, blue in your image is replaced with red.

Changing all of the hues in an image at once like this isn't very useful, although it is very impressive: you're much more likely to want to change individual colours – as described next.

Limiting the Range of Colours Affected by the Hue/Saturation Command

Often you'll only want to alter one particular colour in your image, such as changing the colour of someone's T-shirt from green to red, or lightening the blue in the sky.

If you keep the colours in your image isolated from each other, on separate layers, you can target the specific area of colour that you want to alter simply by choosing the appropriate layer. Similarly, if your colours are on one layer but are in distinct areas of your image you can select the appropriate area of colour with a selection tool or paint a mask onto the adjustment layer.

However, if colours are intermingled and are difficult to separate, such as in a photograph, you can use a specific technique to narrow down the range of colours targeted by the Hue/Saturation command.

To do this, first decide broadly which colour you want to change, such as red or yellow.

In the Hue/Saturation dialogue box go to the panel that's just above the three adjustable sliders (and that normally shows the word Master, indicating that it will affect all of the colours in the selected area). Click the panel to reveal a pop-up list of colours that you can target more precisely. From the list choose the colour closest to the one that you'd like to change.

Now, if you look at the pair of colour bars near the bottom of the dialogue box you'll see that a new control has appeared between the bars (Figure 12-10).

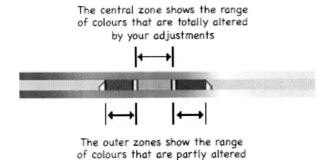

The central zone shows the range of colours that are totally altered by your adjustments

The outer zones show the range of colours that are partly altered by your adjustments

Figure 12-10
The Color Range slider, between the coloured bars, indicating the range of colours that will be affected by your actions

This control shows the range of the colour that you've chosen to target, and which will be altered when you move any of the sliders. So if it's red you're targeting, the range indicator will be alongside the red part of the spectrum.

The central section of this range indicator, between the vertical bars, shows the range of colours for which any changes that you apply to the hue, saturation or lightness sliders above will be fully applied. The surrounding sections, up to the triangular sliders, show the range of colours over which the effect will only be applied partially, ensuring that there isn't a harsh and crude transition between affected and unaffected colours.

When you then adjust your colours you'll notice that in the lower colour bar only the colours within the span of the range indicator change to reflect the alterations.

You can modify the range of colours affected by directly dragging the different parts of the range indicator (Figure 12-11). Dragging on the handles will widen or narrow the ranges of colours affected, while dragging on the gray areas between the handles will move the whole section along the spectrum.

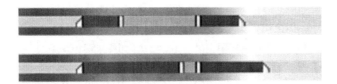

Figure 12-11
The Color Range slider can be moved so that different ranges of colour will be chosen, as in these two examples

You can also specify the colour that you want to alter by directly sampling it from your image. First choose any one of the colours from the pop-up menu above the sliders (in which Master – meaning all colours – is the default setting) in order to make the range control active. Then click on the first of the three eyedroppers above the two colour bars. When you then click the cursor on a colour on the image the colour range indicator will move across to make that colour the centre of the range.

To expand the range to include more colours, use the eyedropper with the plus sign to click on the appropriate colours, and to narrow the range remove colours by using the eyedropper with the minus sign. These can be used in conjunction with moving the range controls manually.

Colouring the Grays in Black and White Artwork Without Colouring the Blacks – Colorize

If you have a grayscale image (that is, an image that contains only black, white and gray, with no colours, such as a black and white photograph), you can turn the grays into colour by using the Colorize command in the Hue/Saturation dialogue box.

As well as being excellent for adding colour to black and white photographs, this command is very good for adding colour to work that has black outlines filled with gray (such as may be the case in some cartoons) – because the outlines remain black while the gray areas become coloured.

You can also use the same command to turn full colour images into single colour images

Just one point before I explain how you use the Colorize command. If you're working on an image that contains shades of gray that are produced by using semitransparent black, read the box on the next page.

Here's how to colorize an image.

First, if you're colorizing an image that's in Grayscale mode, change it to RGB mode, as the Grayscale mode doesn't accept colours.

Then choose the colour that you want to replace the grays with, and make it the foreground colour. If you're not sure what colour you want, just choose any colour, as you can adjust it easily once it's applied (If you leave the foreground colour as black you won't see any change in your image until you adjust it).

Open the Hue/Saturation dialogue box, either by creating an adjustment layer using the black and white circular button at the bottom of the Layers panel or by going to Enhance>Adjust Color>Adjust Hue/Saturation in the menu bar.

Then click on the check box next to Colorize.

Whether you're working on a full colour image or one made up of shades of gray the areas affected by the command will become one colour, like a tinted black and white image.

Slide the control on the Hue bar to move through the spectrum and change the colour.

The default setting for Colorize gives a low saturation for the colour (25%). Increasing the saturation will increase the intensity of the colour.

You can colorize different parts of the same image with different colours by selecting the separate areas and colorizing them individually. This makes it possible to turn suitable black and white images into colour images, by selectively making the sky blue, the grass green and so on.

Colorizing Grays and Changing the Tones Produced by Semitransparent Black

The Colorize command, just described, and the tone adjustment commands, coming next, don't work directly on grays or tones created by using semitransparent pixels, so you may find yourself moving the controls to no effect if you try to alter such pixels. This happens when you're using the commands via the Enhance menu or using an adjustment layer that's set to affect only the one layer beneath it (If you're using an adjustment layer to affect all layers beneath it the command works fine – except in any areas where there are no opaque pixels at all, for the reason explained next).

The reason that the commands don't work on semitransparent pixels is that the commands don't recognise the colours of the pixels as shades, but treat semitransparent colours as the full colour (So, for instance, the commands see semitransparent grays as black because that's what the shade is – semitranspparnt black rather than gray).

But there is a way to get round this. What you need to do is to 'mix' the semitransparent shades with white in order to make them into opaque shades, which the commands can recognize and affect.

One way to do this is to create a new layer below the one that you want to alter, and fill it with white.

Then merge this new layer with the one that you want to adjust. The resulting layer is opaque, and hides any layers beneath it. Depending on your image, one way that you can remedy this is by going to the Layers panel and changing the layer's Blend Mode (at the top of the panel, usually set to Normal) to Multiply, which makes the white in the layer become invisible.

The shadess will now react to the commands as desired.

Changing the Tones in an Image

Elements supplies you with several ways of adjusting the tones in your images. These are particularly useful for perking up the contrast in dull photographs, but as with most other features of Elements they are perfectly suited to adjusting images of all sorts. Here I'll explain how to use these controls to improve the poorly exposed photograph below.

Original

Shadows/Highlights

Brightness/Contrast

Levels

Figure 12-12 An excessively dark photograph (top left), lightened using different methods, with varying degrees of success

Brightness/Contrast

You can change the brightness and contrast of images by using a command called, naturally enough, the Brightness/Contrast command.

This command's main use is for correcting the tonal values of incorrectly exposed photographs such as the one in Figure 12-12 bottom left, which is too dark (because it was taken at sunset in difficult lighting).

Along with the other commands described in this section, the command doesn't work effectively on semitransparent pixels – see the box on page 326 for an explanation and a work-round.

You can open the Brightness/Contrast command either by going to the adjustment layers button (the half black, half white circle at the bottom of the Layers panel), which is the recommended route, or by going to Enhance>Adjust Lighting>Brightness/Contrast.

The command's dialogue box contains two sliders. Moving the Brightness slider lightens or darkens the image, while moving the Contrast slider gives the image more or less contrast by increasing or decreasing the difference between light and dark tones.

The Brightness/Contrast command adjusts the entire range of tones in an image at once. This may mean that in order to adjust some tones to their desired value other tones are affected more than you want. For instance, in my photograph in Figure 12-12, in order to brighten the foreground sufficiently, the sky's been lightened as well, to the point where it's bleached out and made the all-important sun invisible. Fortunately there are several routes to obtaining more refined control of brightness and contrast than are possible using the Brightness/Contrast command, described now.

Shadows/Highlights

One such route is to use the Shadows/Highlights command, which you'll find at Enhance>Adjust Lighting>Shadows/Highlights. This command has three sliders that allow you to alter the shadows (or any darker tones), the highlights or the midtones separately. For instance in my photograph (Figure 12-12, top right) I concentrated on lightening the ground by adjusting the shadows (and the midtones).

This command can achieve quite good results, but it has one drawback – it can't be used in the form of an adjustment layer (see the very beginning of this chapter), so it always acts directly on your artwork. As a result it's best to work on a duplicate of the layer that you're manipulating, in case of mistakes.

The command doesn't work effectively on semitransparent pixels – see the box on page 326 for a workaround.

Adjust Highlights Midtones and Shadows using the Adjust Color Curves Command

A further tool in the arsenal of colour modification tools is the Adjust Color Curves command.

The term color curves is somewhat intimidating and off-putting to those of us not of a technical bent, and the command may better be called the Adjust Highlights Midtones and Shadows command, because the command allows you to target these particular tonal ranges and apply alterations to them separately. In this way it's similar to the Shadows/Highlights command, mentioned previously. It's also similar to that command in that it unfortunately can't be used via an adjustment layer (as described at the very beginning of the chapter).

The command is called Adjust Color Curves because the command's dialogue box displays a graph – the color curve – that shows the modifications that you make in the relationship between various values in an image. You can see the graph in the lower right of the panel in Figure 12-13. Don't be put off by this graph – you can use the command perfectly well even if you completely ignore it.

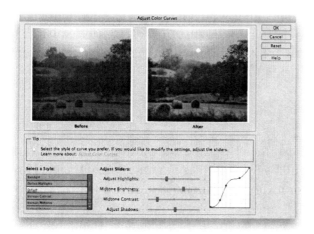

Figure 12-13
The Adjust Color Curves dialogue box allows you to alter the highlights, midtones and shadows of an image independently.
It gets its name from the graph at the bottom right that shows the relationship between the values

When you open the command a dialogue box appears that shows your image alongside a preview of the image after you've applied any alterations to it. To begin with both images will be the same, as no alterations have been made. Similarly, the color curves graph will be a straight line, because none of the values have been altered.

The control panel that occupies the lower part of the dialogue box contains a list of preset adjustments that you may want to make to your image. These include such useful adjustments as Darkening Highlights and Lightening Shadows. It's worth trying out these

adjustments when you're first experimenting with the command, as they give a good idea of the sort of effect that the command is designed to achieve, and because when you choose any particular adjustment the color curve graph will change to reflect the adjustment, thus giving you a good idea of how the graph works.

If you want to make more complex or more extreme adjustments than are offered by the list of presets (say for instance you wanted to darken highlights and lighten shadows, or you want to make the shadows much lighter than the presets allow) you can use the sliders that occupy the centre of the command's controls to modify the settings that have been applied by the presets. The sliders use the settings of the active preset as their starting point, so for whichever preset you choose, the slider controls will remain centred on their scales – they don't jump around if you flip between the preset settings.

Relatively small adjustments of the sliders are advisable for altering photographs realistically. Large adjustments can generate highly unnatural effects (which may be exactly what you want of course!). The color curve graph gives you a clue when you've overdone things – the graph takes on a 'big dipper' appearance rather than a gently undulating upward curve. This big dipper effect shows you that the colour values at some point in the range are doubling back on themselves rather than changing with a naturalistic smooth gradient. The command actually offers you an unnatural effect in the list of presets – the Solarize option at the bottom of the list. If you choose this setting you can then make the effects even more extreme by adjusting the values further using the sliders.

Levels

The Levels command is similar to the Brightness/Contrast command and the Shadows/Highlights command in that it allows you to alter the tones of an image. However, it's more sophisticated and gives superior results. It's superior in that it allows you to make adjustments to different parts of the tonal range separately (unlike the Brightness/Contrast command) and in a more subtle and targeted way than the Shadows/Highlights command (and it can be used on an adjustment layer, unlike the Shadows/Highlights command).

In the photo of a hay field at sunset in Figure 12-12, using Brightness/Contrast to lighten the dark tones in the foreground also lightens the light tones in the sky, bleaching out the sun completely. Using Levels however, the light tones of the sky can be left almost unaltered, while manipulating the darker tones in the foreground.

To open the Levels command use the adjustment layers button at the bottom of the Layers panel, or in the menu bar go to Enhance>Adjust Lighting>Levels.

As usual, I'd recommend that you use the adjustment layers route, which is so superior to the menu route that I'm not quite sure why you have a choice.

Like the other commands described in this section, the command won't affect semi-transparent colours properly. The techniques required to overcome this problem are described in the box on page 326.

When you first open the Levels dialogue box (Figure 12-14) the first thing that you'll notice is how scary it looks, mainly because of the graph that dominates the box. It's not as bad as it appears however: in fact, all you need to do is move the three triangular sliders that run along the bottom of the graph, while ignoring the graph altogether if you wish.

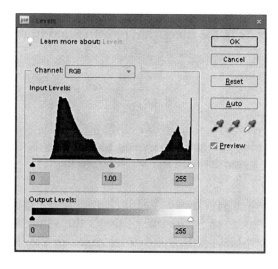

Figure 12-14
The Levels dialogue box.
The versions that open via
the Enhance menu and the
adjustment layers have
slightly different layouts

Put very simply, moving the three triangles affects the image in the following ways.
Moving the black trianglar slider (the left one) inwards darkens the dark tones.
Moving the white slider (the right one) inwards lightens the light tones.
Moving the gray slider (the middle one) to the left lightens the middle tones, and moving it to the right darkens them.

As I said, that's a very simple description of what the three sliders do.
Here's a more in-depth explanation, in case you're interested.
The width of the panel containing the graph represents all of the tonal values that are possible in an image, from black at one end to white at the other. To make the whole thing clearer, imagine that there's a visual scale shaded from black to white across the width of

the graph, just above the sliders (Figure 12-15). The scale would be similar to the one that's a short distance below the graph, although that one's there for a different adjustment.

Figure 12-15
Imagine a shaded scale above the sliders

The trianglar sliders show the points on this tonal scale that represent black (the black triangle), the mid tone (the gray triangle) and white (the white triangle).

You can slide the triangles along the scale and place them in positions on the scale that represent different shades (Figure 12-16).

Then, when you apply the command, the tones in the image are redistributed to reflect the new positions of the triangles.

Figure 12-16
The black triangle has been moved so that it's pointing to a new tone on the scale above it

Let's go through exactly what's happening when you move the black slider, as in Figure 12-16 above. When this slider is repositioned, any tone in the image that's the same as the tone that the triangle is resting at is replaced by black. All of the other tones in the image shift to accommodate this change. The dark tones that the black triangle has been moved past all become black (because there's nowhere else for them to go). The tones between the new position of the black triangle and the mid tone triangle are reassigned to fill the full width of the tonal range between black to the mid tone. Here in Figure 12-16 the light tones in the image (between the gray triangle and the white triangle) would remain completely unaltered, as neither of these triangles was moved.

If you want to know more about what the graph above the sliders is, and how it works, read on.

The graph is called a histogram, and it shows the distribution of the tones in the image.

In order to visualize how the graph relates to the tones, imagine the graph has the same shaded strip below it, showing the distribution of the tones, as in Figure 12-15.

The histogram is actually composed of 256 vertical bars, with each one representing one of the 256 tonal values available on your computer. The amount of each tone that an image contains is indicated by the height of the bar: a bar that goes to the top of the graph shows that there's a lot of that tone in the image, while for any tones that are completely absent there's no bar at all.

I'll now take you through the process of altering the tones in the hay bales photograph in Figure 12-12 with special reference to the histogram. It's an image that contains relatively distinct tonal areas, so they won't be too complicated to alter (or more importantly, to explain).

Figure 12-17 Altering a histogram. The banding effect of the redistributed tones (right) is due to the fact that the individual tones from the original image are spread out, but the gaps between the tones aren't filled in: imagine each original tone like a bead on an elasticated necklace

All of the dark tones in the photo of the hay bales are in the foreground, and all of the light tones are in the sky. If you look at the histogram of the original unaltered photo (on the left in Figure 12-17 above), you can see all of the dark tones of the ground represented by the large peak to the left that reaches right to the top of the panel. The smaller peak on the right shows the light tones in the sky. The graph shows that there are very few tones in the mid-range. Notice that there's a distinct 'blip' of almost pure white in the image, indicated by the thin bar at the extreme right hand end of the histogram – that's the sun.

In this photo what's needed in order to get a decent image is to lighten some of the dark tones in the ground, while leaving the sky as unaffected as possible, to preserve the sun.

To lighten dark tones, move the gray triangle towards the dark end of the histogram (as shown on the middle graph above). The particular tone that the triangle points at will be lightened by being turned into the mid tone when you apply the command (and all other tones will shift to accommodate the change).

The right histogram above shows the way that the tones have shifted after the command has been applied. Notice that the triangles have 'slid' along the scale, returning to their normal positions next to the black, mid tone and white points. The graph above has slid with them (with the graph being stretched out on the left hand, dark end and compressed on the

right hand, light end), showing the remapping of the tonal values in the image.

You can see this shifting effect on the histogram when you're using the Levels command via the Enhance menu (You have to make some adjustments, click okay, then reopen the command again to display the new histogram for the image). If you're using the Levels command via an adjustment layer the graph doesn't spread out in this way, but remains as you left it, with the sliders in the places that you put them. This is because with an adjustment layer the alterations that you make are stored separately, rather than being committed to the image.

In the altered graph the height of the graph lines change because the proportions of the different tones change, but essentially the graph is the same shape as the original, apart from the fact that it's stretched on one end and compressed at the other. The banding effect in the graph is caused because when the individual tones are spread out gaps appear between the tones, which aren't filled in. It's a bit like stretching a bead necklace and creating gaps between the beads.

Because of this spreading and separating of the tones, here's a warning that applies if you use the Levels command via the Enhance menu rather than as an adjustment layer. If you repeatedly move the tonal values by using the Levels command several times, your image may become 'stepped' as the changes in tone become noticeable. (This only applies when using the command via the Enhance menu bar because using that route the image is altered afresh each time the command is used, with a cumulative reduction of tones as they are spread out like beads – if you use an adjustment layer the alterations that you make are stored rather than being committed to the image, so this build-up of effect doesn't occur.)

The original hay bales photo that I'm using is a good example of a photograph in which the tones are dull and lacking in contrast because, amongst other things, there is no absolute black in the image. You can see that there is no black in the image by looking at the histogram (Figure 12-17, left), where the graph drops to zero a short distance from the end that represents black. To improve the contrast, some of the darker tones that aren't quite black can be shifted over to become black. This is done by moving the black triangle inwards to a point where the actual tones began – where the graph started to rise up from the baseline (Figure 12-17, centre).

As well as altering the overall tones of an image, you can alter the tonal values of the different colour components of an image, red, green or blue, separately. Click in the box that's along the top of the histogram to select the appropriate colour (In the Enhance menu version of the dialogue box this box is labelled Channel).

At the bottom of the Levels dialogue box is a slider labelled Output Levels. Moving the sliders reduces the tonal range in an image, making the image either lighter or darker depending on which slider you move.

This is very useful for lightening images so that they're easy to trace over. As usual, it's best to use this command as an adjustment layer rather than from the Enhance menu, so that the effects aren't permanently applied to the layer.

Using Levels to Clean Up Dull Scans of Line Drawings

When you scan black and white line art the resulting image will sometimes have a background that's slightly off-white, and lines that are a variety of dark grays rather than the desired black (specially if you're scanning pencil drawings). You can see such a scan in the left hand image in Figure 12-18. You'll probably also have small dots of gray scattered across your image, where imperfections such as dust on the scanner have been registered.

Using the Levels command is a very good way to improve the contrast in scans of this type. The Brightness/Contrast command will work too, but with less refined results.

Other aspects of scanning are covered in detail on in Chapter 17.

The technique described here is particularly useful when you want to scan in a line drawing in order to add colour to it on your computer, or when you want to retain any subtleties of tone that are in the original image, such as pencil shading. If your aim is to produce a final image that's absolutely pure black and white (with no shades of gray) then you should use the special technique described on page 489.

Figure 12-18 Left: A scan of black and white artwork can sometimes appear rather murky
Right: The image improved using the Levels command

In Figure 12-18 the image on the right is a rather dull scan of a drawing, spoilt because the white background has registered as gray rather than white and the black lines have registered as dark gray rather than black. The tonal values of the image are shown in the histogram in Figure 12-19. I've added a shaded scale beneath the histogram to show the levels of gray that are represented by the different parts of the graph.

Figure 12-19
The histogram of the image above, showing the distribution of the tones (I've added the shaded scale)

The large peak towards the right of the histogram shows the range of light grays that make up the dull background of the scan. Because there are no actual whites in this image the graph hardly registers at the extreme right end, which is where white is represented.

There's also no pure black in the image. All of the dark tones of the lines in the image are in the peak that's some distance from the black end of the graph.

In the original image there are hardly any tones other than the dark lines and the white of the paper, so in the histogram the graph is very low apart from the two distinct peaks representing those tonal ranges.

To see how to improve the tones of this image, look at the histograms in Figure 12-20.

Figure 12-20 Adjusting the sliders to improve the tonal values for the scan

The white slider below the histogram allows you to turn selected gray tones to white. By moving the slider to the left any tones that you pass turn white. In the centre histogram in Figure 12-20 you can see that I've moved the slider past the peak that represents the murky grays in the off-white background. This makes all of the murky grays become white.

At the other end of the histogram the black slider can be moved to alter the point at which the original tones become black. Moving this makes any tones that it passes go black. I've moved the slider close to the peak that represents the range of tones in the dark lines. As a result all of the tones become closer to black. I didn't move the slider past the peak, because I wanted to preserve a degree of tonal variation in the lines.

With the end points redefined, the tones between them spread out to adapt to the new range, as shown in the third histogram. At first sight the white end of the histogram seems to register no white – but a closer look shows a tall single bar of absolute pure white at the very end – showing that there's now a lot of white in the image but very little off-white. (This third histogram is only produced if the Levels command is used via the Enhance menu. If the command is used via the adjustment layers the histogram remains unaltered.)

Altering Small Areas Using the Edit Tools

Most of the techniques for altering your image that have been described so far have been aimed at altering large areas of images, such as large selection areas or whole layers. Often, however, you'll only want to do alterations at the localized or 'brushstroke' level. The following tools can be used to 'paint' alterations into your work.

The Clone Stamp Tool

Figure 12-21 The Clone Stamp tool

The Clone Stamp tool (Figure 12-21) is used for copying, or cloning, small areas of an image to other parts of the image (or even to a different image altogether).

One of its most important uses is to help hide unwanted detail in otherwise hard-to-alter images such as scanned images or digital photographs. At its simplest it can be used to remove blemishes from images (For this task see also the Healing Brushes, page 340). It can also be used to remove entire objects if the image is suitable (Figure 12-22).

Figure 12-22 The Clone Stamp is used for transferring sampled parts of an image as brush-strokes, making it possible to remove objects by painting over them with sampled artwork

As well as being useful for removing objects from images, the Clone Stamp tool can be used to extend them, as in Figure 12-23, where the tree on the right has sprouted extra branches.

Figure 12-23
The Clone
Stamp tool can
be used to
extend areas of
an image

Although it's described as a 'stamp' tool, which sounds as though it's quite crude, the Clone Stamp tool actually works in a similar way to the paintbrushes, the main difference being that instead of painting with a specific colour it paints by first sampling, or copying, part of an image and then laying the sample down elsewhere. It's strength lies in the way that it copies artwork in brushstroke-sized samples, allowing for quite precise control over which parts of the image are copied, and over where they are applied. In its options bar the tool has access to the same selection of brush tips that are available for the normal Brush tool.

To use the Clone Stamp tool, first decide whether you want to duplicate work from only one layer or from all of the layers in the image (apart from ones that are hidden).

If you want to copy from all visible layers, tick the box labelled Sample All Layers in the Options bar. If you want to copy from only one layer make sure that Sample All Layers isn't selected, and make the layer that you want to sample from the active layer.

Then place the cursor over the part of the image that you want to use as your sample.

Hold down the Option key (Mac) or Alt key (Windows) – the cursor will change its appearance to show that it's in sampling mode – and click on the area.

Release the cursor and select the layer that you want to apply the sampled image to (It's often best to lay down the sampled image on a totally new layer, separate from the rest of the artwork, so that it doesn't directly modify the original image. This makes it easier to fix any mistakes that you make).

Move the cursor to the point where you want to start applying the sampled image, and

paint. The tool will lay down an image copied from the area that you are sampling.

When you're painting with the Clone Stamp tool there are two cursors on the screen at the same time – the painting cursor and the sampling cursor. The painting cursor shows the point at which you're painting, as with the usual paint tools. The sampling cursor shows the position from which the sample is being taken. Annoyingly, the sampling cursor is only on display when you're actually cloning and not while you're positioning the cursor ready to clone. The two cursors move in tandem – as you move the painting cursor the sampling cursor moves as well, picking up the colours that you're painting with.

The way that the two cursors relate to each other can be altered in the Options bar by using the Aligned check box. When you've finished applying one stroke with the Clone Stamp tool you can move the cursor and start applying a second stroke straight away. The Aligned option determines which part of the original image the tool will sample on each subsequent stroke.

When checked, the Aligned option selects a new sample point that's the same distance from the painting cursor each time a new stroke is made. So if your first sample was slightly to the left and up a bit from the point where you first applied the painting cursor, subsequent sample points will all be slightly to the left and up a bit from the painting cursor too.

This option is useful for repairing multiple blemishes on scanned artwork and photos. By choosing a sample area near the brush, each blemish is replaced by a colour and texture from close by, which will usually be a good match.

If you uncheck the Aligned box the Clone Stamp will start each new stroke using the same sample point, no matter where you apply it. This is useful if there's only a limited area of your image that is suitable for reproducing, or if you want to reproduce the same sample in several different areas.

It's normally good practice to change the sampling point a few times while cloning, so that the resulting cloned image isn't an exact copy of part of the original (If you want to copy a large part of an image exactly, the Clone Stamp tool isn't usually the best approach – selecting the area by using a selection tool and then copying it would do instead).

The sampled image can be laid down semitransparently by altering the Opacity value, or by using a graphics tablet.

In its normal mode you can't see the effect that laying down the cloned sample is going to have until you've actually done it, however there is a way of displaying a ghostly representation of the effect before it's applied. Click the double rectangle button at the right hand

end of the Options bar. In the dialogue box that opens click Show Overlay. Check the box for Clipped in order to restrict the ghostly overlay to the area of the brush – I'd recommend this setting when you first use Show Overlay, as without it the whole image is visible as a ghost, which is very confusing. If you do use the whole image option it's recommended that you check the Auto Hide box, as this turns off the ghost image while you're actually applying the Clone Stamp – otherwise things just look too confusing. The Invert check box creates a negative ghost, which may be useful on some subjects and backgrounds. The Opacity setting changes the intensity of the ghost image.

Sharing space in the toolbox with the Clone Stamp tool is the Pattern Stamp tool. This copies textures from patterns that are stored in a special folder. See the later section on Patterns if you're interested.

Removing Blemishes and Flaws using the Healing Brushes

It's almost inevitable that at some point you'll need to open a less than perfect image in Elements. Perhaps you'll have to scan in a photograph that's a bit the worse for wear – one that's covered in dust marks or scratches, or that's even been ripped in two and then taped together again. Or perhaps you've got a photograph that has unwanted details in it, such as that bane of many photographers – power lines in the sky (which I personally think add a welcome touch of authenticity to photos, but there you are).

Flaws such as these can be removed from images by simply dabbing them with special brushes that dissolve the imperfections away and replace them with the colours of their surroundings. It's a form of invisible mending. There are two different, though related, brushes that you can use for this mending task: the Spot Healing Brush for removing very small imperfections and the Healing Brush for repairing larger areas. The two brushes share the same space in the toolbox.

The Spot Healing Brush

Use this brush to remove small imperfections from images by simply clicking on or dragging over the imperfection. The tool is excellent for expunging dust marks and speckles from photographs, or as here in Figure 12-25 for removing blemishes from a cartoon that was originally painted in watercolour and then scanned into the computer.

 Figure 12-24 The Spot Healing Brush

Figure 12-25
The Spot Healing Brush is excellent for removing minor imperfections from
photographs and scanned artwork

The tool covers the spot with a blend the colours that it samples from the vicinity of the spot. Use a brush size that's just large enough to cover the area that you want to alter.

There are two different ways that the tool can choose the colours that it uses to hide the spot, accessible through the Type submenu in the options bar. Proximity Match chooses colours from around the edge of the brush and uses them to fill the area, while Create Texture applies a texture from the pixels beneath the brush tip (For most purposes Proximity Match is the best option).

The Healing Brush

 Figure 12-26 The Healing Brush, resembling a sticking plaster

The Healing Brush (Figure 12-26) is used for removing relatively large flaws from images. In some ways it works like a more sophisticated version of the Clone Stamp tool (page 337). It clones a sampled part of the image, as with the Clone Stamp tool, but in the process it also blends the cloned colours with the underlying colours to produce subtle results.

The tool is very useful for removing blemishes and wrinkles from photographs of faces that are anything less than perfect, so it probably gets a lot of use in the fashion and celebrity photography businesses. For my demonstration of the tool I've chosen to use the tool to remove blemishes from a face that's had quite a battering in its time – and it's been around for a very long time – the face of the moon (Figure 12-27).

Figure 12-27 The Healing Brush is used to remove blemishes and irregularities from images. Here I've used it to remove some of the craters from the moon (on the upper right)

In this photograph of the moon an area of the smooth lunar surface was sampled and was cloned onto the different cratered areas on the upper right of the photo as small dabs. The resulting marks took into account both the smoothness of the sampled area and the underlying tones of the craters, so the tonal values of the cratered areas were more or less retained, while their cragginess was removed.

To use the tool in this sophisticated way, set the Mode in the brush's Options bar to Normal. Then sample part of your image as you would with the Clone Stamp tool. While you're actually applying the sample with the tool the cloned stroke will look exactly like that produced using the Clone Stamp, however when you release the cursor the cloned area will change colour and blend into its surroundings in a way that the Clone Stamp never could. The resulting marks are also blended into the surrounding area to avoid harsh transitions (Because of this it's best to use a hard-edged brush as the tool's tip, to avoid excessive blurring of the edges).

The tool can also be made to work just like the Clone Stamp tool, by setting its mode to Replace.

Lightening and Darkening Colours

When you've laid down colours in an image you may sometimes want to lighten or darken them locally. You may want to do this for instance when you want to add three dimensional modelling to areas of flat colour (Figure 12-28).

There are several ways to go about doing this.

Figure 12-28 Left: An image composed of totally flat colours (applied with the Paint Bucket). Right: There are several ways to give the figure some three dimensional form

A simple way to lighten or darken localized areas of colour is to brush semitransparent white or black over the areas, allowing the underlying colour to show through, as shown in Figure 12-29. Do this by painting with white or black, with the opacity value for the brush (in the brush's Options bar) set at a reasonably low value, such as 10%. Use a large, soft brush so that the effect is subtle. Using several brushstrokes on top of each other, as this allows you to build up the tonal effect gradually. Remove excess shading by using a large soft eraser (again with the opacity setting low to produce subtle results).

Whatever you do, make sure that you apply the shading on a new layer, so that you can erase unwanted shading without erasing the original artwork. Working on a separate layer also has the advantage that you can make your effect more subtle by lowering the intensity of the shading after you've applied it – by altering the whole layer's opacity (by changing the Opacity setting at the top of the Layers panel).

When you apply shading like this you'll almost inevitably paint beyond the boundaries of the area that you want to shade, as shown with the black shading in Figure 12-29. To prevent this you can select the area that you want to work on, using an appropriate selection

tool (For instance, with an area of flat colour, as in my illustration here, the Magic Wand would be a good choice). The paint will then only be applied within the selection area. Alternatively, you can simply erase the excess shading with the Eraser after you've finished – which is a simple task as long as the shading is on its own layer.

Figure 12-29 When you paint shading onto an image it will often be applied beyond the boundary of the object, as here. To prevent this you can first create a selection area outlining your object, or as here you can simply erase the excess shading afterwards

Sometimes white isn't the best colour to use in order to create three dimensional light modelling. Objects that are illuminated by coloured lights or that are near to brightly coloured surfaces often reflect these external colours from their own surfaces. These secondary colours are known as colour casts, and are often useful for 'anchoring' an object to its surroundings (otherwise they may look like cut-outs). In order to produce a more realistic appearance, these colour casts can be added as small amounts of colour rather than as white.

The Dodge, Burn and Sponge Tools

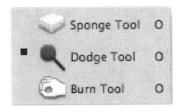

Figure 12-30
The Dodge, Burn and Sponge tools share the same space in the Tools panel

There are a couple of tools that are specially designed to darken and lighten the colours locally in your images.

You can use the Dodge tool to lighten colours, and the Burn tool to darken them.

These tools only work directly on the same layer as the colours that you want to alter. As a consequence it's sensible to copy the layer that you want to work on so that you've got a spare in the event that you make any irreparable mistakes while using the tools.

You can set the tools to selectively affect only the darker or the lighter tones in the area to which you're applying them. Do this by altering the Range setting in the Options bar. Shadows only alters the darker tones, Midtones affects the middle ranges (leaving the darkest and lightest tones unaltered), Highlights only alters the lighter tones.

These ranges are useful when working on photographic or textured images, where they help to give more naturalistic tonal effects.

Figure 12-31 The Dodge and Burn Tools at work. Left: The original image (a flat texture taken from a photograph of a rock). Right: The image lightened at the top with the Dodge tool and darkened at the bottom with the Burn tool, giving it three dimensional modelling

The Exposure slider in the Options bar of the Dodge tool and the Burn tool alters the rate at which the lightening or darkening occurs. It's best to set this low, otherwise the effect is often too harsh. Then do your alterations in several passes of the tool over the same spot.

The tip of the tool is just like a paintbrush, and you can select different tips in exactly the same way as you do with brushes.

You can remember the difference between burn and dodge because burning darkens things, as in real life. You may like to remember that the hand is the icon representing the Burn tool because of the coincidental link with the expression 'getting your fingers burned'. If you're wondering what the significance of the symbols in the buttons is, by the way, they are related to the old days of predigital photography when photo manipulation was all done

at the printing stage in the darkroom. The lollipop symbol on the Dodge tool represents a disk on a stick that used to be waved between the light from the enlarger and the printing paper in order to stop some light reaching the paper. The hand of the Burn tool represents a hand placed between enlarger and print, allowing light through the hole formed by fingers and thumb – a little like the opposite of the Dodge tool.

Very similar to the Dodge and Burn Tools, in that it alters localized areas of colour using a brush tip, is the Sponge tool.

Instead of altering the lightness or darkness of colours it alters their saturation. It can make colours more vibrant (the Saturate mode), or more muted (the Desaturate mode).

The Smudge Tool

Figure 12-32 The Smudge, Blur and Sharpen tools shares the same space in the Tools panel

The Smudge tool smears the image in the direction in which the cursor is dragged (Figure 12-33). It's like smearing wet paint on a canvas using your finger (hence the icon). Use it discretely, as the effects can be a bit crude if you overdo it (as in my example).

Figure 12-33 The Smudge tool drags colour across the image. Here I've used it to an excessive amount, for effect

The degree to which the tool will drag colours across your image can be altered in the Strength box in the Options bar.

The tool can be made to either affect only the active layer or all layers by using the Sample All Layers check box.

Because it's a tool that's conveniently accessible from the toolbox it's very tempting to use it for mixing adjacent colours on your image, and for pushing and pulling forms around, but it's best avoided for these tasks unless you really want a smeary effect.

It's effective for creating specific effects such as ripples in the reflections in water, although such tasks can often be done better using a filter from the set of distortion filters, such as the Liquify filter (page 437).

The Smudge tool has an option that allows you to put down a blob of the current foreground colour, which it then smears when you drag. This is appropriately called the Fingerpainting option.

The Sharpen and Blur Tools

The Sharpen and Blur tools (Figure 12-32) make artwork crisper or more diffuse respectively in the area where you apply the cursor.

You can remember which icon is which because the Sharpen icon is sharp and pointy, while the Blur icon is soft and rounded.

Because they sharpen or blur the artwork only where the cursor is applied they're very good for affecting small, localized areas. If you want to sharpen or blur larger areas it's best to use filters – as described in the pages following page 442.

If when using these tools you find that you've overdone the sharpening or blurring of an image you can't correct the effect by using the other tool on the same area. To correct excessive use, apply the Undo command.

Transforming
13

Elements gives you the ability to pull and push parts of your artwork into different shapes by using the incredible power of the Transform command. An indispensable tool to the computer artist, it's one of the things that make creating artwork on computers so satisfying.

In This Chapter.
Enlarge or reduce the size of objects on your canvas
Rotate objects
Distort objects
Flip objects horizontally or vertically

Figure 13-1 All of these cars are copies of only one vehicle, each pulled into a different shape using the Transform command.

Look at the cars in Figure 13-1. These cars are all copies of only one car (The first one). The only difference between them is that they've been stretched, squashed, squeezed, pulled, pushed and rotated using the Transform command.

Transforming is one of Elements' most useful features.

At its most basic it's a very convenient method for simply changing the size of objects (or parts of objects), as in Figure 13-2. This is a frequent requirement when you paste artwork from one image to another, or when you draw objects to the wrong proportions.

Figure 13-2
The Transform command is particularly useful for changing the size of parts of images - here the bird

But its use doesn't stop there: the command can be used to change the angle of objects, such as by altering the tilt of a head as shown in Figure 13-3.

Figure 13-3
Use the Transform command to alter the angle of part of an image – here the head

Transforming

You can use it to alter the proportions of objects too, such as to make them taller or shorter, wider or narrower (Figure 13-4), or even put them into perspective (Figure 13-5).

Figure 13-4
The Transform command can be used to squeeze (centre) or stretch (right) part of an image, such as the man's body here. The head has been left unaltered

Figure 13-5
Images can be pulled into shape to give the effect of altering the perspective, such as with this tower block

You can even combine the different types of modification all in the same action, as in Figure 13-6, where I've changed the size and angle of the man's head, squeezed it in at the bottom and stretched it out at the top just for good measure.

Figure 13-6
Here the man's head has been transformed in several different ways all in the same operation. Despite appearances, no extra drawing was done to the head – it's all distortion

Transforming is the sort of feature that it's best to play with for a while on a piece of experimental artwork specially created for the purpose, partly so that you don't accidentally spoil your proper artwork if you make a mistake, but mainly because it's fun.

How Transforming Works

Before I describe the different ways in which you can transform images I'll explain the basic method by which you do it.

First you need to select the part of the image that you want to alter, using an appropriate selection tool. If the image is the only object on an otherwise transparent layer you needn't select it, as Elements will automatically assume that you want the whole object altering.

When you're first experimenting with transforming it's a good idea to choose a relatively small area of an image to work on rather than an area that takes up most or all of the canvas – this is because it's useful to have plenty of surplus 'stretch space' around transformations when you're first experimenting with how far you can push them.

When you open one of the several transform commands, described soon, a box appears surrounding the selected part of the image (Figure 13-7). You may have come across this box previously, as it opens automatically when you use the Move tool unless you specifically turn it off by unchecking Show Bounding Box in the tool's options bar (I recommend that you turn it off there, as it's an unnecessary distraction).

This box is called a bounding box, and has small squares positioned half way along each side and at each corner. These squares are called handles. By dragging on these handles you can pull the box into different shapes, which in turn alters the shape of the contents of the box.

If you place the cursor inside the box, rather than near a handle, the cursor can be used to drag the whole box, along with the object inside it, across the image.

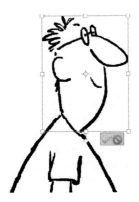 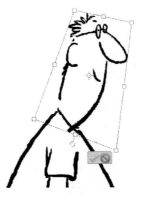

Figure 13-7
The bounding box,
surrounding the area
that's being transformed

How to Accept or Cancel a Transformation

Any changes that you make to your image with the Transform command aren't applied permanently to the image until you deliberately finalize them, up until which point they're only visible on the screen. To finalise your transformation you have to accept or reject the results, as follows.

Accept

If you're happy with the results that you've obtained, complete your transformation by pressing the Return key on a Mac or the Enter key in Windows (Those are both the same key but with different names. It's the one that you usually use for moving on to a new line of type when typing, half way down the right side of the keyboard). Alternatively you can do it by clicking on the tick that's suspended just below the transformation bounding box.

You can also complete your Transformation by simply choosing a tool from the toolbox (in which case a box will open asking you whether you want to accept or reject the transformation) or by double clicking inside the transformation bounding box on the image (Double clicking inside the bounding box holds the danger of you moving the object slightly as you do it, because you may accidentally drag at the same time, so this method isn't recommended).

Cancel

If you want to go back to how things were before you started your transformation, cancel the whole operation by clicking in the circle with the diagonal line through it that's hovering below the transformation bounding box along with the large tick.

Alternatively, just open a new tool in the toolbox. A dialogue box will open asking you if you want to accept or reject the transformation.

How to Select a Transform Command

There are a variety of different transform commands available to you, each making objects change shape in different ways: Rescale (to change the size of objects), Rotate (to rotate objects), Skew, Distort, and Perspective (all three of which pull objects into different shapes). These different commands are described soon.

There's also an all-embracing transform command that incorporates all of the others. This is the Free Transform command, which is so useful that I'll describe it now.

Free Transform

Using Free Transform is by far the most convenient way to apply transformations to your work. In fact it's so useful that once you've used it you'll probably never use the other individual transform commands again.

The keyboard shortcut for Free Transform is Command-T on a Mac or Control-T in Windows.

The reason that Free Transform is so useful is because of the fact that whenever you transform an object you'll often want to apply several different types of transformation at the same time, such as by changing both the object's size and its angle.

Doing this with the individual commands, such as Scale and Rotate, you have to go backwards and forwards between the separate transform commands via the on-screen menus or the command's options bar (explained soon), which is a little frustrating.

With Free Transform you move between the transform modes without needing to change commands. Moving between the most frequently used modes, Scale and Rotate, is so simple that it hardly needs explaining, while using Skew, Distort or Perspective modes is initiated by pressing the modifier keys at the bottom left of your keyboard.

In the next few pages I'll describe the individual Transform commands in their order of usefulness (more or less). For each of the commands I'll mention how to access it in Free Transform, allowing you to skip from command to command.

The Individual Transform Commands

All of the individual transform commands are found in the Image menu in the menu bar. Confusingly they're not all in the same submenu, but are scattered across three different ones. You'll find the Scale command in Image>Resize, while the Rotate command is in Image>Rotate (where it's labelled Free Rotate Selection or Free Rotate Layer), and the other commands are all in Image>Transform.

Once you've opened any one of the transform commands you can move to other transform commands without having to go back to the menu bar, in the following ways.

You can move between different transform commands via buttons in the options bar (Figure 13-8). These buttons unfortunately don't include the Distort mode (the type of transformation that has no restraints on the direction that you can drag the handles), which is a little inconvenient, as it's a very useful mode.

Figure 13-8 Choose from Rotate, Scale or Skew

More usefully, but slightly harder to remember, you can change from one command to another by clicking while holding down the Control key on a Mac or by right clicking on a PC. This will open a menu next to the point that you clicked, displaying the different transform commands (Figure 13-9). This method has an advantage over the previous method of using buttons in the Options bar, as it gives you access to the Distort mode which is unavailable in the Options bar.

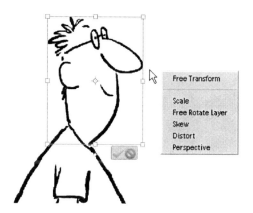

Figure 13-9
While you're using any one of the transformation modes the Transform menu can be opened by right clicking (Windows) or by clicking while pressing the Control key (Mac)

Here's a breakdown of the different ways that you can transform objects. I'll use the basic checkerboard design in Figure 13-10 to demonstrate the effects, as this shows the results very easily.

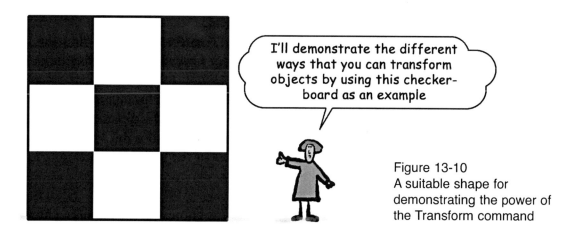

I'll demonstrate the different ways that you can transform objects by using this checkerboard as an example

Figure 13-10
A suitable shape for demonstrating the power of the Transform command

Scale

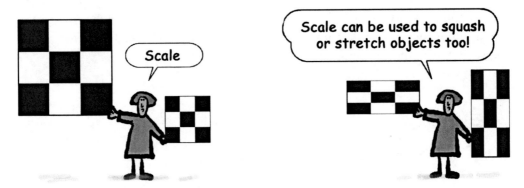

Figure 13-11 The Scale mode

This is probably the most useful of the transformation modes.

Its main use is to change the size of objects by making them larger or smaller, but it can also be used to make objects wider, narrower, taller or shorter.

To scale objects in Free Transform move the cursor towards the bounding box that surrounds the object. When the cursor gets close to the box it will become a straight double-headed arrow. This is the cursor that you want to use (While the cursor is any distance outside the bounding box the cursor is a curved double-headed arrow. This isn't the cursor that you want, as this one rotates the box, described soon).

If you don't want to use the command via Free Transform you can find the Scale command at Image>Resize>Scale. Then move the cursor towards the bounding box until it becomes a double-headed arrow.

This double-headed arrow shows that you're now in the mode for enlarging or reducing the size of the image. The directions of the arrows give a clue to the directions that you can pull and push the image – when the cursor is over the corner handles the box can be pulled in or out in any direction, while when it's over the sides of the box the direction is limited to being perpendicular to that side of the box.

If you change the size of an object only by moving the corners of the bounding box your object will stay in proportion automatically. As soon as you alter it by squeezing or stretching any of the sides though this automatic proportion lock is turned off. To keep it in proportion after that you have to press the Shift key while moving the box corners.

Rotate

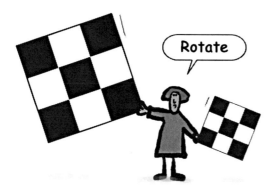

Figure 13-12
The Rotate mode

This is another very useful transformation mode.

In Free Transform place the cursor anywhere outside the bounding box, but not too near to it, so that it appears as a curved double-headed arrow.

If you don't want to rotate objects using the Free Transform command go to Image>Rotate>Free Rotate Selection (or Free Rotate Layer, which will appear if there is no active selection).

The curved double-headed arrow shows that the cursor will rotate your object when you press and drag.

The object always rotates around a specific point, called the anchor point. This is the circle with a cross behind it that is normally at the centre of the bounding box.

You can move the position of the anchor point so that it's in the same position as any of the handles on the perimeter of the box. Do this by clicking on the appropriate handle in the tiny representation of a bounding box at the left hand end of the Options bar (Figure 13-13).

Figure 13-13
Choose your anchor point. By default it's the centre (left)

Using the Shift key will constrain the rotation so that it jumps in steps of 15°, meaning that it's easy to rotate objects by 45°, 90° and so on (To rotate objects by 90° or 180° you can also use the separate commands in the Rotate menu rather than the Transform command. Be sure to choose from the commands that are half way down the list, and that mention selections or layers in their names – the Rotate commands at the top of the list rotate the whole image).

Distort, Skew and Perspective

The three transform commands Distort, Skew and Perspective are all variations of the same theme. The Distort command is the core command, while Skew and Perspective are variants that impose restraints on how the transformation bounding box can be moved. Hence the same effect can often be obtained with several of the commands.

You can skip across from one version of the Transform command to another by clicking while holding down the Control key on a Mac or by right clicking on a PC to open the Transform contextual menu next to the cursor.

Distort

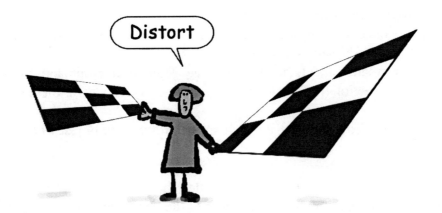

Figure 13-14
The Distort mode

Using the Distort command any corner of the bounding box can be dragged in any direction, and the sides of the box can be skewed by moving the sides.

Unlike the cursors for the other Transform commands the cursor for the Distort command doesn't display any little arrows showing the directions in which it will work, because it works in all directions.

The Distort command works like a completely unrestrained version of the Skew command. This makes it in many ways the most useful of the three Transform commands in this group.

In Free Transform, enter Distort mode by pressing the Command key (Mac) or Control key (Windows). Alternatively, find it at Image>Transform>Distort.

Skew

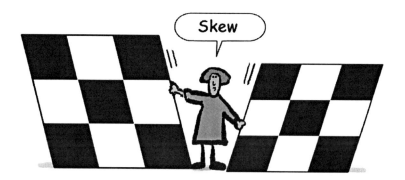

Figure 13-15
The Skew mode

Use the Skew command when you want an object to lean over, or when you want to straighten something that's already leaning. This can be useful if you tend to draw with a 'handwriting slant' that makes your work not quite vertical (Slanting images can be detected by flipping the image round, described on page 388).

You can also use it to move the corners of objects, creating a perspective effect, as in Figure 13-16. It's actually more useful for creating perspective effects than the Perspective tool is (described next).

Figure 13-16
The Skew mode can be used for creating perspective effects

In Free Transform press Command-Shift (Mac) or Control-Shift (Windows). Or find it at Image>Transform>Skew.

Skew works like a restrained version of Distort. When you move one of the bounding box's sides the movement is restrained so that it follows the direction of the box's side, sliding along it so to speak. The movements of corner handles are restrained in the same way, moving along the direction of whichever side of the box is closest to the direction in which you move the cursor.

Perspective

Figure 13-17 The Perspective mode

The Perspective command is similar to the Skew command, except that when you drag a corner the adjacent corner moves as well, but in the opposite direction, mirroring the action. So when you move one corner inwards its counterpart moves inwards too, and when you move a corner outwards the adjacent one moves outwards.

This command isn't particularly useful in my opinion: the fact that opposite sides of the bounding box move inwards or outwards at the same time rather than independently makes the command harder to use and more limited in its use than the Skew or Distort commands, which are both capable of moving corners individually and producing perspective effects themselves, as you can see in Figure 13-16.

On top of this, the Perspective command doesn't even create realistic perspective, so it's rather misleadingly named! Read the next section to find out why.

In Free Transform press all three modifying keys at once: Option-Command-Shift (Mac), or Alt-Control-Shift (Windows).
Or find the independent command at Image>Transform>Perspective.

If you're interested in creating perspective effects there's a whole separate section on more aspects of creating perspective using the Transform command and other techniques, starting on page 375 in Chapter 13. But read the next section first.

Making Perspective Effects More Realistic

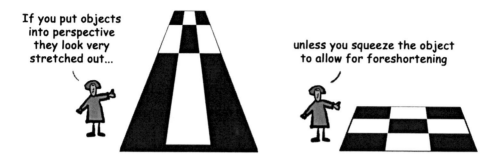

If you put objects into perspective they look very stretched out...

unless you squeeze the object to allow for foreshortening

Figure 13-18 Left: The perspective effect of the Transform command doesn't look realistic if you only apply a distortion in one plane, giving the impression of objects stretched into the distance. Right: For the correct effect you have to squash the shape down

When you use a transform command to create a perspective effect by simply squeezing the sides of an object inwards you don't automatically get true perspective. You still need to do a bit of extra manipulation in order to obtain a realistic effect.

In the example in Figure 13-18 the square checkerboard that I've used to demonstrate the transform modes was squeezed at the top to create a tiled floor effect. But there's something horribly wrong with this floor. The tiles come out looking very unlike squares in perspective, as they're elongated enormously into the distance. This is because although the sides of the checkerboard were squeezed in to give the converging effect of perspective, the distance between the top and the bottom of the board was left unaltered.

To obtain the correct effect the top and bottom of the checkerboard need to be moved close to each other, creating the compressed effect known as foreshortening. It's best to do this in the same operation as creating the original converging perspective effect, before you commit the transformation (such as by clicking on the tick beneath the bounding box). If you perform the task as a second, independent transformation the results aren't as convincing.

If you're using the Free Transform command you can move the top or bottom simply by pressing the cursor on the appropriate side and dragging in order to squash the shape.

If you're using the individual transform commands rather than Free Transform you need to change to the Scale command (*not* the Distort command – see the next page for why) via the menus or the buttons in the Options bar.

This operation moves the far and near edges of the object closer together while, very importantly, retaining the angle at which the sides converge (Figure 13-19, left).

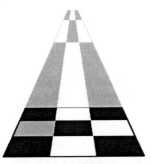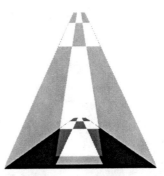

Figure 13-19 Left: The far end of the perspective checkerboard dragged forward using the Scale command to produce foreshortening. I've superimposed the foreshortened image onto a faded image of the version with no foreshortening to show how the sides retain their angles. Right: The far end dragged forward using the Distort command. Here the length of the far end remains constant (resulting in the angle of the sides being altered instead), and the perspective effect remains unrealistic

You can also use the Distort mode to move the top and bottom together, but this doesn't produce foreshortening (Figure 13-19, right). Using this method the far and near edges of the bounding box keep their lengths unaltered as they are moved closer together. As a result the object is still stretched into the distance with the far end remaining as remote as it was before (but as though viewed from a lower position).

A Few More Points About Transforming

You can transform artwork on several layers at the same time. To do this, select the desired layers in the Layers panel by clicking on their panels while holding down the Command key (Macs) or Control key (Windows). This highlights each of the chosen layers in the panel and creates a sort of 'weak link' between them. To release the link when you've finished, click on any layer in the Layers panel.

After you've done a transformation, the transformed object is of a slightly lower quality than the one that you started with, because the computer has to redistribute the colours in the reshaped image across a new set of pixels.

This lowering of quality after you've done a transformation isn't a problem unless you transform the same object many times, allowing the degradation of quality to accumulate. You can push and pull an object round as much as you like in a single transformation operation before you finally commit the changes to canvas without influencing the final quality of the image, as the whole operation only entails one actual distribution of pixels.

While you're in the middle of your transformation you may notice that the image quality of the object you're transforming appears to be very low. This is nothing to do with the actual quality of the image on the canvas, but is because the computer's not bothering to display the whole detail on the screen, as this would take a lot of memory. The image will pop back at high quality after you've finished your transformation (although, as mentioned in the previous paragraphs, not at *quite* such high quality).

It's possible to pull a transformation handle so that the handle disappears out of the side of the image window. Once you've released the handle that particular handle becomes inaccessible unless you alter the size of the window. There are two ways to do this: you can pull on the knurled handle in the bottom right hand corner of the window, or you can use the keyboard shortcut of pressing Command-0 on a Mac or Control-0 in Windows. That's a zero not the letter 'oh'. (This is a special use of this shortcut, which in most other circumstances is used to change the size of your image on the screen in order to make it fit snugly into the space available).

If you try to squeeze or stretch an object into too extreme a shape Elements won't be able to compute the transformation, and the object won't change shape after you've finished. As a signal that you've gone too far with your attempts at distorting a warning message pops onto your screen telling you that you've overdone things (The sides of the bounding box also turn into dotted lines instead of continuous ones). In such cases you should move the handles back to where the lines of the box become continuous again in order to apply the maximum distortion allowed. This may take several attempts, as the warning sign may reappear if you make the wrong move.

Transforming by Numbers

It's possible to make precise numeric transformations by entering the values in the boxes in the options bar.

This can be very useful when you want to make an exact alteration, such as making an object exactly twice its size or rotating it by exactly twelve degrees.

The boxes labelled W and H alter the width and the height of the transfomation bounding box. The measurements can be in percent, pixels, inches, centimetres or millimetres – simply suffix the numerical value with the appropriate abbreviation: %, px, in, cm or mm. The units you choose will remain the chosen units unless you alter them, so you don't have to keep keying in the units every time. You can use different units in each box, such as mm in one and % in the other. To retain the original proportions, check the Constrain

Proportions box – then when you enter a figure in either the width or height box the other one will change automatically in proportion.

The third number box, with an icon next to it that shows a rectangle at two different angles, is for inserting the angle of any rotation you want to apply. To rotate anticlockwise place a minus sign in front of the number.

All three number boxes can have their values altered by dragging the cursor along the invisible slider that lurks alongside the boxes (Place the cursor over the W, the H or the angled rectangle symbol).

Flip Horizontal and Flip Vertical

Related to transforming, but not specifically transform commands, are the Flip Selection Horizontal and Flip Selection Vertical commands. These allow you to create mirror images of objects as in Figure 13-20. Find them at Image>Rotate.

If there's no selection area active the command works on the whole active layer, and the commands modify there names to Flip Layer Horizontal and Flip Layer Vertical.

Make sure that you use the flip commands that include the word Selection or Layer. They are near the bottom of the Rotate menu. Don't make the mistake of using the Flip Horizontal and Flip Vertical commands that are near the top of the Rotate menu. These flip the whole image (The fact that these commands are eyecatchingly near the top of the menu means that you'll inevitably use them by mistake sometimes – I still do it myself).

Figure 13-20 Create mirror images using the Flip Selection Horizontal command. Here I've copied a man and then flipped the copy

These commands are very useful for creating symmetrical objects, as in Figure 13-21. This can cut the effort involved in creating such objects by half!

Figure 13-21
Using the Flip
Selection Horizontal
command to create
a symmetrical object

The butterfly above gives me the perfect vehicle for pulling all of the lessons of this chapter into one single image (Figure 13-22). This *whole* image only took a few minutes to create. Each of the butterflies in it was created in seconds by using the Transform command to alter copies of a single 'master butterfly' (below) that was composed of the two halves of the butterfly in Figure 13-21, with each half on a separate layer (so that no selection areas had to be defined before transforming the image). To create each new butterfly the two layers of the master butterfly were copied and then each copied layer was transformed to produce a new 'pose'. Once each new butterfly was finished its two layers were merged.

The only other action taken to create the butterflies was to change the colours of some of them. This took no time at all using the Hue/Saturation command.

Drawing Aids

14

This chapter describes various ways in which drawing on a computer can be made easier, by using methods of ensuring that your lines or brushstrokes go where you want them to go.

The chapter starts by outlining ways of tracing images directly from reference material, and goes on to deal with ways of creating straight lines.

Drawing a freehand straight line on a computer screen using a mouse, or even a graphics tablet, can be quite a difficult feat, but fortunately there are several simple methods of creating ruler-straight lines. Once you know how to create straight lines you can either use such lines directly in your artwork or you can employ them as guidelines or templates for freehand lines, just as in conventional art you may use faint pencil guidelines drawn with a ruler.

In This Chapter.

Tracing

How to keep things horizontal or vertical

Create perspective guidelines using the Brush, Pencil or Line tools

Using Free Transform for perspective effects

Symmetrical images

Creating frames for cartoons and comic strips

Tracing Over Images

A fundamental technique for artists is to trace over images, either in order to copy from reference material or to improve an image that's already been created. This is an easy technique to emulate in Elements.

The basic process involved in tracing an image in Elements is to place a new layer above the image that you want to trace from, and to then draw your new image onto this new layer, just as you would with a sheet of conventional tracing paper.

The only factor that may hinder this incredibly simple process is that the colour in the image that you're tracing over may be so intense that it makes it difficult to see the tracing above it. To make the traced image easier to see it's often useful to subdue the colour in the underlying image by making it much lighter, as in Figure 14-1.

Figure 14-1 To trace over an image, first fade the image

There are several ways to subdue the colours in an image.

Perhaps the most intuitive method is to create a new layer above the image and to then fill this layer with semitransparent white, allowing the underlying image to show through in a suitably ghostly manner. Do this by filling the layer with white and then lowering its opacity using the Opacity slider at the top of the Layers panel.

Another method is to use the Levels command.

To use this method, click on the layer in the Layers panel that contains the image that you want to trace over (in order to make it active). If the image is on several layers click on the uppermost layer. Then go to the bottom of the Layers panel and click the Adjustment

Layer button (The half black/half white circle). Choose Levels from the list that appears.

This will open the Levels dialogue box. In the lower half of the dialogue box is a slider containing a scale from black to white, labelled Output Levels (Figure 14-2). Move the black arrowhead at the left end of the slider over towards the lighter end of the scale. This will turn any black in the image to the shade of gray against which you position the arrowhead (You can remember that the arrowhead affects the black because the arrowhead itself is black). All of the other tonal values in the image will shift accordingly.

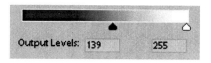

Figure 14-2
The Output Levels control, in the Levels dialogue box

The Adjustment Layer that you've just created is placed directly above the layer containing the image that you want to trace over (because you created it when the image's layer was active). Think of it a little like a sheet of tracing paper, except that you can't actually draw directly onto it. You have to draw onto another layer above it. Whenever you need to return the image that you're tracing from to full intensity (such as when you want to check some detail in the image) hide the Adjustment Layer by clicking on its eye icon in the Layers panel.

Another method of lowering the intensity of an image in order to trace it is to reduce the opacity of the image's layer by moving the Opacity slider at the top of the Layers panel.

This method is very convenient on suitable artwork as it doesn't involve the creation of an extra layer purely for the purpose of creating a low intensity effect. However it has a few disadvantages in some instances. Because the layer containing the image has been made semitransparent any artwork on layers below it may show through and interfere with the image (or if it's the lowest layer you may be able to see the underlying checkerboard effect beneath it). Another drawback is that if your image is on several layers you'll have to reduce the opacity of each of them separately.

Using any of these methods it's a good idea to hide the reference image occasionally so that you can see what your own efforts look like without the distraction of the image below.

If you own a graphics tablet you can trace material by placing it directly on the tablet and going over it with your electronic pen. This isn't as precise as tracing over an on-screen image, but it means that you don't have to scan the image into your computer first, so if accuracy isn't as important as speed it's worth bearing in mind.

Drawing Straight Lines

There are a variety of ways to create ruler-sharp, absolutely straight lines in Elements, such as the ones that make up the cube in Figure 14-3. Most of these methods are covered elsewhere in the book in the individual sections dealing with the relevant tools, however here I've brought them together as part of a raft of techniques for aiding drawing.

Figure 14-3
There are several methods
of creating perfect straight
lines in Elements

While perfect mechanical straight lines can be used in images in their own right they're also very useful as temporary guidelines over which you can trace in order to control the direction of freehand lines, as in Figure 14-4.

(By the way, if you find it difficult to draw freehand straight lines on a graphics tablet due to the smoothness of the surface, try putting a piece of paper over the tablet's drawing area in order to give it some 'bite'.)

Figure 14-4 Mechanically produced lines can be useful as guidelines for freehand drawing

When you use guidelines in this way you should create them on their own layer so that they don't interfere with the rest of your artwork. To make the lines light enough to trace over you can make them faint using one of the methods described on the preceding pages.

Aids to Drawing

Creating Horizontal or Vertical Lines

Figure 14-5
A perfect horizontal
'freehand' line, created
by holding the Shift key

If you want to draw a perfectly straight horizontal (or vertical) line using the Brush or the Pencil, as in Figure 14-5, hold the Shift key down while you're drawing.

The resulting line will then be restrained to the vertical or horizontal depending on which is closer to the direction in which you move the cursor.

If you're using a graphics tablet you'll still be able to vary the thickness of the line by varying the pressure. This is useful if you want a straight but relatively naturalistic line.

Creating Straight Lines at Angles

Figure 14-6
Angled straight lines

You can create straight lines in any direction using the Brush or Pencil (Figure 14-6).

Do this by holding down the Shift key, then clicking the tool in different positions (rather than the usual method of dragging it). With each click a straight line is generated between the present click and the previous one.

If you're using a graphics tablet the line may be much thinner than you expected, due to the lightness of pressure on the tablet – in fact it may be so thin that it's invisible. If this happens the easiest solution is to use your mouse for this particular operation instead. The tablet alternative is to go to the Tablet Options panel in the Brush's Options bar (That's the very obscurely positioned downward pointing arrowhead that's sandwiched between the Airbrush button and the brush-shaped button) and turn off the Size option – but that's a little tedious if you just want to produce a few lines.

Creating Straight Lines with the Line Tool

A convenient way to create straight lines is, naturally enough, to use the Line tool. It's the third to last tool in the Tools panel – its button is just a line, and it shares its slot with other tools that have buttons in the form of a rectangle, ellipse, polygon or heart.

As well as being useful for creating straight lines that are integral parts of your artwork this tool is particularly useful when you're in the middle of creating an image and all you want to do is to temporarily add a single guideline to draw over or to help you to line things up, such as when you want things to be either along a horizontal or vertical line (The Move tool has a feature that lines up objects on separate layers which is also useful for this – described in a few pages' time).

It's a better way of producing guidelines than using the Brush or Pencil because it's easy to alter the angle of a line as you're creating it. However it requires a little explanation, as it uses a tool that hasn't been introduced yet (See page 460 for more on the tool).

When you press and drag the Line tool's cursor a perfectly straight line will be drawn from the point at which you first press to the point at which you choose to release the cursor. As you drag the cursor the line appears on the screen as you drag, with one end anchored to the point where you started the line and the other at the position of the cursor. This allows you to position the line accurately at any angle.

After clicking on the Line tool's icon in the toolbox you should set the width that you want the line to be (For producing guidelines this need only be an approximate width). Do this in the Options bar, in the field labelled Weight. If you want to change the units of the line's thickness type in your prefered units after the number. You can use px, mm, cm or in.

When you create your line it's automatically placed on its own layer, so it won't interfere with the rest of your artwork.

The lines that you create with the Line tool are generated in a different way to ordinary artwork and are technically called Shapes. You can't use the normal tools such as the Brush or Eraser on the same layer as the line: a message will pop up telling you this if you try.

The default name of a layer that contains a line will be the word Shape followed by a number: Shape1, Shape 2, etc, depending on whether you've created other lines already.

The colour of the line will automatically be the colour of the foreground colour swatch at the bottom of the toolbox. If you don't like the colour you can change it in the Options bar by double clicking on the colour swatch (That's the unlabelled square with an arrowhead alongside it – it may be black, white or a colour). This opens the Color Picker. Choose a new colour from the picker and the line will change to that colour.

Keeping Lines Horizontal or Vertical by Using the Grid

Figure 14-7
The Grid (left) can be
used to help you to
keep lines horizontal
or vertical

One way that Elements can help you to keep freehand lines more or less horizontal or vertical is to let you superimpose a grid of guidelines onto the screen (Figure 14-7).

To do this, go to View>Grid. To remove the grid when you've finished with it go back to the same command.

The grid only appears on the screen, and won't appear in prints, even if it's visible when you make a print.

You can alter the spacing of the grid lines: in Windows go to Edit>Preferences>Guides & Grid, or on a Mac go to Photoshop Elements>Preferences>Guides & Grid.

The colour of the lines can also be altered, and they can be changed into dots or dashes.

It's possible to make your drawn lines 'stick' to the lines of the grid when the drawn lines are close to the grid lines (Figure 14-8). To do this, go to View>Snap To>Grid. This option can only be activated when the grid is in use. It stays active until you specifically turn it off by going back to View>Snap To>Grid. If you find that your lines are unexpectedly sticking to the grid lines it means that you've left it on.

Figure 14-8
Make drawn lines stick to the grid
lines by activating Snap To Grid

As a rule it's best to use the grid sparingly, and only turn it on when you really need it, otherwise you may find that the lines in your artwork will start conforming to the grid instead of to your imagination.

Lining Things Up and Spacing Things Out

Sometimes you'll want to impose a bit of order on your work, such as by placing elements of it onto the same horizontal axis or by spreading them out evenly, or both (Figure 14-9). Or you might want to align some elements of an image on a vertical axis, and possibly distribute them at equal distances vertically too.

Elements provides you with the means to do these things, via the Move tool.

To familiarize yourself with aligning and distributing objects it's a good idea to do a trial run in which you create perhaps four basic objects – simple rectangles or circles are excellent – that you can experiment with.

Figure 14-9 Top: Randomly placed objects.
Centre: The objects aligned horizontally.
Bottom: Horizontal and spaced equally

To align or distribute objects in your image the individual objects need to each be on their own separate layer. You then need to select all of the layers that you want to move (such as by clicking their positions in the Layers panel while holding down the Command key on Macs or the Control key in Windows).

Now that the layers are selected you can align or distribute their contents by using the options in the Move tool's options bar.

To align the objects click on the Align button in the Options bar. This will open a dialogue box that shows different alignment options. If you want to align the objects along a horizontal line click the appropriate button in the top half of the dialogue box – the most commonly used option is to align along the bottom edge (so that the objects appear to be standing on the same line). To align objects along a

vertical axis click the appropriate button in the lower half of the dialogue box instead. If you make a mistake go back by using the Undo command (Command-Z on a Mac or Control-Z in Windows).

To distribute the objects at equal distances go to the Distribute button in the Move tool's Options bar. To distibute objects horizontally choose an option from the bottom half of the dialogue box (Horizontal Centers is probably the most useful). For vertical distribution choose from the top half of the box. The Distribute option is most effective for spacing out objects that are more or less the same size and shape, where the result is a very nice even distribution. If the objects differ in size significantly the effect isn't quite as useful, as the process doesn't put equal space *between* objects, only equal space between their centres (or left or right edges), so that large objects will muscle in on the space of smaller objects.

Creating Perspective Guidelines

Perspective is the phenomenon whereby objects appear to be smaller the further away they are from the observer.

For artists this presents the problem of working out the relative size of distant and near objects so that the perspective looks convincing on the flat plane of a picture.

Fortunately there's a very basic rule that you can apply to images in order to make your efforts at perspective appear to be reasonably accurate.

This rule is that parallel lines appear to converge on one spot, called the vanishing point, as they recede into the distance (Figure 14-10). As a result, any objects that are the same height or width will appear to get predictably smaller the further away they are.

In landscapes the vanishing point is generally on the horizon.

Figure 14-10
Parallel lines converge
on a vanishing point

In Figure 14-10 you may notice that the vertical lines of the building and the lamp posts are all vertical and parallel. This is despite the fact that in real life these lines are subject to the laws of perspective in just the same way as horizontal lines, and they should all converge on a point that's way up in the sky. I've ignored this vertical perspective because unless you specifically want to emphasis the vertical dimension of objects for dramatic effect it's best to minimize the vertical perspective effect applied to them, otherwise they can look a bit too dramatic. This over-dramatic effect is often encountered in photographs of buildings when the camera is pointed upwards rather than being held horizontally: the buildings in the photographs seem to lean over excessively, even though they are actually in true perspective. This effect is known as converging verticals. It's caused because in everyday life the brain ignores vertical perspective quite a lot and compensates for it (in the same way that it compensates when you look at things with your head at an angle, in which case you don't see the world tilted sideways). However, when the effect is recorded on a two-dimensional image the compensation system is by-passed and you notice the effect.

There are a number of ways to create a layer of guidelines as a template to help you to achieve realistic perspective effects (Figure 14-11). Here are what are probably the easiest methods.

Figure 14-11
Perspective guidelines can be created with the Brush tool in conjunction with the Shift key or by using the Line tool

Perspective Guidelines Using the Brush or Pencil

You can use the Brush or Pencil to draw an array of perspective lines, using the keyboard to restrain the lines so that they're perfectly straight.

First draw a horizontal line as your horizon or eye level line, by holding the Shift key to restrain the direction of the line to the horizontal while you're drawing.

Then draw a selection of other lines all radiating away from a single point (the vanishing point) on the horizontal line. You don't have to be too precise about getting the lines all radiating from exactly the same point when you're creating a guide for a freehand drawing.

To draw straight lines with the Brush click and release the tool where you want to start

the line (in this case at the vanishing point), then hold the Shift key and click the cursor where you want the line to end. It's often best to use the mouse to do this, as with a tablet the lines may be too thin unless you adjust the Tablet Options settings in the Options bar.

If you want any of the guidelines to be at precise angles, such as 30 degrees, draw a horizontal line on a layer of its own then use the Free Transform or Free Rotate command to rotate it precisely by entering the exact angle desired in the Rotate box in the Options bar.

Perspective Guidelines Using the Line Tool

The Line tool (page 460) is a convenient tool for creating perspective guidelines.

When you create more than one line with this tool each line is automatically placed on its own separate layer unless you specifically ask the programme to keep them all on the same layer. If you create more than a few guidelines it's advisable to place them all on one layer, as if they're on individual layers the number of layers can soon become unwieldy.

To place all of the lines on one layer, create your first line, then go to the Line tool's Options bar and select the second button in the row of overlapping squares (The button can only be activated once there's a line in place already).

Using this option all new lines will be on the same layer while you remain working on that layer. The option is deactivated when you change tools.

Perspective Guidelines Using Free Transform

Another easy method for producing lines in perspective, and a lot of fun if you like this sort of thing, is to use the Free Transform command, as shown in Figure 14-12.

Figure 14-12 A series of vertical lines turned into a perspective guide using Free Transform

First, create a series of parallel lines on a new layer. The series can be of vertical lines or horizontal lines, but for simplicity of explanation I'll stick to vertical lines here.

You can create your lines by using the Brush tool or the Line tool. I'll describe only the Brush method here, because it's marginally more straightforward.

Start by creating a single vertical line on an empty layer, holding down the Shift key to

restrain the direction. Place the line more or less in a position where it can form one edge of your row of guidelines. Don't use a line that's too thin, otherwise when you eventually create your perspective effect it may disappear in the 'distance'.

Duplicate the layer several times (such as by dragging its box in the Layers panel down to the New Layer button at the bottom of the panel). Do this until you have as many layers as you need lines for your guidelines. You will then have a stack of layers, each containing one line for your row of guidelines – they'll all be directly above each other so you'll only be able to see one line though.

Now activate the Move tool, and drag one any one of the lines across so that it's separated from the rest. Hold down the Shift key while you move the line, in order to restrain its movement to the horizontal (or vertical). Move it until it's approximately in the position of the other edge of your row of guidelines. You now have the opposite edges of your guidelines defined, and you now need to string the other lines out evenly in the row between these two positions To do this, select all of the layers containing the lines in the Layers panel and use the Move tool's Align options (as described on page 374).

You now have a nice even distribution of lines (Figure 14-12, left).

It's probably a good idea to merge all of the lines onto a single layer now, to keep things simple. The layers containing the lines are still selected from the previous operation, so all you need to do in order to merge them is to click Command-E (Mac) or Control-E (Windows).

You're now ready to squeeze one end of the lines together to form a perspective effect. Do this by using the Free Transform command, which can be opened by using the shortcut of Command-T (Mac) or Control-T (Windows).

A bounding box will appear round your set of lines.

Hold the Command key (Mac), or Control key (Windows), to put the Transform command into Distort mode, and drag one of the bounding box's corner handles inwards or outwards to modify the lines (Figure 14-12, centre). Holding the Shift key as well will keep the movement restrained to the horizontal or vertical, depending on which is closer to the direction of the movement.

Then drag the adjacent corner in the same manner if necessary (Figure 14-12, right).

And that's it.

The resulting basic fan of guidelines as in Figure 14-12 can be used to produce perspective on the ground, for railway tracks and all of the usual things, or the same fan can be rotated through ninety degrees to use for vertical objects such as walls.

If you place two fans edge to edge as in Figure 14-13 they can be used for the corners of buildings. Keep each fan on a separate layer (at least to begin with) so that each fan can

be stretched or squashed separately (by using the Free Transform command) in order to achieve the desired angles.

Figure 14-13
Fans of guidelines can be used together to help draw 3D objects, with each fan being independently adjustable

There's a Perspective mode in the Transform menu, but it's less useful than using Free Transform because it's not very flexible (see page 360). It adjusts both sides of the object that it's altering at the same time, producing a slightly boring central vanishing point. And very importantly, it doesn't properly adjust the object to allow for foreshortening, described next (a fact that should really disqualify the command from being called Perspective).

Adjusting Foreshortening in Perspective

First, what is foreshortening?

It's illustrated in Figure 14-14, which shows an image of a square on the left, as seen from above, alongside a view of the same square in perspective. The side of the square that goes backwards into the distance appears very much shorter in perspective than on the actual square. This visual compression is foreshortening.

Figure 14-14
The apparent compression of objects in perspective is known as foreshortening

You can create a grid of perspective guidelines that will help you to judge the effects of foreshortening, as shown in Figure 14-15 (right).

To do this, first you have to create a grid of parallel horizontal and vertical lines, as shown in Figure 14-15 (left). The grid has to be much taller than it is wide, because the

vertical dimension is eventually going to be compressed when the foreshortening effect is applied (as with the square in Figure 14-14).

You can create the grid in the following way (This explanation looks more complicated written down than it is in practice).

Start by creating the horizontal lines. Create a series of evenly spaced horizontal lines using the Align option in the Move tool's Options bar as described on the previous pages. Try to obtain a column of lines that is noticeably taller than it is wide (as in the proportions of my grid in Figure 14-15). Then duplicate the layer that contains the lines and rotate it by ninety degrees in order to give you a set of vertical lines. Delete any vertical lines that fall outside the area occupied by the horizontal lines. Then stretch the remaining vertical lines (using the Free Transform command) so that they stretch from the top to the bottom of the horizontal lines, formong a grid. Now that you've got your grid, merge the layers that contain the horizontal and vertical lines so that the whole grid's on one layer. That's your basic grid finished.

Figure 14-15 The stages involved in producing a fore-shortened perspective grid

Now to put it into perspective.

Squeeze the top or 'far end' of the grid in order to make the vertical lines converge (using the Free Transform command as described on page 378). The effect is shown in the centre image in Figure 14-15.

You can see from this image that although the vertical lines converge nicely something very strange has happened to the horizontal set of lines. They have been redistributed so that they are far apart in the foreground and close together in the distance, just as they should be when in perspective, but the whole effect looks odd. This is because while the horizontal lines have been repositioned more or less in accordance with the laws of perspective, the grid as a whole hasn't been foreshortened by being compressed (in the way that the square in Figure 14-14 has) – the perspective grid's total height on the screen is the same as that of the original grid, giving each square in the grid the appearance of being a rectangle stretching back into the far distance.

To rectify this you need to compress the grid by dragging the top of the grid down towards the bottom using Free Transform, simply by dragging on the top side of the bounding box. Do this during the same transforming operation as the squeezing in of the grid's sides, otherwise the horizontal lines won't be repositioned properly.

If you want to extend a perspective grid backwards, as shown in Figure 14-16, you can add to the grid by making a duplicate of the transformed grid, then reducing the duplicate in size (using Free Transform), and then fitting it into place behind the original grid. If you look closely you'll see that this effect isn't perfect, as the foreshortening isn't a hundred percent accurate – but it's accurate enough for most freehand work. (If you need to create multiple copies of the grid to go further and further into the distance always use the original version of the grid to create each copy, as copies of copies cumulatively degrade in quality every time you use the Transform command on them to change their size.)

Figure 14-16 Perspective grids can be placed together to extend the effect

Creating Frames

When cartoons and illustrations are published, either in print or on the internet, they're sometimes presented with frames round them, as in the left hand example in Figure 14-17.

Figure 14-17
A cartoon may work well with or without a frame

You may think that therefore you need to put these frames round your own images when you create them, especially if you know that they are going to be published with a frame. However, this isn't necessarily the case.

The frames round published images are usually added at a later production stage, using the software that's employed for designing page layout (either for printed pages or for web pages). Word processing programmes such as Microsoft Word can also add frames to images when you import them, and desktop printers can be set to add frames too. As a result, for single panel images adding a frame in Elements is often unnecessary.

Sometimes however, you may find that you need to add your own frame while the image is still in Elements. This would be necessary if you wanted the frame to be inside the actual edge of the entire Elements canvas. This was the case with the penguin cartoon in Figure 14-18, where the caption to the cartoon is an intergral part of the Elements page, so the cartoon's frame has to be smaller than the whole canvas (Depending on the use, captions can often be added separately in page layout software).

Here's how to add a frame.

First, it's advisable to create a new layer for your frame. Then you need to define the frame by placing a rectangular selection line round the image. There are several ways of doing this.

"It's impossible not to see them as ludicrously cute penguins!"

If your image fills the whole area of the canvas you can place a selection line round the whole image by going to Select>All.

If the image is smaller than the whole canvas (as is the case with my penguin cartoon) the most obvious way to create a rectangular selection line round the image is by using the Rectangular Marquee tool. That's fine, but it may be tricky getting the frame exactly the right size.

It's better to get Elements to automatically define the edge of the image by using a suitable selection method. For instance, if the image is surrounded by white on the canvas select the white area using the Magic Wand and then invert the selection (in the menu bar at Select>Inverse). Or, if the whole image is on one layer, click on the image's thumbnail in the Layers panel while holding the Command key (Mac) or Control key (Windows).

Now that you've got a selection outline defined you need to replace the outline with a solid line. To do this go to Edit>Stroke (Outline) Selection. In the dialogue box that opens choose a thickness for your line and a colour (usually black). You also need to decide whether you want the line applied inside, centred on, or outside the selection line – if the image goes right up to any of the edges of the canvas apply the line inside the selection line as otherwise part of the resulting line will be cropped from the image.

If you create images such as multiple panel cartoon strips (such as Figure 14-19) the frames round the individual panels are usually best added to the artwork in Elements itself. This is because the individual images are within the body of the artwork, making the addition of frames later on when the artwork is imported into other software for printing or display on the web impractical.

If you produce a lot of cartoon strips it's a good idea to design a frame template that can be used over and over again, rather than having to construct new frames from scratch every time you create a new strip.

There are innumerable ways of doing this. The most intuitive of these is to create a template from the correct number of rectangular panels and to line them up side by side.

Figure 14-19 A strip cartoon with adjustable frames so that the panels can be different sizes

Simple. However, distributing the panels across the strip and getting the gaps between the panels the right width can require a little bit of tweeking. You can do this by eye, pushing and pulling the sides of the panels until they fit the space nicely. This process can be more time consuming than you expect, due to the fact that altering one dimension of one panel means that you have to alter the dimensions of other panels too. Fortunately there are a number of ways in which Elements can come to your assistance over this matter. Here's one of them.

A good way to get round the problem of having to tweek the widths of separate panels in a strip is to approach the whole subject from a different direction – to not actually create the individual panels themselves, but to create the dividers that separate them!

How can this possibly work? And what does it mean anyway?

Look at Figure 14-20, which shows the whole process that I'm about to describe.

The bottom two panels of the figure show a finished template that has adjustable panels. You can see that they are adjustable because they're different.

How did I adjust them? I simply slid the spacers that separate the panels into different positions across the strip. The spacers, you see, are individual, free-floating components of the template, each on its own layer, and they can be moved with ease. You can see their true form in the second panel in the figure. Of course the divider looks terrible here – the trick is to hide its top and bottom in some way. I'll show you how to do it now. It'll probably help you yo visualise what's going on if you refer to Figure 14-21, which shows a 3D visualisation of the template's structure.

The first stage of creating a strip template is to create a rectangular, hollow 'letterbox' with a black outline that acts as the frame to your strip (Figure 14-20:1). A bit like a sheet of card with a slot cut in it. Due to the fact that you'll be working with a lot of white in this

Creating a Comic Strip Template

1: Create a hollow slot as your frame. Place the black outline on a separate layer beneath the white surround

2: On a separate layer create a divider to separate panels

3: Place the divider between the other two layers

4: Duplicate and distribute the divider

5: Adjust the position of the dividers as necessary

Figure 14-20 How to make an adjustable cartoon strip template

exercise, it's a good idea to either hide the background layer (revealing the underlying checkerboard effect) or giving the background layer a tint that isn't white, as I've done.

Create the letterbox on its own new layer using the Rectangular Marquee tool, either judging the box's dimensions by eye or entering their values into the height and width boxes in the options bar. Make sure that the overall canvas size that you're working on is larger than your proposed strip, so that you have a reasonable amount of border round the strip.

You want the actual letterbox to be 'hollow', but framed by a thin black line surrounded by white. To achieve this, once you've defined your box's outline with the marquee tool go to Select>Inverse in the menu bar. This will flip the selection from the rectangle to the rectangle's surroundings. Fill the selection with white, which will create your basic 'card with slot'.

Now for the clever bit, which will make sense in a moment.

While the marquee tool's selection outline is still active, create a new layer *beneath* the one you've just worked on. This is the layer onto which you're

going to apply the black line that frames your strip (It has to be on a separate layer beneath the white surrounding it). To create your black line go to the Edit menu, to Stroke (Outline) Selection. In the stroke dialogue box choose a thickness for your line, choose the colour (black), and – importantly – choose to put the line outside the selection line (otherwise it will be hidden by the white on the layer above). That's your slot finished.

Top layer:
white with slot
(and no black
frame)

Middle layer:
movable divider

Lower layer:
black frame
(white surround
optional)

Figure 14-21
A three dimensional visualisation of the template's structure, showing a divider sandwiched between the layer that contains the white slot and the layer that contains the black outline of the frame

Next you need to create a divider between separate panels of the strip, as shown in Figure 14-20:2. This is a narrow white rectangle with a black outline. In my figure I've added such a divider on a new layer above the others. As you can see it has a problem – it's resting above the rest of the strip and its ends are showing. The trick is to place this divider on a layer that's *between* the two layers that form the strip's slot (Figure 14-20:3), so that the ends of the divider are hidden behind the white of the top layer (while *very importantly* still leaving the black of the strip's frame hidden behind the divider).

Having created one divider, all you need to do now is to duplicate the layer that contains the divider so that you've got enough dividers for the number of frames that you've got planned.

Spread the spacers out a bit by dragging them along the length of the strip (Figure 14-20:4).

That's it – your adjustable template is complete.

You can now reproduce the template for each new strip that's drawn, creating the artwork on new layers beneath the template.

To change the width of individual panels simply drag the dividers to new positions, as in Figure 14-20:5.

You can use an extension of the technique described above to create complex multi-panel cartoons, such as the one in Figure 14-22. You do this by using horizontal dividers as well as vertical dividers.

Figure 14-22
A complex cartoon layout such as this can be produced using an adjustable template, allowing the frames to be laid out in seconds

This method can be used equally easily to produce either regular grids or irregular layouts of panels of any proportions (Figure 14-23). In either case the entire layout can be altered in seconds.

Figure 14-23 Complex cartoon layouts can be achieved and altered in seconds

To produce a template for such a strip, first produce a set of dividers in one direction, as described previously. You can produce a set of dividers either horizontally or vertically, but for the sake of clarity, let's say that you've produced a horizontal set first.

The dividers in the other (vertical) plane have to be produced in a slightly different manner to the first set. This is because if you simply place a second set of dividers on top

of the first set, the black edges of the top dividers create a continuous line that crosses the white space in the lower dividers, spoiling the effect.

To avoid this you need to create the second set of dividers in two parts, as follows.

Create a new layer above your set of horizontal dividers, and create a rectangular selection outline for your first vertical divider. Fill the outline with white. This acts as a mask, so it hides the black lines of the horizontal dividers where they pass beneath it.

Keeping the selection outline active, create a new layer *below* the horizontal dividers, so that the horizontal dividers are sandwiched between the two new layers. Onto this lower layer place the black edges of the vertical dividers, by going to the Stroke command as above (making sure that in the dialogue box the setting for Location is Outside). Because this black edge is below the horizontal dividers the white of the horizontal dividers hides the parts of it where they cross. The arrangement is shown in Figure 14-24.

Figure 14-24
To create a seemless crossover between dividers (left), a horizontal divider is sandwiched between the two layers that make up the vertical divider

The vertical divider that you've produced is in two separate parts on separate layers. In order to slide both parts simultaneously when you need to adjust your frames you need to link the two layers (by activating the link icon for one layer while the other is active).

Create extra dividers by duplicating the two layers.

Flipping Images

Here are some tips that are not exactly related to templates or guides to drawing as such, but are definitely linked to helping you get your image looking right.

Flipping Images to Judge Composition and to Find Errors

After you've been working on an image for a while you can get a bit too familiar with what it looks like. To judge how the work's progressing you need to look at it afresh.

Short of putting it to one side for several days and then coming back to it, the best thing to do is to look at it as a mirror image (Figure 14-25).

You can do this by going to Image>Rotate>Flip Horizontal (or Flip Layer Horizontal if it's only one layer that you want to affect).

Figure 14-26
Flipping images can make you
notice aspects of their composition
that you'd otherwise miss

Flipping your work horizontally can bring your attention to aspects of your composition that you didn't notice previously, such as errors in composition or proportion. And it'll reveal solutions to problems because of the new way that you're looking at things.

If you have a tendency to draw verticals at a slight angle, as with a handwriting slant, and your work leans slightly as a result, you might not notice the lean when your work's the right way round, but reversing it will suddenly make it obvious. If you want to straighten things up, use the Transform command to skew the work in order to correct the lean.

Flipping Images to Create Symmetrical Objects

Drawing objects that are symmetrical can be challenging, because inconsistencies between the two sides can emphasize errors.

Not only that, but drawing the almost identical opposite sides of symmetrical objects can be frustrating because you're drawing the same thing twice.

Both of these problems can be overcome by only drawing one half of an image, then duplicating it and flipping it over to supply the other half (Figure 14-26). The same process was applied to the butterfly in Figure 13-25 (page 365).

Figure 14-38 A symmetrical object created by flipping half of an image. The original image was drawn with a grid (described earlier in this chapter) to help retain horizontals and verticals

Text
15

It's a simple matter to add text to images in Photoshop Elements.

You may want to do this to give an image a title, to add a cartoon caption, or to use text as an integral part of the image (such as on a shop sign or noticeboard).

To do this you have the choice between using the Type tool or creating your own hand-lettering.

Using either method you can alter the text endlessly until you're happy with the results: you can change its size to fit the space available for it, change the design of the letters, or simply correct spelling mistakes.

Adding text with the Type tool can be the work of only a few seconds, while hand-lettered text takes a little longer but isn't too difficult to create either.

The great advantage of hand-lettering on a computer over its pen and ink counterpart is that the conventional method can be both tedious and nerve-wracking at the same time, with the slightest mistake ruining your efforts.

On a computer you can even turn your own hand-drawn letters into a keyboard font so that you can type it directly onto your work.

In This Chapter:

Typing and editing text
Special text effects
How to produce hand lettering
Creating a keyboard font of your own hand-drawn letters
Creating speech balloons

Keying in Text with the Type Tool

I was tempted to begin this chapter with the observation that adding text to an image in Elements is as easy as ABC, but thankfully I thought better of it.

However it is pretty straightforward, as you'll see.

It's almost just a matter of opening the Type tool and starting typing.

One of the joys of using the Type tool is that you can type in your words in any size and any typeface that you want (Figure 15-1), and then you can alter them all later with ease in order to make them more interesting or more legible (or indeed less legible).

Not only can you add words to your work, but you can add special effects to your resulting words, such as by distorting them or by making them seem three dimensional. All will be revealed later.

> When you use the Type tool you can change the **SIZE** of the letters, or their **thickness**, or the **TYPEFACE**, or more...

Figure 15-1
It's simple to change the
characteristics of your text

Getting Your Words onto the Screen

In order to type your text you have to open the Type tool, by clicking its button in the Tools panel (Figure 15-2). It's in the form of a letter T, as in T for Type. Alternatively use the keyboard shortcut of pressing the letter T.

 Figure 15-2 The Type tool

The tool's position in the toolbox contains several different versions of the Type tool.

Before you start worrying about this abundance of tools let me tell you that there are actually only two different tools there, as the other two are simply the same tools in versions that type vertically rather than the usual horizontally (So that's two tools you probably won't be using very often). Of the two horizontally typing tools the top one – the Horizontal Type Tool in fact – is the only one you'll need to begin with. This tool has to be selected if you want to type normal text. The two tools with the large dotted Ts next to them – called Type Mask Tools – are for producing a specialized sort of type (which you may never use), which I'll explain later.

The Type tool always opens in the version that it was last set at. If you only use the standard type tool this will be no problem, but if you use any of the other ones ocassionally and you forget to change back to the normal mode you may get a slight shock when your letters start appearing differently to the way that you were expecting.

So let's look at the normal Horizontal Type Tool.

To apply type once you've activated the Type tool move the cursor onto your canvas. The cursor initially appears as a small dotted square box containing a vertical line that is slightly reminiscent of a letter I. In fact, this vertical line is called an I-beam.

Click the I-beam more or less where you want your text to appear (although position isn't critical as you can move your text very easily later).

When you start typing, a new layer is automatically created for your text to appear on. This layer is a special sort of layer specifically designed for accepting text, called, logically enough, a text layer. You can recognize a text layer by the letter T in its thumbnail in the Layers panel. Text needs to be placed on this special layer because the letters aren't generated in the same way as normal artwork. Each letter is a self-contained object in its own right, rather than an array of pixels in the shape of a letter.

You can type separate pieces of text onto individual text layers so that they can be treated independently and can be placed in different parts of the image. This is particularly useful in graphic arts, comics and cartoons. The text in all of the speech balloons in this chapter were created in exactly this way.

When you click the cursor, a vertical line will start blinking on and off at the point at which you clicked. This point is where the text will appear, and is called the insertion point. The vertical flashing line indicates the size of the text you're about to enter: if the size seems too large or too small you can change it, as I'll explain in a moment.

The cursor (in the form of the I-beam) will still be on the screen, independent of the insertion point. If you move the I-beam a little distance from the insertion point it will turn into a Move tool icon. For now, consider the cursor to have been put to one side for a moment, and just concentrate on the blinking vertical line, the insertion point.

Type in a few letters of text to see what the effect is. The words Hello or Test are common choices.

The chances are that the letters will be the wrong size – either too large or too small. To change the size of the letters move the cursor back onto the letters. The cursor will become an I-beam. Double click anywhere on the letters to select them. They will become highlighted to show that they are selected. A simple way to then change their size is by going to the Options bar, to the size box (that's the third box along, with a number in it). Click on the arrow at the side of the box, which will open a list of different sizes to choose from. If the exact size that you want isn't there, pick the closest one, as you can alter it more precisely later, as I'll explain soon.

To resume typing, click the I-beam at the point in the text where you want to type: the highlighting will disappear and you can continue typing (You can move the insertion point along the line of type by clicking the left or right direction arrow keys near the bottom right of your keyboard).

Whenever you click the I-beam on top of existing text, Elements will assume that you want to alter or add to that piece of text, so the new text will be entered in the body of the text that's already there. If you click the I-beam on an area where there is no text already, it'll assume that you want to create a totally separate piece of text, so a new text layer will be created.

You may notice, by the way, that the Options bar changes slightly once you've moved from having the cursor on the screen (which allows you to choose where to add the text) to having the insertion point there (where your text is added). This new options bar is the one that's used when you're actually in the process of typing something. In this new Options bar two new icons have appeared at the far right end: a circle with a line through it and a tick. These can be used for committing or rejecting your text, as described in a moment.

In the Text tool's normal mode, when you type in your words the text all stays on the same line until you press the Return key (Mac) or Enter key (Windows), at which point the text insertion point moves down to a new line. Text doesn't automatically move onto the next line when it meets the edge of the page, as it does in word processing programmes, so at appropriate points you should hit the key to move to the next line. Don't be too concerned about where you make these line breaks, as you can easily alter them later. Equally, don't be too worried if your text disappears off the edge of your image temporarily, as it's still there although it's out of sight – all you need to do to see it is to grab hold of it and pull it across the image later.

Manually configuring your text as described above, moving from line to line using the keyboard, is quite useful when you're only typing in a few words or lines, however it can become a little tedious in some cases. Fortunately, Elements offers you a way of creating a special 'text box' into which you can type your text so that the text moves on to the next line automatically when it reaches the box's edge (Figure 15-3).

You can type text into a text box, where it will flow to fit the box, reflowing when you change the box's size

You can type text into a text box, where it will flow to fit the box, reflowing when you change the box's size

Figure 15-3
Type inside the box if you want things to remain constrained. The text will flow to fit the box if you change the box's shape

To create such a box, press and drag the Text tool's I-bar cursor (instead of simply clicking it on one spot). The cursor will define a dotted rectangle. When you release the cursor the dotted rectangle will acquire square handles on its corners and its sides, and a text insertion point will start blinking inside the box. You can alter the dimensions of the box at any time by pressing and dragging on the sides or the corners (You have to do this using the Text tool, so if you've moved away from using the tool you'll have to reactivate it). The text inside the box will 'rewrap' to accomodate itself to the new size. If the box is too small for the amount of text that's in it the excess text will disappear out of the box and out of sight – to warn you that this has happened the bottom right handle of the box will display a small cross (Too small a cross in my opinion).

One drawback of the text box is that it doesn't allow you to choose where all of your individual lines of type end. If you only need a few lines of text, such as in a cartoon caption, it's often best to avoid using the box. This allows you to be more efficient about the use iof space for text and allows lines to end where there's a natural break in the flow of the words (Figure 15-4).

SOMETIMES YOU SHOULD CHANGE THE NUMBER OF WORDS ON A LINE SO THAT THE SENTENCE FLOWS BETTER THAN THIS

SOMETIMES YOU SHOULD CHANGE THE NUMBER OF WORDS ON A LINE SO THAT THE SENTENCE FLOWS BETTER – LIKE THIS

Figure 15-4
Try to end lines at natural breaks in the flow of words

Committing (Saving) or Rejecting Your Text

While you're actually in the process of typing new text, the text appears on your screen but isn't saved in the file as you do so. It's saved automatically when you move on to do other work on a different layer of your image, or when you save your image.

If you try to close Elements when the last thing that you did was to work on some text, and you've neglected to save the image, a message will appear on your screen asking you whether or not you want to 'commit' the text to the document. Committing is simply another word for saving.

There are a few times when you might want to commit text while you're in the middle of typing: a typical example being when you're in the middle of typing something and you're unsure of what to type next, so you want to ensure that the work you've done up to that point is safe. Commit the text by clicking on the commit button, which is the large tick at the right hand end of the options bar. Having said that, the text is also committed in exactly the same way when you click the Text tool's cursor anywhere on the image (outside of the text), so I'm not quite sure of the point of the commit button

While you're in the process of typing, if you decide that you don't like what you've just written you can click the cancel button (the circle with the line through it at the right hand end of the options bar). This will make any changes that you've made to the text since it was last committed (or saved) disappear.

Choosing or Altering the Properties of Your Text

You can choose the properties of your text, such as the size of the letters or their typeface (the design) at any time, either before you start typing or after you've commenced (unless you convert the text into pixel artwork, as explained later). In order to alter text that you've already written, you have to select it first, as described next.

Selecting Text for Editing

You can select text for editing in the following ways.

If the Type tool isn't already active, select it in the Tool panel or press T on your keyboard (The Type tool will already be active if you're in the middle of entering text, but if you're going back to the text after using another tool you'll have to activate it).

To create an insertion point in a piece of text, click the I-beam on the point in the text

where you want to edit. You don't need to specifically select the layer containing the text first, as when you click the cursor on the text the layer is selected automatically (Having just said a moment ago that if you're using a tool other than the Type tool you have to go back to the Type tool itself, if you're using the Move tool you can reactivate the Type tool simply by double clicking on the text that you want to edit). If the text you're intending to edit is already active (that is, you're in the process of writing it) it'll have a flashing insertion point in it already. This insertion point will move to your chosen position if you click the I-beam elsewhere.

If you simply want to add, delete or change a letter or two, such as when you notice a spelling mistake, you can just delete the letters using the Delete key, or add the letters by typing them as normal.

To select several letters or words at once, press and drag the cursor across the text that you'd like to modify (Figure 15-5). The selected text will be placed on a coloured background, the exact colour depending on the colours that are behind it in the image.

To alter, or edit, a word or phrase, it first needs to be selected, like this

Figure 15-5
Selected text is indicated
by a coloured background

You can also select specific parts of text by clicking the cursor rather than by dragging it. If you double click inside a word the whole word will be selected; click three times and the whole line will be selected; click five times and the whole text on the layer is selected (the seemingly redundant fourth click is maybe used by the tool in order to prepare itself for jumping lines).

If you want to select all of the text on a text layer you can double click on the layer's thumbnail in the Layers panel. This is the method I use almost all of the time.

The selected text can then be modified in the ways described on the following pages.

Choosing The Size of Your Type

Figure 15-6
Different sizes of type

You can choose the size of the letters in your text before you start typing or you can alter them afterwards. The easiest way to choose a size before you start is to enter a value in the size box in the Options bar (the third box along, with a number in it). The number is followed by the name of the units that are being used to measure the size: the default units are points (the traditional units in which type size is measured), abbreviated to pts. You don't have to include the letters for the units as that will automatically be added.

You can also choose a size for your type from the list of sizes that opens when you click on the arrow on the right side of the box.

Perhaps the best way to alter the size of text is simply by using the keyboard shortcut.

To do this, first go to the options bar and press and drag across the value in the font size box, so that it's highlighted. Then press the up and down arrows that are towards the bottom right on your keyboard (You'll find these arrow keys in a small group of four arrow keys, with the other two pointing to the left and right). The up arrow increases the type size, while the down arrow decreases it.

This method is particularly useful for changing the type size after you've written the text, as you can see the size alter in small steps as you press the keys. Select the text that you want to alter, as explained above. To change the size in single sizes press with short repeated steps: to change the size in a continuous flow, press and hold.

Professionally the size of type is always expressed in points. There are 72 points to an inch, or 30 points to a centimetre.

You can change the units of measurement of the type size in the menu bar, at Edit>Preferences>Units and Rulers (Windows), or Photoshop Elements>Preferences>Units and Rulers (Mac). Alternatively, you can type your choice of units after the number in the font size box and that unit will be used to determine the size – you can use mm, cm or in. The value that you enter in the font size box will be converted into the units that are set in Preferences.

The size that the text appears on your image can be a little perplexing, especially if you move text from one image to another. Text that was one size on one image suddenly appears as a different size on another one. That's because the size of the text on the image is dependent on the resolution of the image (This is exactly the same thing that happens with objects when you move them from image to image, however it seems strangely more unexpected when it happens to text). Text that's moved from one image to another one that has a different resolution doesn't rescale itself when it's moved – it stays the same pixel height. Say that you add text that's 100 pixels high to an image that has a resolution of 100 pixels per inch. The text will print out as one inch high (because it's got the same number of pixels as one inch worth of the image). If you then move this same text to a different image that's at a resolution of 300ppi the same text would display at about a third of an inch at print size, because it's still only 100 pixels high (In fact, if you then select the text and look at its size in the Options bar you'll notice that its height in points is no longer what it was on the original image, but is a third of the height).

Lining up Your Text

Figure 15-7
Type can be lined
up to the left,
centre or right

Text can be arranged so that the separate lines of type all align themselves neatly one above the other (Figure 15-7). You have a choice of aligning them to the left, straight down the middle, or (less commonly) to the right.

The usual text alignment for normal use is aligned left, however for graphics and cartoon captions it's often best to have the text symmetrically aligned, or centred. Sometimes you won't want to use any form of alignment at all, so that you can squeeze text into oddly shaped spaces – one way to do this is to choose the closest form of alignment and then to shunt the lines of text by adding spaces at the beginnings of lines.

Select your desired alignment by clicking the alignment button in the Options bar (Figure 15-8) and then choosing from the list. Each button in the list show a representation of text lined up in the appropriate way.

Figure 15-8 Choose the way your lines of text align with each other

If you change the alignment of the text after you've applied it the text will change position to realign itself, which can be a bit startlingly if you don't realise what it's doing. You may then have to reposition the whole body of text to compensate for the change. To move the text while it's still selected move the cursor far enough away from the text for the cursor to turn into an arrow, then press and drag, and the text will move. Hold down the Shift key if you want to keep the text on the same horizontal or vertical line. Alternatively move it using the Move tool when the text isn't selected for editing (i.e. it isn't highlighted).

Changing Typefaces

You can pick the typeface, or the design of the letters (Figure 15-9), from a long list that opens when you click the down arrowhead that's attached to the box at the left hand end of the Options bar (The box will almost certainly have a strange word in it, which is the name of the currently chosen typeface).

The list is alphabetical, so the position of the typefaces in the list bears no relation to their usefulness. Alongside each typeface is the word 'Sample' in the typeface to show you what the face looks like.

Figure 15-9
A selection of the many typefaces that you can choose from in Elements

As well as using standard typefaces you have the option of choosing thicker (bold) or italic versions of the letters (Figure 15-10).

Figure 15-10
Regular, bold and italic versions of the same typeface

To choose the bold or italic versions of the typefaces go to the second box in the Options bar, the font style box, to choose from the available styles. The standard style is usually called Regular.

Not all typefaces have alternative styles available via the font style box. In these cases you can make the typeface bold or italic by clicking the appropriate T shaped button from the row of alternatives in the Options bar (Figure 15-11). These buttons also work on letters that have already got a style applied to them via the font style box, so for instance you can make a bold typeface bolder.

Figure 15-11 The second best way to change the style of your typeface

The bold and italic typefaces that are generated via these buttons have a slightly different appearance to the ones that you find in the font style box, and should only be used when the style isn't available via the font style box. This is because the bold and italic letters that they create are basically just the ordinary letters that have been thickened up or otherwise altered artificially, while the ones in the font style box are actually specially installed, separate letters, designed in their bold or italic form. Thus the versions accessible via the letter T buttons lack the subtlety of the properly designed versions. Because these T buttons don't produce specially designed letters they're properly called the Faux Bold and Faux Italic buttons (Faux, pronounced foe: French for false). The Faux buttons remain active until you specifically cancel them, so once you've finished using one make sure that you turn it off.

There's a quick way to change the typeface of your text if you know the name of the typeface you want to use. First, select the text that you want to change, then highlight the name of the text's current typeface in the Options bar. Type in the first letters of the name of the new typeface, and the full name will appear as predictive text. Then press the Enter key (Windows) or the Return key (Mac).

Moving Text Round the Image

It's almost inevitable that you'll want to reposition your text once you've finished entering it. Frequently the insertion point will have been only approximately in the right place, and if you've altered the size, typeface, alignment or number of lines of your text it's very likely that the text will have changed its position somewhat.

You can move a text layer just like any other layer, by using the Move tool. If you've got Auto Select Layer active in the Move tool's Options bar you can just press and drag on the type to select it and move it (although you have to actually hit the type itself, not any spaces in it – even the middle of the letter O counts as a miss). As long as Auto Select Layer is turned on you don't actually need to activate the Move tool via the toolbox. If Auto Select Layer is off you can either select the text layer in the Layers panel first, or you can temporarily activate Auto Select Layer by pressing Command (Mac) or Control (Windows).

With any other tool active you can press Command (Mac) or Control (Windows) to temporarily activate the Move tool (which will then work in whichever setting of Auto Select Mode is set in the Move tool's Options bar).

You can also move text by using the Type tool. First click on the text to place the insertion point in it (anywhere) or drag across the text to highlight it. Then move the cursor away from the text so that it changes from the Type tool's I-beam into an arro whead. Pressing and dragging will then move the text.

Coloured Type

When you activate the Text tool and you start typing fresh text on a new text layer your text will be in the colour that's in the foreground color swatch at the bottom of the Tools panel. If instead you click the Text tool on text that's already been typed (perhaps so that you can edit it) any new text that you type will be in the colour of the original text. In either case the colour of the text is displayed in the square colour swatch in the Options bar.

You can choose a different colour with which to type before you start typing, or you can change the colour of text after it's been typed.

To choose a colour before you start typing you can either change the colour in the fore-

ground color swatch in the Tools panel or the colour swatch in the Options bar. Clicking on either will open the Color Picker, allowing you to choose a new colour. When you've chosen your new colour both swatches will change to that colour.

To change the colour of text that's already been entered, first make the text layer active. Then change the colour in either colour swatch. All of the text on the layer will change colour.

To change the colour of selected letters rather than all of the text on a layer, select the specific letters before you change the colour. Or, if the desired colour is already in the foreground color swatch, select the letters then click the foreground color swatch (not the swatch in the Options bar, which will be displaying the original colour of the letters).

To add text in a new colour, place the insertion point into the text and then choose the colour. Or place the colour in the foreground color swatch – but do this *before* you activate the text layer, as changing the colour swatch when a text layer is active changes all of the text in the layer to that colour.

Changing the Space Between the Lines of Text (Leading)

Figure 15-12
You can alter the distance between lines of text

You can alter the spacing between lines of type, spreading them out or squeezing them together.

The spacing between lines is referred to as the leading (rhymes with heading). This name refers back to the days of mechanical printing presses, when pages of text were made of metal, and the gaps between lines were created by placing strips of lead between the rows of words.

Normally you won't want to modify the leading, and for this reason Elements usually sets it for you automatically. However occasionally you may want to alter it for aesthetic

effect or in order to fit your words into a particularly awkward space.

To alter the leading go to the box that displays two letter As on lines above each other, separated by an arrow (symbolizing the distance between the separate lines). Open the box to reveal a list of leading values, or type in your own value. It's generally best to use a value that's slightly larger than the value in the type size box (the only other number in the Options bar).

Alternatively, and better, highlight the value in the box by dragging across it and then press the up or down arrows that are at the lower right of your keyboard.

It's advisable to leave the control on its automatic setting if possible, displaying the word Auto, except when you specifically want to alter the leading. This is because on the Auto setting the leading is automatically readjusted whenever you modify the size of your text, whereas when the leading isn't on Auto the leading value has to be adjusted manually every time you change the size of your text.

Creating Black Type for Line Art

When you add text to most types of image using the Type tool the letters are anti-aliased – that is, they have slightly soft edges (Figure 15-13). This is important at normal image resolutions as it stops the lettering looking jagged and crude.

In high resolution (i.e. about 1200ppi) pure black and white artwork that's destined for printing this soft edge is unwanted, as it adds gray to the image. See Chapter 7 for more on this type of artwork.

Anti-aliased type Aliased type

Figure 15-13 Left: Normal text in Elements, greatly magnified to show the gray edges produced by anti-aliasing. Right: Hard-edged text, produced by turning off the anti-alias option

To apply text without a soft, anti-aliased edge, click the Anti-alias button in the Type tool's Options bar. That's the two small letter A's that are diagonal to each other (Not the one's that are above each other with a number box next to them).

You can apply this option to the lettering at any time, not necessarily when you first enter the text – just select the layer containing the text and click the button.

The setting that you choose, aliased or anti-aliased, remains selected, affecting all subsequent lettering until you alter it again – so if you only want to apply the chosen option to one particular piece of text don't forget to change back to your usual setting afterwards.

Rotating and Skewing Your Words

Rotate → *Rotate*
Rescale → Rescale
Skew → *Skew*

Figure 15-14
Text altered using the
Transform command

It's possible to rotate, skew and resize text (Figure 15-14) by using the Transform command, described in detail in Chapter 13. The text is still editable after you've altered it.

You can use the Transform command while you're still working on your text, without the need to close the Type tool, by pressing the Command key (Mac) or Control key (Windows).

You *can't* use the Transform command in Distort mode on editable text (that is, to make opposite edges of the text converge or diverge) and you can't put it into perspective (Figure 15-15). If you want to create distortion or perspective effects you have to change the text into pixels first. This means that the text becomes ordinary artwork rather than editable letters. See the section Turning Text into Pixel Artwork in a few pages time for more.

Figure 15-15
To put text into perspective
like this you have to turn it
into ordinary pixel artwork
first, before you use the
Transform command

Warp Your Words with the Warp Text Command

If you want to bend your words into improbable shapes, such as those in Figure 15-16, you can use the Warp Text command.

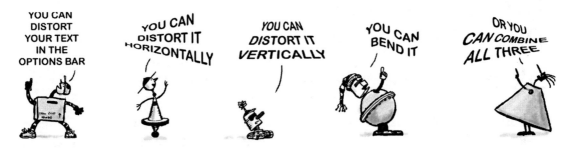

Figure 15-16 The Warp command (the letter T) can distort text in a variety of directions

This command is useful for such tasks as writing dynamic messages on greetings cards, posters or invitations, or for making text fit onto curved surfaces (Figure 15-17).

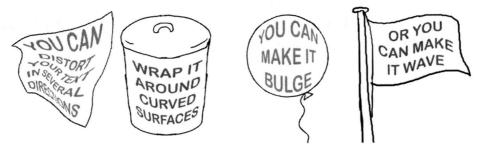

Figure 15-17 Bending text to fit curved surfaces

At first sight some of the warped shapes that you can achieve give a perspective-like effect, but a closer look will show you that it's not true perspective, as the letters only change size in one dimension (for instance, using the vertical warp, at the centre of Figure 15-16, the text squeezes in at the top but the lines of text stay the same height rather than getting smaller as they go into the distance). For slight changes in perspective the effect is fine, but to obtain more realistic perspective effects it's better to use the Transform command.

To alter your text, click the Warp Text icon in the Options bar, then choose from the selection of effects on offer in the panel that appears. These effects can easily be removed

from the text, returning it to normal, so you can play with them as much as you like. What's more, the text is still editable even though it's distorted, so you can always correct spelling mistakes or change typefaces at any time.

Distorting Text Using Filters

There's yet another way to distort text – by using the Distort filters from the Filter menu (Figure 15-18). These filters are covered in more detail in the next chapter.

To use filters on text you first have to turn the text into pixel artwork, meaning that you can no longer edit it (See the following page for more on this).

THIS TEXT WAS DISTORTED LIKE THIS BY USING THE SPHERIZE FILTER IN THE DISTORT FILTER LIST

Figure 15-18
Text can be warped by
using a distorting filter

Creating Three Dimensional Effects Using Layer Styles

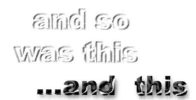

This effect was created using Layer Styles

and so was this

...and this

All in a few clicks of the mouse

Figure 15-19
Just a few
examples of
Layer Styles
applied to
text

You can add three-dimensional and other special effects to your text in a couple of clicks by using features from the Layer Styles panel (Figure 15-19).

I won't go into detail about how Layer Styles work right now, as there's a whole section dedicated to them in the next chapter (page 451). All I'll say here is that you choose a style

from a selection of ready-made effects, and apply it in just a single click. It involves no complicated manipulation, and the stylised text is still editable! As a result, if you notice a dreaded spelling mistake in your stylised text, or if you decide that you don't like the typeface you've chosen, you can just alter it as though it was normal type. Equally, if you decide that you don't like the effect that you've used you can choose a different one or remove the effect altogether, returning the text to normal type.

Layer Styles are used so frequently with text that the styles are accessible directly from within the Type tool's Options bar. To apply a Layer Style, first type in your text. Then click the Text tool's cursor on the text layer in the Layers panel. In the Text tool's Options bar go to the box labelled Style. Clicking this box will open a panel that displays one of several sets of Layer Styles, the others being accessible by clicking the double arrowhead at the top right of the panel. You can go back to the panel in order to apply effects cumulatively (or to remove them). The settings for the effects (such as the depth of the bevel) can be adjusted by clicking the small letters fx that appear in the Layers panel in the text layer that the effect has been applied to. Once an effect has been applied to a layer any new text that is added to the layer will have the effect applied to it automatically (so if you've applied a bevelled effect your text will appear bevelled as you type).

Turning Text into Pixel Artwork

When you type conventional text into Elements the text is placed onto a special kind of layer called a text layer, which is specifically created to contain the type. Text needs to be placed on this special layer because it isn't generated in the same way as the rest of the image: each letter is a self-contained, immutable object, represented by a short string of computer code, rather than being simply an arrangement of pixels on the screen.

As a result, there are many things that you can't do to type that you can do to ordinary, pixel-based artwork – things such as removing parts of it with the Eraser or applying filters (covered in the next chapter). In order to do these things to type you have to convert the letters into pure pixels first, so that they become 'normal' artwork.

Once you've converted your text to pixel artwork the text is no longer editable, as it's now been stripped of its computer code for letters. Because of this, before you convert text into pixels it's a good idea to copy the text so that you've got an editable backup in case you need to make alterations later (Create the copy by dragging the text layer in the Layers panel down onto the New Layer icon).

To turn text into pixels go to Layer>Simplify Layer (or go to the Layers panel, to the insignificant little four-line button near the top right, where you'll open a submenu that contains the same command).

Text is automatically converted into pixels when you merge a text layer with other layers (so remember to make a copy of the text before you merge layers if you think that you may want to edit it afterwards).

Making Selections That Are Shaped Like Letters

Figure 15-20 Selections can be made in the shape of letters, which can then be cut out or filled with artwork

It's possible to create letters in the form of selection outlines – outlines that work in exactly the same way as the selection outlines created using the standard selection tools. You can fill these outlines with artwork such as photographs or brushstrokes, or use them to make holes in your artwork (Figure 15-20). It's normally best to use bold or generally bulky typefaces for this sort of activity so that you can see the effects well.

The Type tool offers you a way of doing this directly, described in a second, but it has a drawback. When you finish keying in your text and you turn it into selection outlines you completely lose the ability to edit it. As a result making corrections or alterations is exceedingly difficult. So here's an alternative, and possibly simpler method.

All you have to do in order to create selection outlines from text is to type in your text as normal, and then as a separate operation select the text as a selection outline. Before you do actually select the text it's advisable to check that it doesn't need altering (such as by correcting spelling mistakes or changing the typeface), as it order to do these things later you'll need to go back to the original text layer, edit it and repeat the selection process.

To select the text, go to the Layers panel and click on the text layer's thumbnail while holding down the Command key (Mac) or Control key (Windows). This will select all areas of the layer that contain any artwork (When the key is held down and the cursor is over the thumbnail, the cursor changes its appearance to include a rectangle with a dotted edge – symbolising the marching ants of a selection outline. This shows that the cursor will now select the artwork on the layer).

If you can't remember this method you may be tempted to select the text by using the Magic Wand, but this isn't a good method, as the wand may have difficulty deciding where the exact edges of the letters are (as it does with a lot of types of artwork).

Once you've created a selection outline from the text you can use the selection on any layer just as you would with any selection. For instance you can use it to cut part out of an image as I've done in Figure 15-20.

A technique that's worth experimenting with is to paste an image directly inside the outlines by going to Edit>Paste into Selection. This method pastes artwork 'behind' a selection outline so that the artwork is only visible inside the selection area. You can then move the artwork around behind the selection outline until the most suitable part of the image is revealed inside the outline.

To create letter-shaped selections directly using the Type tool do the following. Remember that you won't be able to edit the text once you've finished, unlike with the method that I've just described.

Click and hold on the Type tool in the Tools panel to reveal the hidden tools and go to the Horizontal Type Mask tool. The icon alongside it depicts the letter T as a dotted selection outline.

While you're entering text by this method the entire image area is overlaid with colour, with the letters that you type being transparent (allowing any colour on layers beneath to show through). Think of the coloured film as a kind of stencil, with the letters as the holes.

When you've finished typing your letters you can turn them into a selection by clicking the cursor anywhere in the image area that's away from the letters. The colour film will disappear and the letters will acquire the typical marching ants edges of selection outlines. Unfortunately, as I mentioned earlier, once you've done this you can't edit the letters any more.

Because these letters are selection outlines, they aren't applied to a special text layer as normal text is, but can be used as selections on any layer that you make active. You can for instance fill the letters with artwork, such as the flowers in Figure 15-20.

Lettering by Hand

Typed text is perfect for many uses, but sometimes you may want your words to be a little less mechanical and structured than is possible with the typefaces that are installed on your computer.

A few typeface designs, such as Comic Sans, Chalkboard and Mistral go some way towards jettisoning the formulaic precision of most typefaces, however sometimes there's no substitute for creating your own lettering by hand.

Although you probably want to reject the mechanical perfection of typed text when you produce hand lettering you'll usually still want some sort of restraint imposed on it, for instance to ensure that the letters are kept in straight lines or are all the same size. Here are a few suggestions of how to keep your lettering under some sort of control.

Tracing over Typed Text

A simple trick for creating neat hand-written text is to trace over words that you've typed in first (Figure 15-21).

Figure 15-21
You can trace over faded typed text to create neat hand lettering

First, type in your text, then make the words fade by reducing the text layer's opacity (using the Opacity control at the top of the Layer panel). Trace over the faded letters on a new layer, using the Brush.

Generally, capital letters are easier to keep neat than lower case letters.

A major advantage of typing text first and then tracing over it is that the typed text is much easier to alter than hand drawn text, so you can change the wording, correct spelling mistakes or change the size of the letters, and then trace over the results when you're happy with them.

Creating Guidelines for Hand Lettering

If you don't want to trace straight on top of typed text, maybe because you find it a bit too restricting, you can write directly onto the screen, keeping your lettering neat by using straight lines as guides.

One way to do this is to place a grid of horizontal and vertical lines on your screen by going to View>Grid (Figure 15-22).

THIS WAS WRITTEN USING A GRID

Figure 15-22
Text written using the Grid

The grid that appears is only visible on the screen – it won't appear in a print should you decide to print your image while the grid is in use. To remove the grid go back to View>Grid.

You can modify the appearance of the grid, altering the spacing between the lines, the number of subdivisions and their colour, in Preferences>Guides & Grid. That's in the Photoshop Elements menu on a Mac or the Edit menu in Windows.

Using the grid is undoubtedly very convenient, but it can sometimes impose its own uniformity onto your work.

In this case the simple device of creating horizontal lines to use as guides can often be more effective.

At its simplest this just entails creating a single horizontal line in order to keep text horizontal.

You can produce a horizontal line using the Line tool, keeping the line horizontal by holding down the Shift key (See page 372).

Alternatively, you can produce a horizontal line using a thin brush or pencil, again keeping the line horizontal by holding down the Shift key while drawing. Put the line on its own layer so that it doesn't interfere with the rest of the artwork, and then fade the layer so that the line isn't too dominant.

If you want to keep the height of your letters uniform you can add an extra line above this baseline to show the height of the letters (Figure 15-23). You can also add a third line to indicate the difference in height between tall letters and short letters, and even add a line beneath the lettering to show where letters that drop below the baseline (such as p, q and y) should end.

THIS LETTERING IS DONE ON DRAWN LINES.

Figure 15-23
Text written using
drawn guidelines

As well as deciding on the height of your letters, you also have to decide on the gap between the separate lines of text.

When you first start hand lettering you may find it easiest to write each line of text on a different layer. Then you can nudge the separate layers up or down to get the distance between them right (Figure 15-24). This is much easier than writing all of the text on one layer and then having to select the lines one by one (using selection tools such as the Rectangular Marquee tool or the Lasso) so that they can be nudged into position.

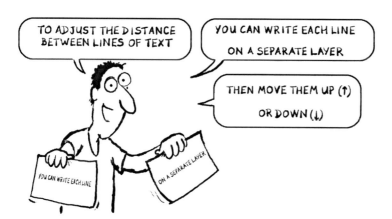

Figure 15-24
It's often useful to
write each line of
hand written text on
a separate layer so
that their distance
apart can be altered
simply by nudging
the layers

After a while, when you've done enough lettering to know what sort of gap you want between your lines of text, you can create multiple rows of guidelines, producing an effect a little like lined writing paper, as in Figure 15-25. Do this by duplicating a single set of guidelines and moving it down to produce subsequent rows. Then you can enter all of your text in one go, on one layer.

You can alter the height of the guidelines for different sizes of lettering by using the Transform command.

Figure 15-25
You can change the height of
your guidelines by using the
Transform command

To avoid having to create new guidelines every time you want to add text to an image you can save the guidelines as an image file in their own right, with a suitable name such as Text Guidelines, and paste it into other images whenever you need to add any lettering to your artwork.

After all of this talk about using guidelines to regulate your writing, bear in mind that sometimes it's best to just let things rip and to use no guidelines at all (Figure 15-26)!

Figure 15-26
Text written with no restrictions at all can sometimes be much more appropriate than highly regulated lettering

Squeezing and Stretching Your Text

Once you've written your text you can alter its size and shape so that it fits the space allocated to it (Figure 15-27).

You can stretch or squash your hand lettering by using the Transform command, being careful not to stretch or squash it to a degree that makes it too hard to read.

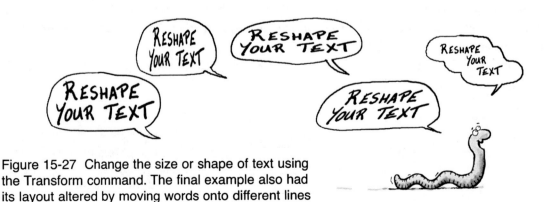

Figure 15-27 Change the size or shape of text using the Transform command. The final example also had its layout altered by moving words onto different lines

You can also modify your text by changing the number of lines that it occupies, in order to improve the fit or the flow of the text. Do this by selecting some words using the Rectangular Marquee tool or the Lasso, and dragging them to a different position (as in the final example in Figure 15-27).

Calligraphy Pens

To produce normal lettering it's simplest to use an ordinary round brush tip, as the regularity of the tip produces predictable and legible results. However if you're after something a bit more fancy the Brush tool includes a set of calligraphy tips that you can use to produce more stylized lettering. Calligraphic tips are very similar to round tips except that instead of being round they're elliptical, producing strokes that vary in thickness depending on the direction of the stroke (Figure 15-28).

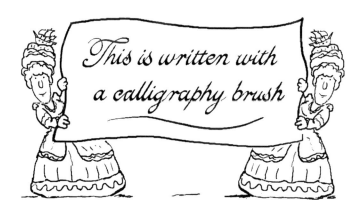

Figure 15-28
Calligraphic brushes
can be used to
produce traditional
calligraphic lettering

Open the calligraphic tips the same way that you'd open any other set of brush tips – by going to the Brush's Options bar and clicking the Brush Sample box at the left hand end (the box with the wavy brushstroke in it), then opening the list labelled Brushes.

The tips of the calligraphic brushes come as a variety of ellipses at different sizes, shapes and angles. If one of the tips is suitable apart from its size, you can resize it by pressing the square brackets keys on the keyboard: the left one makes the strokes smaller, and the right one makes them larger (or you can enter a value directly into the Size field in the Options bar).

You can modify the shape of the tip, altering its angle or the flatness of the ellipse, quite easily too. To alter a tip see the section on altering brushes in Chapter 6, page 152.

Type Your Hand Drawn Letters Using the Keyboard

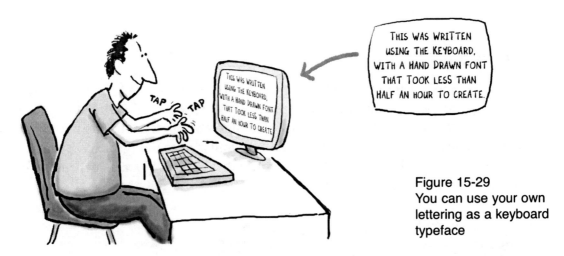

Figure 15-29
You can use your own
lettering as a keyboard
typeface

If you like using hand-drawn letters but find that the whole process of actually doing the hand lettering is just too time consuming, you can install your own hand-drawn letters in your computer as a typeface. You can then type your letters straight from the keyboard just like all of the existing typefaces (Figure 15-29).

You can't convert your hand lettering into a keyboard typeface directly within Elements, but it's a simple matter to do it using other resources.

You can buy software that'll do the conversion, but such software is usually aimed at high quality typeface design and is quite expensive. It's much cheaper and simpler to use an internet based service that'll take a sample of your hand lettering and that then does a quick, one-off conversion for you.

You can find a list of companies that provide the appropriate software or services for your needs by typing suitable key words into an internet search engine – words such as 'handwriting font creator'. You'll come up with useful sites such as yourfonts.com, vletter.com and fontifier.com.

Once you've created a font it's added to all of the other fonts on your computer and it can then be used by any software on your computer, such as your word processing programme. You're not just limited to using it in Elements.

Just to be pedantic for a second, although computer software often uses the word font synonymously with typeface, strictly speaking a font is a complete set of charaters in a particular typeface, all at the same size – so Helvetica 20 point is a separate font to

Helvetica 12 point. The term comes from the days of mechanical printing when all of the letters in a particular typeface and at a particular size, weight etc were all stored in one big tray. Computers have possibly adopted the word font because it's shorter than typeface and fits into the restricted space available in menus more easily.

Here's an example of how to acquire a font.

I've chosen a very simple, cheap (just a few dollars), no frills conversion available from www.fontifier.com. This is only one example of several similar services that you can find on the web. Because things change all of the time I'd recommend that you do a search before you decide on which service is best for you.

To use Fontifier or a similar service, go to the website where you'll be asked to download a template.

Draw your letters into the boxes provided on the template (Figure 15-30), either directly on the screen if you have a graphics tablet, or by printing it out and using a normal pen.

If you used a printout, scan the completed page back into your computer.

Then email the finished template back to the company.

Figure 16-30
Hand lettering drawn onto the
template supplied by Fontifier

A couple of minutes later a preview of your font will be sent to you, with simple instructions of how to place it into the library of available fonts on your computer.

If you're happy with the results you pay a small fee (less than $10 at the time of writing) and you get to keep the font.

If you're using a graphics tablet to draw your letters on the template on-screen you can maximize the quality by first converting the template's colour mode from Indexed Color to either RGB Color or Grayscale and then increasing the number of pixels in the template so that you can draw more precise letters. To do this, go to Image>Resize>Image Size, where you should change the Resolution setting from 72ppi to something higher, such as 288ppi (which is an exact multiple of 72, thus making for slightly crisper size conversions). After you've drawn your letters, reduce the resolution to 72ppi again so that you can send it back to the company.

Here are a few tips about font creation using this method.

Don't try to draw lower case letters (that's letters that aren't capitals) that are meant to join together in the form of joined-up writing, because different combinations of letters join differently (for instance, joining an 'o' and an 's' is different to joining an 'n' and an 's'), and the results will look untidy. Some services can deal with this issue, but they're more expensive. They are called lower case letters, by the way, because in predigital days they were kept in a lower tray (or case) than the capitals, which were in the upper case.

Font creation tools give you spaces in which to draw both lower case and capital letters. If you're creating a font in which you'll only ever use capital letters you can use the space for the lower case letters to draw a second, slightly different set of capitals. Then you can use the two sets of letters to add variety to your lettering, by sometimes typing a letter in its 'lower case' version and sometimes in its capital version. For instance, you can type the word 'different' and use different 'f's next to each other (and different 'e's too) to make the lettering look more naturalistic.

If there are any keyboard symbols that you never use, such as perhaps the * or the %, you can put other symbols in their place, including such things as small logos. In fact you can put any designs into any of the positions of the keyboard, as long as they're simple enough to be legible – along the lines of some of the installed fonts such as Webdings that you'll find on your computer.

The font that you create will have the thickness of line that you used when you drew it, and you won't be able to make the letters bold via the font style menu in the options bar (next to the typeface's name). However you can convert them to bold letters by using the button near the centre of the options bar showing a bold letter T. This button, called the Faux Bold button, is described in more detail on page 401.

Similarly, you can make your lettering italic by using the Faux Italic button, which is next to the Faux Bold button.

Cartoon Speech Balloons

As a cartoonist myself, I know that one of the difficult and tedious aspects of cartooning is drawing speech balloons. They can be particularly frustrating because the balloons are usually peripheral to the contents of the cartoons, but if they're badly drawn they can diminish the quality of the work. One solution to this problem is shown in Figure 15-31.

For some styles of work, casual hand-drawn balloons are perfect (Figure 15-32), while for other types of work it may be better to use more formal, structured balloons. In this section I'll be concentrating on how to create the more precise type of balloon, using techniques other than simply drawing them freehand with the Brush or Pencil.

Whatever method you use to create balloons, if you find that you use very similar ones in different images, it may be worth storing the balloons in a file of their own so that you can reuse them, thus saving you the effort of redrawing them every time (Figure 15-40). If you use this method it's worth bearing in mind that the tails on balloons, which point to the speaker, often need separate consideration for each use, so it may be a good idea to keep a stock of tailless balloons and to add the tails on a case by case basis, either by drawing them afresh or by keeping a stock of separate tails.

A quick way to draw accurate and neat balloons is to use the Elliptical Marquee tool, as shown in Figure 15-33.

To use this method, first create a new layer on which to place your balloon. Then, using the Elliptical Marquee tool, make an oval that's more or less the size and shape that you want your balloon to be. This creates an ellipse of marching ants, defining the shape.

You now need to replace these marching ants with a solid line, to create the edge of your balloon. To do this, in the menu bar go to Edit>Stroke (Outline) Selection. A panel will open into which you enter the thickness and colour of the line that you want to create.

Figure 15-31
One way of dealing with speech balloons is to not use them

Figure 15-32
You can store speech balloons for repeated use

Figure 15-33 Easy stages in making a speech balloon

Having created your oval outline you then use the Brush (or the Pencil if you're creating very high resolution line art) to draw the pointer or tail that sticks out of the balloon towards the speaker. It's a good idea to create this pointer on a separate layer above the oval so that you can move it into different positions while you work on your composition.

If you want to create perfect straight lines for your pointer, hold the Shift key and click the brush's cursor at the start and end points of your line instead of dragging the brush as you normally would. A straight line will automatically join the two points.

To hide the small area of the oval line where it crosses the pointer apply a patch of white to the area where the pointer crosses the oval. This is preferable to erasing part of the oval line itself, as this way you can adjust the position of the pointer by moving it to different parts of the oval without leaving a gap behind. By applying the white carefully and 'plugging' the end of the pointer you can fill the inside of the pointer with white using the Paint Bucket.

You can alter the size and shape of the oval and pointer using the Transform command.

If you don't want to create your own speech balloons you can use ready-made ones that are conveniently supplied by Elements. These balloons are amongst the stock of pre-formed shapes that can be found by opening the tool called, naturally enough, the Shape tool. How to use this tool is dealt with in the next chapter (page 455). For now I'll just I'll just confine myself to mentioning a few points that are specific to its use for speech balloons.

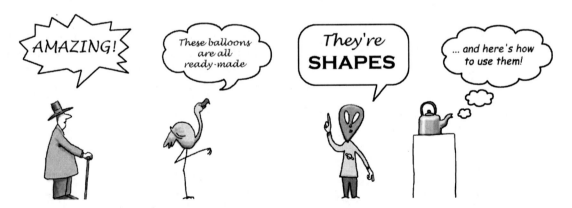

Figure 15-34 You can use ready-made speech and thought balloons using the Shape tool

To create a speech balloon using the Shape tool, open the tool in the Tools panel and then in the Options bar navigate to the stock of Talk Bubbles. Click on the balloon (or bubble) that you want to use.

You now need to place the balloon into your image. Now, let me stop you here for a moment, because when you do actually place the balloon into your artwork you're going to be slightly crestfallen. You're probably expecting a nice white balloon to appear, surrounded by a crisp and uniform black outline. That's not what you'll get. You'll get a rather cumbersome and clunky blob-like object. That's what Shapes are.

But don't worry – the following explanation shows the steps needed in order put your speech balloon into your image, and how to make it presentable (see Figure 15-35).

First, drag the cursor across your image more or less where you want the balloon to go. The outline of the balloon will appear, and will expand to occupy the area that you drag across.

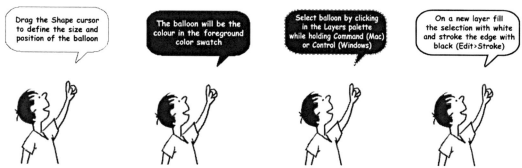

Figure 15-35 How to create a speech balloon using the Shape tool

When you release the cursor the balloon itself will appear. It will be filled with the colour that's in the foreground colour swatch at the bottom of the toolbox. It doesn't really matter what colour this is, as you can change it later (most probably to white).

Balloons produced using the Shape tool are just a single flat colour and don't have a nice black line round the edge. In fact shapes aren't even composed of pixels in the same way that normal artwork is – they are mathematically generated shapes that you can only modify in a limited number of ways. If you want a line round the balloon it's best to use your shape-generated balloon as a template rather than as a finished balloon, creating your final balloon separately on a different layer.

To do this, in the Layers panel go to the shape layer that contains your balloon and click on its panel while holding the Command key (Mac) or Control key (Windows). This will select the outline of the balloon. You'll see the marching ants walking around it.

Once you've selected the balloon's outline, create a new, normal image layer on which to place your final balloon.

The selection outline that you created will now be working on your new active layer, so

you can fill the selection with white (or any other colour) to produce the fill of your balloon.

To give your balloon a black border, go to Edit>Stroke (Outline) Selection while you still have the selection line defining the balloon. In the panel that opens, set the width of the line that you want for your border. The colour of the border will be the same as the foreground colour, and is shown in the colour swatch in the Stroke dialogue box, labelled Color. To change the colour click on the swatch, which will open the Color Picker. Move the cursor on the picker to choose your colour: if it's simply black that you want, drag the cursor on the colour square down to the bottom left corner (When you've done this, all of the numerical values in the boxes to the right of the square will change to zero, confirming that you've chosen black).

If the line round the resulting speech balloon is the wrong colour or thickness, use the Undo command to go back a step, and alter the settings.

Because the balloon that's created in this way is an ordinary part of your artwork, rather than a shape, you can alter it just like any other pixel artwork. For instance, if you don't like the position of the pointer at the bottom, you can cut it out and reposition it or erase it and draw a completely new one.

There are only a few predefined speech balloons available using the Shape tool, but if none of them are suitable for your purposes you can quickly create more flexible and versatile balloons using another of the Shape tools, the Rounded Rectangle tool.

The big advantage of using this tool is that you can control how rounded the corners of your speech balloons are (Figure 15-36). This tool can be found in the pop-up list that appears when you hold the cursor on the current Shape tool in the Tools panel.

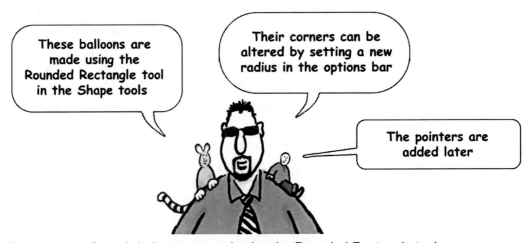

Figure 15-36 Speech balloons created using the Rounded Rectangle tool

When you choose the tool you'll see a box in the options bar for entering a radius – this is the curve that you apply to the corners of the rectangle.

You produce your balloons in more or less the same way as with the Shape tool's talk bubbles described immediately above – the main difference is that because the rounded rectangles don't have pointers you have to add your own. The flexibility of being able to alter the roundness of the corners and the freedom of being able to design your own pointers generally make this method superior to using the ready-made balloons.

You can produce more complex speech balloons by using several rounded rectangles to form one balloon (Figure 15-37). Create the shapes on separate layers, then move them round individually with the Move tool and alter their proportions with the Transform command until you're happy with the results. Then merge the shapes together onto a single layer. This will automatically change them from mathematically generated shapes into normal, pixel-based artwork. You can then go through the same final steps as above – by selecting the balloon, filling it with white (or any other colour), giving it a dark outline using the Stroke command, and adding a pointer.

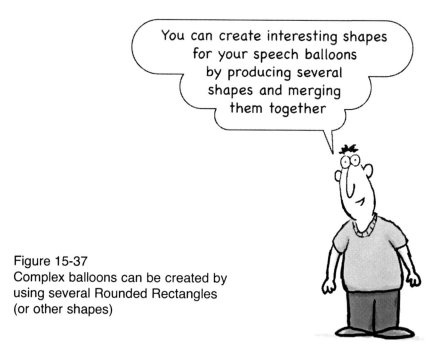

Figure 15-37
Complex balloons can be created by
using several Rounded Rectangles
(or other shapes)

Special Effects
16

Elements supplies you with a number of ways of applying special visual effects to your work – from making photographs look like oil paintings to applying three dimensional modelling to images.

Many of these effects take practically no time at all to apply, yet give quite startling results.

Even if you think that you don't want to use these techniques in your work, they're worth exploring purely for the shear fun of it.

In This Chapter:
How to apply filters for paint-like finishes and other effects
The Impressionist Brush
Layer Styles
Shapes
Blend Modes
The Effects Panel
Creating patterns

Applying Paint-like Effects and Other Distortions Using Filters

Some of the most interesting special effects that Elements can apply to images are achieved by using filters.

Filters are the computer equivalent of the special effects filters that you can put in front of camera lenses in order to distort the image that's being photographed (Elements takes the names of a lot of its tools from their counterparts in the world of photography because of its use for editing photographs). The similarity is only superficial though, because many filters in Elements can alter your image in ways far beyond anything that a piece of glass placed in front of a camera lens can ever achieve.

The filters vary in usefulness, depending on the type of work that you produce. Some you may never use at all, but others you may go back to over and over again because of the transformational effects that they have on your images.

You'll find the filters in the menu bar, in their own exclusive menu labelled Filters.

There are several ways to open the filters, and different ones have different controls depending on their functions. I'll delve into such things soon, but for now just to give you a general feel for filters I'd recommend that you open one of the artistic filters at Filters>Artistic. Opening any of these filters will open a standard filter dialogue box that contains a number of controls on the right with which you can modify your image and a preview image on the left, showing you the effects on the image. If there's also a rather large and over-imposing display of apples running down the middle, as in Figure 16-8, don't worry – you can get rid of them by pressing the double arrowhead that's slightly to the left of the OK button. I'll explain what they are later.

When you open the Filters menu you're presented with a list of about a dozen groups of filters, with each group containing filters that are broadly related to each other in the effects that they achieve. Altogether there are nearly a hundred filters, which is far too many to describe individually, so I'll only introduce the most useful and interesting ones. To illustrate the effects of some of the filters I'll show their effects on photographs rather than on drawn or painted artwork, as that way it's easier to see the distortions that they produce. Some of these images can be seen in colour on the back of this book, and they're all in colour at www.chrismadden.co.uk/create.

After I've introduced the filters to show their effects, I'll explain how to actually use them.

The Effects of a Few Filters

Artistic Filters

Artistic filters (Figure 16-1) simulate the effects of different painting techniques. Their names, such as Colored Pencil, Fresco, Palette Knife and Watercolor, give a hint of what the effect will look like (or are supposed to look like).

They're very useful for making photos look like paintings, and can also transform otherwise flat and lifeless artwork into something more vibrant and dynamic.

You can alter the 'brush size' and other settings to modify the effects, as explained soon.

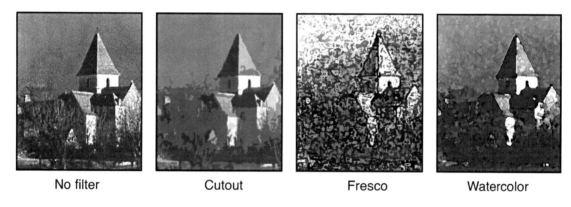

| No filter | Cutout | Fresco | Watercolor |

Figure 16-1 Some of the effects that can be achieved with the Artistic filters

Brush Strokes

The Brush Stroke filters affect artwork in similar ways to the Artistic filters, as you can see in Figure 16-2, which shows the Spatter and Ink Outlines filters from the selection.

Figure 16-2
The Spatter filter and the Ink Outlines filter, in the set of Brush Strokes filters

Some Brush Stroke filters are very effective when applied to simple black and white line drawings (Figure 16-3), turning the lines into an approximation to brushstrokes. In work of this type the black lines have to be on an opaque white layer rather than on a transparent one – a little like ink lines on paper. This is so that the filters can affect both the black and white areas of the image together, effectively 'mixing and moving' them – the filters will have little or no effect if the lines are surrounded by nothing but transparent pixels.

Figure 16-3 Some Brush Strokes filters can make uniform brush lines more artistic. Left: The original drawing. Centre: The Spatter filter. Right: The Sprayed Strokes filter

Pixelate

Pixelate filters work by clustering the colours of an image into little blobs with various characteristics (Figure 16-4).

In these examples I've set the effects to be quite extreme, so that the results don't simply look like slightly modified photos. They almost become works of art in their own right.

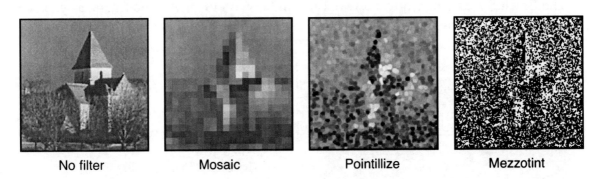

No filter Mosaic Pointillize Mezzotint

Figure 16-4 A selection of Pixelate filters

Sketch

The Sketch filters (Figure 16-5) alter images so that they look as though they've been drawn with chalk, charcoal, even a kitchen mop (There is no actual Kitchen Mop filter, but with many filters the effects may look as though they've been applied with one, as the results are often nothing like you'd expect – a lot depends on the settings you choose and the artwork that you choose to apply it to).

The Sketch filters generally use the foreground colour as the colour of their sketching medium (that's the chalk, charcoal etc), and the background colour as the colour of the 'paper', so if you want a normal black and white sketch effect, use black and white as the foreground and background colours respectively.

These filters are sometimes a little mechanical in their output – which is the antithesis of what a sketch should be – but used on the right artwork they may be just right.

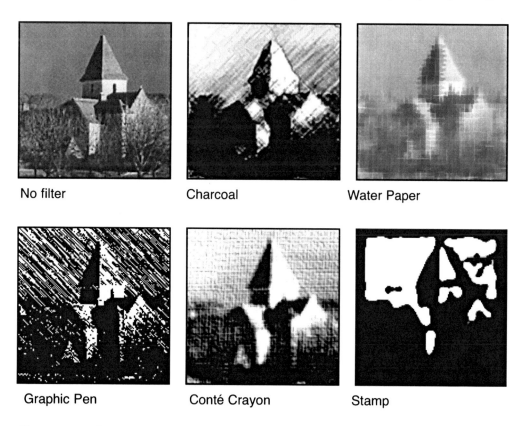

No filter Charcoal Water Paper

Graphic Pen Conté Crayon Stamp

Figure 16-5 A selection of the Sketch filters

Texture

Figure 16-6 The canvas effect from the Texture filter's Texturizer submenu (right)

If you want to make your work appear as though it's on a textured or rough surface, such as cloth or stone, you can use the Texture filters (Figure 16-6).

The Texture filters are good for some types of image (working quite well with the photo of the Chinese junk above for instance), but they produce rather flat effects, so sometimes it's better to experiment with using textures from other sources.

For instance in Figure 16-7 I've drawn a sketch based on a prehistoric cave painting of a mammoth. Adding the sandstone effect from the Texturizer filter submenu, as in the second image, gives the vague suggestion that the mammoth was drawn on stone, but in all honesty it actually looks much more as though it was drawn on the plastered wall of a house rather than on the inside of a cave. A much more convincing stone effect is achieved when the drawing is placed in front of a photograph of real rock, as in the third image.

Figure 16-7 A rock texture applied to a cave painting. Left: No texture. Centre: The sandstone effect in the Texturizer filter. Right: A photograph of real rock

How to Apply and Adjust Filters

When you're experimenting with filters you're bound to produce some effects that you decide are unsuitable, so the first thing that you need to know about filters is how to remove the effects after you've created them.

While you're in the middle of experimenting with a filter you can press the Cancel button in the filter's dialogue box at any time to return the image to its original state and to close the filter.

If you actually finish applying a filter and then immediately realize that the effect isn't what you wanted, you can remove the effect by using the Undo command – either by pressing the left pointing arrow at the top of your screen or by using the keyboard shortcut of Command-Z (Mac) or Control-Z (Windows).

Before you use a filter it's always best to create a copy of the work that you're going to apply the filter to, so that you have an unaffected backup in case things don't go as expected, which happens frequently. Filters are applied to single layers, so creating a backup only entails making a duplicate of the relevant layer.

There are several routes by which you can gain access to the filters.

1: The easiest way to open the filters is by going directly to the Filter menu in the menu bar, which will open a simple, easy to navigate list of the filters.

2: You can go to Window>Effects in the menu bar, which will open a panel in which you can display the filters. If you've still got the Elements interface in its default layout with the Panel Bin running down the right side, the Effects panel may be found there.

The Effects panel can be used to display several different types of effect, of which Filters are just one. To choose Filters click the button that looks like three overlapping coloured circles near the top left of the panel, directly under the word Effects (These three circles symbolize coloured filtersof the type that are placed over camera lenses).

In the Effects panel the effect of each filter is displayed in a thumbnail image of an apple (even in Windows!) which you click in order to activate the filter. The name of the filter pops up in a little box when you move the cursor over the thumbnail (if Tool Tips is active).

To display a particular group of filters in the panel click the box that's to the right of the row of buttons (To display all of the filters choose Show All from the bottom of the list).

There are a few filters that can't be accessed directly via the Effects panel. None of the Adjustment filters are there, and a few other random ones are missing, such as the Poster Edges filter in the Artistic filter set.

Figure 16-8 A typical Filter Gallery dialogue box, showing the preview image to the left and the controls to the right. Down the middle of the panel is the selection of filters available

Figure 16-9 The panel from the previous figure, but with the display of apples removed

When you activate most filters a dialogue box opens containing controls that adjust the amount that the filter affects the image (The few filters that don't display a dialogue box are ones that create effects that you can't adjust. The names of these filters in the Filters menu lack the ellipsis (three dots) that signify that a further panel will open. An example is the Solarize filter in the Stylize set).

Most filters open with a dialogue box similar to the one shown in Figure 16-8. This may or may not have a panel of apple thumbnails down the centre. If the display of apples are there, and you find them a bit overwhelming, you can remove them (Figure 16-9). Do this by clicking the double arrowhead in the little circle just outside the panel of apples at the top right.

Despite the fact that you've opened this dialogue box by clicking on a specific filter, the dialogue box is actually a portal that is shared by most of the other filters, and as a result you can hop from filter to filter without actually leaving the box. You don't have to keep going back to the Filter menu (or the Effects panel) every time you want to change filters.

The separate filters can be accessed via a very nice and discrete drop-down menu on the right of the box (Figure 16-11) or via the large and rather over-assertive display of apple icons that can be made to appear down the middle of the panel.

A few filters open with a much simpler and smaller dialogue box than the one on the previous page in Figure 16-8. An example is the Motion Blur filter in the Blub filter set (Figure 16-10). These filters can't be hopped to via the Filter Gallery dialogue box. Don't ask me why not – perhaps they are 'old' filters that are simply incompatible with the Filter Gallery.

When you use the Filter Gallery panel you can hop from filter to filter, as I mentioned, and you can also use the panel to apply several filters cumulatively in one operation, adding their effects to each other. I'll explain exactly how to do this soon, but first I'll describe the basic techniques that are used for applying (most of) the filters individually.

Figure 16-10
A simple filter dialogue box

Apart from a few exceptions, filter dialogue boxes include a preview image showing the effect of the filter on your work, which changes to reflect any alterations you make to the controls (which are usually simple sliders or boxes into which you enter numeric values).

To get a closer look at how the filter affects your work you can magnify the preview image by clicking the plus sign below it. Conversely you can reduce the size by clicking the minus sign. To move the preview image in the window in order to show different parts of the image press and drag inside the window (where the cursor appears as a hand).

When you've adjusted the controls and you're happy with the results click OK to apply the filter, or cancel the operation by clicking Cancel. If you realize immediately after clicking OK that you don't like the effects that you've just applied use the Undo command.

The name of the last filter that was used is displayed at the top of the Filter menu in the menu bar. Clicking this name applies that particular filter to your image, using the same values that were applied the last time it was used, which is useful when you want to apply the same filter settings to several different images. Remember that clicking this name

doesn't open the filter's dialogue box. (You can also re-apply the last filter by using the keyboard shortcut of Command-F (Mac) or Control-F (Windows).

There's a small complication concerning the name at the top of the Filter menu though. If the last filter that was used was opened by hopping to it from within the Filter Gallery (rather than via the Menu bar) the name Filter Gallery will be there at the top of the Filter menu instead of the name of the actual filter. The name Filter Gallery in this case stands in for the name of the last filter that was used in the gallery, but it doesn't give a clue to which filter it actually was. Fat lot of good that is then. On top of this, when Filter Gallery is displayed as the last filter that was used you'll notice that the term Filter Gallery appears twice at the top of the Filter list. The lower of the two is actually there all of the time and is a route to opening the Filter Gallery panel rather than a route to automatically reapplying the last filter that was used in it – you can tell this because its name is followed by an ellipsis (three dots), indicating that there's a dialogue box to open, while the upper version is followed by the shortcut for re-applying the last filter.

One last thing. The Correct Camera Distortion filter and the filters in the Adjustments submenu don't appear at the top of the menu when they are the last filter used – just to complicate things even further.

As I've mentioned several times already, once you've opened the Filter Gallery dialogue box, via the Filter menu or the Effects panel, you can change filters from within the dialogue box itself, rather than by returning to the Filter menu or the Effects panel.

The filters can be accessed via a very nice drop-down menu just above the controls on the right of the dialogue box (Figure 16-11). This menu lists the filters in alphabetical order, without splitting them into separate categories, meaning that the individual filters are easy to find if you're not sure which categories they're in.

Figure 16-11
A useful alphabetical list of filters can be accessed via the filter name panel

Alternatively you can find filters by looking through the gallery of apple thumbnails that you can open down the centre of the dialogue box (Figure 16-8). Open the gallery by clicking the arrowhead that's at the top of the dialogue box and slightly to the left of the OK button. These thumbnails show the effects that the filters create. The thumbnails for the separate categories of filter are all in collapsible panels that can be opened or closed by clicking on their name panels. When you're familiar with the filters and you feel that you don't need the thumbnails to remind you which filters do what you can hide the thumbnails by clicking the arrowhead again (Figure 16-9). Removing this panel frees up a lot of space in the dialogue box and allows you to display a much larger preview image.

You can change the dimensions of the preview image by dragging the lower right corner of the preview image's frame, and you can change the dimensions of the whole dialogue box by dragging the lower right corner of the whole box.

Apply Multiple Filters Using the Filter Gallery

As mentioned above, the Filter Gallery dialogue box not only allows you to alter the settings of filters but it allows you to apply several filters to an image at the same time. It also allows you to experiment with the way that the separate filters interact.

Here's how to do it.

First, pick whichever filter you want to start with, and adjust its settings.

The name of this filter will appear in the panel at the bottom of the right hand, control side of the dialogue box (Figure 16-12).

Figure 16-12
The list of filters that are
being applied appears
at the bottom right of
the dialogue box

To apply a second filter click the small button that's supposed to look like a sheet of paper with the corner turned up, just below the panel. This creates a new filter, the name of which will appear at the top of the panel. The new filter will originally be a duplicate of the previous one, however to replace it with a different filter all you have to do is to go to the Filter Gallery's filter list or thumbnails and choose another filter.

You can repeat the process to add more filters to the image.

Filters can be hidden, to temporarily remove their effects from the image, by clicking the eye button next to the name (as with the Smudge Stick filter in Figure 16-12). When a filter is hidden the eye button is replaced by a blank square. Click this to reactivate the filter.

To remove a filter, make its name active then click the trash icon beneath the panel.

To rearrange the order of the filters drag the names up or down the list. The order of the filters will affect the image, as higher filters act on the image that's already been affected by lower filters. For instance, in the list in Figure 16-12 the Ink Outlines filter is affecting an image that's already been distorted by the Sponge filter.

Here's a little tip that you may find useful when using filters.

When you apply a filter to an image it's very hard to remember the settings that you've applied once you've changed them, so you may find it helpful to note the settings when you actually apply them. A convenient way to do this is to change the name of the layer that you've applied the filter to so that the name of the layer incorporates the name of the filter and any relevant settings (so a layer named Spatter 13-4 would be a layer to which the Spatter filter had been applied with setting for its two adjusable parameters of 13 and 4). Using this method you can create several filtered versions of the same image, labelling each layer and then comparing the effects before choosing the one you like best.

Applying Filters to Selected Parts of Images

If a filter is applied to a whole image the result can sometimes be excessively uniform, in which case it may be better to use the filter on only part of an image as in Figure 16-13.

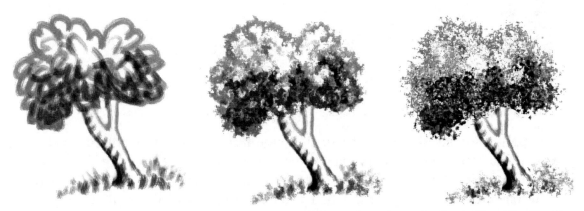

Figure 16-13 Filters can be applied to parts of images by using selections. Here the Spatter filter is applied to only the leaves and the grass, leaving the tree trunk unaffected. Left: The original drawing. Centre and Right: The filter at different settings

Similarly, when you use a filter on a whole image you'll sometimes get better results by varying the settings for different areas of the image so that they are affected to differing extents. For instance if you use a brush effect filter that breaks an image down into brush strokes, you might want to experiment with applying the filter with different brush size settings on the foreground and on the background.

To apply a filter to a specific part of a layer you need to isolate the area from the rest of the layer by using an appropriate selection tool. If you've got different elements of your work on separate layers you may be able to simply apply the filter to the appropriate layer.

In the example here (Figure 16-13) I've applied the Spatter filter to a drawing of a tree.

Because I only wanted the filter to affect the leaves and the grass (and not the trunk) I selected those areas before applying the filter, ensuring that the tree's trunk remained unaltered. The leaves have become remarkably leaf-like considering how crudely the original lines were drawn, as shown in the image at the left.

In line drawings like this one the lines have to be on a white layer so that the filter can 'mix' the black and white areas of the image – it won't work if the lines are surrounded by transparent pixels.

Distort Images Using the Liquify Filter

Figure 16-14 The Liquify filter can distort any image, and is particularly fun to use on faces.

Among the categories of filter that are available in Elements is a set called Distort filters. Most of these filters warp or bend the image in some predetermined way, indicated by the filter's name. Ripple for instance makes an image look as though it's being viewed

under water (useful for creating reflection effects), while Twirl twists images into spirals.

Buried within this selection of filters is one that's unlike any of the others, known as the Liquify filter. Find it by going to the list of filters in the Menu bar, as it doesn't appear in the Filter Gallery.

I'm giving this filter its own little section here because it's so interesting, and because it works in a unique manner. Unlike any other filter, it provides you with a brush with which to apply the filter's effect. The brush allows you to slide parts of your image around as though the image were made of liquid (hence the name).

It can be used either to subtly change the shape of objects by nudging them slightly or to create major distortions with intensely comic or grotesque results.

Figure 16-15
One of the photographic caricature heads from Figure 16-14 attached to a cartoon body

It's particularly useful for distorting the features of people in photographs in a caricature-like manner, as shown in Figure 16-14. One of those heads is mine. I'm not telling you which.

Using traditional drawing techniques, caricature-like distortion is a highly skilled business. The caricaturist not only needs to be capable of capturing a likeness of a person, but has to know precisely which features of the person are the most suitable to exaggerate. Using the Liquify filter on a photograph the likeness is already there, and you can pull and push the features around at will until you achieve the effect that you're after.

If you want to turn the photographic caricature into a drawing you can then trace over it, or as I've done in Figure 16-15 add it to a cartoon body.

When you open the Liquify filter a preview panel opens displaying a copy of the image you're working on. Alterations are applied directly to this preview image with the brushes provided. This leaves the original image unaffected until you choose to commit the changes. You can reject the changes if you're not happy with them, leaving your original image unaffected.

If you want to zoom in on a section of an image in order to see it better, use the zoom settings at the bottom left of the preview image.

The filter provides you with a selection of brushes that distort the image in different ways, ranged down the left of the dialogue box (described in a moment).

You can modify the brushes' characteristics in the Tool Options panel, to adjust how much the brushes alter your image.

Brush Size affects the area over which the distortion occurs.

Brush Pressure alters the rate at which the image is distorted. Lower pressures make the distortions occur in a less pronounced way, allowing for much more control. Brush Pressure is not the same as the pressure applied with a graphics tablet (which comes into play independently when the Stylus Pressure box is checked) and it works just as well with a mouse.

Turbulent Jitter only affects the Turbulence brush, described soon, where it modifies the smoothness of the effect. Higher values increase smoothness.

Here's a description of how the different brushes affect an image, listed in approximate order of usefulness.

The Warp brush

The most useful brush that the Liquify filter provides is the one at the top of the list.

This brush drags the colours along as you move the brush. The colours near the centre of the brush are dragged further than those at the edge, which are only moved slightly. The distance that the colours are dragged is dependant on the Brush Pressure setting. A low setting will produce the smallest of movements, while with a high setting the colours can be dragged right across the screen (which looks dramatic but isn't very useful, unless you want to produce abstract, slightly metallic looking effects).

With the brush on a low pressure setting, and by using short strokes, you can gradually distort an object with a high degree of control.

The Bulge brush

The Bulge brush makes objects expand outwards from the spot where you press the brush. If you keep the brush on the same spot the object under the brush will keep expanding. A low pressure makes it expand more slowly and with more control. Moving the brush slightly over a small area rather than keeping it on a single point can produce more naturalistic results, as the single point method can result in a 'fisheye' effect

This brush is useful for enlarging features that you want to keep in proportion.

The Pucker brush

The Pucker brush works in the same way as the Bulge brush, but makes objects smaller rather than larger. Again, low pressure gives more control, as the object shrinks more slowly. Try using it on someone's head in a photograph for hilarious or disturbing effect.

The other brushes – listed next, are less useful (to me at least), although as with everything else, when the right job comes along I'm sure that they're the perfect tools.

The Turbulence brush

At low Brush Pressure settings the Turbulence brush works in a similar way to the Warp brush. At increased Brush Pressures random variations are added to the strokes (These variations are the turbulence after which the brush is named). The degree of turbulence is altered using the Turbulence Jitter control.

The Twirl brushes

The two Twirl brushes, Twirl Clockwise and Twirl Counterclockwise, make the image form into spirals beneath the brush.

The Shift Pixels brush

The Shift Pixels brush shifts colours over to one side, at right angles to the direction that you drag the brush. The side to which they move depends on the direction that you drag.

The Reflection brush

The Reflection brush partly flips the image over in the region that you apply the brush. The direction of the reflection (up, down, left, right) depends on the direction that you move the brush.

The Reconstruct brush

See the bottom of this page.

Removing the effects of the Liquify filter

If you don't like the effects that you produce with the Liquify filter there are several ways that you can undo the distortions.

When you're in the middle of altering an image you can cancel the last brush stroke that you applied by using the Undo shortcut of pressing Command-Z (Mac) or Control-Z (Windows). This is in spite of the fact that the Undo arrow at the top of the screen doesn't work while you're using the filter.

You can remove all of the effects you've applied by pressing the Revert button.

To partially remove the effect you can use a special brush called the Reconstruct brush. This brush slowly restores your image in the area that you apply it, allowing you to partially return to the original state of the image. To make the effect occur slowly so that you have more control, give the brush a low Brush Pressure setting.

The Reconstruct brush is at the bottom of the list of brushes, separated *very* slightly from the others in order to show that it's different.

Here's a tip that you can use with the Liquify filter. While you're altering an image, save the results occasionally as you progress by applying the filter. Then copy the layer and resume work on one of the versions of the partly altered image. This way you end up with several versions of the image with different degrees of distortion. As a result you finish with a choice of effects, or you can go back to an interim level of distortion should your work have started to go wrong along the way.

Filters for Blurring and Sharpening Images

The Blur Filters

Figure 16-16 The Blur filters. Left: No blur. Right: Different amounts of blur applied to the two figures in the background

You can soften parts of images or make them appear to be out of focus by using one of the blur filters (Figure 16-16). These filters are particularly useful with photographs, where they can be used to make backgrounds go out of focus so that objects in the foreground stand out better.

Simplest of the blur filters is the Blur filter itself and its relative, the Blur More filter. These filters have a fixed effect, so when you use them they only blur the image by a specific amount. The Blur More filter, as its name implies, blurs the image more than the normal Blur filter (by a factor of about four).

You can tell that these filters have a fixed effect because their names in the Filter menu aren't followed by an ellipsis (three dots). An ellipsis indicates that there's a dialogue box waiting to be opened in which you can change the settings.

It's not advisable to increase the amount of blur on an image simply by repeatedly

applying either of these filters, as the effect can become a little crude (due to the fact that with repeated use you're blurring the blur rather than blurring the original image). For more control over the degree of blurring it's best to use the Gaussian Blur filter, described next.

The Gaussian Blur Filter

The Gaussian Blur filter allows you to adjust the degree of blur applied to an image more accurately than is possible with the Blur and More Blur filters.

The filter uses a simple dialogue box into which you enter a suitable value of blurriness, either by moving the slider or by typing in a value directly.

This filter is named after the German mathematician Carl Friedrich Gauss, possibly one of the greatest mathematicians ever. He's important enough to have appeared on stamps, which must be a pretty rare honour for mathematicians (Figure 16-18). As you can see, he wasn't a computer specialist as you may have presumed, having been born in 1777.

Figure 16-17 Carl Friedrich Gauss, after whom the Gaussian Blur filter is named

The Smart Blur Filter

The standard use of this filter is to create blurring in areas of images where the colours are similar, while leaving areas of high contrast, such as edges, sharp. It's useful for smoothing out areas of unwanted texture or 'noise' while leaving outlines crisp.

Like the Gaussian Blur filter this has a control for setting the amount of blurring.

It also has a threshold control that dictates the amount of contrast above which the filter won't blur the image.

This filter has a hidden use however, which you'd never guess from its name. It can be used to convert continuous tone images such as photographs into outline drawings. This is covered in more detail on page 445.

Adjusting Sharpness

In earlier versions of Elements there were a variety of filters in the Filters menu that allowed you to sharpen images. They were a bit like the opposite of the Blur filters. Due to the fact that when it comes to photographs (the primary images manipulated in Elements) you're *much* more likely to want to sharpen blurred images than to blur sharp ones, the Sharpen filters have been moved out of the Filters menu and placed much more sensibly in the Enhance menu. They've also undergone a bit of a revamp, with the main sharpening method now going by the name of the Adjust Sharpness command.

Using this command (or other sharpening methods) doesn't miraculously put blurred images into focus unfortunately. That particular technology may take a year or two more to develop. What it does is create an optical effect that gives the impression of sharpening the image. It works by increasing the contrast where it detects a large change in tone, such as along the edges of objects. This gives the effect of a sharper edge. Relatively uniform areas, which probably therefore aren't at an edge, remain unaffected. This targeting of the appropriate pixels helps keep the effects of the command subtle and relatively realistic.

Here's how to use the Adjust Sharpness command.

Before you use it try to make sure that you've finished making any other alterations to your image, as any alterations made later may interfer with your results slightly.

When you open the Adjust Sharpness command you're presented with two sliders, the exact purpose of which need explaining, as their names don't really make sense until you know what they do.

The **Radius** slider sets the distance from each targeted pixel that the effect will work over. So a setting of three pixels will mean that where the command detects a major change in tone (indicating an edge), pixels up to three pixels away will be affected.

The **Amount** slider affects the degree of change that's applied to the chosen pixels. Raising the setting increases the contrast between the affected pixels, making edges look sharper. If you overdo this setting your image will acquire edges that have too much contrast and that look fringed.

There are several other controls in the command that may need your attention.

Remove. In this pop-up menu you can choose which type of blur you want to remove from a photograph. Motion blur is the type of blur you get when you photograph a moving object or you move the camera. It's a blur that tends to be spread out in one direction. Lens blur is a more uniform type of blur that you might get if a subject is out of focus or if your lens isn't quite up to the job of taking pin-sharp photos. Using this setting detects fine detail

and reduces edge halos. Gaussian blur is a general soft blurring, as generated by the Gaussian Blur filter.

Angle. This setting is used in conjunction with the motion blur setting in the Remove menu. Set the angle to the angle of the blur.

More Refined. This setting makes the command responsive to greater detail in an image. As a result it works more slowly. It may sometimes pick up too much detail, giving a mottly effect.

The Unsharp Mask

The Unsharp Mask used to be found in the filters list in earlier versions od Elements. It's now in the Enhabce menu along with the other sharpening commands.

Despite its rather cumbersome and almost meaningless-sounding name, which is enough to put almost anybody off using it, this command can provide an excellent method of sharpening blurred images. It's very useful for improving the quality of scanned images and for sharpening up fuzzy photographs, although it's in the process of being superceded by the newly introduced Adjust Sharpness command (described above). In some ways it's very similar to the Adjust Sharpness command, as is this explanation.

It works by darkening or lightening pixels where it detects a large change in tone, such as along the edges of objects. This gives the effect of a sharper edge. Relatively uniform areas, which probably therefore aren't at an edge, remain unaffected. This targeting of the appropriate pixels helps keep the effects of the filter subtle and relatively realistic.

When you open the Unsharp Mask filter you're presented with three sliders, the exact purpose of which need explaining, as their names don't really make sense until you know what they do.

The **Radius** slider sets the distance from each targeted pixel that the effect will work over. So a setting of three pixels will mean that where the filter detects a major change in tone (indicating an edge), pixels up to three pixels away will be affected.

The **Amount** slider affects the degree of change that's applied to the chosen pixels. Raising the setting increases the contrast between the affected pixels, making edges look sharper.

The **Threshold** slider sets the degree of difference that there has to be between adjacent pixels before they're deemed to be different enough to be affected. A high threshold means that only pixels with very large differences between them will be affected, while a low threshold will affect even slightly different pixels.

The name of the Unsharp Mask command, by the way, derives from the manner in which it works. Behind the scenes it creates a slightly blurred (or unsharp) version of the image, which it then compares with the original. Any areas of the two versions that are relatively similar, such as flat, low contrast regions, are then masked off so that the effect of the command doesn't affect them. Thus the command only alters areas where the contrast between pixels is highest, which tend to be well-defined edges.

Converting Photographs into Line Drawings

Figure 16-18
A photograph
converted into a line
drawing by using the
Smart Blur filter

Elements provides you with a very neat way of converting continuous tone images, such as photographs, into outline drawings (Figure 16-18).

You'd expect such a task to be done by a filter with a name such as Outline Drawing filter, however this isn't the case (even though there is a filter called the Ink Outlines filter in the Brush Strokes category – which doesn't really do what its name implies). The task is done, intriguingly and incredibly, by the Smart Blur filter in the Blur filter category.

Figure 16-19
The Smart Blur filter's dialogue box, showing a line drawing being created from a photograph.
Left: The original image.
Right: The filter applied in Edge Only mode

Here's what you do.

First, duplicate the layer of the image that you want to turn into an outline, so that you can apply the filter to the copy. This keeps your original image safe.

Open the Smart Blur filter at Filter>Blur>Smart Blur.

In the dialogue box (Figure 16-19), set the Mode to Edge Only.

The image in the preview panel will turn into a rather dramatic black panel with white lines on it. Think of this as a negative of your final line image (or at least of the part of it that's visible in the preview panel).

By moving the sliders for the Radius and Threshold values you can adjust the complexity of the line effect.

What the filter is doing is placing a line along all tonal transitions where the contrast is above a certain level (which often indicates an edge between objects). The Threshold value defines this level of contrast. If you use a very low Threshold setting a line will be drawn along even the slightest variations of contrast, filling the image with lines. A high value reduces the number of lines to a sensible level.

When you're happy with the amount of detail in your outline click OK.

This will turn the layer that you're working on into a black layer with white lines on it, just like the preview image.

Reverse the black and white in the image so that it's made up of black lines on a white background by going to Filter>Adjustments>Invert.

You now have your basic outline drawing.

This image may be effective in its own right, or it can be used as an overlay above another version of the image altered using a different filter.

When it's used as an overlay the white on the layer will hide any artwork beneath it, so the white needs removing. One way to do this is to select the white by using the Magic Wand, with the options for Anti-alias and Contiguous turned off, and to then delete it. There may be times however when you want to keep the black lines on a white layer rather than on a transparent one – you'd want to do this for instance if you wanted to apply another filter to the lines to give them some texture (see Figure 16-3 at the beginning of this chapter). To retain the white background but to make it invisible, go to the Layers panel and set the layer to Multiple (in the drop-down menu that usually displays Normal).

Here in Figure 16-20 (right) I've used this overlay technique to place the 'line drawing' above a version of the image that has been modified with the Graphic Pen filter from the Sketch category.

A good watercolour effect can be obtained by placing the line drawing above the image filtered with the Smart Blur filter set to its Normal mode and with a high Threshold setting, This reduces the detail in the image significantly (while leaving edges sharp – that's the smart bit).

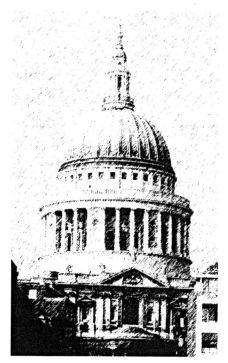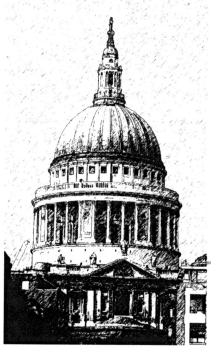

Figure 16-20 The line image produced with the Smart Blur filter placed above a version of the photograph altered using the Graphic Pen filter. Left: The Graphic Pen filter on its own. Right: The line image adds strength to the composition by defining the edges

When you create a line drawing using the Smart Blur filter the lines that are generated are very thin and uniform. If you'd prefer thicker or more varied lines here's a way to add variation to them (Figure 16-21).

Firstly, here are two ways in which you can thicken your lines.

Method one involves using the Magic Wand.

Select all of the lines in the image by using the Magic Wand with its options for Anti-alias and Contiguous turned off (and Use All Layers turned off if other layers are visible).

In the menu bar go to Select>Modify>Expand. Enter a value in the box (I'd recommend one pixel to start with). This will widen the selection area by the amount that you choose.

Create a new layer.

Fill the selection area with black. This will create a black line image on the new layer.

Method two involves using Layer Styles.

I haven't covered Layer Styles yet (They're on page 451), so I'll just point you in the right direction here.

Firstly, make sure that the lines in your image are on a transparent layer rather than being on a white layer.

Duplicate the layer so that you've got two copies of it.

Then open the Layer Styles panel via Window>Effects. It's the button that looks like two overlapping rectangles. In the pop-up menu go to Strokes. Click on the first button in the Strokes panel (because it's got the smallest stroke). Then go to the Layers panel and double click the letters *fx* that have appeared alongside the layer's name. This opens a panel in which you can adjust the thickness of the stroke. The best way to adjust the thickness is to delete the size and to retype other sizes in the box. The effect can be seen as soon as you enter a new value, which can then be changed if the results aren't right.

Using either of the methods above will give you a line that's wider than the original one, but the lines will still look very uniform – because all that you've done is uniformly thicken an already uniform line (although some areas may be overfilled with black where the lines were very close together and thus merge into each other).

To add variety, use the Eraser to remove selected parts of the thicker lines that you've just created. This will reveal some of the original thinner lines on the layer that contains the original unaltered line image.

One last thing. The lines that are generated by the Smart Blur filter are sharp, aliased lines with no soft edges. If you'd prefer a softer edge you can add one by selecting the line

using the Magic Wand (with Contiguous turned off) then by modifying the selection edge using the Refine Edge feature in the Options bar. Adding a small amount of Feather (about one pixel's worth) and expanding the edge by a few percent should do the trick. Use the Undo command to keep returning to the original version until you get it right.

Figure 16-21
Adding variety to the thickness of the lines. Left: The original image, with thin lines. Right: The lines thickened (then erased in parts to reveal the thin lines beneath for variety)

The Impressionist Brush

Figure 16-22 The Impressionist Brush

The Impressionist Brush (Figure 16-22) is a brush that redistributes the colours under the brush, rather than applying new colour itself (Figure 16-23).

The brush shares the same space in the toolbox as the normal brush. The curved line behind the brush's button is to suggest the stylized swirly strokes that the tool produces.

449

Using the Impressionist Brush is a little like using a filter that only affects the image at the brushstroke level, with the resulting effects being reminiscent of those of the French Impressionist painters, hence the brush's name.

The brush can make work created with only a mouse become much more complex than is possible when using only the normal brushes.

The brush won't alter areas of completely flat colour, because there needs to be a colour difference in the image with which the brush can build up its strokes.

Figure 16-23 The Impressionist Brush in use. Left: This image was produced with only a mouse, using very simple techniques. As a result it's very flat. Centre: Passing the Impressionist Brush over parts of the image (even with a mouse) applies stylized brushstrokes to the existing colours. Right: By repeatedly applying the brush to the same area the effect is increased.

In the brush's options bar there are a number of settings that you can alter in order to apply different effects. The ones that are unique to the Impressionist Brush can be found by clicking the button at the right hand end of the bar, (that looks like the button).

These are:

Style: This determines the shape of the squiggles and curls created by the brush.

Area: Determines the distance over which the brush will spread its effect.

Tolerance: A low tolerance applies the brush effect to only colours similar to those directly below the brush, while a high tolerance affects more colours.

Repeatedly passing the brush over an area builds up the level of the effect.

Layer Styles

Layer Styles are a quick way of adding special effects to the artwork on a layer, usually by giving it a three dimensional quality such as embossing or by the addition of a shadow effect, and sometimes by altering the colour and texture too (Figure 16-24).

Figure 16-24
Using Layer
Styles, the very
ordinary lines in
the drawings on
the left are altered
completely in only
a couple of clicks

Layer Styles are very useful for adding interest to lettering and in web page design for the production of navigation buttons, where they're used to convert very simple shapes into quite complicated forms in a matter of moments (Figure 16-25).

 →

Figure 16-25 A simple oval shape (left) altered out of all recognition in the Layer Styles panel. Each version of the oval was created by just one click.

You can remove the effects of a Layer Style at any time and return your work to its original appearance, or choose a different effect. This is because the effects aren't applied directly to the actual image but simply affect what the image looks like. Think of it as though the effect is created by viewing the image through a special distorting layer, and that this distorting layer can be removed at any time.

Once you've applied a Layer Style to a layer, any new work that you add to the layer will be affected by the style. So, for instance, if you're using a Layer Style that makes your artwork look as though it's embossed, when you apply new brushstrokes to the affected layer those strokes will be automatically embossed too. I'd recommend you to try painting on a layer that's got a style applied, if only because it's great fun – the chrome effect, called Wow Chrome, is a good one to use, as it gives you the impression that you're actually

painting with molten metal! Here it is in Figure 16-26.

Figure 16-26 Applying the chrome effect (called Wow Chrome) to a layer and then painting on it gives the effect of actually painting with chrome (wow!)

Layer Styles mainly affect the *edges* of artwork (where coloured pixels are next to transparent ones), such as by giving the edge a bevel or a shadow. As a result the effects are most dramatic when you're applying them to artwork that has a relatively large amount of edge, such as small objects or artwork composed of individual brushstrokes. That's not to say that you should only use the effects on such artwork. In fact the effects are particularly useful when applied to whole images in order to make them stand out from their backgrounds, as in Figure 16-27.

Figure 16-27
Layer Styles affect
the edges of artwork,
making it capable of
standing out from its
background

Because the major effects of Layer Styles, such as bevels and drop shadows, are applied to the edges of the artwork, this means that coloured objects that are embedded within other colours can't be affected.

For instance, in Figure 16-28, if the light circular area is on the same layer as the outer

shape, any Layer Style applied will only add an effect round the edge of the outer shape, ignoring thelighter area within it. To add a bevel to the light area you have to put the area onto its own layer so that it has an edge of its own for the style to be applied to.

Figure 16-28 To add bevels internally to areas, the areas have to be on separate layers. Left: The original image. Centre: A Layer Style applied to the image when all of the colours are on one layer. Right: When the colours are on different layers, Layer Styles can be applied to the colours separately.

For the same reason, if you try to add a Layer Style to artwork that's on a white layer the effect is applied to the edge of the white, not to the coloured artwork.

With a Layer Style applied to text, the text is still editable after the style has been applied, so you can change the typeface, correct spelling mistakes, and generally rewrite everything that you've written, with the text always looking as though it's been produced by some incredibly complex technique.

This text was typed with a layer style applied, so the type actually appeared like this as I typed...

Figure 16-29 Layers Styles can be applied to text, and the text is still editable!

How to Apply and Modify Layer Styles

The Layer Styles panel is opened from the menu bar at Window>Effects. Choose the Layer Styles button (two overlapping rectangles) from the row at the top left of the panel.

When you're experimenting with styles you can remove a style that you don't like by using the Undo arrow at the top of your screen or by pressing Command-Z (Mac) or Control-Z (Windows). To remove styles after you've finished them go to the Layers panel and drag the little letters fx that are next to the layer's name down to the bin, or go to Layer>Layer Style>Clear Layer Style.

Once you've applied a Layer Style you can modify the effects, such as the amount of bevelling applied to the edges or the distance of the shadow from the object (Figure 16-30). Do this by clicking on the small letters fx that appears next to the layer's name in the Layers panel. This opens the Style Settings control panel.

You can alter the direction from which the effect seems to be lit, which is important for embossed and recessed effects and for the positions of shadows. It's generally most naturalistic to have the light seeming to come from above, and slightly over to one side.

The bevel setting affects the degree by which the artwork seems to be embossed. The Up or Down setting affects whether the artwork appears to be raised above the surface or recessed into it.

Shadow distance alters the position of any shadow that appears behind the artwork, making the artwork appear to float at different heights above the surface.

You can apply several different styles to a layer at once, creating a cumulative effect. For instance you can apply a bevel and a drop shadow at the same time. Do this by opening the controls of both types of style by clicking the appropriate checkboxes in the Style Settings control panel.

Figure 16-30
Changing the Style Settings alters the amount that the style affects the image (here the drop shadow)

Shapes

Figure 16-31 A selection of the shapes that can be generated using the Shape tool

Shapes are pre-defined outlines or silhouettes that you can place straight onto your artwork (Figure 16-31). They include a variety of geometric forms such as rectangles, ellipses and polygons along with numerous silhouettes of diverse objects such as cakes and fish. Once you've chosen a shape you can apply it to your image simply by pressing and dragging the cursor across the intended location on the image.

Figure 16-32
All of this illustration is composed of shapes. (The buildings are simply superimposed rectangles)

In their raw state shapes can be used in order to very quickly create flat, two dimensional objects. That's what I've done in Figure 16-32, which is composed entirely of shapes (which is overdoing it a bit, but at least it demonstrates their use).

You don't have to limit yourself to using flat colours with shapes however. Three dimensional effects can be applied to them in a matter of moments by utilising the special effects

available when using Layer Styles, described on the preceeding pages. A typical Layer Style effect is shown in Figure 16-33. Layer Styles are actually used so frequently in conjunction with Shapes that there's a special button in the Shapes Options bar to make it easier to access the Layer Styles.

Figure 16-33
Shapes can be turned into three dimensional forms
in a matter of seconds by using Layer Styles

Shapes combined with Layer Styles make particularly good navigation buttons for web pages, especially with the addition of some appropriate wording (Figure 16-34).

Figure 16-34
Shapes combined with Layer Styles and an appropriate
word make excellent web navigation buttons

The computer process that generates Shapes is different to that which generates the usual pixel-based artwork that images in Elements are based on. They're not composed of coloured pixels but are made up of mathematically generated outlines. Because they're different to pixel artwork the two types of artwork can't be mixed on the same layer, so Shapes are automatically placed on their own dedicated layers called, naturally enough, Shape layers. These layers will include the word 'Shape' in their titles rather that the usual 'Layer'. It's similar to the way that text is always placed on its own dedicated Text layer.

A significant difference between shapes and pixel artwork is that shapes are resolution-independent - that is, you can change their size in your image (such as by using the Transform command) and they will retain the same precise edge at all sizes. Here in Figure 16-35 I've created a small star using the Shape tool and a similar small star using normal pixel-based methods. I've then enlarged each star by using the Transform command. The enlarged Shape star has retained its crisp, detailed outline, while the pixel star has become fuzzy.

Figure 16-35
Left: When you enlarge a Shape
using the Transform command it
retains its sharpness.
Right: Enlarging pixel artwork
produces a fuzzy edge

Because Shapes aren't based on pixels you can't use the normal painting and editing tools such as the Brush or the Eraser on them or on their layers – a message will pop onto your screen telling you so if you try.

It is however possible to convert shapes into pixel artwork so that you can use the normal painting and editing tools on them. When you do this the Shapes become pixels and stop being Shapes, and as a result they lose their resolution-independent nature. To convert them, go to the button marked Simplify in the Shapes Options bar (When you hover over this button a box may open that helpfully explains what the button does. Rather disconcertingly it tells you that it's going to 'rasterize' the Shape. Don't worry – rasterize is just a jargonistic way of saying 'convert to pixels').

Shapes are also converted to pixel artwork automatically when their layers are merged.

How to use Shapes

Figure 16-36 The Shape tool button in the toolbox displays the last version of the tool that was used

The button for the Shape tool in the toolbox (Figure 16-36) displays the icon for whichever version of the tool was used last - Straight Line, Polygon, etc - so when you look for the Shape tool you may become momentarily confused if you can't find the icon that you're expecting. All of the different versions can be accessed by holding on the button.

How to Select a Colour for a Shape

When you open the Shapes tool the shapes will use the colour that's in the foreground swatch as their colour. This is useful, as it means that if you know what colour you want a shape to be you can choose the colour before you create the shape, by making it the foreground colour before you start.

You can change a shape's colour at any time after you've created it. To do this, make the

shape's layer active by clicking it in the Layers panel. The shape can then be filled with the colour that's in the foeground colour swatch at the time by using the normal fill method of going to Edit>Fill or by using the keyboard shortcut of Command-Delete (Mac) or Alt-Backspace (Windows), or you can use the Paint Bucket.

If you want to change colours while the Shapes tool is open you can change the colour of the shapes via the colour swatch in the tool's Options bar. Changing this swatch will change the colour of the active shape. It'll also change the colour in the foreground colour swatch (Changing the foreground colour via the foreground colour swatch itself won't change the colour in the Shape tool's colour swatch however. The Shape tool's swatch changes the foreground colour swatch, but the foreground colour swatch doesn't change the Shape tool's swatch).

Each type of shape generated by the Shape tool has its own particular characteristics that can be altered. These are reflected in the slightly different Options bars of each version of the tool.

Most of the options for the tools are displayed directly in the Options bar, but a few of them are hidden away and are revealed by clicking the small downward pointing arrowhead that's immediately to the right of the blue icon for the shape near the left hand end of the Options bar (Figure 16-37).

Figure 16-37
An options panel opens when you click the arrowhead at the right of the blue shape icon. The options are specific to the particular tool in use (here the Rectangle tool)

These hidden options generally allow you to constrain the shapes in various ways, such as by setting their sizes to definite measurements or by allowing you to keep their width and height in proportion. Among the options for the straight line tool is one allowing you to add arrowheads to the line, while one of the options for the polygon tool allows you to create stars by indenting the sides of the polygon.

When you create shapes, each shape is automatically created on a new layer by default.

You can place separate shapes on the same layer by using the Shift key. After you've created a shape hold down the Shift key before you start your next shape, and the shape will be placed on the same layer (A plus sign appears next to the cursor to confirm that this is the action that'll be taken).

Holding down the Shift key *after* you've started creating a shape does something different: it restrains the proportions of the shape (for instance, the rectangle is restrained to a square).

If you want to use the Shift key for both functions at once, placing different shapes on one layer and restraining the proportions too, combine both actions by holding the Shift key while registering the start point of your next shape, then releasing it and then pressing it again so that it restrains the proportions. Sorry this is so complicated.

You can place your shapes on the same layer and make them interact with each other in different ways by using the row of buttons showing overlapping squares in the Options bar (You can see them in Figure 16-37). These buttons are known as area option buttons. You have to create your first shape before the buttons become active.

You may find that in a lot of cases it's easier to put your shapes on separate layers and then to merge or otherwise manipulate them later, as you get more flexibility that way.

The buttons work in the way suggested by the overlapping squares on the icons, which I've (hopefully) illustrated more clearly in my enlarged interpretation in Figure 16-38. I've applied a Layer Style (described earlier in this chapter) to my examples in order to emphasize the edges of the resulting shapes - hopefully showing the way that the shapes interact more clearly. The lightly shaded areas have been added to the figure to indicate where the parts of the shapes are removed as part of the interaction, and aren't part of the actual image.

Figure 16-38 How the shapes interact is governed by the area options buttons. The first button places the individual shapes on separate layers (left), while the rest put shapes on the same layer and make them interact in specific ways. The light gray shading has been added to indicate the parts of the shapes that have been subtracted as part of the interaction

The first button in the row, composed of a single square, is the most useful setting, creating each shape on a separate layer. The rest of the buttons place all shapes on one layer.

The second button, in which the overlapping squares are equally shaded, merges the shapes where they overlap, creating a single, more complex form.

The other buttons remove parts of the overlapping shapes in the ways indicated by the icons.

After you've created a shape you can alter its proportions, pull it out of shape, or rotate it, using the Transform command.

Here's a rundown of the different versions of the Shape tool that you can choose from, along with their individual variations. I've added Layer Styles to the examples, to make them look a little bit more interesting.

Lines

When you use the Shape tool in its Line tool mode a line is produced by pressing and dragging the cursor. The line starts at the point where you first press, and ends where you release the cursor.

Set the width of the line in the Weight box in the options bar. You can change the units by typing in a different unit: px for pixels; cm for centimetre; mm for millimetre; in for inch (The units you enter will remain the units of choice until you change them again).

You can add an arrowhead to the beginning or end of the line. Or both. To open the panel into which you can enter the properties of your arrowhead click the small downward pointing arrowhead immediately to the right of the blue Shape tool icon in the Options bar.

Rectangles

The Rectangle tool creates rectangles when you press and drag the cursor. The rectangle starts where you first press the cursor and ends where you release it.

To constrain the shape and size of the rectangle in various ways, click the downward pointing arrowhead at the right of the blue Shapes icon. You have the options of restraining the rectangle to a square (which can also be done by holding down the Shift key *after* you've started to drag), making each rectangle automatically the same size or the same proportions, or making the rectangle grow from the centre rather than from the corner (which can also be done by holding the Alt key in Windows or the Option key on a Mac *after* you've started to drag). The Snap to Pixels option makes the rectangle change size in pixel-sized steps, ensuring a crisp edge with no anti-aliasing (With this option turned off, if the edge of the rectangle intersects pixels rather than being exactly along their edges, the intersected pixels are anti-aliased, or faded).

Rectangles with Rounded Corners

This tool is the same as the Rectangle tool except that its options bar includes a box, labelled Radius, into which you can enter a value for rounding off the corners.

Ellipses

Again, the same as the rectangle tool, except that it creates ellipses (or circles if you constrain it by pressing the Shift key).

Polygons and Stars

The icon for the Polygon tool is a straightforward hexagon, which doesn't really do justice to the myriad shapes that this tool can generate.

The tool produces regular polygons with as many sides as you choose, from three to a hundred. Enter the number of sides in the box in the Options bar (labelled Sides).

The size of the polygon changes as you drag the cursor away from your starting point, and the polygon rotates as you move the cursor round the point.

To produce stars, go to the small downward pointing arrowhead immediately to the right of the blue Shape tool icon in the Options bar and check the box labelled Star. To set the 'spikiness' of the star, enter a value in the box labelled Indent Sides By. Indenting the sides moves the centre of each side towards the middle of the polygon. A low value produces just a small dent in each side, while a higher value produces a proper star effect. A value of 50% would move the dents halfway to the centre of the polygon, while 99% (the maximum allowed) would move the dents almost right on the centre point.

You can also create rounded corners for the polygons and stars by checking the Smooth Corners or Smooth Indents boxes.

Custom Shapes

Custom Shapes are ready-made outlines of a miscellany of objects.

To choose one of the objects click the box in the options bar labelled Shape. This will open a panel of objects – usually a selection on a particular theme. To choose from other selections of objects go to the small double arrowhead at the top right of the panel to reveal more choices (To see all of the objects at once choose All Elements Shapes from the top of the list).

Blend Modes

Blend Modes are ways of altering the colours on a layer by making them interact with the colours on layers beneath it in different ways. Depending on the type of work that you produce, they're the sort of thing that you may find incredibly useful, or that you may never use at all.

Their main use is for blending the images in photographs in interesting ways.

Here's a demonstration of how they work, using the two photographs in Figure 16-39.

Figure 16-39 The two photographs that I'll use to illustrate the principles behind blend modes: one of a city scene and one of a flagstone and floorboard (purely for its textural interest)

I want to add some extra interest to the photograph of the river scene (the Thames in London) by incorporating the textured effects of the second photograph (of part of an old flagstone and wood floor). The results that I want are show in Figure 16-40.

Figure 16-40
The two photographs above blended together.
Remember that these images are viewable in colour at
www.chrismadden.co.uk/create

This effect can't be achieved simply by placing the two photographs one above the other, because by doing so the top photo hides the one below (Figure 16-41, left).

Figure 16-41 Left: Normally when you place one image above another the top image hides the one beneath it. Right: Changing the top image's opacity to see the image below produces a ghostly version of the top image, which is usually too weak

One way to be able to see the lower image through the image on the upper layer is by lowering the opacity of the upper layer, but that would produce a rather faint, wishy-washy version of the image on it, without much intensity (Figure 16-41, right).

To produce a much stronger and more interesting effect you should have a go at using Blend Modes. Blend Modes not only allow you to see through a layer, but they allow the layer's colours to interact with those on layers beneath, sometimes dramatic ways depending on the colours involved and the Blend Mode that you use.

The effects of Blend Modes are sometimes hard to anticipate: as a result, choosing which mode to use is often a matter of flicking through the modes and using trial and error. (Although they're hard to anticipate, they're actually very predictable, being mathematically calculated by your computer. It's just that your brain can't work them out.)

Figure 16-42 shows the photos in my demonstration blended in two different ways. In the first example, using the Darken blend mode, the sky in the river scene has dropped away completely, revealing the textured effect of the stone on the layer beneath it while the darker tones in the bridge etc have remained intact – which is exactly what I wanted. Meanwhile in the second example, using the Overlay blend mode, the colours on the two layers have interacted in a different way that's totally inappropriate for my purposes, producing what is essentially a mess.

Fortunately, the results that the blend modes produce aren't permanent and unchangeable. You can get rid of any effect simply by changing to a different Blend Mode or by

removing it altogether. So they're completely worry-free, which compensates very much for their unpredictability.

The effects only become permanent if you merge blended layers or flatten the image.

Darken

Overlay

Figure 16-42
Different Blend Modes make the colours on layers interact differently. Here the Darken blend mode (top) creates quite a pleasing effect, while the Overlay blend mode (below)produces a mess

The Blend Modes are listed in the pop-up menu at the top left of the Layers panel. The panel usually displays the word Normal, which means that no blending is being applied.

When you're experimenting with blends, and you want to switch between the blended

and the normal modes for comparison, the easiest way to flick back and forth is to use the Undo and Redo commands, via the keyboard shortcuts (Command-Z and Command-Y on a Mac, or Control-Z and Control-Y in Windows) or via the arrows in the bar at the top of the screen.

Here are brief explanations of some of the modes, and how they work.

Dissolve

The first blend mode, other than Normal (which is really no blend mode at all), works in a totally different way to the rest.

This is why, along with Normal, it's separated from the other modes in the list by a horizontal line.

It only works on pixels that are semitransparent, so applying it to something like an unmanipulated photograph won't have any effect until you move the opacity slider in the Layers panel.

The Dissolve blend mode takes the semitransparent pixels in a layer and turns some of them totally opaque and others totally transparent (Figure 16-43). The ratio of opaque and transparent pixels is directly related to the transparency of the pixels – so for instance at eighty percent opacity eighty percent of the pixels are opaque, while at fifty percent opacity fifty percent of the pixels are opaque.

The effect is easiest to observe by taking an image, setting its mode to Dissolve, and then sliding the opacity slider. The effect will be applied as you move the slider.

100% opacity 65% opacity 40% opacity

Figure 16-43
The Dissolve mode with the opacity set at different levels.
The lower the opacity, the more pixels become transparent (here revealing writing on a lower layer)

Dissolve mode affects any semitransparent pixels, whether they're transparent because they're on a layer that's had its opacity lowered, or because they're produced by brushstrokes (or even anti-aliased edges).

Multiply

Figure 16-44 Multiply mode makes opaque white become transparent. Left: The top layer in Normal mode conceals any artwork beneath the opaque white. Right: The top layer in Multiply mode, allowing underlying artwork to show through

Multiply mode turns white completely transparent (Figure 16-44), and makes other colours semitransparent, allowing artwork on lower layers to show through. The lighter the colours, the more transparent they become.

Multiply mode was used to make the photograph of the river scene semitransparent in Figure 16-40.

It's particularly useful for making the white background in line art images transparent in order to reveal colours on lower layers, as in Figure 16-44 above.

To explain how Multiply mode works, here's an analogy (Figure 16-45).

When a layer is in Normal mode, the image on the layer can be thought of very much like a photographic print on paper. Photographic prints are opaque, so you can't see through them.

In Multiply mode a layer changes from being like a print to being like a photographic slide or transparency. When you hold a slide up you can see through it to varying degrees to whatever you're holding it up against. Any very light parts of the slide (which would be

white in a print) are *totally* transparent, allowing whatever's behind to show through completely, while darker areas are seen as a mixture of the image on the slide and the object behind it.

Figure 16-45
Left: Normally, solid colours on a layer are opaque like those on a photographic print.
Right: In Multiply mode you can see through colours as though they were on a photographic slide or transparency

Why is it called Multiply?

It's because it produces its effect by *multiplying* the brightness values of the colours on the different layers to get the final value that it displays. This is a bit mathematical, and doesn't really mean much in the real world, so perhaps it should be called Transparency or Slide mode, after the photographic effect that it resembles.

Screen

Upper layer

Lower layer

No blend mode

Screen blend mode

Figure 16-46 Screen mode in use

With the Screen blend mode, black disappears from the layer that the blend mode is applied to, and all of the colours are lightened, as shown in Figure 16-46.

If you can't quite envisage how blending black with a colour can make the black disappear, it's probably because you're thinking of the colours as though they're acting like inks or paints. It's better with this mode to think of them as though they're projected light.

Look at it this way.

As with Multiply mode above, it's useful to use the analogy of photographic slides or transparencies. This time though, the layer that the blend mode is being applied to is on one slide, and the image from the layers below it are on another slide.

Instead of just looking through the slides by holding them up to the light, as with the Multiple mode, imagine that the two slides are projected onto a screen in a darkened room (the screen that gives its name to this blend mode), as in Figure 16-47.

No light from the projector shines through any areas of black that are on a slide, so areas of black (such as the black in the sky in my photo of the Moon) don't affect the screen at all. This means that the parts of the screen that correspond with these black areas will only be illuminated by the light from the other slide. Similarly, the darker the colours are on a slide, the less effect they have on the screen, and the less they affect the colours from the other slide.

Because you're always adding light to light using this method, all of the colours on the screen become lighter.

Figure 16-47 How Screen mode works. The black areas in a projected image don't affect the screen (such as the black around the Moon), so colours from a second slide projected onto the same parts of the screen as the black will be unaffected by the black

Overlay

No blend mode Overlay mode

Figure 16-48 Left: The smaller, lighter circle is on the layer that the blend mode is applied to. Centre: The small circle in Normal mode. Right: The small circle in Overlay mode

This is one of the most useful Blend Modes.

The effect is similar to lowering the opacity of the layer that you're applying the blend mode to, but it has more intense highlights and shadows.

Overlay is a hybrid of the Multiply and Screen blend modes. For colours on the blend layer that are dark it uses Multiply, and for those that are light it uses Screen.

Soft Light and Hard Light

Figure 16-49 The Soft Light (left) and Hard Light (right) blend modes applied to the layer containing the small circle

These modes are similar to the Overlay mode, but are of different intensities. Soft Light produces a softer, subtler lighting effect, while Hard Light is harder, with more contrast.

Color Dodge and Color Burn

No blend mode

Color Dodge

Color Burn

Figure 16-50
A stripe that goes from
black at one end to white at
the other, placed on a layer
over a textured background

Color Dodge retains the light colours from the blend layer, while dark colours on the layer apply a tint the underlying colours. As colours get darker the tint gets less, until at black the effect disappears altogether.

Color Burn is more or less the opposite of Color Dodge. It retains the dark colours from the blend layer, while light colours on the layer tint the underlying colours. The lighter the colour, the less the tinting, until at white the effect disappears completely.

Darken and Lighten

Figure 16-51
A stripe that goes from white to black,
blended with a uniform background.

Top: The strip in Normal mode
Middle: Darken
Bottom: Lighten

These modes compare the brightness of the colours on the layers.

Darken displays the darker colours from the layers and ignores the lighter ones, regardless of whether they're from the blend layer or the lower layers.

Lighten displays the lighter colours from the layers and ignores the darker ones.

Difference

No blend mode

Difference mode

Figure 16-52
A strip that changes from white to
black, above a layer of flat colour

The Difference mode compares the layer that the blend mode is applied to with the image below it, and subtracts the less bright colour from the brighter one.

So if a colour on either layer is very dark, with no brightness at all, subtracting that colour from the other colour will hardly affect the other colour. Black, with a brightness of zero, leaves other colours totally unaffected. Look at the right hand end of the strip above to see this effect.

If either layer is white, which is the maximum brightness, the other colour (which by the very nature of things must be less bright than white) will be subtracted from it. The resulting colour is the complimentary colour to the one that's been subtracted – so if blue has been subtracted from white (which is made up of red, green and blue), only the red and green are left, which is orange. (If you were to use the Difference mode on a completely white layer, the effect would be to invert all of the colours on the underlying layers, as though it had become a photographic negative.)

If colours are very similar to each other, their values will be almost the same, so subtracting one from the other will result in almost zero, or black. See the centre section of the strip above, where the strip is a similar colour to the background. (This effect can be seen dramatically if you use Difference mode on a layer that's identical to one below it: the whole image will go black, as each colour subtracts itself from itself.)

Hue, Saturation, Color and Luminosity

This little family of Blend Modes all work in the same way. Each takes the relevant values of the colour, Hue, Saturation, and Lightness (Luminosity), in the layer that the blend mode is applied to, and applies the values to the colours below. The Color mode uses the hue and saturation values together.

Patterns

In Elements a pattern is a repetition of a single image laid out as a grid.

Patterns can be repeating copies of well-defined shapes that produce the effect of tiling, or, if the image is suitably designed, they can give the effect of seamless areas of tone or texture.

Figure 16-53
Left: All of the tones in this image were created using patterns
Right: Some examples of preset patterns available in Elements

Elements has a set of pre-designed images that you can use to create patterns.

Patterns are often applied using the Paint Bucket, but can also be applied by other methods such as the Brush tool or the Clone Stamp tool.

I'll look at the Paint Bucket approach here.

After selecting the Paint Bucket, go to the options bar, and click on the checkbox next to the word Pattern. The box next to it will then become active. A small image will appear in the box. This is an image of the currently chosen pattern. Click the image or the arrow next to it, and the Pattern panel will open, displaying an array of patterns similar to the ones in Figure 16-53.

There are a number of separate sets of patterns available. The default set actually isn't the most useful (in fact it's one of the most useless), as some of its patterns are a little garish and unsubtle, to put it mildly. To look at the other sets, click on the double arrowhead near the top right of the panel. The sets are listed at the bottom of the list that opens. This submenu works in the same way as the one in the Brush panel, described in Chapter 6.

In the default layout of the panel the thumbnails of the patterns are very small, so I'd recommend that you choose Large Thumbnail from the same list that opens when you press the double arrowhead at the top right of the panel.

Choose any pattern by clicking on its thumbnail image in the panel.

Now, when you use the Paint Bucket tool to fill a selection with a pattern, the selection will fill with the chosen pattern. Turn the Pattern check box off when you've finished using the bucket's Pattern mode, otherwise you'll find yourself inadvertently filling inappropriate objects with patterns later on.

Making Your Own Patterns

You're not limited to using the ready-made patterns that come pre-installed in Elements – you can use any piece of artwork to create a pattern of your own design.

You can lift a section out of an image that already exists, or you can create an image specially for the purpose. The main consideration that has to be taken into account is whether the image will look good in a regular tiled effect.

To demonstrate the process, I've designed an actual tile (Figure 16-54) with which I've created the tiled background in Figure 16-55. You don't have to limit yourself to creating tiles of course, unless you specialize in designing bathroom interiors. Any regularly repeating motif will do. It doesn't have to be square either – any rectangular form will do.

17-54
The pattern design on the left was specially created for the image below

To create a pattern design, use the Rectangular Marquee tool to select the area of your image that you want to use as your pattern. If you want to use a whole image as a pattern no selection is necessary. The tile will be the size of the selected image.

Then go to the Edit menu, and choose Define Pattern from Selection (It'll say Define Pattern if you're using a whole image as a pattern).

A panel opens showing a thumbnail of the image that you've selected for your pattern. You can give your pattern a name by entering it in the box.

Click OK to place your new pattern into the currently open set of patterns.

You can see the new pattern at the end of the display of thumbnails in the panel, although the new pattern isn't automatically loaded as the pattern in use. To use it, you have to click on it first.

If you change from one set of patterns to another you lose any new patterns that you've added to the set unless you specifically save the set with its new patterns added to it. To save the set with its new patterns click on the arrowhead at the top right of the panel and go to Save Patterns in the pop-up menu.

If you change sets without having saved any new patterns you're

17-55 The entire tiled background of this image was created in one second by using the single tile design in Figure 16-54, which only took a minute to design itself

warned by a panel that opens asking you if you want to save the changes that you've made (unless, for some reason that eludes me, you change to the Default set, in which case you get no such warning).

If you want to save a pattern in a different set, click on the pattern to make it active, then change sets. With the new set open, place the pattern in the set by choosing New Pattern in the pop-up menu, then choose Save Patterns to save the resulting altered set.

When you save an altered set, a panel will open, asking you to give the set a name (You

have to enter a name, even if you only want to update the original set, in which case you have to type in the original name of the set again. If you can't remember the name, just use a new name and correct it later).

As with saving other types of set such as brushes, for some bizarre reason saved sets aren't immediately available for use should you want to reopen them after going to a different set – you have to quit Elements and restart it again before they're accessible. Until you do this, sets with new names don't appear in the set list, and sets that you've updated (by typing their original name in the save box) won't open when you click on their name.

Creating Seamless Patterns

The tile pattern that I designed on the previous pages worked very well partly because the whole design was contained within the confines of the tile – it was basically just a square with a motif in the middle of it. Sometimes however you'll want to create a tile effect that's a little more ambitious, where the design crosses the edge of the tile and extends onto the adjoining tiles – less like bathroom tiles and more like wallpaper where the design marries up across sheets. Such tiles are a little harder to design due to the fact that unless you take suitable steps your tiles will end up exhibiting the fatal flaw that's present in the tiles in Figure 16-56 – the pattern is discontinuous.

Figure 16-56 Discontinuities in pattern designs can spoil the effectiveness of patterns

It's possible to create patterns where the tiles merge seamlessly with each other, producing a continuous design. This is done by making the details on each edge marry up with details on the adjoining edge (Figure 16-57).

Figure 16-57
A seamless pattern (left) is created by using tiles where the image on each edge is a continuation of the image on the opposite edge. On the right I've indicated the borders of the tiles to show how they join

In simple pattern designs composed of lines, as above, this means that when a line leaves one side of the tile a corresponding line must enter on the opposite side, so that when the tiles are laid out the two lines join as one.

A good example of the process in action is in the creation of brickwork patterns, such as in Figure 16-58.

Figure 16-58 A brick wall, created in less than a minute (including creating the pattern)

The tile that creates this brick effect (Figure 16-58) follows the rule mentioned above – that when a line leaves the tile at one edge, its compliment must enter from the opposite edge, so that when the tiles are laid out the lines marry up.

A second factor that has to be taken into account with the bricks is that the bricks must be divided proportionately at the opposite sides of the tile – so if the top row is half a brick high, the bottom row must be half a row too, otherwise when the tiles are laid out the top and bottom rows joined together will make bricks that are a different height to those on the intermediate undivided rows.

To make it easier to judge the positions of the lines you can use the grid, as in Figure 16-59, by going to View>Grid.

Figure 16-59
The simple layout for a brickwork pattern (with a grid imposed to help alignment of the lines)

Once you've created a pattern effect you can use the Transform command to pull it into perspective (Figure 16-60).

Figure 16-60
A wall pulled into perspective

In the above examples of tile making all of the tiles have been specially designed from scratch, so it was relatively easy to make sure that the separate tiles married together as seamless patterns. If you want to create seamless patterns from pre-existing images however, you have to do a little bit of image manipulation in order to ensure that opposing sides of the tiles match up.

It works like this.

Using the Rectangular Marquee tool select the part of the image that you want to use as the basis of your pattern. In my example here (Figure 16-61) I've drawn a simple image specially for the purpose, so that it's easier to see the principles at work.

Figure 16-61
Left: The image that I'm going to use to make a seamless pattern tile.
Right: The part of the image that I've selected as a tile

If you make this selection into a pattern tile (via Edit>Define Pattern from Selection) you'll find that its edges don't marry up at all well (Figure 16-62).

Figure 16-62
A pattern made with the selection is discontinuous

To remedy this you need to insert missing portions to the artwork from the original image to create seamless joins.

The important thing to remember is that the missing portions of the image that need to be inserted into the pattern have to be added inside the tile itself. For instance with my plant, to complete the cut off flower at the top of the tile the missing part of the flower is added at the bottom of the tile, so that when the new tiles are laid out as a pattern, this bottom part marries up with the top part of the tile below. It's tempting to think that to reinstate the complete flower at the top of the tile you have to add petals to that top flower itself, but that would place the new petals outside the tile, where they'd be excluded from the new tile that's being made.

As with many techniques in Elements, there are several ways to go about doing this. Here's an easy to understand and relatively straightforward method. Refer to the figure. I'm going to explain the process for inserting the missing portions of the image along one side of the pattern only. The process then needs to be repeated for the other sides.

Follow these steps to make a seamless pattern tile

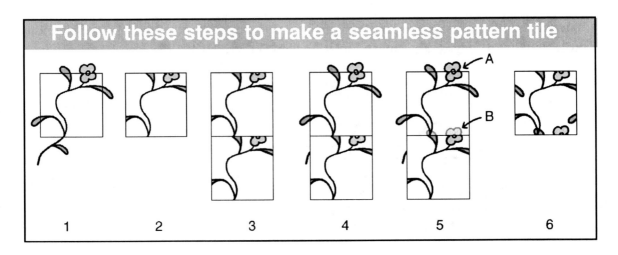

1: First, place a selection rectangle round the part of the image that you want to use as a pattern tile.

2: Copy the selection onto a new layer. Then hide the original image from which you copied the selection, just so that you can see clearly what you're doing.

3: Duplicate the layer that contains the pattern tile. Then drag it across so that it abuts the original tile along one edge. In my example I'm moved it so that it abuts the bottom of the tile. Do this very accurately – zoom in close and nudge the tile into place so that there isn't even a pixel-wide gap or overlap between the two tiles.

4: Make the original image from which the pattern was selected visible again. (In my figure you can see the top of the flower and the ends of the leaves are visible, protruding from behind the tile.)

5: Now you're all set up, and you can start the process of inserting the cut off portions of the image onto your tile. In my figure I've copied the top of the flower that's outside the tile (A) into the inside of the tile (B) where it's missing from the repeated flower on the copy of the tile below (I've lightened the copied flower here to make its appearance obvious).

To do this, first zoom in very closely to the tile so that you can see the individual pixels, as this process usually needs pixel-level accuracy.

Then open the Clone Stamp tool. Use the tool to copy areas of artwork from outside the tile to the positions inside the tile where it marries up with the cut off part of the adjoining tile. It's easiest if you take your initial sample from a spot that's just inside or on the very edge of the tile itself, just before the cut off portion, so that you can locate the exact same pixel in the copy of the tile at the opposite side. Clone the artwork onto a new layer, just in case of errors.

When you've finished one edge of the tile repeat the process for the other sides, abutting

copies of the tile against each side in turn and then copying portions of the underlying image to eliminate any cut-offs.

Adding portions of artwork to your tile in this way may involve applying it over areas of the image that are already there, specially if it involves a photographic image. It's a matter of judgement which parts of the internal area of the original image to retain and which parts to alter.

6: Finally you need to reinstate the selection area around your pattern so that you can actually convert it into a pattern.

Here's an easy way to do this. Whatever you do, don't just try to select the tile by dragging the Rectangular Marquee tool around it. Accuracy is very important.

In the Layers panel go to the layer that contains your tile and click on the thumbnail while holding down the Command key (Mac) or Control key (Windows). This will select the artwork on the layer, which in this case is the selection outline of your tile.

Save the selection as a new pattern (by going to Edit>Define Pattern from Selection).

Here's the finished pattern effect of my example (Figure 16-64).

Figure 16-64
The finished seamless pattern

Patterns can also be used with the Pattern Clone Tool. This is hidden behind the normal Clone Tool.

To use it you choose a Pattern from the Pattern panel, which is accessible through the options bar. Then, when you drag the Clone Tool, it reproduces the pattern onto your image. Think of it as a Pattern Paintbrush.

Part IV

Scanning
Outputting
Organizing

Scanning
17

Although this book is mostly about how to create images from scratch directly on your computer screen, you're bound to want to use work from other sources at some time. For instance you may have a line drawing on paper that you want to import so that you can colour it in or alter in some way, or you may have a photograph that you want to use as reference, or that you want to trace over or incorporate into an image as part of a montage.

Scanners and digital cameras can be used for transporting images from the outside world onto your computer, and you can also get reference material from the web. How to use these resources is described here.

In This Chapter:

How to Scan
Scanning Black and White Line Art and Pencil Drwaings
Removing Speckles fron Line Art
Rotating and Straightening Scans

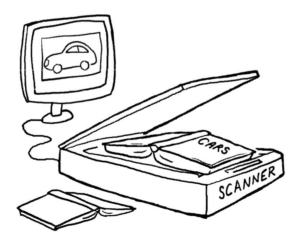

If you have an image on paper, and you want to put it onto your computer, the easiest way to get it there is to use a scanner.

A scanner works a little like a photocopier, except that instead of turning your image into ink on paper it turns it into digital code on your computer. It has a glass plate onto which you place the image that you want to copy, and it has a light beam that sweeps the length of the glass plate in order to record the image.

How to scan

I'll assume that you've got your scanner up and running, with all of the wires and the software in the right places.

To use a scanner you first turn it on (something that's easily forgotten), then go to the File menu, where you'll find the name of your scanner in the Import submenu. If it's not there, the scanner software isn't installed properly, so you should consult your manual.

When you click on the name of the scanner in the Import submenu a dialogue box will open. As is often the case with computers, the dialogue box may look much more intimidating than it actually is. Most of its contents may never need altering, or they may alter themselves automatically.

Different scanners have dialogue boxes in which the settings may be displayed and labelled differently, but here are the main considerations that you have to take into account on all of them.

Decide whether you want to produce a colour scan or a black and white scan. For colour scans you should choose to scan in Color, or RGB. For black and white scans you should choose Gray, or Grayscale. You may be given a third option, which may be labelled Line Art, Bitmap, or Black and White. This option produces images in pure black and white (with no shades of gray), and is best avoided, even if you want to scan in pure black and white, as explained later, on page 489.

There will be a large white panel in the dialogue box. This represents the area of the scanner's glass plate. By clicking Preview or Overview the scanner will do a quick initial sweep of your image and will display a low resolution version of the image in this panel for reference purposes. By pulling the handles on the corners of the dotted rectangle that's inside the panel you can alter how much of the area of the scanner's glass plate is processed when you do your proper scan. It's best to make the scan area larger than the area of the image that you need, so that you can crop off superfluous parts of the scan afterwards.

The dialogue box will give you the option of setting the Resolution.

This is the resolution that you're scanning your image in at, not the resolution of the finished work.

How do you work out what resolution you want to scan at?

The scan resolution is determined by the intended use of the finished artwork. Here are a few guidelines to help you to work it out.

Firstly, although these rules involve a bit of basic arithmetic, you don't have to be too precise about things, so if you're rubbish with numbers, don't worry. The chances are that once you've scanned an image into your computer you'll want to change the size of the image anyway, which will alter the image's final resolution (meaning that you could have well used a different input resolution to begin with). If you find that you want to decrease the size of an image once it's been scanned in you don't have to worry excessively about the input resolution that you used, as it's bound to have been high enough. Where you have to be careful is when you scan an image in and then find that you have to *increase* its size for your final image. I'll explain why in a moment.

Scanning for print use.

If you want to scan an image in so that you can print it out again in a different form here are a few basic rules of thumb.

The first rule of thumb is that you don't have to be as precise as the following paragraphs suggest – their seeming precision is solely in order to keep the numbers simple and to avoid muddying the water with vagueness.

The second rule of thumb is that essentially, the scan resolution should be the same as the print resolution multiplied by the scale that the image is going to be printed at.

For instance...

If you want to print the image out at the same size as the original, scan it in at the same resolution that you intend to print the final image. So if you intend to print at 300ppi, scan in at 300ppi too. (Some scanners use the term dpi (dots per inch) instead of ppi, which is a little confusing, as this term is also used to describe a totally unrelated measurement related to printing, as described on page 503)

If you want the scanned image to be printed out larger than the original image you have to take this increased size into account when setting the resolution. All you have to do is to multiply the intended print resolution by the amount that you want to magnify the image by. So for instance, if you want to print an image out at twice its original size, multiply the intended print resolution by two (so, for an image printed at 300ppi, scan at 600ppi).

If you want to print the image smaller than the original, reduce the scan resolution proportionately. For instance to print at half the original size, halve the print resolution to determine the scan resolution (so, to print at 300ppi that would mean scanning at 150ppi).

I'll explain the reasoning behind this using the example in Figure 17-1.

In this example I've used a postage stamp that's exactly one inch high (to make the arithmetic easier). It's going to be printed at a normal print resolution of 300ppi (where there are 300 pixels to every inch on the page).

In order to print the stamp out at its actual size, with a height of one inch, the image ideally needs to have 300 pixels from top to bottom because it's being printed at 300 pixels per inch. Scanning it in at 300ppi will give you that number of pixels.

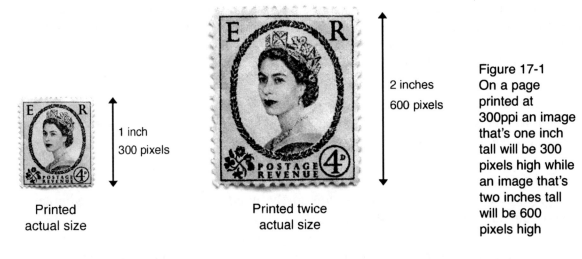

1 inch
300 pixels

Printed
actual size

2 inches
600 pixels

Printed twice
actual size

Figure 17-1
On a page
printed at
300ppi an image
that's one inch
tall will be 300
pixels high while
an image that's
two inches tall
will be 600
pixels high

To print the same stamp out at twice its original size, two inches high, the scanned image ideally needs 600 pixels from top to bottom, because the printed image is two inches tall and there are 300 pixels to each inch. If you scanned the image in at 300ppi as in the previous example the scanned image would only be 300 pixels high, and those 300 pixels would have to be stretched to span the 600 pixel height that make up a two inch printed image. This would result in a lower quality image, as the detail in the image is spread over twice the size. If the image is going to be twice actual size it really needs twice the number of pixels, so it's best to scan it in at twice the resolution.

Now, what if you wanted to print the image at half its original size instead?

In theory, according to my previous rule of thumb (that the scan resolution should be the same as the print resolution multiplied by the scale that the image is going to be printed at), you should set the scan resolution at half of the intended print resolution (so in my example of a print resolution of 300ppi you should set the scan resolution to 150ppi).

However, when you want to reduce the size of images after scanning things aren't quite

as important, so here's a nice simple rule of thumb for scanning such images.

Scan them in at a resolution that's higher than you need (such as 300ppi, which will allow the image to be used at any size up to actual size when printed at 300ppi), then reduce their size later, either in Elements or other software.

Here's the reasoning behind this.

If you scan an image in at the same resolution as the final print resolution (300ppi in my example) the image would have enough pixels to be displayed full size on the page (in other words, too many of them) and it would need to be reduced in size. In the process of reducing the size, the scanned image would be resampled so that it contained fewer pixels, thus detail in the image would be lost. This sounds bad, however, it's not a problem. The original scan had more detail in it than could physically be printed at the planned size, so this detail would be lost anyway, so it's no loss

Scanning for on-screen use.

If you want to scan in an image purely for on-screen use, such as for a web page, it's easiest just to scan the image in at a relatively high resolution, such as 300ppi, so that the image is larger than necessary for on-screen use. The resulting image will then need to be reduced in size, but that's not a problem. As with images for print, problems only arise when you find yourself having to increase the size of images (as the images may not contain enough detail to be able to cope with enlarging).

Scanning Black and White Line Art and Pencil Drawings

If you want to scan in images that are composed purely of black and white (with no shades of gray) for use in high quality printed material there are a few extra factors that you need to take into account (This doesn't apply to black and white work that's destined only to be used on-screen).

To achieve the highest quality print results you need to scan pure black and white images in at a higher resolution than you use for other types of artwork. This is because on a suitable high quality printer (not your desktop one though) the work can be printed out at a much higher resolution than other types of image – at a resolution in the region of 1,000ppi instead of the usual 300ppi.

Images that are composed of pure black and white are commonly called line art, or sometimes bitmap art (see Figure 17-2), while images that contain any tones at all, in the form of shades of gray or colours, are referred to as continuous tone art.

Figure 17-2
The difference
between line art
and continuous
tone art

Line art gets its name from the fact that it's often made up of black lines, but it can equally well be made up of other types of black mark, such as stippling (random dots), or areas of solid black. The term line art helps to differentiate pure black and white images from black and white art that contains shades of gray, such as black and white photographs.

As I mentioned, this section is mainly of interest if you want to scan line art at high quality suitable for *printing*, because line art can be printed with much more detail than continuous tone art, as explained in a moment. However it may also be of interest if you want to scan in line art so that you can work on the resulting scanned image in much greater detail than normal.

Line art images that are destined solely for on-screen use can be scanned in the same way as normal continuous tone work, described previously. This is because on-screen images are never pure black and white, but have a certain amount of gray present, making them in fact continuous tone artwork (Figure 17-3), This gray prevents the image appearing blocky and jagged on screen (See Chapter 5 for more on the subject of on-screen images).

Figure 17-3
Black and white images for on-screen use, such as on
web pages, are never pure black and white
This image is a very highly magnified view of part of the
line art image in Figure 17-2 as it would appear when
used on a web page or similar on-screen use

The reason that line art is scanned in at a higher resolution than continuous tone art is because of the different ways that the two types of image are eventually printed. Continuous tone images are converted into dots before they're printed, as in Figure 17-4, so that the

colours or shades of gray can be reproduced using the limited number of inks available in the printer (see page 502). The size of the dots dictates the finest detail that will print, so there's no point in having detail in the image that's smaller than the dots. It's different with line art images however. Being composed purely of black, which is a colour of ink that all printers possess, printers can print line art images more or less exactly as they are without the need to break them down into dots first. This means that the images aren't degraded, so the detail in the images can be much greater.

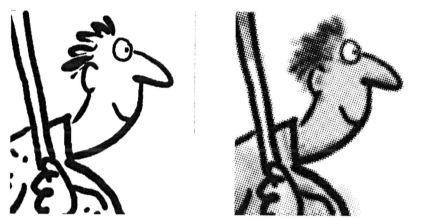

Figure 17-6 Magnified views of Figure 17-2. Left: Line art retains most of its detail. Right: Continuous tone art is broken up into dots of ink that are almost too small to see at normal size

Your scanner may have a special setting for scanning line art. Depending on the scanner this setting may be called Bitmap, Line Art, Black and White or something similar. Despite the presence of this setting it's best to scan line art in on the Grayscale (or Gray) setting, ignoring the line art option altogether.

This may sound strange, because you'd think that a setting that actually mentions the very type of work that you're intending to scan must be the right setting. The problem is that most original artwork, even if it's nominally black and white, contains a number of tones (for instance the white may actually be slightly off-white depending on the paper that the image is on, or the black might be dark gray), so the artwork often needs to be manipulated slightly in order for it to become pure black and white. When you use the scanner's own line art setting to convert images to line art this manipulation is done before you scan, making control slightly hit and miss, and more importantly, it means that you may have to do another scan with different settings if you find that the settings weren't quite right.

By scanning using the Grayscale mode this inconvenience is avoided because the scanned image retains all of the tonal values of the original image. You can then adjust the

image directly from within Elements, where you can turn it into pure black and white by using the Threshold command, as shown next.

As an example of how to scan line art I've chosen an image that's composed of extremely pale pencil lines, so that the adjustments that have to be made to the image are quite extreme and easy to see (Figure 17-5).

Despite its faintness it's possible to convert this drawing into pure black and white line art very easily.

First, scan in the image in Grayscale so that it retains all of its original tonal values.

Figure 17-5
A scan of a faint pencil drawing,
and an enlargement of part of it

Next, with the scanned image as the active layer go to the Adjustment Layer button in the Layers panel (the half black and half white circle) and go to the Threshold command.

This command turns all of the darker tones in an image black and all of the lighter tones white (Figure 17-6).

Figure 17-6
The Threshold command applied
to the image turns it into a pure
black and white image

The tonal value at which the division occurs between the tones that turn black and those that turn white is called the threshold value (hence the name of the command). You can alter this value by moving the triangular arrowhead that's half way along the base of the histogram (the graph-like panel) in the dialogue box. Moving the arrowhead to the right

causes progressively lighter tones to turn black, and vice versa. Moving the slider too far will make the image contain too much black or too much white (Figure 17-7).

As you move the arrowhead the image changes to reflect the new setting.

The effects of the Adjustment Layer aren't applied directly to the artwork, being more like a filter above it. Therefore when you're happy with the results that you've obtained you need to merge the Adjustment Layer with the artwork layer in order to apply the effects directly (It may also be a good idea to keep an unaltered copy of the artwork in case you decide that you need to make further alterations).

Figure 17-7
Over-adjusting the threshold level will make some values fall on the wrong side of the threshold.
Here I've made too many shades of gray turn to white

Removing Speckles from Line Art

Figure 17-8 Left: Scanned artwork including dust speckles. Right: The speckles removed

When you turn scanned images into line art you may find that your resulting image acquires a smattering of speckles, as in Figure 17-8. These appear where small and normally insignificant imperfections (such as dust on the scanner glass) are turned black.

You can remove these speckles by going to Filter>Noise>Dust and Scratches. Using a setting of one pixel in the Radius field will remove any blemishes that are one pixel across.

A drawback to this method is that if your work contains very fine detail that's only one pixel across, such as very thin lines, this detail will be removed at the same time, because the Dust and Scratches filter mistakes such marks for scratches.

Better results may be obtained by using the Despeckle filter.

First duplicate the layer that you want to work on, to avoid spoiling your work if things go wrong.

Then apply the Despeckle filter.

This filter has no settings that you can adjust - it simply recognises pixel-sized dots on your image and it makes them less noticeable by changing their colour so that it's closer to the colour that surrounds them. So in the case of line art it turns the dots a shade of gray - it turns pixels that are completely surrounded by white a very light gray and it turns pixels that are next to one or two black pixels as well as some white ones a darker shade of gray.

Now, in the case of line art, the chances are that the individual isolated black pixels that were surrounded completely by white (that were turned very light gray by the Despeckle filter) were unwanted speckles, while the pixels that were next to at least one other black pixel (and that therefore turned a darker gray) were actually part of the artwork, albeit a very fine and delicate part. So you'd want to keep the dark gray pixels - indeed you'd want to turn them back to black. And you'd want to remove the light gray pixels that represent the speckles - indeed you'd want to turn them white.

There's an easy way to do both of these things in one action. Use the Threshold command. This command will turn all of the grays in your image either black or white depending on the shade of gray.

Use the command by opening an Adjustment Layer (via the half black-half white circle at the bottom of the Layers panel). When you first open the command any grays in your image that are darker than mid-gray are turned black and any that are lighter than mid-gray are turned white. Moving the slider in the dialogue box will alter the shade of gray at which pixels become either black or white. Move the slider to the right (by quite a long way) until only the very light gray pixels are turned white. These light gray pixels are the ones that were created by the solitary black pixels that made up the unwanted speckles in your image. All of the darker gray pixels in the image, which were created from pixels that were probably part of your artwork, will turn black as you move slider.

This technique isn't infallible of course. You'll probably lose a few pixels that you'd rather keep, because Elements hasn't recognised their artistic purpose, but that's only to be expected. When you're happy with the results merge the Adjustment Layer with the artwork

(otherwise the result isn't actually applied to the artwork – it just looks as though it is).

Don't forget that there's always another method of removing speckles - select them manually. Of course I don't mean literally selecting each unwanted dot on your image one by one. I mean such methods as throwing a lasso round clusters of them. Alternatively, if your line art is composed of lines that are mainly touching each other, you might try clicking on the lines using the Magic Wand in contiguous mode, which will select the line art but not the isolated and disconnected dots that aren't touching it. Then you can invert the selection (Select>Inverse) so that everything except the line art is selected, and fill the resulting selection with white or you can cut or copy the selected image and place it on a new layer.

Rotating Scans and Straightening Badly Aligned Ones

Often when you scan an image you'll find that you've accidentally scanned the image at a slight angle and it needs straightening up. You can do this using the Crop tool.

First, drag the tool's cursor to create a rectangular crop area round the image. The Crop tool automatically allows you to rotate its border - its cursor turns into a curved rotation arrow whenever it's outside the box that defines the crop area. Rotate the border to align it with the image. Push the sides in or out in order to fine-tune your crop area if you need to, then crop by clicking the tick in the options bar. The cropped image will automatically be rotated so that it sits squarely on your screen.

If the image that needs straightening is a well defined rectangle surrounded by white you can straighten it in a single click via Image>Rotate>Straighten and Crop Image, or via Image>Rotate>Straighten Image, depending on how much white space there is round it.

If you want to scan a wide image, the original image may have to be placed on the scanner glass sideways in order for it to fit. This results in an image that's on its side on your computer screen. To correct this, go to Image>Rotate>90° Left (or Right).

Outputting
18

When you've finished your artwork you'll undoubtedly want to do something with it, rather than simply leaving it sitting on your computer. You may want to print it out, or you may want to send it to someone as an email attachment. Or perhaps you'll want to put it onto a web page.

Here's how to do all of these.

In This Chapter:
Printing
Adding your work to emails
GIFs and JPEGs (and PNGs)
Save for Web
Online Albums
The Web Photo Gallery
Animated GIFs

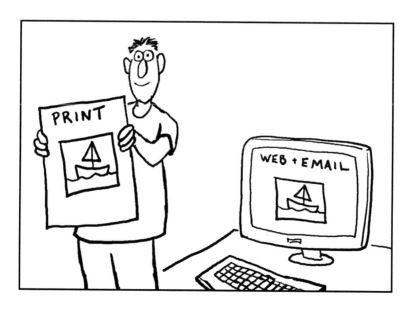

Printing

There are generally two ways that you may want to print your work - either by doing it on your own home/office desktop printer that's sitting next to your computer, or by sending it off to a professional printer.

First I'll explain how to use a desktop printer, then I'll say a little about professional printing. After that I'll describe some of the technical aspects of how printers work - this may come in useful should you ever come across terms such as halftone screens, lines per inch and dots per inch, which are all concerned with aspects of the printing process.

Printing with your Desktop Printer

Here's a quick overview of how to go about printing images on your own printer. Different printers vary in what they're capable of doing, and in the ways that they present their options, so for detailed information you should consult your printer's instructions.

If up to now all of the documents that you've printed have been standard word processing documents you may not have felt the urge, or had the need, to alter many of the settings of your printer, however to get the best out of printing images a little awareness of the options available is useful.

When you're ready to print an image in Elements, go to the Print command, at File>Print or by pressing Command-P (Mac) or Control-P (Windows). This will open the Print window (Figure 18-1).

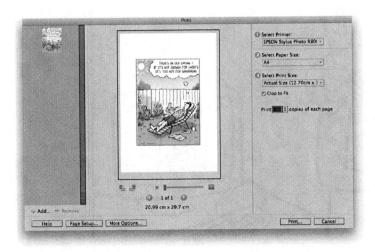

Figure 18-1
The Print window.
This is the Mac
version.
The Windows version
has more options in
the right hand column

The Print window is split into three parts. On the left is a column that contains thumbnails of images that are open. Remove unwanted images from this printing list by clicking their thumbnails and pressing the Remove button at the base of the column (This only removes them from the printing list, so don't worry that you may be removing them from your computer). The centre section of the window shows a preview of the image that's going to be printed. The whole preview panel represents the paper that you're planning to print on, with the image displayed at the size that it will appear on the paper. The blue line around the image shows the edge of the printed area (You can move the image round inside this area if you want). Beneath the preview image are some controls for adjusting the appearance of the image. On the right side of the window are more controls. Use these controls to choose the printer that you want to use (if you have a choice), set the size of the paper that you're printing on, the size of the image on the paper and the number of prints that you want. In Windows you can also use these controls to set the print quality and the number of images that will print on one sheet of paper (which is useful if you want small sized images for reference purposes). On a Mac these last settings are found when you press the Print button, as explained in a moment.

When you change the size of the image in the Print window you're only affecting the size that the image will print at – you're not affecting your original artwork. This means that your artwork is left safely untouched (unlike when you change the size of an image by resampling in the Image Size dialogue box).

Positioning the Image on the Paper

Elements automatically positions images bang in the centre of the paper when printing. In earlier versions of the programme you could move the image around, so why you can't do so now is a mystery to all of us. The result of this is that if you don't want the image to be at the centre of the sheet you have to cheat. Here's how. You can take advantage of the fact that although you can't move the actual position of the image on the preview panel, you can move the image within the bounds of the image area (the blue outline). The image area is set at the size of the actual image, so what you need to do is to expand the size of the image area by giving the original image a white border (at least temporarily while you print it). The best way to do this is to place the image on a white background that's approximately the same size as the sheet of paper that you're going to print on. Then when you open the Print window the blue frame will have expanded beyond the edge of the original image, as it now includes the area occupied by the white border. You don't have to position the image accurately within this border, because once the image (including the white border, which is now part of the image) is in the Print window's preview panel you can slide the image round

behind the blue frame – so as long as the blue frame is far enough away from the image you should have plenty of space available for repositioning.

If you want to orientate an image so that it prints in landscape format (that's with the long side of the paper horizontal) rather than the more usual portrait format go to the Page Setup button at the bottom of the Print window and alter the Orientation.

You can also change the paper size and other options in the Page Setup box, however these are better chosen directly in the main Print window.

Print Quality

The Print window allows you to alter the printing quality to suit which type of paper you want to print on, ranging from standard Plain Paper to high quality Glossy Paper.

In Windows it's easily accessible in the column on the right, labelled Print Settings.

On a Mac the print quality options are somewhat hidden away, as are several other controls, and have to be accessed by pressing the Print button. On a Mac this button doesn't actually instigate the printing process as you might have thought, but opens another dialogue box – you can tell that this is going to happen because of the three dots after the word Print, which indicate more choices to be made. The print quality controls can be found by opening a pop-up menu in the centre of the dialogue box, which will probably be displaying the label Layout. Choose Print Settings from the menu.

On low quality paper, ink tends to soak into the paper and spread out, producing slightly fuzzy results – this isn't a problem with a lot of work, such as when you're printing text, but it may become an issue if you want to print highly detailed images (Figure 18-2). The higher the quality of your work, the higher the quality of paper that it deserves.

Figure 18-2 A magnified detail of the same image when printed on glossy paper (left) and plain paper (right). The plain paper image is blurred due to the ink soaking into the paper.

When you select different papers the printer automatically chooses the appropriate quality of printing (so that, for instance, it automatically prints with more detail on higher quality paper).

You can control other aspects of the print quality via the Print Settings dialogue box. For example, if you want a quick, low quality print you can move the quality control to Speed, or you can choose whether to print in colour or in black and white.

If you'd like a little insight into how a desktop printer constructs its image there's some information coming up in a moment.

Professional Printing

If you get your printing done professionally, all of the technical side of the operation will be taken care of for you, so the main thing you have to take into account is that your image is of a high enough resolution for it to print well. If you stick to a resolution of 300ppi you'll cover everything (unless you're getting high quality line art printed, which works best with a resolution of about 1,200ppi to retain the detail - see Chapter 7). If in doubt, ask the people at the printers what they need.

Bear in mind that images produced in Elements are optimized for viewing on-screen, using RGB colour mode, and the colours won't print exactly the same as they appear on your monitor. (For more control over colours for printing, you need a programme that has the capability of working in CMYK colour mode - see page 284 - such as the full version of Photoshop.)

It isn't a problem sending RGB images to a printers, as they will convert them to CYMK if necessary, with the click of a button. In fact most photographs that are sent to printers will be in RGB colour mode anyway, as this is the mode that is used in digital cameras.

How a Printer Prints an Print

Here I'll try to explain a few technical terms such as dots per inch and lines per inch.

The key to understanding printing is to realize that printers only use a very limited number of colours of ink to create all of the different colours and shades that you see in printed images. In black and white printing, such as for black and white photographs, the only colour used is black, while full colour printing often uses only four colours: cyan, magenta, yellow and black (the CMYK of the colour mode mentioned a few sentences ago).

What's more, the printer's colours are always applied to the paper at their full values. So, for instance, a black and white image is printed using only pure black, even when the

result that's needed is a shade of gray.

How such limited resources achieve the impressive results of modern printing is explained here. I'll use as my example a black and white photograph (Figure 18-3). Colour printing uses essentially the same techniques but with several colours.

How Desktop Inkjet Printers Work

Figure 18-3
Although this photograph appears to contain shades of gray, the only colours in it are the pure black of the ink and the pure white of the paper

As I mentioned, the black (or colours) in a printed image are applied at full strength. A shade of gray in a printed photograph, such as the one above, isn't produced by diluting the black to the right value - it's produced by converting the image into a series of small black dots. The more dots there are, the darker the image - the fewer dots there are, the lighter the image (Figure 18-4). Seen from a normal viewing distance these dots are too small to see, and combined with the white of the paper they give the impression of shades of gray. (Colour printing works the same way, but by using separate dots for each colour - cyan, magenta, yellow and black - to produce the effect of a full colour image.)

Figure 18-4
A close-up of part of the photo-graph above when it's printed using a desktop inkjet printer, showing the black dots that give the impression of gray

On a desktop printer the dots are laid down in a semi-random distribution as the print head moves across the paper.

The dots in a print are all the same size, although their size can be varied depending on the quality of print that you're making, with high quality printing uses smaller dots (Don't confuse these dots with the dots in halftone images, which are explained below, in How Commercial Printers Work).

Figure 18-5
The semi-random dot distribution of an inkjet printer.
Left: For a light gray. Right: For a dark gray

The size of the dots is measured in dots per inch, or dpi.

The term dots per inch is often misleadingly used to refer to other types of dots generated in the process of digital image making. It sometimes crops up in scanning, where it's used synonymously with pixels per inch (even by the manufacturers of the scanners), but it should really only be used to refer to the dots in printing, as dots and pixels are definitely not the same thing (People who happily use the term for several unrelated measurements say that you can tell which measurement they mean due to the context, but unfortunately unless you're familiar with the concepts you don't know what the context is).

These dots are yet another example of images being composed of lots of tiny, separate units of colour, just like the pixels in a computer image and the dots of light on the computer screen - and again they're used as a matter of technical necessity, because the image has to be broken down into the limited colours that are available.

How Commercial Printers Work

Most commercial printers produce shades of gray by using small, uniform dots similar to those employed by inkjet printers - but instead of semi-randomly distributing the dots as in Figure 18-5 they're bunched together at regular intervals to form larger dots of different sizes (Figure 18-6). This distribution of dots is called a halftone. (I'll refer to these large, bunched dots as halftone dots to differentiate them from the smaller dots that they're composed of.)

Areas of large halftone dots give the impression of dark grays, while small halftone dots, surrounded by a lot of white, appear as light grays.

In Figure 18-6 the two examples, for a light gray and a dark gray, contain the same

numbers of small dots as in Figure 18-5, producing the same impression of gray when seen at normal viewing size.

Figure 18-6 With commercial printers the uniform small dots that create the image are grouped together to form larger halftone dots. Compare these to the random dots of inkjet printers in Figure 18-5, where the examples have the same number of small dots as here. At normal viewing size both figures 18-5 and 18-6 would produce the same impression of gray

Commercial printers use halftone dots rather than the more refined random dots of inkjet printers because the quality of the resulting images is easier to control at the level of mass production.

Different print qualities use different sized halftone dots (Figure 18-7). Newspapers, which print at low quality, use large, distantly spaced dots that you can actually see quite easily with the naked eye. They use such large, spaced-out dots because the ink spreads out on the low quality paper used for newspapers, meaning that if the dots were closer together they would merge and give a blotchy print. Glossy magazines, on high quality paper that can hold a lot of detail, use fine halftone dots that are almost invisible.

Figure 18-7 Magnified views of halftone dots. The size of the dots is different for different qualities of print. Left: A coarse halftone as used in newspapers. Right: A fine halftone as used in a magazine. (If you view the images from several feet away the dots disappear)

The terminology of halftone printing comes from the days when the images were prepared optically rather than electronically.

In pre-digital days, halftones were produced by placing the original, continuous tone image behind a glass plate that had a grid of lines etched into it. This grid of lines optically broke the image down into the dots. The glass plate was called a screen.

Different screens would have different numbers of lines etched into the grid, to create different numbers of dots.

The number of lines on the screen was referred to as the screen frequency, which was expressed in lines per inch (lpi), with the resulting number of halftone dots per inch being the same as the number of lines.

These terms are still used today as the units of measurement for halftone printing, even though the technology is now digital.

Low quality printing, such as newspapers, uses a screen frequency in the region of 85 to 100lpi.

Glossy magazines and other sophisticated forms of printing use smaller halftone dots that provide more detail. Their screen frequency is around 133 to 200lpi.

If you ever have to deal with lines per inch, and you're trying to relate the number of pixels per inch in your digital image to the number of lines per inch used by the printer, it's standard practice to multiply the printer's lines per inch by 2 to give you your pixels per inch. So for a printer that prints at 100lpi you should supply artwork at 200ppi. In practice you can get away with using the same figure for both lpi and ppi, so for a 100lpi printer you can supply 100ppi artwork, but you don't have much room for manoeuvre if the image needs resizing. To avoid any worry about such matters, you can't really go wrong if you produce your work at or above the recommended standard resolution of 300ppi, which covers most contingencies.

Sending Images in Emails and Adding Them to Web Pages

Adding Images to Emails

You can send your work to other people by placing it in emails, in the form of attachments – files that you add to your email so that they're sent as part of the email itself. Attachments are duplicates of the files that you want to send, automatically copied as part of the emailing process – the original files remain safely on your computer.

There are several ways that you can attach files to emails.

The E-mail Attachments Command

The simplest way to add an image to an email is to use the E-mail Attachments command. This command only works if you're using email software that's installed on your computer – it won't work for web-based email systems. The command is perfect for sending an image to someone when it's only going to be viewed on-screen. If you want to send emails for other purposes, such as for printing out, you'll often need more control over the quality of the image that you're sending than is available when using this method.

The command semi-automatically makes images ready for emailing and then opens your email system (if you're using a suitable form of email system) and places a copy of the image into an email. It allows you to email images without the need for any background knowledge of what's actually going on (Not that there's all that much going on anyway).

It works slightly differently in Windows and on Macs.

Windows

If you're using Elements in Edit mode click the Share tab and then click E-mail Attachments in the list of options that appears. This will then open the Organiser which will display the command proper (The button that you just pressed simply told Elements that you wanted to use the command). If you were already using the Organiser you'll go straight to the command when you open the Share tab.

Choose the images that you want to send by adding them to (or by taking them out of) the panel of thumbnails. Images that are open in Elements will appear automatically in the panel. To add images that are in the Organiser navigate to them then either drag their thumb-

nails into the E-mail Attachments thumbnail panel or click on them to select them then click the plus sign above the email thumbnail panel. To remove images select them then click the minus sign.

Beneath the thumbnails is a tickbox that allows you to convert your photos into JPEGs. This is a type of file that uses less memory than a normal Elements file, as explained in the section, File Formats for Email and the Web, page 510. Unless you specifically want to send images in their original format tick this button. It stays ticked unless you alter it. If images are already JPEGs the box will be dimmed.

The pop-up menu labelled Maximum Photo Size allows you to choose a suitable size for your image. If the original image is large and is therefore taking up more memory than is strictly necessary for a standard email it may be worth thinking about making the image smaller. Large images take a very long time to download via dial-up connections, and it's just generally bad practice to send over-large images unnecessarily.

The Quality slider allows you to set the quality of JPEG images (See page 515). The lower the quality the smaller the file size. The higher qualities are normally only necessary if the image is going to be printed.

Mac

On a Mac you'll find the E-mail Attachment command by clicking the Share tab, or by opening the File menu (where it's slightly reworded as Attach to Email).

You may have to give yes or no answers to a couple of simple questions as part of the process of attaching your image to an email, depending on the nature of your image. This is in order to send the image more efficiently.

If the original image is saved as a normal Elements file a box will open asking you if you want to convert the copy of the image that's going to be placed in the email into JPEG format. This is a type of file that uses less memory than a normal Elements file, as explained in the section, File Formats for Email and the Web, page 510. Unless you specifically want to send the image in its original format answer yes by clicking the Auto Convert button. Remember, you're creating a copy of the image as an email attachment, so your original image isn't altered by this process.

If you try to send a very large image a panel will open asking you whether you want to send the image as it is or whether you want it to be automatically modified for more efficient transmission. Unless you specifically want to send the image at its original size click Auto Convert. This makes the image smaller by reducing the number of pixels that it contains to a number that's sufficient for viewing on most screens (The reason why is explained in Preparing an Image for Emailing, in a moment). The image is also converted into JPEG format, as described in the previous paragraph.

Other Methods of Adding Images to Emails

The E-mail Attachment command isn't the only way that you can add attachments to emails. You can also add attachments when your email programme is open and Elements itself is closed.

You can add attachments by clicking the appropriate command in your email window while you're in the process of composing your email – the command will be called Attach or Add Attachments or something similar. Then navigate to the file that you want to attach. You'll see that the email now has an attachment in it because the attached file's name appears in the part of the email that lists attachments.

If you're using a suitable email method you can just drag an image file's icon over onto the open email window. This copies the file into the email (and leaves the original in the position that you dragged it from). The image may be displayed in the body of the email itself, depending on your setup, leaving you in no doubt that it's been imported successfully.

Preparing an Image for Emailing

Whenever you add an attachment to an email you have to take into account the consideration of file size. In days gone by, when all internet connections were dial-up connections through a standard phone line, this used to be a major consideration for absolutely everybody who sent emails, because sending a very large file through a dial-up connection could take an inordinately long time, with all of the digital information in the file having to be squeezed down a standard phone line that wasn't designed for the purpose. Nowadays, with the advent of broadband, the size factor for files is less significant. However, even if you have a broadband connection yourself you should bear in mind that not everyone is in your enviable position, so you should still take file size into account.

On top of this, large image files take up a lot of space in the in-boxes of the people that you send them to. If those in-boxes only have a limited amount of space, such as with some web-based email systems, large images can use up an unnecessarily large amount of the in-box's storage capacity.

Because of these considerations any image files that are attached to emails shouldn't be any larger than is necessary for their purpose.

Image files can be reduced in size by converting them from the Photoshop format that Elements uses into a format that retains only the essential data in the image. These formats are described on the following page, in the section, File Formats for Email and the Web.

You can also reduce the size of a file by reducing the number of pixels in the image.

If you're sending an image to someone who needs a high resolution copy, such as for printing, then you should send a copy with as many pixels as they need – if however, the image is only going to be viewed on-screen, the image probably wouldn't need to be more than about 1,000 to 1,200 pixels across (unless, that is, you want people to be able to magnify the image on-screen in order to see small details).

Why 1,000 to 1,200 pixels? When an image is being displayed on-screen at its most 'efficient' size each pixel in the image is displayed by one screen pixel (the dots of light that make up the image on the screen). This means that the image need have no more pixels than there are screen pixels to display them with. Most screens are 1,280 screen pixels across, with a significant minority being just over 1,000 screen pixels across, so as a rule of thumb 1,200 pixels is a good maximum width for an image.

There's an in-depth look at the relationship between image pixels and screen pixels in Chapter 6.

When you place an image into an email, the email software may automatically display the image within the email itself. If the image is larger than the email's window the image may be scaled down so that fits – a little bit like zooming out. This can be misleading, as the size that the image appears is just the display size, and the actual image may contain many more pixels than are necessary solely for viewing within the email (Figure 18-8).

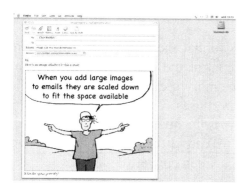

Figure 18-8 Large images displayed within email are displayed at a size to fit into the email window. Left: A large image as it appears in an email. Right: As it appears full size in Elements

There are two ways to reduce the number of pixels in your image. You can do it either by going to Image>Resize>Image Size (see page 126), or by using the Save For Web command, described in a moment.

File Formats for Email and the Web

Giving an image fewer pixels isn't the only way in which you can reduce the amount of memory that the image consumes. You can also save memory by simplifying the way that the information in the image's computer code is arranged. There are a variety of ways in which computer code can be encoded, known as formats.

Different formats are designed for different purposes.

The Photoshop format is designed so that it can remember every single piece of information about an image, such as every variation in colour and every layer. However, you can save files in other formats that retain a more limited amount of information – typically by dispensing with the layers and reducing the number of colours in the image – thus using a lot less memory than the Photoshop format.

You can recognize the format of a file by the three extension letters that are added to the end of the file's name, after the dot. Files that are in Photoshop format, for instance, all end in .psd, and Microsoft Word files end in .doc. (If you're using a Mac and the files don't have these three letter suffixes it's because the option to remove them from view has been chosen in the Preferences panel – they are still there behind the scenes though.)

There are two main file formats that are used in order to provide less memory-hungry images for use in emails and on the web. These are the JPEG (or JPG) format and the GIF format, with the file names ending in the extension letters .jpg and .gif respectively. They each create smaller files in different ways, and as a result each is good at saving different types of image, as explained soon.

When you convert an image into JPEG or GIF format the number of colours in the image is reduced, as mentioned above. You can control the number of colours in the converted image in order to control the amount of memory used by the resulting file. The fewer colours there are in the image, the less memory it uses.

Lowering the number of colours in an image lowers the quality of the image as well as reducing the amount of memory that it uses, and striking a balance between the image quality and the memory used is a major consideration when converting images.

When you create a JPEG or GIF file you're creating a copy of your Elements file, leaving the original file unaffected. Because images that are saved as JPEGs or GIFs are usually of a lower quality than Elements images it's important that when you store files you always keep the original Elements file rather than the JPEG or GIF version, as you can't get your quality back once it's gone.

As well as JPEG and GIF formats there's a less commonly used file format known as

PNG, pronounced ping. It comes in two versions, PNG-8 and PNG-24.

PNG-8 is similar to GIF, but its compression is better.

PNG-24 is more like JPEG but with some GIF characteristics too.

You'd think that therefore the PNG formats may be the best of the bunch. The problem is that older versions of browser software – the programmes that you look at web pages with – don't always recognize them, although this is becoming less of an issue with every passing year.

How To Save Files as GIFs, JPEGs or PNGs

The Save For Web (and Email) Command

If you want to send an image in an email and you need more control over its size or quality than you get using the Email Attachments command you can use the Save For Web command instead, in the File menu.

This command is a relatively simple route to creating copies of your images in JPEG, GIF or PNG format.

Despite its name, this command isn't exclusively for saving images so that they can be placed onto web pages – it can be used whenever you need JPEGs, GIFs or PNGs for other reasons, such as for placing in emails. A few of the features are however aimed specifically at creating images for web pages, which I haven't dealt with yet so in this explanation the more esoteric web orientated features are clearly flagged, and can be skipped if you're not interested. (I'll deal with web pages later. I'm assuming that you're more likely to start using this command for creating email attachments before you tackle web images.)

The command creates a copy of your image in the chosen format, leaving the original Elements file unaffected and still open on the screen. The new file is created closed, so if you want to look at it you have to open it.

When you use this command to save very large files it can become impractically slow. If you do try to convert large files a warning panel opens alerting you to this possibility, giving you the option to cancel the operation before you start (You can also cancel it once you've started, but this can seem very sluggish too, to the point where you may think that your computer has crashed). With very large files it's better to reduce the number of pixels in the image first or to use a different route to creating JPEGs, GIFs or PNGs, using the Save As command in the File menu (page 523).

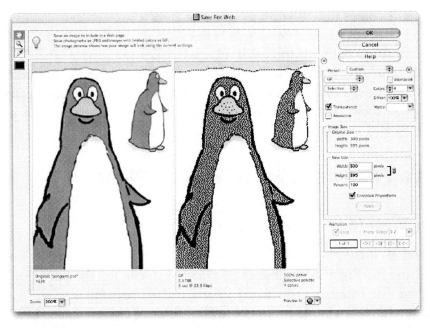

Figure 18-9 The Save For Web dialogue box. The image on the left is a representation of your original artwork. The one on the right is a preview of how it will look after you've changed its format and altered the number of colours in it. Here I've deliberately altered the image excessively in order to show a difference between the images

The Save For Web command opens a dialogue box like the one in Figure 18-9.

The most obvious feature of the dialogue box is the pair of images, both of which are representations of part of the image that's going to be saved. The image on the left is a representation of your original artwork, while the one on the right is a preview of how it will look after it's been converted into a new format and has had its number of colours reduced. You convert the image by using the controls on the right. When you change the settings the preview image changes to show the effect (exaggerated in Figure 18-9).

Before I describe how to actually go about creating a copy of a file using the Save for Web command I'll describe a few features of the dialogue box that don't actually alter the file but that help you to get the most out of the command.

When you open the dialogue box the images in the panels display the image at the size that it appears on screen at a ratio of one image pixel to one screen pixel, which is the ratio that you should use for displaying images on web pages and in most emails. You can zoom in for a closer look at your image by selecting the Zoom button (shaped like a magnifying glass) from the top left of the panel, and then by clicking either image. Alternatively, you

can temporarily open the zoom tool by using the keyboard shortcuts of Command (Mac) or Control (Windows). To zoom out, press Option (Mac) or Alt (Windows). The degree of zoom that's been applied is displayed at the bottom left of the dialogue box.

You can move the images around in their windows in order to reveal parts that are out of view by choosing the Hand button at the top left of the panel (It's the default button whenever you open the dialogue box). Then press and drag on either image to move it as desired. Both images move in unison to maintain the comparison between the two.

Displayed below the second image is the crucial information concerning what all of this conversion malarkey is for – setting the amount of time that the image will take to download onto someone else's computer.

The download time for any given computer is dependant on the speed of the connection of the computer to the internet. You can set the display to show the download times for different types of connection by going to the arrowhead in a circle at the top right hand corner of the preview image. This will open a list of standard types of internet connection. Remember that not everybody is using the latest, fastest connections, so unless you know that the person who is going to receive your file has a fast link don't judge by speeds above that of a 56Kbps modem (Kbps stands for Kilobytes per second – the amount of information per second that can be transmitted by the connection).

In the same pop-up menu you are given the option of viewing the preview image as though it was appearing on a Mac or a PC (This is independent of which type of computer you yourself are using). This is because images on Macs and PCs are displayed using slightly different colours, with PC images being slightly darker than those on Macs.

As I mentioned, the settings introduced so far don't affect the actual file conversion, and are simply for the purpose of previewing the image. To actually create your compressed file, follow the instructions below.

If you want to resize an image so that it has a different number of pixels you can do so by entering different settings in the New Size panel. If you know how many pixels wide or high you want the image to be you can enter the values into the fields provided: entering one of the values will automatically alter the other if Constrain Proportions is checked, which it usually should be. For an email the maximum width necessary for displaying an image on-screen on an average monitor is about 1,200 pixels. If you want to reduce or enlarge the image by a percentage, enter a new value in the percentage field instead.

Clicking the Apply button (just below these settings) will then change the size and will make the preview images change size to reflect the new dimensions.

Now for the main function of the Save for Web dialogue box – actually converting your image into a suitable compressed file.

You do this by setting values in the part of the dialogue box directly beneath the OK, Cancel and Help buttons.

At first sight the boxes and controls in this panel look very bewildering, however it's not as difficult as it looks, as most of them probably won't need changing.

The panel offers you the ability to use one of a number of predefined settings in order to convert your file in a single step. Choosing one of these settings will automatically adjust all of the controls at once.

You can find these predefined settings in the menu that opens when you click the top, central box in the panel – the one next to the name Preset.

If none of the preset settings are suitable (the meanings of which are explained in a moment) you can enter your own values in the other boxes in the panel below, in which case the name Custom appears in the Preset box. The preset settings are chiefly biased towards optimizing photographs for compression, so if you create radically non-photographic artwork (such as black and white cartoons or images with flat colours) the chances are that you'll want to tweak the settings to create your own custom values.

Of course whether you use the preset settings or enter your own, you need to know what the values mean, as I'll explain now.

First I'll describe the features and the settings for the more commonly used compression format, JPEG, which is used for almost all photographic work. Then I'll describe the GIF format, which is more useful for work composed of areas of flat colour and for black and white line art.

To choose the desired format you can select the format from the box just below the word Preset, which will be displaying one of the format names already: GIF, JPEG or PNG. Alternatively you can select one of the preset settings from the box next to the word Preset and then over-ride any of the automatically selected settings.

Saving JPEGs (or JPGs)

JPEG is short for Joint Photographic Experts Group, and it's pronounced jay-peg.

The JPEG format is the best format for compressing images in which the tones change gradually, such as photographs and continuous tone artwork (Figure 18-10). It's less efficient at compressing images that are composed of areas of flat colour or that are composed of black and white line art, in which case the other major compression format, GIF, is preferable.

You can vary the degree of compression to suit the work and its proposed use. The more compression you apply, the lower the quality of the final image.

Figure 18-10
JPEGs are best suited for images
in which tones change gradually

Quality

There are two alternative ways of altering the quality of a JPEG.

You can choose from the settings Low, Medium, High, Very High or Maximum in the box that's already displaying one of those options. Low is low quality, and therefore has the fastest download time, while Maximum is the highest quality (obviously) and is correspondingly the slowest to download.

Alternatively, if you want more precise values rather than these broad settings, you can enter exact numerical values in the box labelled Quality. The lower the number you enter, the lower the quality of the image. Maximum quality is 100.

Here in Figure 18-11 are parts of showing how the image quality is affected by different levels of compression.

Figure 18-11
JPEG compression
quality compared.
Left: High quality
Right: Low quality

On the left in Figure 18-11 is a detail from a high quality JPEG, which looks very similar to the original artwork. On the right is a low quality JPEG. You can see how much the image has been degraded in the low quality image, especially where there are abrupt changes in tone near the edges of flat colours (such as the sky).

Using broadband the high quality version would only take a few seconds to download, however on a dial-up connection the download time may be counted in minutes. The low quality version would take about a tenth of the time to download – almost instantaneous on broadband or a few seconds on dial-up.

You need to strike a balance between download time and image quality. If the image is small, the download time will be short anyway, so the degree of compression that you use won't be such an issue.

Progressive

Ticking the box labelled Progressive makes images download onto web pages in observable progressive steps. The images first appear as low resolution versions and gradually improve in quality as more information in the image is downloaded. This feature is most useful applied to large images that take a long time to download, allowing the viewer can see what's coming. It makes the file size slightly larger. It's the equivalent of the Interlaced option for GIFs.

Matte

When you save an image that contains transparent pixels as a JPEG the transparent pixels are turned white. This means that if you put such an image onto a web page that has a coloured background any formerly transparent pixels in the image will be displayed as white against the background. This is usually a problem that you'll encounter when you want to place an irregularly shaped image onto a web page, as the transparent areas round the original image will have been replaced with white, which will show up as a crude rectangle (Figure 18-12). To solve this problem you can apply the colour of the web page's background to the transparent pixels, which will make the image merge seamlessly with the page. Do this by using the box labelled Matte.

This is a rather second-rate solution to the problem of JPEGs' inability to support transparent pixels to be honest, as the substitution of transparent pixels with opaque coloured pixels negates the whole point of transparent pixels at one stroke. The colour that's applied by the Matte command will only work when the image is placed on a background of the same colour. On top of this the colour is a flat tone, making it inappropriate for display in front of tonally varied backgrounds.

To choose your colour click the arrow at the right side of the Matte box, which will open a menu of methods of selecting the appropriate colour – for instance you can use the

Eyedropper to sample the colour from a web page or you can use the Color Picker to enter the colour's values or its hex code (This is the six digit HTML code in the panel with the # symbol). For some reason the Matte submenu lists the Color Picker under the name Other rather than Color Picker.

Figure 18-12 Left: JPEGs normally convert transparent pixels to white, so on a web page with a coloured background any transparent space surrounding irregular artwork such as this fish shows up as a white rectangle. Right: The Matte option replaces transparent pixels with flat colour

Saving GIFs

Figure 18-13
The GIF format is used for images with flat colours and for black and white line images

GIF stands for Graphics Interchange Format, and is supposed to be pronounced jiff, although it's often pronounced giff.

This is the best compression format for artwork that's made up of flat colours or black and white line art (Figure 18-13), so it's perfect for many cartoons and other graphic styles. If you want to convert black and white line images into GIFs make sure that you read the special section about this at the end of this section.

517

A GIF image can only have a maximum of 256 colours in it – they can be any colours, but there can't be more than 256 of them. When you convert an Elements file into a GIF the colours in your image are converted into the closest colours available out of those 256.

Saving GIFs is ever so slightly more complicated than saving JPEGs, as there are more choices that you can make in order to optimize your image.

Although GIFs use a maximum of 256 colours, you don't have to use the full range of 256. You can set the number of colours in your GIF at anywhere between the maximum of 256 and the minimum of two. When you reduce the number of colours the original colours in the image all shift to become the nearest colour out of those remaining (Figure 18-14).

The fewer colours that your image contains, the smaller the GIF file is, as it only has to remember the actual colours that are in the image.

Figure 18-14 An illustration converted into GIF format with different numbers of colours (overdone here for effect). Left: The original illustration. Centre: 16 colour GIF. Right: 4 colour GIF. (For a colour version of this image see the back cover)

Colours
Set the number of colours that you want in your GIF in the field labelled Colors. Clicking the single arrowhead at the right will reveal a list of standard settings: clicking the double arrows on the left will change the displayed number one at a time. Alternatively, just type in the number of your choice.

The number of colours that you choose indicates the maximum number of colours that you want the image to contain. If there are fewer colours in your original artwork than you specify in your choice of setting, the number of colours in the artwork will remain unaltered. For instance, if you've chosen the 32-colour setting and there are only six colours in your image to begin with, the image will remain with six colours.

Selective, Perceptual, Adaptive, Restrictive
The colours available in the reduced palette of a GIF aren't fixed, but reflect the original colours in the artwork. For instance, the colours available in a three colour GIF (if you ever

wanted a GIF with such a low number of colours) aren't fixed at, say, red, green and blue: if the image only contains shades of green the colours may be light green, mid green and dark green. You can choose to reduce the colours in the palette in different ways so that the resulting palette is biased towards different colours. Do this using the box that's displaying one of the words Perceptual, Selective, Adaptive or Restrictive (Web). If in doubt about which to use, choose Selective, which is the default setting (You may be able to remember that Selective is the safest choice because it's the choice that you should *select*).

Here's a rundown of how the different options choose their colours.

Adaptive: This chooses its palette based on the colours that are most used in an image. So for instance a seascape will favour a palette of various blues, which will produce subtler colouring of the sea (but which may significantly skew the colour of a tiny red boat on the horizon). You could say that it adapts the colours for the genre of image (such as seascape).

Perceptual: This puts the emphasis on using colours that the eye is sensitive to.

Selective: This also puts the emphasis on using colours that the eye is sensitive to, and is best for images with bright colours and distinct transitions between colours.

Restrictive (Web): This option creates a specific limited palette of colours that can be displayed accurately on *very* old computer screens or when using *very* old browser software that can only display a limited number of colours. Technology has moved on, so only use this option if you think that the true rendering of the colours on old equipment is important.

You can flick through the different options to see which one gives the best results for your particular image, which can be seen in the Preview panel.

Dither

Dithering is a way of applying the colours on your reduced palette in a dot-like effect (Figure 18-15) to give the impression of more colours. For instance areas of red dots and yellow dots next to each other will give the impression of orange. It's useful in avoiding sudden transitions between colours.

Dithering doesn't look very good when it affects large areas of flat or subtly varying colour, as the dots can become intrusive.

Dithering also makes the compression of the image less effective, as compression works most efficiently on expanses of flat colour where neighbouring pixels are all the same colour (because the fewer changes of colour that there are, the less there is to remember).

If the dither option isn't active in the dialogue box go to the Preset sub-menu and choose one of the GIF options that has dither activated, then alter the settings that appear.

You can specify the amount of the effect by altering the value in the box labelled Dither. The Dither option distributes the dots randomly in the image. (There are two other types of dither distribution available when using the Save As command, described on page 523.)

The original image GIF with dither Gif without dither

Figure 18-15 Dithering in use. The images are magnified to show the individual pixels

Transparency

Checking the box labelled Transparency means that any pixels in your image that are transparent will remain transparent when the image is placed on a web page.

This is useful for placing non-rectangular images, such as navigation buttons, onto web pages that have coloured backgrounds, as it means that the colour on the web page will show through in the areas of the image that are transparent. If you don't use Transparency the transparent areas appear white (in a similar way to the fish in Figure 18-12).

To create a GIF that contains transparent areas you have to create the artwork on transparent layers and dispense with the background layer before you convert your image into GIF format. This is because the background layer is always opaque, so if the image includes a background layer the whole image will become opaque when all of the layers are merged (or flattened) as part of the process of converting it into a GIF.

Matte

The Transparency option, above, isn't very effective if an image has soft edges that fade from opaque to transparent. To obtain a transparent effect in such cases you can use the Matte option. This fills any transparent pixels in your image with a colour of your choice (You'd normally choose the same colour as the web page background onto which the image is going to be placed). You can use the Transparency and Matte options together, with Transparency applied to 100% transparent pixels, and Matte adding colour to any semi-transparent ones.

Interlaced

Checking the box labelled Interlaced means that when your image is opened on a web page it'll first appear as a very low resolution image and will gradually get sharper as the page renders itself. If you don't check the box, the image appears on screen more or less all at once, but only after the whole image has been rendered – meaning that there'll be a delay in the image appearing. Checking Interlaced gives people something to look at while the image downloads (but it does use slightly more memory, so downloading takes a little longer). It's the equivalent of the Progressive option in JPEGs.

Converting Black and White Line Art into GIFs for the Web

If you've created pure black and white line art, with no shades of gray in it, such as by using the Pencil, and you want to put it onto a web page, there are a few factors that you need to consider.

The first is that you shouldn't use pure black and white artwork on web pages – you should only put black, white and gray artwork on web pages. This is because if an image on-screen is made up of nothing but black and white pixels the effect can look crude, with the edges of lines appearing harsh and jagged (Figure 18-16, left). On-screen images generally look much better where the boundaries between the black and the white are softened with gray (Figure 18-16, right).

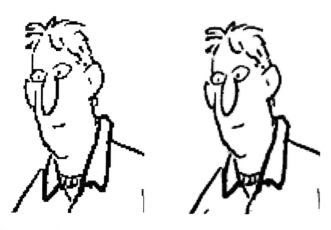

Figure 18-16
Left: A magnified view of a pure black and white image at the resolution used on a web page, which looks jagged
Right: An image with gray edges, which looks softer

Fortunately, you'd rarely ever find yourself putting pure black and white artwork onto a web page, even if you have an example of pure black and white artwork that you want to put there! The reason for this is that whenever you put artwork onto web pages you generally have to reduce its size by resampling it (in order to optimize its use of memory).

When you resample a black and white image it automatically generates gray pixels along the boundaries where the black and the white meet (unless you resample it using the Nearest Neighbor option). The reason for this is that when an image is resampled the black and white areas that make up the image are redistributed across a new number of pixels – and where a black and a white area overlap on a new pixel the new pixel averages out the amount of black and white and displays it as gray (as shown in Figure 7-9).

If an image is in Bitmap mode (which it very rarely will be unless you make a point of saving images in that mode for high quality printing), convert it to Grayscale before resampling. Bitmap mode uses *only* pure black and white, all of the time, so as a result resampled images won't acquire the desired gray fringes.

If you've produced black and white artwork by using the Brush rather than the Pencil your work will always have soft gray edges.

A black and white image with soft gray edges can have up to 254 shades of gray in it, even though it may just be a simple line drawing. This number of shades of gray is actually unnecessary when displaying line art on computer screens, as the shades can't all be differentiated from each other by the human eye. What's more, all of these different grays make the file relatively large, which may be an important factor on a web page (or an email attachment), as the larger the file the longer the download time if the web page/email is being viewed via a slow dial-up connection. Very usefully, you can substantially reduce the number of grays in a black and white image, thus reducing the file size and the download time, without significantly degrading the image. You can actually set the number of grays to as low as *two* shades without necessarily affecting the quality of the image when viewed on the screen. Look at Figure 18-17, which shows hugely magnified details of part of an image saved with different numbers of grays. The image on the left contains all of the possible 254 shades of gray (plus black and white), while the one on the right contains only six grays (plus black and white). How different do they look to you?

Figure 18-17
You can greatly reduce the number of grays in black and white line art when you convert it to a GIF – without affecting the quality, as shown in this magnified detail from an image.
Left: all 256 shades
Right: only eight shades

Set the number of grays by altering the value in the Colors box in the Save for Web dialogue box. The number of colours has to include black and white, so to obtain two grays set the number of colours to four (black, white and two grays). Don't set the number of colours to two, as this reduces an image to pure black and white, which produces the harsh blocky effect described earlier – the effect that you have to avoid!

None of the preset GIF settings gives a number of colours below 32, probably because the presets are aimed primarily at modifying photographs, which generally need a wider colour range.

Creating JPEGs, GIFs and PNGs Without Using the Save for Web Command

If you try to save a very large file as a JPEG, GIF or PNG using the Save for Web command you may find yourself sitting staring at your computer screen fora very long time indeed while Elements grinds away processing your work.

Save for Web works great with small to medium sized files, but it can get jammed up badly when it's dealing with anything truly substantial (A warning notice appears if you try to convert a large file, telling you that it may be inconvenient to save this way).

When you find that the Save for Web command is chugging away without seeming to be doing anything, hit the cancel button (which may work quite sluggishly itself) and use the following route to JPEG, GIF or PNG production instead.

Go to the Save As command in the File menu.

This will create a copy of your image in the chosen format, which will be placed in whichever folder you choose, while leaving the original unaltered.

In the dialogue box that opens when you choose this command you'll see a panel labelled Format. Click on the panel and a list of different formats will appear. These are all ways of saving your files so that they can be understood by different programmes. Many of these are rather arcane formats for transferring files between different programmes that you may never use, so don't feel intimidated by the length of the list. On Windows computers the entries in the list are each followed by the three or four letter suffixes that the formats apply to the file names, thus making the list seem even more intimidating than it actually is.

In the list you'll see CompuServe GIF, JPEG and PNG.

(If JPEG isn't in the list of formats in the Save As dialogue box, it's because the file you've opened is in a mode that can't be converted directly into a JPEG. This means that

the chances are that the image is probably better saved as a GIF or PNG. However, if you really do want to save it as a JPEG change its mode by going to Image>Mode – if the mode that it's in is Index Color change it to RGB Color, and if it's Bitmap change it to Grayscale. JPEG will then appear in the Save As list.)

Scroll down to whichever of the formats you want to use.

If you choose JPEG a dialogue box will open when you press Save asking you how much compression you want to apply to the image (and if there are transparent pixels in the image the option labelled Matte will be activated). For more information on these see the section on saving JPEGs using the Save for Web command, on page 514.

If you choose GIF, a dialogue box will open when you press Save, containing fields that are described in the section above about the Save for Web command, page 517. (If your image is in Grayscale (or Bitmap or Indexed Color) a simple box opens asking if you want to save your image as Interlaced, which makes the image appear progressively on a web page rather than all at once after a delay. The other options aren't offered as they only apply to full colour images.)

There are a few fields in the dialogue box that are different to those in the Save for Web command, so they're described further here.

Palette

The Palette is literally the palette of colours available from which the image can be composed. GIFs can include up to 256 colours, but you can vary which colours they are by using different palettes.

The list includes the following choices.

If in doubt, use the Exact option if it's available (it'll be grayed if it isn't), or the Local (Selective) option.

Exact: This palette is used when your image contains less that 256 colours, meaning that every colour in the image can be used just as it is.

System (Mac OS or **Windows):** Only use these options if you know that your image is only going to be viewed on computers of the type you choose.

Web, and **Uniform:** These use restricted palettes of colours aimed at older monitors or older browser software that can only display a limited number of colours. Usually avoid.

Custom: With this option you can see the colours in the palette that you've chosen. It opens a swatch palette containing the range of the colours that are available for the image that you're working on. You can remove colours from the palette (and thus from the final image) by clicking the swatches while pressing the Command key (Mac) or Control key (Windows). Change a colour by double clicking its swatch, which opens the Color Picker.

Local/Master: The Adaptive, Perceptual and Selective palettes described in the section on Save for Web come in two versions here: Local and Master. Local means that the colours selected for the palette will be based on the specific image that's being worked on, while the Master option selects colours for the palette based on a series of open images.

Forced

When you reduce the number of colours in an image it's possible to lose important colours that you'd rather retain, as the colours shift to be replaced by those in the new restricted palette. The Forced submenu allows you to lock certain colours so that they're preserved. If in doubt, use either None or Black and White.

The choices are:

None: Doesn't lock any colours.

Black and White: Locks black and white.

Primaries: Locks black and white, and all of the primary colours, both additive and subtractive: that's red, green, blue, cyan, magenta and yellow.

Web: This locks any of the browser-safe colours that are suitable for older browsers. This option is unnecessary for modern computers.

Custom: This allows you to create your own selection of locked colours by adding them to a palette.

Dither

Dithering is the mottling of colours in GIFs that creates more subtle colour transitions. Its principles are covered in the section on the Save for Web command, page 511.

There are three ways that you can distribute the mottled dots in a dithered image.

Diffusion: The most useful option, creating a random dot distribution. This is the type of dither that's available when using the Save for Web command. The degree of dither is adjustable in the panel labelled Amount.

Noise: Like Diffusion Dither, this distributes the dots randomly, but allows the colours to spread slightly into each other.

Pattern: This is not a useful option for most purposes, as it produces a rather obvious distribution of dots that looks quite crude.

Preserve Exact Colours: This prevents dither being applied to any colours in the original image that are exactly the same as those in the colour palette. It's useful for preserving fine lines and text for web images. You can turn it on or off when using Diffusion Dither.

Sending Elements Images to People Who Don't Have Elements or Photoshop

If you need to send someone an Elements image with all of its information intact, such as its exact colours and its layers, it's best to send it in its original Photoshop format (with .psd after the file name).

However if the recipient of your file doesn't have Elements or Photoshop (or other software that can read Photoshop files), they may not be able to open the file when it arrives.

This is because different programme can't always read the data from other programmes – it's as though they're written in foreign languages. When one programme can't read the language of another one the solution is to translate files into a language that both programmes can understand.

To save an Elements file so that it can be opened in programmes that can't read Photoshop's language, save a copy in TIFF format. Do this in the Save As dialogue box in the File menu.

TIFF stands for Tagged Image File Format by the way.

Putting Images onto Web Pages

Putting images onto web pages is slightly more complicated than putting them into emails, as you have to have a web page to put them onto first, but it's still relatively straight-forward.

You may want to put images onto your own web site or you may want to add them to pre-existing sites that display images, such as Facebook or Flickr.

If you have some experience of working with web sites you can process your images using the Save for Web command or the Save As command and then upload them to a web site.

If you have little or no experience of working with web pages you'll be pleased to hear that Elements offers an amazing semi-automated method of generating sets of web pages specifically for displaying images. These web pages can then be uploaded to the internet or, if you're just experimenting with them, they can be left on your computer (where they will have the appearance of a web site, but one that only you will be able to see). These semi-automated methods of web page generation are described in a few pages' time, in the section titled Online Albums and Web Photo Gallery.

Outputting Images

What Size Should Images be for Web Pages?

On web pages it's sensible to display images at a size that is appropriate, but no larger. This is because large images, with lots of pixels, take longer to download onto your computer. This isn't an issue if you're using a broadband connection, but not everybody has that luxury, yet.

The amount of time that it takes to open a web page on a dial-up connection, is critical. If a page takes too long to open, people will give up and move on to another page, on someone else's web site.

When you're deciding on the size that an image should be on a page, don't cover the whole screen area with an image if half of the screen will do. And don't cover half the screen when a quarter is more than enough. Every time you double the width of an image, you quadruple its file size, and thus quadruple the time it takes to download.

Images on web pages should be displayed at a size where one image pixel is displayed by one screen pixel. This is the most efficient size to display images.

If the image pixels in an image are smaller than the screen pixels, several image pixels have to be averaged out to be displayed by each screen pixel, which means that the image uses more memory than is necessary for its size, and thus takes longer than necessary to download. There's more about the relationship between image pixels and screen pixels in Chapter 5, on page 115.

When you construct a web page you'll find that the software that you're using for the task gives you the option of changing the display size of your images once you've pasted them onto the web page itself, so that you can make them fit your design better. Don't use this facility to reduce the size of a large image. This is because the entire large image still has to be downloaded from the web, and is then rescaled on the screen. It's best to resize images by resampling them *before* you put them on web pages, so that they're the correct size to start with.

How do you Resize an Image for the Web?

There are two ways to reduce the size of an image to make it fit a web page – either by using the Save For Web command, described on page 511, or by going to Image>Resize>Image Size, described on page 125 (which you should use if your original image is too large to be dealt with efficiently by the Save for Web command). If you use the Save for Web command the image is automatically saved as a GIF or a JPEG, suitable for placing on a web page, but if you resize using the Image Size command you should then

save the resized image as a GIF or a JPEG by going to File>Save As and choosing the desired format from the pop-up list.

It's common practice when sizing images for web pages using the Image Size command to put the resolution setting at 72 ppi. This isn't necessary, as resolution is irrelevant to screen-based images and only applies to prints.

Online Album and Web Photo Gallery

If you're going to put complex web pages on the web you'll need to consult a book dedicated to the subject, but if you just want to create a few simple web pages on which you can show off some of your images Elements offers you a simple, no frills page generation facility.

You can put the resulting set of pages onto a web site, but even if you don't do so the pages will act just like a proper web site on your computer (except that, because it's sitting on your computer rather than being on the internet, you'll be the only person who can look at it).

Once you've selected a few basic features to define the look of your gallery of images, as explained below, Elements will create a mini web site for you automatically. While it's doing this you'll be able to sit back, put your feet up, and let the site take shape all by itself. Your computer will copy all of your selected artwork into the correct format and lay out the pages – all in the amount of time it takes you to say 'That's amazing!' (So maybe you won't have time to put your feet up after all). If you don't like the results you can change them as easily as you created them.

The processes involved in doing this are slightly different on Windows and Mac computers, producing slightly different results (The image galleries achieved in Windows are a little more gimmicky and less professional looking than the Mac version, I think).

Let's look at them in turn.

Windows

You can create a series of image-based web pages in Windows by using the Online Album command.

First, use the Organiser to choose the images that you want to display in the album.

To find this, click on the green Share tab near the top right of the screen. Click Online Album the top of the list that appears in the column on the right.

A different column appears on the right, at the top of which is a button labelled Create Online Album. This is automatically selected by default.

Lower down the same column you can choose what you want to do with the album that

you're creating, such as upload it onto the web via ftp (file transfer protocol) or upload it onto Adobe.com (Adobe's own on-line service for displaying your albums).

Then go to the bottom of the column and click Next.

The column changes again. In the new column enter a name for your photo album.

Click and drag the image thumbnails from the central window and place them in the window that's appeared in the new manifestation of the right hand column, under the tab labelled Content.

Click the Share tab that's next to the Content tab.

The Organiser then starts to process the images ready for display, and then presents you with a preview of what the album will look like.

You can choose different album designs by picking a different template from the row that is displayed above the central window of the interface.

The templates are split into themes, such as travel, family and so on, and most of them display the images by integrating them into 'animated' backgrounds. For instance, one of the travel templates displays your images on billboards and suchlike along the side of a road as you travel along it. Another allows you to turn the pages of a book that has one of your images on each page.

The resulting pages can then be uploaded to the web, placed on a disk or left on your computer.

Mac

You can create a series of image-based web pages on a Mac (Figure 18-18) by using the Web Photo Gallery command.

Figure 18-18
The Web Photo Gallery on a Mac, complete with thumbnails of the images in the gallery.
This is just one possible layout

To find this, click on the green Share tab near the top right of the screen. Web Photo Gallery is at the top of the list that appears.

Web Photo Gallery doesn't run from within Elements itself but from within Elements' sister programme, Bridge, which is a media storage and retrieval programme (Available on Macs only). When you click Web Photo Gallery, Elements automatically opens Bridge. You can also open Web Photo Gallery directly from Bridge by clicking on Output near the top of the screen.

When the Web Photo Gallery interface has opened (Figure 18-19) you can navigate to the folder that contains the images that you want to display by using the column of folders on the left. The images in the chosen folder will then be displayed as thumbnails in a panel titled Content across the bottom of the screen (not unlike the Project Bin that can be displayed across the bottom of Elements). Click on the images that you want in your gallery – select a single image by clicking its thumbnail, select several images by clicking on their thumbnails while holding down the Command key, or select all of the images by pressing Command-A. The chosen images will appear in the interface's main panel.

Figure 18-19 The design interface for the Web Photo Gallery (Mac only)

In the right hand side panel click the option Web Gallery (or PDF if you want to produce a slideshow of pdfs instead.

You can then choose a preconfigured design as the layout for your gallery by clicking the Template menu.

If you click Refresh Preview a representation of the finished page will appear in the main panel on the interface, replacing the display of chosen images. Alternatively, if you click Preview in Browser your web browser software will open and display the results there, which will give you a more realistic impression of the results.

Further down the panel you can enter information about the gallery, such as a title that will appear at the top of every page and a description of its contents, and you can choose settings for image size, thumbnail size and so on. Whenever you make any changes you can click the preview buttons to observe the results.

You can alter the colours of the gallery's background. The default design of the gallery gives the pages black backgrounds, which at the time of writing is deemed to be the cool colour for sophisticated photo sites. You can change the colours of different parts of the page design by double clicking on the relevant swatches in the Color Palette section of the panel. In the colour picker that appears move the slider on the vertical column upwards in order to change the colours from black. Then choose a colour from the circle.

When you've finished altering these settings you're ready to create your gallery. The whole gallery is saved in a new folder, which you give a name in the field labelled Gallery Name (This isn't to be confused with the field labelled Gallery Title near the top of the panel, which refers to the 'presentation' title that's displayed on the gallery pages themselves rather than the purely 'administrative' name of the folder that you're dealing with here).

You can then save the resulting gallery on your computer by clicking Save to Disk, or if you want to place the gallery onto a web site you can upload it directly to the internet by clicking Upload and then filling in the necessary ftp (file transfer protocol) information).

When you save the gallery on your computer you can view the gallery by going to the gallery's folder and clicking on the file labelled index.html.

Creating Simple Animations

To see the animations in this section in motion, go to www.chrismadden.co.uk/create.

Figure 18-20 Frames from a simple animation.

If you've ever wanted to try your hand at creating animated images, Elements offers you the perfect introductory method.

You can create simple animations using a special feature of the GIF file format that allows you to show a sequence of images in turn (which is the basis of all animation processes) when viewed on web browsing software, such as Internet Explorer or Safari. The animation doesn't have to be placed on an actual web page on the actual internet in order for you to see it in action – you can view the image by opening your web browsing software and then navigating to the file on your computer.

To create an animation you need to produce a single file that contains each frame of your animation sequence on a separate layer (Figure 18-21) – then save the file as a GIF via the Save For Web command, where you need to tick the box labelled Animation (and specify a few settings to optimize the effect of the animation).

Animations are generally used to create the impression of movement. This is done by taking one image and then copying it several times, making slight alterations to the position of objects in each copy. The series of images are then displayed in quick succession one after the other, with the differences in the images giving the effect of motion.

The process doesn't have to be restricted to creating movement however.

You can use the same technique to make letters spell out words one letter at a time, or you can create sequences where colours change (instead of position).

You can also use the animation process to display totally different images sequentially, like a slide show (where the rate at which the image changes from frame to frame is slowed down considerably compared to that of a conventional animation). This can be used for instance to display the individual frames of a cartoon strip one frame at a time.

Figure 18-21
Separate frames
from a single
animation

Animated GIFs often work best where the action is simple. Actions such as of someone moving their eyes (Figure 18-22), a globe turning or lights flashing on and off. One of the reasons for this is that the animations are frequently displayed by showing the sequence of images in a loop, so that when the end of the animation is reached it starts to be shown again from the beginning, giving the impression that the action is going on forever. With complicated movements, marrying the end of the sequence with the beginning can be difficult, resulting in a jump in the action. Simple actions however are relatively straightforward to marry up (and thet're also easier to draw).

Figure 18-22 Very simple animation sequences such as this are easy to produce, and are effective when run as continuous loops.

If you're animating a large complex image that you intend to place on a web page don't give the animation too many frames, as each frame uses memory and adds to the download time. Smaller images however can have more frames.

Bear in mind that with GIFs the amount of memory used is dependent on the amount of detail in an image, not necessarily the physical size (because large areas of a single colour don't take a lot of memory). This means that a large image with little detail in it will take up a relatively small amount of memory. This fact is useful if you want to create a large animation area that contains a small animated object. For instance, Figure 18-23 shows a frame from an animation of a man running across an image area that's as wide as a computer screen. When viewed on the screen the sequence shows the man running across the screen, disappearing out of the right hand side of the screen, then reappearing at the left hand side again in a continuous loop. The image is very wide, but is a single uniform colour apart from the little man running, so it hardly uses any more memory than an image that's the same size as the man alone.

Figure 18-23 A GIF that contains a lot of uniform space (top), uses hardly any more memory than one without the space (bottom). The memory is used in recording the detail

The simplest way to produce an animation is to draw the first image for your animation on a layer, then to copy the layer and alter the image on it slightly. Then copy that layer and repeat the process.

If you want to set the animation to repeat endlessly make sure that the action in the last frame links to that in the first one, otherwise you'll get a jump where the action starts again at the beginning. The last image shouldn't be the same as the first, but should be one 'step' away from it, otherwise there'll be a jerk as the animation displays two images the same one after the other. This doesn't apply if the animation includes static sequences, such as the blinking boy in Figure 18-21.

If you want your animation to repeat itself, but with a time lag between showings, you should add a few blank frames at the end of the sequence of images. The displaying of these

frames will give the effect of a pause in the animation.

If you want an image to seem stationary except for the occasional movement (such as the blinking boy in Figure 18-21), you should use a sequence of the same image repeated to provide the stationary sections. Having a stationary segment linking the final and first frames makes marrying the action in a loop easy to achieve.

When you've created all of your layers go to Save For Web and choose GIF. Alter whatever settings you want as with a normal GIF, described in the section about the Save For Web command, page 511.

Then tick the box next to Animate.

The image in the preview panels will change so that only the bottom layer of the stack in your file is shown instead of all of them on top of each other, and the Animation panel near the bottom of the dialogue box will become active so that you can enter information into it.

Tick Loop if you want the animation to keep repeating endlessly.

Alter the Frame Delay to choose the rate at which the animation moves from one frame to the next. For conventional animation, where you want to give the effect of movement, a speed of a fraction of a second should be used. For displaying other types of image in sequence, such as the frames of a cartoon strip, or a slide show, choose a rate that gives people time to take in the individual frames.

To preview the frames one by one, click the various arrows in the panel, which will move the display from frame to frame.

To observe the whole animation in action click the button labelled Preview In (which is at the very bottom of the dialogue box, not in the Animation panel). This will open your web browsing software and display the true effect of the animation. To select which browser software you want to view it in, click the arrow next to the button.

Organizing
19

Most manuals about Elements put the section about how to organise your files at the beginning of the book, largely because they are aimed at people who probably have thousands of disorganized photographs floating around on their computers.

I'm putting it at the end because this book is less about dealing with torrents of photos but more with dealing with dribbles of hand-drawn artwork. So organizing is secondary.

Treat it as an appendix.

In This Chapter:
Windows Organizer
Mac Bridge

If you work with any type of image on computers it doesn't take long before you've got so many image files stored on the computer that you don't know where to look in order to find a specific image. Some sort of system is needed in order to retrieve them.

One way to deal with this problem is to impose a degree of order onto your images by placing them into folders that reflect the subject matter of the images. So, for instance, if you're a cartoonist you can create a folder specifically for storing, say, gardening cartoons and another one for cookery cartoons. The problem is though, which folder do you put cartoons about barbeques (cookery in the garden) into? The simplest answer is to put it into the folder that it has the strongest affinity to, and to give it a file name that reflects its contents so that it can be found by using the computer's search facility (So for instance a cartoon about barbeques should probably have the word barbeque, or bbq, in the title).

That system may be fine when you're simply trying to file the occasional drawing or other hand-made image, because by their nature they're relatively slow to produce. The organizational problem gets significantly worse when you're dealing with photographs however, This is partly due to the torrent of photos that can pour into your computer every time you go out of doors with your camera and partly due to the categorisation quandry –. do you store a photo of your sister Emma standing in front of the pagoda in Kew Gardens under family photos, Kew Gardens or architecture?

The whole thing seems impossible.

Fortunately Elements offers you a solution.

You can create lists of descriptive words, known as keywords or tags, that can be 'clipped onto' your image files, allowing the files to be found simply by searching for any one of the words. This information isn't visible on the image: it's hidden out of sight, something like the digital equivalent of the information that the more organized amongst us write on the back of conventional photo prints. This hidden background information about images (or any other type of file) is known as metadata.

So, for example, if you have a cartoon about barbeques as described above, you can clip the words gardening, cookery, barbeque, bbq and cartoon to it, along with anything else that comes to mind such as summer, leisure, charcoal, man-cooking and so on. Similarly, if you have a photo of your sister Emma standing in front of the pagoda in Kew Gardens you can clip the keywords Kew Gardens, pagodas, London, England, family, archetecture and Emma to it. The list of reference words can be as long as you have time to add or as short as you think is adequate.

Then, when you search for the keyword garden, for instance, your barbeque cartoon will be found, as will your photo of Emma in Kew Gardens (and any photos of Covent Garden Opera House).

How do you add these keywords, and how do you search for files containing them?

Well, you don't do it using your computer's standard search facility – you do it using Elements' dedicated search and display system.

This system is slightly different on Windows computers and on Macs, but the essential principles are similar. Both systems work by displaying a panel of thumbnail images of any images that fit your search criteria.

In Windows the system is called the Organizer, while on Macs it's known as Bridge (In Elements 9 the Mac version will also incorporate the Organizer). The Windows version is an integral part of the Elements programme, while the Mac version is actually a totally separate piece of software that's bundled with Elements.

Windows Organizer

Organizer is the part of Elements that is used as a filing and retrieval system for your images. It's an integral part of Elements, but it has its own separate interface, or workspace, which is opened independently of the normal image-editing interface (known, logically, as the Edit interface).

At the beginning of a session of using Elements you can choose to open either the Organizer or the Edit interface by selecting the one you want on the Welcome Screen. If you open the Organizer interface and you then want to work on an image in the Edit interface you can open the Edit interface by going to the Fix tab near the top right and then clicking Edit Photos.

The Organizer can also be opened directly from the Edit interface by clicking on the Organizer button at the top of the Edit interface.

The Organizer interface is divided into either two or three columns.

The main column is taken up with a large panel, known as the Media Browser, which shows thumbnails of any files that fall into whatever category the Organizer is displaying at the time. (It's called Media Browser rather than Image Browser because it can display not only image files but other types of file too, such as video). The size of the thumbnails can be altered by moving the slider in the bar near the top of the screen.

The upper part of the right hand column contains a list of any albums that you've created. The lower part of the column shows a list of keywords, or tags. Initially this list will display a preinstalled selection of basic keyword categories, however it's a simple matter to add your own (and to delete any unnecessary preinstalled ones).

A third, left hand column can be added to the interface, showing the folder hierarchy on your computer, and allowing you to search for images in specific folders. This column can be opened by going to the Display button at the top of the screen and clicking Folder

Location in the drop-down menu, and it can be closed again by going to Thumbnail View in the same menu. There's a danger when using this column that you'll inadvertently narrow down your search more than you intend, so it's probably best to only use it for search purposes once you're very familiar with the workings of the Organizer. One handy use of the column is that you can enlist it in order to move files from one folder to another – click on any image thumbnail in the main panel and drag it over to the desired folder in order to move the associated file from its current folder to the selected folder. When you do use this column for search purposes it's worth noting that you can recognize any folders that contain images that are directly accessible within the folder (that is, not within folders within the folder) – they will have a small representation of a photograph added as part of the standard folder icon. Click on a folder to display any images that are in it in the thumbnail panel (Unfortunately this ignores any images what are within folders within the folder).

One of the main uses of the Organizer, as mentioned above, is to facilitate the retrieval of files by utilising keywords, or tags, that have been added to them.

These keywords are added to files directly within the Organizer, using the panel in the lower section of the right hand column. In the panel you'll see a display of categories and subcategories. The names of these categories and subcategories are keywords. The Organizer comes with a number of these categories and subcategories preinstalled, just to give you a feel for how they appear. For instance, People is a category that contains the subcategories Family and Friends. You can remove any of these preinstalled categories, and any categories or subcategories that you devise yourself, by clicking on the category and then clicking on the bin icon at the top right of the panel. You can move categories and subcategories to new positions in the hierarchy simply by pressing on them and dragging them. You can move subcategories between categories and you can drag subcategories into other subcategories, thus demoting them to sub-subcategories, and you can promoting sub-subcategories into subcategories. Similarly you can demote categories by dragging them into a different category or subcategory. Basically you can move anything anywhere.

Turning subcategories into categories is slightly harder than the other operations descibed above, as you can't simply drag a subcategory out of a category and place it on an empty part of the panel. To turn a subcategory into a category, right click on the subcategory and in the pop-up menu that appears go to Edit Subcategory. In the panel that opens click inside the box labelled Parent Category or Sub-Category and choose None (Convert to Category).

If the file or files that you want to add the keyword to are displayed in the Media Browser panel (which they usually will be because that's why you're thinking about

specific keyword possibilities) click on the files' thumbnails. If you want to assign the same keyword to multiple files click on all of the relevant thumbnails while pressing the Control key (or the Shift key if all of the files are displayed in a continuous sequence). Then type the appropriate keyword into the box that contains the label Tag Selected Media (When you click inside the box a list of pre-existing keywords will pop up in a menu, however when you start typing it will disappear). The resulting tag will be added to the selected files, and the tag itself will be deposited in the keyword category called Other. This isn't a very useful category for it to be in, I think you'll agree, so it's a good idea to drag it out and place it into a more appropriate category. (It's possible to create a tag directly in the appropriate subcategory by clicking on the subcategory and then going to the large plus button at the top of the categories list. Then click on the New Keyword Tag command that appears in the pop-up menu. There's only one thing against using this route – it doesn't automatically include a tiny photo of the tagged image in the keyword, which the other route does. Instead you just get a nasty looking question mark unless you navigate to an appropriate image).

You can then create new categories or subcategories by pressing the large plus sign or the small plus sign (with the angled arrow next to it) at the bottom of the keywords panel. The small plus sign creates a new subcategory within whichever category or subcategory is currently selected. (So say you had a category called France with a subcategory called Paris in it, if you clicked the small plus sign while the Paris subcategory was selected you'd be able to make a sub-subcategory within the Paris subcategory called Eiffel Tower, giving a hierarchy of France>Paris>Eiffel Tower). Clicking the large plus sign creates a new subcategory one step above the selected subcategory, rather than one step below it as above – in other words it puts the selected subcategory inside a higher subcategory. Using my example of files about France, if you pressed the plus sign while Paris was selected you'd be able to create a subcategory called, say, Cities, so the hierarchy would be France>Cities>Paris. If a top-level category is selected when you click the large plus sign a new, independent top-level category is created (rather than placing the selected category inside the new category). Similarly, a new, independent category is created if no categories or subcategories are selected when the large plus sign is clicked.

Should you want to move any keywords into more relevant categories simply press and drag on the keyword and move it onto the category or subcategory name that you want to include it in. You can move any categories or subcategories around in this manner.

When you search for files that contain a particular keyword any categories or subcategories that contain the keyword are listed in the lower part of the left hand column. You can narrow down the number of files that are displayed in the main window by clicking on any

categories that are particularly relevant to your search. For instance, if you want to search for images of a particular type of rodent and you looked for the keyword mice, you'd be advised to click on the category mammals (assuming that you had created one) in order to filter out any images of computer mice (again, assuming that for some reason you had lots of images of such devices stored on your system).

Mac Bridge

There are several ways in which you can add keywords to Elements files on a Mac.

You can add them directly to the Elements file while it's open or you can add them via Bridge.

Let's look at how to add them directly to the Elements file first, as that way you don't have to familiarize yourself with the slightly unfamiliar environment of the Bridge interface.

To add keywords in Elements all you have to do is go to File>File Info, which will open a rather large panel that contains information about the file. Some information about the image may already be pre-entered. For instance, if you open a photo that was taken with a digital camera you'll probably be able to find lots of information about the camera that took the photo by going to the part of the panel that's labelled Camera Data (where you can find out not only which model of camera took the photo, but such details as the shutter speed and aperture that were used). The area of the panel in which keywords are entered can be found in the Description part of the panel. Simply type in a list of suitable descriptive terms for your image, with the terms separated by commas or semicolons. That's all there is to it.

Now let's look at Bridge itself.

Bridge is a separate programme to Elements, although you wouldn't necessarily realize this, as the two programmes work seamlessly together. Because they are separate, they have to be launched independently. If you use Bridge frequently you can arrange for it to open at the same time as Elements by going to the Elements Preferences panel and ticking Automatically Launch Bridge in the General section.

Make sure that the interface is set on its Essentials option in the short row of options near the top of the screen.

The Bridge interface is divided into three columns. The main, centre column shows thumbnails of any files that fall into whatever category Bridge is displaying at the time. Frequently this will simply be the contents of a specific folder unless you impose different criteria on it. The size of the thumbnails can be altered by moving the slider at the bottom right of the interface. The left hand column contains information that allows you to narrow

down or expand the range of files that are on display. The right hand column contains information about any specific file in the display that is selected (by clicking on its thumbnail).

You can use Bridge simply as a way of navigating from folder to folder on your computer, taking advantage of the large thumbnail images. Do this by clicking on the list of folders at the top of the left hand column. You can go backwards and forwards through any folders that you've navigated through by clicking the left and right arrows near the top left of the screen.

Navigating from folder to folder in this way is fine if you have a limited number of files to search through or if you have a ludicrously efficient filing system, but more often than not you'll want to narrow your search down. This is where those keywords that I dealt with a moment ago come in.

If you typed any keywords into any Elements files as described earlier see what happens when you type one of those words into the search box at the top right corner of the interface (making sure beforehand that the folder list at the top of the left column is set on the whole computer rather than a specific folder). Any files that have the keyword associated with them will appear in the image panel, regardless of which folders they are stored in.

Keywords can be added to files from within Bridge itself rather than directly while you are using Elements. In many circumstances this is the preferable route, as the keywords are easier to manage and to re-organise, and you can assign the same keyword to multiple files in one action.

To add keywords in Bridge go to the lower section of the right hand column, and click the keywords tab.

In the keywords panel you'll see a display of categories and subcategories. The names of these categories and subcategories are your actual keywords. Bridge comes with a number of these categories preinstalled, just to give you a feel for how they appear. You can remove these categories by clicking on them and then clicking on the bin icon at the bottom right of the panel. What counts as a category or a subcategory is purely a matter for your own organizational preferences. You can change subcategories into categories simply by pressing and dragging on them to take them out of their position in the hierarchy. Similarly you can turn categories into subcategories.

To add new keywords to a file, do the following.

First, click on the file's thumbnail. If you want to assign the same keyword to multiple files click on all of the relevant thumbnails while pressing the Command key (or the Shift key if all of the files are in a continuous sequence).

You can then create new categories or subcategories by pressing the large plus sign or the small plus sign (with the angled arrow next to it) at the bottom of the keywords panel.

The small plus sign creates a new subcategory within whichever category or subcategory is currently selected. (So say you had a category called France with a subcategory called Paris in it, if you clicked the small plus sign while the Paris subcategory was selected you'd be able to make a sub-subcategory within the Paris subcategory called Eiffel Tower, giving a hierarchy of France>Paris>Eiffel Tower). Clicking the large plus sign creates a new subcategory one step above the selected subcategory, rather than one step below it as above – in other words it puts the selected subcategory inside a higher subcategory. Using my example of files about France, if you pressed the plus sign while Paris was selected you'd be able to create a subcategory called, say, Cities, so the hierarchy would be France>Cities>Paris. If a top-level category is selected when you click the large plus sign a new, independent top-level category is created (rather than placing the selected category inside the new category). Similarly, a new, independent category is created if no categories or subcategories are selected when the large plus sign is clicked.

Should you want to move any keywords into more relevant categories simply press and drag on the keyword and move it onto the category or subcategory name that you want to include it in. You can move any categories or subcategories around in this manner (Any keywords that have been applied to files directly within Elements, rather than in Bridge, will be listed within a category called Other Keywords at the bottom of the keywords panel. You may want to move these in this way if you're particularly well organized).

When you search for files that contain a particular keyword any categories or subcategories that contain the keyword are listed in the lower part of the left hand column. You can narrow down the number of files that are displayed in the main window by clicking on any of categories that are particularly relevant to your search. For instance, if you want to search for images of a particular type of rodent and you looked for the keyword mice, you'd be advised to click on the category mammals (assuming that you had created one) in order to filter out any images of computer mice (again, assuming that for some reason you had lots of images of such devices stored on your system).

Organizing

Index

Index

Index

Index

Lightning Source UK Ltd.
Milton Keynes UK
UKOW021909130613

212241UK00009B/616/P